Your Body Can Talk

*How to Use Simple Muscle
Testing to Learn What Your
Body Knows and Needs*

The Art and Application
of Clinical Kinesiology

Susan L. Levy, D.C.

and

Carol Lehr, M.A.

HOHM PRESS
Prescott, AZ

ISBN: 0-934252-68-8

Library of Congress Cataloguing-in-Publication Data:

Levy, Susan, 1952–
 Your body can talk : how to use simple muscle-testing to learn what your body knows and needs : the art and application of
clinical kinesiology / Susan Levy and Carol Lehr.
 p. cm.
 Includes bibliographical references and index.
 ISBN: 0-934252-68-8 (alk. paper)
 1. Applied kinesiology—Popular works. 2. Muscle strength—Testing.
I. Lehr, Carol, 1953– . II. Title.
RZ251.A65L48 1996
615.5—dc20 96-14124
 CIP

Typesetting, Design and Layout: *AV Communications*, Mesa, AZ

Cover: Kim Johansen, Black Dog Design

HOHM Press
P.O. Box 2501
Prescott, AZ 86302
520-778-9189

Disclaimer: Any information in this book is not intended to be a replacement for medical advice. Any person with a condition requiring medical attention should consult a qualified health professional.

THIS BOOK IS DEDICATED to our husbands:

Dr. Burt Espy

and

Peter Muncaster

The more I can love everything — the trees, the land, the water — my fellow men, women and children — and myself, the more health I am going to experience and the more of my real self I am going to be.
 O. CARL SIMONTON, M.D.

ACKNOWLEDGMENTS

THIS BOOK COULD NOT have been possible without the contributions of so many people. We are indebted to the pioneering doctors who've shared their professional expertise through years of research. They include the late Dr. Alan G. Beardall, Dr. George Goodheart, Dr. John Thie, and Dr. John Amaro, who provided a clear understanding of acupuncture principles and organ relations. We especially want to acknowledge Dr. Burt Espy, our primary consultant on procedural facts, for his contribution to the field of Clinical Kinesiology.

For mentoring us through the initial phases of the book project we thank Dr. Mary Kouri whose extremely helpful advice and editorial expertise were invaluable. For her keen sense of the publishing world, her support and helpful suggestions, we thank our literary consultant, Alice Knight.

Our deep appreciation to the professional staff at Hohm Press for their unending support and faith in this book, especially our editor, Regina Sara Ryan, for her gentle guidance and for the trust she placed in these novice authors. To Christopher Beardall for providing editorial contributions and valuable insights on the life of his father, Dr. Alan Beardall. Our gratitude also to Dr. William Crook, Dr. Guy Abraham and Dr. Theresa Dale for graciously sharing their information and research. Special thanks to Jim Butler for his outstanding contribution on EMFs. We thank Dr. Amaro, who graciously allowed us to reproduce the excellent illustrations. Also to our graphic designer, Tom Mares, for his expertise and countless hours arranging the graphics in this book and to Regis University reference librarian Judy Anders for her valuable research assistance.

During the years it took to write this book, many wonderful friends stood by with encouragement and love. They are Nancy Mills, Alison Harder, Susan Forbes, Ken Lesser to name only a few. Also, to our families who provided daily unconditional support and devotion. And again, for their unwavering love and sacrifice during this project we thank our husbands, Dr. Burt Espy and Peter Muncaster. Finally, to the many patients whose stories we share within these pages we express our gratitude to them for inspiring our lives and, hopefully, the lives of the thoughtful readers who will read this book.

CONTENTS

FOREWORD

THE STORY OF CLINICAL KINESIOLOGY (CK) is the story of Alan G. Beardall, BS, DC. It begins in 1968 when Dr. Beardall graduated from the Los Angeles Chiropractic College. His desire to offer his patients the most effective technique for their particular problems led him to advance his study at over 100 different technique seminars. Each technique seminar was designed to teach the methods of dealing with one or more conditions of the body—low back pain, for example. Despite his vast range of skills, however, Dr. Beardall became increasingly frustrated by his inability to determine precisely which chiropractic technique to use for an individual patient's needs, since many had complaints for which the generally recommended technique would do little or nothing.

Clinical Kinesiology is the outgrowth of the failure of any one system of treatment to solve all problems, since it gives the doctor and the patient the ability to determine the appropriate technique, as well as the appropriate time in which to administer it. (The most important criteria is timing. There is a "...time for every purpose...," as the great prophet wrote.)

Clinical Kinesiology looks upon the body as a living biological computer—one with numerous complex biological functions and enormous stores of memory. Meticulously observing the blueprint of the body, the Clinical Kinesiologist searches for the underlying causes of the apparent symptoms. Once finding the "errors" at the causal level and examining the ways in which the body has adapted based on those errors, a technique can then be chosen to specifically treat the underlying cause.

In treating underlying causes Dr. Beardall developed the most extensive research, to date, on the proper functioning of 576 muscles of the human body, together with specific methods of testing each muscle. He has invented more than fifty Core Level™ nutrients to address nutritional deficiencies. Dr. Beardall is further credited with the development of over 300 handmodes and seventy therapies specific to Clinical Kinesiology, and has authored ten books on the subject, all for physicians.

The book you are about to read is about Clinical Kinesiology. Dr. Susan Levy, D.C. and Carol Lehr have here produced one of the finest texts on the subject. I recommend it as a "must have" for any person interested in Clinical Kinesiology.

Christopher Beardall, B.S., D.C.

INTRODUCTION

A STRONG JOLT AND the sound of crunching metal shattered my peaceful morning drive. I knew instantly I'd been rear-ended. Being a doctor, of course I hopped out to see if the driver of the other car had been hurt. Luckily, she was fine, so I proceeded on to my office and a full day of treating patients.

As the day wore on, however, I began experiencing a bit of neck and upper back pain, so I scheduled some basic chiropractic treatment which addressed the spine and muscles. I felt confident the problem wasn't serious. I was wrong. The pain persisted on and off for the next five years! Many times, by the end of a long day of treating others, areas in my middle back were spasmed and burning. I kept treating and hoping.

Then, in 1989 during an acupuncture seminar, I met a colleague who gave me new hope. Dr. Burt Espy had trained for four years with Dr. Alan Beardall, the originator of Clinical Kinesiology energetic muscle testing. Although I had previously observed at Dr. Beardall's clinic, I'd never been evaluated with the technique.

When he heard my symptoms, Dr. Espy offered to assess and treat my mid-back pain. With Clinical Kinesiology testing, he "asked" my body what was wrong and *my body talked back*. Based on what my body "said," Dr. Espy quickly determined that my problem didn't stem from the accident but from a heart imbalance. That discovery marked the turning point in my recovery and the beginning of my personal experience with this amazing method for accessing the body's wisdom, known as Clinical Kinesiology.

In a few months of treatment I fully regained the health I had lost five years before. My quick recovery inspired me to begin learning this intriguing technique for myself. With my condition dramatically improved, and new knowledge gained, I was so impressed with Dr. Burt Espy that I married him!

For many years prior to my experience with Clinical Kinesiology, I'd integrated a holistic viewpoint into my ten year practice of chiropractic treatment. I'd conducted numerous classes, including weekly lectures and day-long seminars—for my patients, the public, special groups of nurses and even medical doctors—which enabled me to educate others on wide-ranging topics involving alternative healthcare.

After a year of extensive study with Dr. Espy and others trained in the method, I began incorporating Clinical Kinesiology evaluation, processing and testing procedures into my practice. I also began educating my patients on this new method.

One of those patients was Carol Lehr, a producer at local Denver television station KCNC-TV. She too suffered from acute mid-back pain and stiffness, yet no previous treatment had provided a complete cure. Carol was shocked yet intrigued by her first Clinical Kinesiology evaluation. I assured her that Clinical Kinesiology provided a new method of diagnosing and healing problems on a deeper level and more expediently.

Naturally, with her television background, Carol was automatically "programmed" to keep her eyes and ears open for new information. Clinical Kinesiology offered an alternative—a healing method people would surely want to know about. Her first reaction? "We have to tell somebody about this!" No, we couldn't keep this amazing new tool a secret any longer. Together, Carol and I decided that if patients were expected to make educated choices regarding healthcare, they couldn't do it without information. Someone needed to get the ball rolling—and that "someone" would be *us*. This book is the result of our partnership.

For me this book would not have been possible without the help of a professional writer who had experienced Clinical Kinesiology. A deep understanding of how Clinical Kinesiology affects her body allows Carol to write from that place of experience.

The message of this book is simple: "Yes, there is help. Yes! You can solve your health problems. And yes, Clinical Kinesiology can help you to hear what your body already knows about health and well-being."

OVERVIEW

PART ONE

The initial chapters of the book serve as an introduction to the energetic system which links mind and body. In Chapter One, learn how the body can talk, and therefore be used as a diagnostic tool to measure body "function," along with specific treatment modes that heal energetic imbalances. In Chapter Two, discover how Clinical

Kinesiology expedites Chinese acupuncture and facilitates realignment of energetic imbalances.

Chapter Three will help you understand the critical role emotions play in maintaining physical health by presenting the Chinese Five Element theory, which interprets organ/emotion relationships. In Chapter Four, learn how Clinical Kinesiology diagnoses and allows healing of Chakra imbalances through the use of Bach Flower Remedies.

PART TWO

Armed with a deeper understanding of your body's multileveled energetic system, Chapters Five through Eight will offer specific methods of fighting disease through a healthy and well-functioning immune system.

Chapters Five and Six show how Clinical Kinesiology diagnoses energy sensitivity to foods, along with ways of protecting the immune system from unnecessary drugs, antibiotics and immunizations, which further undermine immune function.

Rebuilding the body's ecology following an overgrowth of unhealthy bacteria or *Candidiasis* is the focus of Chapter Seven, while Chapter Eight provides recommendations for maintaining the integrity of the immune system through safe exposure to unhealthy electromagnetic fields or EMFs.

PART THREE

The last three chapters are specifically devoted to optimal health for male or female energetic systems. Chapters Nine and Ten for women address solutions to premenstrual syndrome and a healthy transition to menopause through natural balance of body cycles. Chapter Eleven educates male readers on steps to maintain overall health throughout life.

Self-testing instructions and treatment recommendations for unique health problems may be found at the end of each chapter.

PART FOUR

A Resource and Product Guide contains a list of products which complement the Clinical Kinesiology diagnostic method and are especially appropriate in the healing process. An Association and Referral Guide provides a list of organizations from which interested readers can help locate Clinical Kinesiology practitioners, or alternative healthcare providers who use similar or related diagnostic techniques. Endnotes are also provided for cross-referencing purposes and to identify the sources used in writing the book. Additional book lists of suggested reading are also available at the end of each chapter.

Carol and I are so thankful for this wonderful legacy of Clinical Kinesiology left by Dr. Alan Beardall—the "daVinci" who has painted a portrait of the human body, the intricacies of which we have only begun to discover. Tragically, Alan Beardall was killed in an automobile accident on December 1, 1987 while on a teaching assignment in England.

For practitioners and their patients searching for long-awaited answers to renewed health, Dr. Beardall's method lives on deep within our bodies. By inspiring you to learn the language in which your body can talk and thereby get in touch with your body's own unique energetic system we hope you will begin to use that system for new understanding, new energy, and new hope for a healthy future.

Susan L. Levy and Carol Lehr

I

Your Body-Mind Energy System

Clinical Kinesiology

CARLA, A FORTY-YEAR-OLD MOTHER of four, was desperate. She firmly believed she wouldn't live to see her children become adults. On the day she hobbled into my office she was taking no less than twelve prescription drugs. Over the years, several different doctors had "diagnosed" her condition as everything from rheumatoid arthritis to Lyme disease to lupus. Despite the diagnoses and medications, her swollen joints and excruciating knee pain quickly progressed from bad to worse. Carla came to my office as a last resort before ordering a wheelchair.

I gathered her history and long list of symptoms, then asked her to lie down on my treatment table, raise one arm and resist the pressure I applied to that arm as I attempted to muscle test her normal strength. I instructed Carla to place the open palm of her other hand over her painful knee area as I performed the muscle test a second time. This time, Carla's previously strong arm muscle responded helplessly weak.

More simple tests followed. Within minutes I pinpointed Carla's "knee" problem as stemming from a chronic kidney imbalance. Her medications and unhealthy diet had compounded the stress to her energy-depleted organs. Left untreated, the imbalance had reached the point where Carla could barely walk.

With the problem identified, I performed two or three more tests and quickly determined the appropriate treatment. The plan for Carla

would involve acupuncture; vitamin, mineral, and herbal support for the kidneys; simple detoxification and additional treatments for symptom complexes relating to other organs.

Today, the idea of Carla in a wheelchair is unthinkable. Symptom-free and medication-free, she exercises, takes care of her four children, prepares healthful meals, and provides informational tours of her neighborhood health food store. With a renewed sense of self-confidence, Carla now trusts her body's power to heal itself. She is one of many who have experienced the healing benefits of Clinical Kinesiology diagnosis and treatment.

WHAT IS CLINICAL KINESIOLOGY?

The doctor of the future will give no medicine, but will interest patients in the care of the human frame, in diet, and in the cause and prevention of disease.
THOMAS EDISON

On the frontier of the healing arts, Clinical Kinesiology muscle testing (the simple "straight arm" test described above) applies non-traditional, bio-energetic methods which allow you to unlock or ascertain your body's hidden messages, and obtain insightful answers to health problems you've been searching for through more traditional approaches.

Through this unique feedback system of muscle testing, you can learn how to interpret your own special "body language." Your body can "talk" simply through changing the response of the muscle test. Ask the body specific questions and you can get answers to growing health concerns, and gain valuable information which cannot be attained through traditional types of laboratory testing or symptom analysis.

Clinical Kinesiology taps into an early warning system that displays changes in body *function* before they appear physically. This new diagnostic method evaluates energetic imbalances or dysfunction "before" heart disease, cancer, or other serious disorders have the chance to develop. Using this simple noninvasive energetic-based information, a practitioner may look into the pre-disease stage and gain insights into the changes necessary. Meanwhile, traditional lab tests and physical symptoms may still be showing up normal.

Clinical Kinesiology also indicates changes necessary to pinpoint specific modes of treatment such as acupuncture, magnetic therapy, nutritional recommendations, and other holistic protocols which strengthen, cleanse, or rebalance the energy system of the body,

thereby "releasing" the energy and abating any impending physical change or symptom. Since your body works like a powerful "living computer," each microscopic cell and bit of energy within that cell contains intelligence regarding body function. This vibrating energy alone exerts tremendous power to produce solutions to complex problems in the body. Clinical Kinesiology employs simple ways to tap into these same electrical connections that run the "software" system in your body.

THE ORIGINS OF CLINICAL KINESIOLOGY

Clinical Kinesiology monitors and tests the energetics of the body. The word Kinesiology or *kinetics* originates from the study of muscle and joint movement. From original muscle response research called Applied Kinesiology, developed by Dr. George Goodheart, D.C., in 1964, simple body movements (especially muscle movements) were used to evaluate physical functioning. Over fifty-four muscle tests were discovered and correlated to other reflex (related) points to organs and spinal segments.

In 1968, Dr. Alan Beardall, a graduate of Los Angeles Chiropractic College, became one of Dr. Goodheart's most brilliant protégés. While treating a famous marathon runner, Beardall discovered that individual muscles did not function as one unit. Through study, personal observation and testing procedures, he identified functional divisions *within* muscles, and went on to isolate reflex points which further differentiated those muscle divisions. Beardall's first paper presenting his exciting new findings was published in "Selected Papers of the International College of Applied Kinesiology."[1]

In 1975, Beardall began innovating and testing the Clinical Kinesiology method, discovering over 250 specific muscle tests while concentrating primarily on related muscle *reflexes*.

Following his first paper, Beardall also published five muscle testing instruction books from 1980 to 1985.[2] His new diagnostic method would thereafter be officially known as Clinical Kinesiology.

In 1983, while conducting a muscle test on a patient, Beardall noticed a unique phenomenon. The patient touched a painful area with an open hand and the muscle test indicated weakness. In a second test on the same injury, the patient shifted the position of his

Health may be regarded in a general sense as a robust existence, a feeling of optimum vitality and strong resistance, a state of alertness and awareness. I like to think of it as being able to do physically whatever you envision for yourself mentally.

DR. ALAN BEARDALL

thumb and small finger. As a result, the muscle registered strong. Beardall instantly saw an exciting relationship between the hand and finger positions (*handmodes*) and the body's reaction.

This discovery allowed Beardall to further modify Clinical Kinesiology and extend his method of diagnosis to discover deeper, more underlying imbalances in the body's energy patterns. Today, many hundreds of handmodes have been discovered as "words" in a new body language.

Dr. George Goodheart had contributed all of the groundwork on Applied Kinesiology muscle testing from the Chinese acupuncture philosophy. By 1975, Goodheart became so inundated in other research projects that Beardall undertook personal research efforts himself which achieved a new measure of understanding eventually surpassing previous information from muscle testing research. Drawing from a vast education, experience and intuition, Dr. Alan Beardall integrated all major chiropractic techniques, numerous adjunctive therapies such as acupuncture, nutrition, and homeopathy, including Flower remedies and Chinese Five Element diagnostics into his verification research of Clinical Kinesiology.

"Health," according to Dr. Beardall, "may be regarded in a general sense as a robust existence, a feeling of optimum vitality and strong resistance, a state of alertness and awareness." He liked to think of it as "being able to do physically whatever you envision for yourself mentally."[3]

Clinical Kinesiology provides a new and fascinating way of communicating and healing through the inseparable energy linking mind, body and spirit.

BODY LANGUAGE:
WHY CLINICAL KINESIOLOGY WORKS

In the Chinese system of acupuncture, every reflex point on your body contains electrical potential. Through stimulation of acupuncture points, the treatment re-aligns the energy in the body.

Dr. Alan Beardall's Clinical Kinesiology method also relies on the extremely precise energy connection between mind and body. Your body has been pre-programmed to sustain life. Each cell, body part, organ and energy system is genetically encoded to work for

continued survival of the organism. Your brain acts as a giant "switching" center to channel this energy into action to maintain body function, coordinate messages, store data and retrieve information. As connections are made, energy flows and intelligence is communicated. Your body "talks," thus the "tapping in" to this communication through muscle testing "works."

THE BRAIN AND THE BODY WORK TOGETHER

The brain processes information precisely like a binary (functioning on a system of "two") computer systematically turning "on" or "off" in relation to any given subject, or perception. Based on the Clinical Kinesiology test, we're looking for a "lock" or neurological reflex that's "on" or "off." This makes a muscle test that is strong (on) or weak (off) a simplistic, yet invaluable diagnostic tool.

What you make of your life is up to you. You have all the tools and resources you need. What you do with them is up to you. The choice is yours.
RULES FOR BEING HUMAN, ANONYMOUS.

If I say to you, "Don't think about pink elephants," you *have* to think about pink elephants! I just turned "on" the pink elephant switch in your brain. It will stay on until your brain determines the next priority, or the next important thing that it needs to think about. Then, you'll drop the "pink elephants" and move on.

When a practitioner of Clinical Kinesiology taps into your body's software system by testing a designated muscle, the muscle responds either "strong" or "weak;" the brain's way of saying "on" or "off." If a muscle proves weak during the testing of a problem area or the touching of an acupuncture point, you've uncovered a relationship which may be a clue! Many underlying stimuli cause your muscles to react as they do.

All messages from your sensory, visual, auditory and other nerve endings, including all thoughts, are processed through the brain. The brain must immediately decide, "Yes, that's important," or "No, that's secondary. Let's file that information in the subconscious in case it's needed later." (Relax, it doesn't really matter that you retain every detail in your conscious mind. After all, who reads all the junk mail?)

The part of your subconscious mind which regulates the special software program in your body is called a Reticular Activating System. While not something you have to remember or think about very much, the Reticular Activating System functions as a filtering

system—working to filter data into either your conscious or unconscious mind as needed.

Imagine getting dressed each day, feeling your clothing briefly on your skin. Now, imagine having conscious and intense awareness of that cloth all day long? Imagine "feeling" all your body functions—the cellular processes, or the coursing of blood through your veins? You'd constantly be distracted and couldn't function well. Mercifully, your brain filters the unnecessary information into your unconscious mind—storing the data in your Reticular Activating System. Needed information lies just below the surface for recall and, specifically, to monitor the body. If the system records an imbalance, you're notified immediately—the body-mind works together to create a symptom.

THE RIGHT TEST

In studying symptoms, Dr. Alan Beardall searched for truth and found that the key to diagnosing any problem with Clinical Kinesiology depended on the energy feedback from each individual's unique body. Dr. Beardall monitored "yin" and "yang," two forces of opposing energy in motion, taking into account each person's changing balance. The essence of treatment, he concluded, must be appropriate to the current state of the body at the time of testing. Beardall discovered this uniqueness through testing and monitoring the energetic activity of the body, rather than drawing conclusions from staid academic observation or what he "thought was needed" based on initial symptoms. Alan Beardall believed that the body *knows* what's going on internally, what is needed and how to heal itself.

Unfortunately, many people today spend huge amounts of money on various laboratory tests, including CAT scans, blood tests, MRIs, and virtually every other known test in the medical repertoire. Even then, most never find the true solution to "functional" problems which go undetected by modern medicine—because these tests do not take into account the energetic patterns that proceed the physical—until they become full-blown pathology or disease.

Clinical Kinesiology includes the testing component for each individual which translates what is going on energetically in the body. The Reticular Activating System continually evaluates, sorts, and

prioritizes possible danger, which becomes the feedback or "body language" interpreted through the muscle test. It is simple in concept and design. No longer must you depend on chemical drugs or questionable surgery to obtain answers. Your body can talk, so, simply ask it! Information from your software system relays hidden, energetic messages to the surface for consideration and indication of healing through Clinical Kinesiololgy muscle testing.

SYNERGY OF THE BODY

Like a jigsaw puzzle, each "piece" of your body connects to another "piece." However, modern medicine believes it can extract a piece here or there and simply discard that piece without problems. In contrast, Clinical Kinesiology relies on the synergy (the combined action or function) of all parts of the body, and recognizes that there are no "quick fixes" to maintaining your whole body. Everything affects everything else.

A cheerful heart is good medicine, but a downcast spirit dries up the bones.

PROVERBS

Only by learning the principles of how your bioenergetic system works can you happily and healthily resolve that *you are much more than just individual body parts*! Clinical Kinesiology reveals the link between pain or symptoms in one part of the body and the underlying cause of that pain or symptom. Often, the cause may not lie in the same area where the symptom manifests.

For example, think about your organs. While their functions are vitally important, they contain few pain nerve fibers. The majority of pain fibers rest on the surface of the body. Consequently, most people feel more in touch with the outer than the inner body. On one hand, too much conscious awareness of the body's organs would be distracting. On the other hand, the organs have so few pain and sensory fibers that one could remain unaware and detached from recognizing energetic imbalances affecting the organs.

All unbalanced organs refer pain externally to corresponding energy meridians on the surface of the body. The locus of pain depends on the segment of the body from which that particular organ developed embryologically. Theoretically, internal organs in the lower half of the body refer pain to the surface of the lower body. Upper organs refer pain or symptoms externally to the upper body.

EXPRESSIONS OF THE HEART

The heart represents one of the body's most important organs. Dr. Burt Espy, former colleague of Dr. Beardall, confirms that during body development in the womb, the heart originated in the neck and upper thorax. Thus, the heart refers energy mainly to the base of the neck, over the shoulders, to the pectoral muscles, down the arms, and directly beneath the sternum.

In the same way, according to Dr. Espy, minor or sub-clinical heart imbalances refer pain throughout the neck, shoulder, arm, wrist, elbow or any point on the heart meridian. Pain may also be experienced in the chest itself.

Many times, heart "functioning" may be out of balance, without signaling pathology or disease. To explain further, if over half a million people in the United States die each year of heart attacks, with statistics indicating that fifty percent of them had "no previous symptoms," does that mean they had no symptoms, or that no one knew what those symptoms were?

It is unreasonable for a person to live healthily for many years with no apparent heart problem and then suddenly suffer a fatal heart attack. Does a car wear out in one day? No, it's a lengthy process. Your body doesn't wear out in one day either, and neither do any of its parts.

Many people experience chest pain but simply brush it off. "Oh," they say, "it's just indigestion." Their doctors may even concur. Undiagnosed, they go on thinking their pain is indigestion until they suffer a heart attack.

Many times, when doctors perform an EKG and a blood test for heart problems and nothing shows up, they automatically rule out the heart. Take caution: if your ongoing symptoms don't medically show severe heart pathology, look at what else they could mean.

Dr. Espy has discovered that many people experience common symptoms such as fatigue, mid-back pain, numbness, swelling, wrist pain (medically known as Carpal Tunnel Syndrome), yet are not uncomfortable enough to seek treatment. However, few realize the potential seriousness of the symptoms until it's too late.

George's Story

One morning, a vague *inner knowingness* stirred in George, a fifty-five-year-old golfer. He abruptly informed his wife Flora, "I think

I'd better get a checkup." His doctors promptly scheduled an entire cardiac workup including stress EKG, cardiac enzyme evaluation, blood test, and chest x-ray. The results came in and all were "normal." Sadly, a few weeks later, George suffered a fatal heart attack.

Were George's medical doctors correct in assuming there was no problem prior to his heart attack simply because all his tests came back "normal"? Or, did they miss something? Let's assume we look at George's medical history for clues leading up to his fatal attack; clues that no diagnostic machine could possibly detect. No machine, that is, except for the most sensitive diagnostic tool ever created...the human body!

Fifteen years ago, George played several rounds of golf each week. One day, he developed elbow pain. Unbeknownst to him, his heart was already energetically out of balance. The lack of sufficient energy running through his heart meridian, and added muscle stress from golfing, further compounded George's elbow pain. He decided then and there to "quit playing golf." With his elbow no longer physically stressed on top of his heart imbalance, his elbow pain eventually faded out.

Five years later in a serious car accident, George suffered a whiplash injury which resulted in a great deal of neck pain and stiffness. "Well," George reasoned, "it may take awhile, but this pain will go away too." What George didn't know was that the whiplash injury superimposed over his weak or unbalanced heart meridian would become much more serious and longer lasting than a trauma to an area with no previous imbalance.

Consequently, George's whiplash pain and his aching, stiff and burning muscles continued for two or three more years. He could have chosen any number of treatments, but finally decided he'd "...take a few aspirins every day." Afterwards, George didn't notice the pain quite as much.

George suffered four or five episodes of fairly severe chest pain in later years. Again, he chalked it up to "...just something I ate!" Thus, George battled a whole string of symptoms over the years, yet no one picked up on them; and George himself had never been taught what those symptoms meant, or how important they really were as precursors to a heart condition.

We are all under-exercised as a nation. We look instead of play. We ride instead of walk. Our existence deprives us of the minimum of physical activity essential for healthy living.
JOHN F. KENNEDY

Symptoms Unnoticed

Millions of people trained in CPR (cardiopulmonary resusitation) know the referred pain patterns of the heart meridian. CPR students are taught that prior to a heart attack the victim might notice shoulder, elbow, arm or neck pain. They may also experience upper back or jaw pain, headache or nausea. The heart meridian continuously sends energy to all those areas. However, most CPR certification classes do *not* teach students to look more broadly at what those symptoms mean throughout life.

Imagine how George's life might have changed if he or someone else had been able to diagnose these symptoms early. George might have made the necessary changes that would have allowed his heart to grow stronger instead of weaker.

Your heart, your body, your spirit communicates with you. If you can only begin to understand its language you won't miss those early warnings that may one day save your life.

If Clinical Kinesiology testing had been widely used for the past thirty or forty years, thousands of people like George would not have died from heart attacks. Most would have known how to read their symptoms and heed the messages being sent. In correcting and making changes in these seemingly minor afflictions, they would have lessened and even dissipated their pain; their bodies would have changed to grow stronger; and their lives made longer and healthier.

ENERGETIC AND PSYCHOLOGICAL THERAPIES AND TREATMENTS

Your body contains the information for what's wrong—along with what's needed to cure it. When an initial imbalance is confirmed, Clinical Kinesiology testing may also be used to determine which aspects of treatment will be most helpful. Dr. Beardall identified three main categories of treatment based on a chemical, structural, or electromagnetic response model of the body.

CHEMICAL

Imagine an island floating in a vast ocean. The whole ecology of the island, including the water, coral reefs, fish, trees, air, sun and sky

is interdependent. Each element complements and sustains every other element. Ecological balance and survival requires the synergism of all. Your body is like this island. Its survival depends upon a balanced ecology: all nutrients working together to support the whole.

Daily, the body faces problems which reflect inadequate nutritional support. Such deficiencies promote a wide range of biochemical reactions. Chemical imbalances diagnosed through Clinical Kinesiology testing require treatment of biochemical components in the body. Diet changes and the addition of appropriate nutrients will support the body's survival.

Since all nutrients work in a synergistic relationship with the body, Beardall developed Nutri-West® Core-Level™ nutrients to strengthen the body. (These nutrients are unique because Clinical Kinesiology testing was used to formulate ingredients and dosage.) When the body chemistry tests out of balance, a Clinical Kinesiology practitioner will recommend specific nutrients to rebalance it. In addition to the Core-Level™ nutrients, other supplements such as specific vitamins, minerals, glandulars, enzymes, herbs or amino acids may be required depending on what the body is "asking for" to heal itself. (See Product Guide.)

Food, one assumes, provides nourishment; but Americans eat it fully aware that small amounts of poison have been added to improve its appearance and delay its putrefaction
JOHN CAGE

STRUCTURAL

A variety of chiropractic treatment methods may be used to address imbalances in body structure, which include the bony joints, muscles, tendons, and ligaments. Insufficient energy balance during the fetal stages of body development often affect the body's muscular and skeletal structure, specifically in cases of spinal abnormalities such as scoliosis (a curvature of the spine).

Clinical Kinesiology identifies the structural imbalance and pinpoints the specific areas and types of tissues involved and what is needed to changes these imbalances. Structural treatments involve gentle chiropractic adjustments, muscle work, therapeutic massage, and others.

ELECTROMAGNETIC

Many times, Clinical Kinesiology diagnosis indicates an electromagnetic or energetic imbalance in the body. Electromagnetic imbalances

usually implicate the organs and acupuncture meridians. Different treatment methods can bring about specific results, however, Clinical Kinesiology electromagnetic considerations rely primarily on acupuncture, herbal and homeopathic philosophies of treatment (see Chapter Two). Therapeutic magnets may also be used to realign body energy, along with laser therapy and Neuro-emotional remedies (see Chapter Three) or Flower remedies—including Bach (see Chapter Four), petite, California and Western. These particular remedies work on an energetic level rather than a chemical/nutrient level. (Homeopathic remedies, which are taken under the tongue, are absorbed directly into the bloodstream without digestion. Although synergistic with the body, they are assimilated and function differently than nutrients.)

PSYCHOLOGICAL KINESIOLOGY

It's widely thought that more than half of all medical complaints contain a strong emotional or psychological component. Identifying and reprogramming such components is the goal of Neuro-Linguistic Programming practitioners.

Robert M. Williams, M.A. of Psych-K Centre™ in Denver, Colorado, has merged Neuro-Linguistic Programming and a branch of Kinesiology called Psychological Kinesiology to provide training courses in stress management.

NLP practitioners like Williams help people tap into unconscious thought and behavior patterns in an attempt to alter psychological responses which aid healing. Incorporating Kinesiology muscle testing, Williams utilizes NLP, auditory, kinesthetic, and visual inputs to reverse negative belief systems.

MUSCLE TESTING RESEARCH TODAY

Other recent research on muscle function as it relates to muscle testing has been completed by Dr. Craig Buhler, D.C. at the University of Utah. Dr. Buhler, the primary research associate who helped create Dr. Beardall's early muscle testing books, is team Chiropractor for the professional basketball team, Utah Jazz, and a fellow at the University of Utah Medical School.

Today, there are about three hundred Clinical Kinesiologists in the United States. Many of these practitioners (including Dr. Beardall's original protégés and his son, Dr. Christopher Beardall) have developed modifications of Alan Beardall's original work and offer training classes for other doctors.

While it requires much study to become a fully trained, professional Clinical Kinesiology practitioner, limited self-testing may be performed by interested laypersons and others. This book will teach you some simple and immediate methods which you can use to get your body to talk about what it knows and needs for health and happiness.

LISTEN TO YOUR BODY TALK

A. LISTEN TO YOUR SYMPTOMS

The first step in using Clinical Kinesiology is to begin listening to your body by recognizing the importance of your symptoms. Remember, every symptom in your body constitutes a signal—a warning that something is not quite right.

Our remedies oft in ourselves do lie.

SHAKESPEARE

Imagine driving your car when the oil warning light goes on. If you pay attention to the "symptom," you will stop, check the oil and supply more oil if necessary. After taking the appropriate steps, you're able to keep driving as usual.

But, if you ignore the "symptom"—or worse yet, try to cover it up by unhooking the wire that makes the oil warning light work, you'll only cover up or ignore the message. If you continue to drive, you may also ruin the engine of your car.

When you notice a symptom, it's your body computer flashing its warning light signaling that you may need to make some changes. Somewhere, something needs to be improved, balanced, or regulated. Allopathic medicine often says, "Symptoms? That's all there is to the problem! Let's get rid of them." To modern medicine, symptoms lie only on the surface, and are routinely eliminated with drugs or surgery! In essence, from the viewpoint of Clinical Kinesiology, *symptoms* are your friends—little warning messengers that should be listened to. Pay attention to your symptoms and regard them as clues. The more carefully you listen to your "body language" the more you

will come to know what those symptoms mean and how to treat
them. Clinical Kinesiology will show you how—through muscle test
changes and handmodes related to the symptoms. With Clinical
Kinesiology you can begin to achieve real insights about the
interconnectedness of problems; opening and creating the
opportunity for a new and balanced state of health by making the
changes indicated instead of merely covering up your symptoms.

Observe your symptoms cautiously. What appears on the sur-
face may be an important indicator of unseen problems beneath the
surface. The size of most icebergs in Arctic waters can be deceiving.
Ninety percent of a massive iceberg may float silently underwater,
while only ten percent appears in view.

Generally, the problem is *not* where the pain is, as we saw ear-
lier in George's case. Classically, acute problems are of local origin.
Chronic problems manifest distantly from the pain site. Clinical Ki-
nesiology testing perfectly utilizes your mind-body computer in
uncovering underlying causes of symptoms; it's simply the tool re-
lied on to detect pre-stage dysfunction to disease, which your
symptoms represent.

The problem is not where the pain is.

Dr. Burt Espy

B. LISTEN TO THE STRATEGY OF ADAPTATION

The second step in using Clinical Kinesiology is to recognize that
your body's primary method of survival often requires that it alter
its own state of physiology from time to time. Lacking adequate en-
ergy to support the body, the body's living computer develops
adaptive strategies to continue operating at reduced efficiency and
robustness, Dr. Beardall discovered. When unable to operate at op-
timal function, the body performs an "adaptation," the process of
removing current energy patterns from affecting current body func-
tioning rather than allowing itself to become open to disease. Clinical
treatment of such a reaction entails healing indirectly by removing
layer upon layer of adaptations until your body's own innate intelli-
gence is once again able to heal itself.

An oyster represents a good example of an adaptation. In order
to tolerate the tiny grain of sand in its shell, the oyster makes its
situation livable by secreting a substance known as mother of pearl.
By surrounding the grain of sand, the oyster successfully adapts to a

potential problem that once threatened its life by creating a pearl as its adaptation. The body performs the same action through rechanneling energy, changing posture or eventually accepting disease.

Treating a series of adaptations in the human body requires dissolving or breaking through those many layers of protection. Lori's story explains how Clinical Kinesiology does this.

Lori: Case Study of an Adaptation

During one of many educational seminars, I tested Lori, an audience participant with a pain complaint in her left shoulder. As instructed, Lori lay down for testing, raising her right arm perpendicular to her body. I firmly pushed against her arm while she resisted. Confirming the apparent strength or strong response of Lori's right arm as an "indicator" muscle enabled me to use it to perform further testing.

It is part of the cure to wish to be cured.
SENECA

Lori identified her left shoulder as her major area of complaint. Touching the painful area with her free hand activated Lori's "on" button in her brain. (Remember pink elephants?) Now, Lori could not avoid thinking about her painful shoulder and her "indicator" muscle instantly tested weak. In this way, her body confirmed the shoulder problem.

Lori's weak muscle response indicated an insufficient flow of available energy to one of her meridians; thus her inability *to maintain enough strength for resistance*. Her Reticular Activating System channelled the most important information, her painful shoulder, and communicated it through the Clinical Kinesiology muscle test. At this point in time, Lori's shoulder pain represented only her most noticeable symptom.

To form a complete diagnosis, I needed more specific data to move into the root of her problem. Why was her shoulder really hurting? What inner problems radiated such pain to the surface? What adaptations needed to be treated?

Each test supplied more and more data—more hidden information.

Dr. Alan Beardall, as mentioned earlier, developed specific finger positions known as handmodes, which serve as messengers or electrical connections to the brain. I instructed Lori to touch her fingers together in certain ways, and change the position of her arm. This triggered energetic reactions which enabled me to categorize Lori's problem as structural, biochemical, or electromagnetic.

I continued the investigation through a process of elimination, monitoring her body muscle responses, loading and re-loading data, and saving information in Lori's marvelous "living computer."

Using the specific handmode for organ imbalance, I instructed Lori to curl three fingers into her palm along with her index finger touching her thumb.

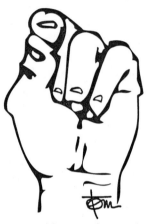

HANDMODE FOR TESTING ORGAN IMBALANCE

Weakened and wobbly, Lori's muscle reaction indicated that her shoulder pain was connected to a specific organ in her body. But which organ was involved? I tested several.

With my help, Lori located her pituitary gland and placed her hand on the area. With her mind trained on her pituitary, I tested. Her indicator muscle remained strong. Next test? The thyroid. Again, her muscle held strong. Finally, the heart. Lori resisted, but her muscle instantly responded weak.

The pain energy had traveled somewhere else since Lori's heart lacked enough pain fibers to make it actually "hurt." And so, programmed to avert a serious heart problem, the pain/energy "stepped down" a notch on the heart meridian, localizing specifically at Lori's left shoulder. In this masterful way, pain diverted away from the affected organ serves as a warning signal. (An adaptation represents one or more ways the infinite intelligence of the body strategizes to produce solutions which allow survival or protection of life.)

Lori's heart was so energetically stressed that it wanted desperately to tell her something was wrong. Through her shoulder pain symptom, her body was crying out, "Stop, slow down, pay attention to me. This is your heart speaking!" Fortunately, by using Clinical Kinesiology muscle testing, interpretation of the heart's message didn't go unheard.

As in Lori's case, most challenging heart stress symptoms generally stem from inadequate diet, negative emotions, genetic weakness and prolonged mental or physical stress. Eventually, by cutting down stress, using acupuncture treatment, adding supplemental nutrients to her diet and realigning her body through chiropractic adjustments, Lori's body was rebalanced. This made her heart happy and re-energized enough that her left shoulder stopped hurting.

Listen to your body. Adept at hiding underlying or secondary problems, it is programmed to draw attention to the most critical problem first in locations or ways you may not expect.

APPLY CLINICAL KINESIOLOGY RIGHT NOW

When people first see the Clinical Kinesiology muscle test being performed they often experience shock and disbelief. Reactions to the procedure range from, "It looks kind of weird!" to "There has to be some trick!" Or, they challenge that the "testers" are not testing the muscles with consistent strength.

When one is pretending the entire body revolts.
ANAIS NIN

The principles of Clinical Kinesiology testing remain simple:
- The person performing the testing asks questions and tests the body's response through strong or weak indicator muscles.
- The individual being tested communicates the reservoir of data (all the internal information about his or her particular body function) through the language of muscle responses.

Through self-testing you can discover:
- Which specific energetic imbalances or chemical sensitivities exist in your body.

- The health status of various organs, acupuncture points, and meridians.
- The specific and ideal treatments which will enhance your health.

PRE-CONDITIONS FOR ACCURATE TESTING

Before beginning the Clinical Kinesiology muscle testing procedure, certain checks and balances may be required to optimize the accuracy of your test.

1. *Make sure the person being tested is not distracted by any other activity.*

 A simple activity such as gum-chewing can divert the conscious mind, adding an unwanted stimulus into the temporomandibular jaw joint (which holds many nerve endings leading to the brain). If a test subject had a history of problems with the jaw joint or bite function, a negative input might be sent into the brain, resulting in a weak muscle test. The results of this test would not reflect a "true" response from the muscle.

2. *Put aside any items which may cause a negative influence on the test-subject's electromagnetic system.*

 The body's electromagnetic system is extremely sensitive. A conflicting influence in a subject's energy field, such as a bottle of prescription medication or pack of cigarettes in his or her pocket, would disturb normal muscle test results.

 In some cases, items such as wristwatches need to be removed. Other jewelry items are rarely suspect, but it's good to keep these checks and balances in mind as jewelry may interfere with testing.

3. *Make sure the test-subject is properly hydrated prior to testing.*

 Following a sequence of tests, you sometimes find a person's arm wobbly when it should be strong (especially during a

simple preliminary indicator test). Several influences may be involved, but dehydration is the primary problem to look for. It's always a good idea to have a test-subject drink some water prior to testing.

4. *Maintain a healthy atmosphere for accurate testing by eliminating interfering factors.*

Performing Clinical Kinesiology muscle testing in a building with extreme electromagnetic disturbances may affect the test. (Later, we'll explain how you can test a person for his or her sensitivity to electromagnetic fields.) Always be wary of any testing in a high-voltage electrical power line area or within a building that contains a great deal of high-technology equipment such as computers, programmable controllers, and other uninterrupted electric power supplies. Choose another location, or improve the electromagnetic condition of the area by turning off all electrical appliances before you proceed.

Hurry, hurry has no blessing.
SWAHILI PROVERB

A private atmosphere affording complete relaxation is much more desirable than the middle of a busy cafeteria. Avoid places where testing becomes a spectacle; where hoards of people become interested and want to watch. The onlookers may learn something, but the person being tested may become nervous or self-conscious. Such conditions do not allow the most accurate testing to occur.

Also avoid loud music, disturbing noises, traffic sounds, noxious or industrial smells, chemical odors and other disruptive sources of input which may affect your test. Bright lights are a negative factor, especially if the test-subject is light sensitive. Use dim lighting or a table lamp rather than fluorescent lights to cut down on stress from electromagnetic output.

HOW TO MUSCLE TEST

THE TECHNIQUE

1. The Best Position:

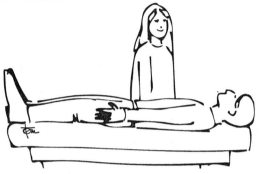

The typical Clinical Kinesiology muscle test utilizes a group of muscles which support the shoulder. For accurate testing, the person being tested should lie down. This position increases the chances that all other muscles of the body remain relaxed.

If it's inconvenient to test an individual who is lying down, you may test the subject by having him/her sit up or stand. Seated is preferable to standing, however, because in standing the body is more likely to become off balance, resulting in an inaccurate test. A person standing can also widen his or her stance, thereby gaining firmer support than normal. Tightening muscles throughout the body or recruiting other muscles will skew the test results.

Only the shoulder muscles are needed to secure an accurate test. Of course, the more comfortable and relaxed the person, the more reliable the test.

2. The Elbow Straight:

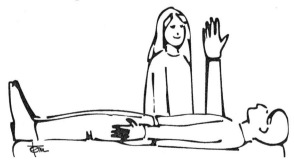

The person lying down raises her or his dominant arm (for most people, the right arm is stronger) at a ninety-degree angle perpendicular to his or her body. The arm should be held stiff, but not rigid. The elbow must be straight, or otherwise functional changes in the arm muscles can cause inaccurate and unreliable test results.

3. The Push and the Resist:

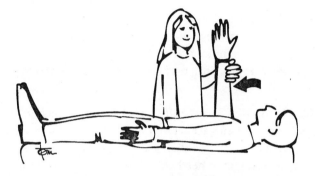

The tester should stand at a forty-five degree angle facing the test-subject's right side and may use either arm to perform the test. One arm's length from the test-subject's upright arm should assure a comfortable position.

Once assuming the correct positions, the tester places the flat or palm of his or her hand at the top of the wrist of the person being tested and performs the muscle test by pushing down toward the subject's feet. Begin by commanding the subject to gently "resist" the tester's push.

An alternative method for testing a subject in a sitting position requires the person to hold his or her arm directly out in front of the body, parallel to the floor. The tester then exerts pressure with an outstretched palm against the wrist of the subject, bearing downward while the subject resists.

If the person being tested is physically weak or unsure of the level of pressure to apply, encourage him or her to exert more energy or strength. It's a good idea to take several "trial runs" or practice tests with a new person to guide them in facilitating the test.

4. The Monitor:

Always monitor the accuracy of the arm position as the tests are administered. Most people tend to drop the arm back toward the head which results in more of a mechanical advantage. They unknowingly become stronger by utilizing extra muscles which support the backside of the shoulder. As always, correct positioning is imperative in performing an accurate Clinical Kinesiology muscle test.

5. The Muscle Response:

Some testing situations prove more difficult than others to ascertain whether a weak or strong muscle response is being given. This happens for a few reasons and may be remedied by the following appropriate steps.

- Watch for significant differences in strength between the tester and test-subject. Frail, ill, elderly persons or small children require less force than a strong or robust person. In this case, a tester may need to use only two fingers instead of the whole palm of the hand during evaluation.
- In opposite cases, a test-subject (a muscular body builder, for example) may be much stronger than the person doing the testing. Lowering the testing table often helps in this situation. Or, begin by testing a particularly "toxic" substance (such as sugar), which renders *everyone* weak. Test at various table heights until a comfortable and accurate testing position is determined.
- In confusing situations, it's also helpful to lower the test-subject's arm to between a forty-five and ninety degree angle as opposed to the standard ninety degree angle. Experiment with finding a different angle which allows the tester a little more leverage, while not overpowering the test-subject.
- If the test is unclear, *retest, retest, retest*! Change the conditions. Assess the test-subject's comfort level, the tester's position, and both persons' relative strengths. Determine such incompatibilities with good testing procedures and then test several times to find the most consistent (and most accurate) answer.

THE INDICATOR MUSCLE TEST

In order to establish a baseline for comparing the strength of a test-subject's muscle, you need to perform what I call the "Indicator-muscle test." The second purpose of this test is to ask the body whether it is O.K. to proceed with the test.

Either arm of the subject or tester may be used to check the initial strength of a test-subject's indicator muscle. If, of course, the test-subject has a painful arm or a problem with one or the other, refrain from testing that arm.

To confirm the strength of the indicator muscle, have the test-subject lie down and, for convenience, test the person's right arm, simply because many people are right-handed. Since you may want to perform a number of tests at one time, the dominant arm usually has more endurance than the other.

Assume Test Position + Muscle test + Strong Indicator arm
= Proceed with further testing

THERAPY LOCALIZATION

Therapy localization, or TL, is the diagnostic term used to evaluate problem areas through Clinical Kinesiology muscle testing. For example, using the therapy localization procedure to evaluate a test-subject complaining of knee pain requires the following:

Step 1: Always begin testing by first performing preliminary indicator muscle test.

Step 2: Instruct test-subject to place his/her left hand on the painful knee area, while tester performs the muscle test on the subject's right or opposite arm.

Step 3: If the muscle test renders the arm weak, it's an indication that a problem exists in the knee.

This diagnosis is referred to as a *positive TL or positive therapy localization*. The pain or imbalance has been localized and the patient can now seek correct therapy.

Therapy Localization/(Touch Problem area) + Muscle test + Weak arm = Positive TL = See Chapter Two for complete lists of symptoms associated with imbalances of each acupuncture meridian, along with suggested treatment alternatives.

Therapy localization may be used as a screening test to determine imbalances in the body's organs. Some of the more important and more commonly affected organs in the energetic system are the heart, lung, liver, kidney, and pancreas.

Heart Test

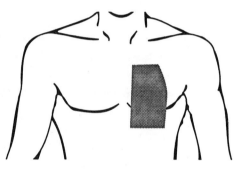

Therapy localizing for the heart has been determined by the pathway in which the heart energy projects onto the surface of the body. While anatomically the heart rests mostly mid-line in the upper body, its energy pathway radiates slightly to the left side of the chest. To therapy localize, the test-subject lays his or her hand palm down to the left of the sternum or breastbone (instead of directly on the body mid-line).

Heart TL (Touch over heart) + Muscle test + Weak arm = Heart imbalance = Seek guidance from an alternative healthcare professional.
Heart TL (Touch over heart) + Muscle test + Strong arm = Heart balance

Analyzing Heart Test Results

Immediately following a weak muscle test, you will still not have enough information to determine if a heart imbalance is mild, moderate, or severe. However, on the first test, *you will know an imbalance of some type exists.* For most people, the heart test proves mild or moderate. In comparison, the test of someone with a documented heart problem may prove extraordinarily weak.

HELPFUL HINT: One caution: Following a weak heart test, do not be frightened into thinking you are about to suffer a heart attack or heart disease. A weak test simply alerts the test-subject that the heart may be out of balance and require follow-up testing by a knowledgeable practitioner. The practitioner then uses more advanced Clinical Kinesiology techniques to further evaluate the problem and recommend treatment.

Lung Test

To locate the lung for muscle testing, the person being tested should first outstretch the fingers of the opposite hand from the arm being tested, then place the outstretched hand from the mid-line of the sternum and over the right side of the chest. Try to avoid touching the heart area (on the left) to avoid getting crossed information.

Do not use the back of the body for testing the lungs because of its conflicting and close contact to the ribs and the spine. Lung energy is better projected through the front of the body.

> Lung TL (Touch over lung) + Muscle test + Weak arm =
> Lung imbalance= Seek guidance from an alternative
> healthcare professional.
> Lung TL (Touch over lung) + Muscle test + Strong arm =
> Lung balance

Lung balance depends on several factors. If the person being tested smokes currently, or has been non-smoking only one to three years, more than likely the lungs will prove weak during therapy localization. In addition, anyone who suffers from asthma or bronchitis will probably prove weak during the muscle test.

> **HELPFUL HINT:** It is unnecessary to take a deep breath, or to stress the lungs in any way during the muscle test. In some cases, where a very mild lung problem has been diagnosed, or reasonable, natural treatment has been pursued, the lung may still prove strong. However, it's best to refrain from running up a flight of stairs before the test—or the test may turn up weak.

Liver Test

Large and floppy, the liver covers nearly one quarter of the upper abdomen. During therapy localization, the liver may be evaluated by the test-subject laying one hand over the lower-right rib cage,

with the remaining arm free for testing. Normally, the lower four to five ribs contain the liver.

Liver TL (Touch over liver) + Muscle test + Weak arm = Liver imbalance= Seek guidance from an alternative healthcare professional.
Liver TL (Touch over liver) + Muscle test + Strong arm = Liver balance.

If the correctly performed muscle test results in a weak arm, therapy localization has determined that the liver may be out of balance, under too much stress, or not functioning correctly.

HELPFUL HINT: Therapy localization over the liver also means touching the gallbladder area or energy field. If a weak muscle test is determined in this area, consult with a natural healthcare practitioner for further guidance on whether the test is linked specifically to the liver, the gallbladder or both. In either case, give special attention to your diet; avoid toxins such as additives and preservatives; reduce excess fats, and lessen environmental pollution.

Kidney Test

The kidney is another important organ commonly found to be out of balance in many people. Therapy localizing for the kidney is performed

on the posterior of the body. The kidney's center line rests more toward the back of the body than the front and is deep to the skin, ribs and muscles.

To test the kidney, the test-subject uses the flat palm of the hand laid over the lower back, or, the lowest four or five ribs. Each kidney should be tested separately. Generally, the kidneys function together; the right and left kidney meridian and the two kidneys combine as one energy circuit.

> Kidney TL (Touch over kidney) + Muscle test + Weak arm = Kidney imbalance = Seek guidance from an alternative healthcare professional.
> Kidney TL (Touch over kidney) + Muscle test + Strong arm = Kidney balance.

I've treated two patients who each had one kidney removed. The first patient, Ermalinda, had a tumor, while the second, Eddie, sustained a damaged ureter and had the kidney removed as a child. When I therapy localized over the area of the missing kidney in each, obviously the body registered an energetic disturbance. Automatically, both patients' arm muscles were rendered weak.

Upon testing the opposite kidney in each, I found another weak arm test. Because of the energetic balance of the kidney system, the whole circuitry had been disturbed. The remaining kidney in each patient was working double time.

Many people do live a full, long life with only one kidney. However, that kidney probably is working very hard. Try to test both kidneys to determine any kidney imbalance in the body's energetic system.

> **HELPFUL HINT:** If the kidneys test out of balance, it's very important to begin drinking a great deal of good-quality water. The amount of water to drink equals the amount which makes your urine appear practically clear. If you take B vitamins, for the next few hours your urine will appear bright yellow. Once the excess is excreted, the urine should

become clear. In addition, the darker the urine, the more de-hydrated the body. Of course, leaving out soda pop, coffee or other similar stressors on the kidney will also facilitate a better balance.

Pancreas Test

A pancreas imbalance may be present in someone with hypoglycemia or diabetes. In either case, the area used for testing the pancreas may be found by locating the spot directly in the middle of the inverted V between the right and left halves of the rib cage.

Using only fingertip touch, locate the pancreas—a long, horizontal organ which overlaps the lungs, small intestine, and stomach. Attempting to cover the entire pancreas with your hand may result in a weak muscle test, which may be inaccurate since you may actually be testing the other organs in close proximity.

To avoid overlapping of other organs, touch the tiny space in the narrow V between the ribs. Approximately two inches down from the apex of the inverted V you'll find the pancreas. It's important to therapy localize with only fingertip contact, even though the pancreas is a large organ.

Pancreas TL (Touch over pancreas) + Muscle test + Weak arm = Pancreas imbalance = Seek guidance from an alternative healthcare professional.
Pancreas TL (Touch over pancreas) + Muscle test + Strong arm = Pancreas balance.

> **HELPFUL HINT:** Following any weak muscle test response, be sure to avoid sugar and refined carbohydrates of all types. To strengthen the pancreas, you may need additional B vitamins and trace minerals as well as further help through acupuncture, nutrition and lifestyle adjustments.
>
> Anyone with undiagnosed, severe hypoglycemia in younger years who continues on the same dietary path, will risk becoming a victim of a much greater health consequence—adult onset diabetes.

YOU ARE THE EXPERT

You have a rendezvous with life.
ERIC BUTTERWORTH

The Afterword of this book contains a valuable Organ Meditation exercise which will guide you in balancing and strengthening each of your organs. Take a minute now to locate (p. 329) and read the Organ Meditation. As you read through each of the book's chapters feel free to incorporate all or part of the Organ Meditation in your healing work on specific organs or for other daily health challenges.

Your magnificent mind-body computer is the expert on energetic diagnosis, treatment and healing. The body knows which organs or systems are out of balance and which treatments help to rebalance. With Clinical Kinesiology you ultimately take more responsibility for your health and well-being.

Improving the chemical, structural, and electromagnetic balance in your body restores energy flow to all of these systems, while also giving relief to the organs that share those systems. Restored energy affects the entire mind-body balance. Consequently, you think and feel differently. Your healing has begun.

You've now learned how the body can "talk," and therefore be used as a diagnostic tool to measure body "function." In addition to discovering the history and principles of Clinical Kinesiology, you've also practiced how to apply the method. In Chapter Two, *Acupuncture: The Healing Energy*, we'll introduce you to *specific* treatment modes that heal energetic imbalances and show you how to answer your body's own unique "alarm" system that can help deactivate illness in your body's energy system.

CHAPTER ONE SUGGESTED READING

Cranton, Elmer M.D. and Brecher, Arline. *Bypassing Bypass*. Virginia: Hampton Roads Publishing Co., 1990.

Goodheart, George J., D.C. *You'll Be Better, The Story of Applied Kinesiology*. Geneva, OH: AK Printing, 1989.

Kowalski, Robert. *Eight Steps To A Healthy Heart*. New York: Warner Books, 1994.

Maffetone, Philip. *Everyone Is An Athlete*. New York: David Barmore Productions, 1990.

Ornish, Dean M.D. *Dr. Dean Ornish's Program For Reversing Heart Disease: The Only System Scientifically Proven to Reverse Heart Disease Without Drugs or Surgery*. New York: Random House, 1990.

Shepard, Dr. Stephen Paul. *Healing Energies*. Provo, UT: Woodland Health Books, 1983.

Walker, Morton. *The Chelation Way: The Complete Book of Chelation Therapy*. Garden City Park, New York: Avery Publishing, 1990.

Whitaker, Julian M. *Reversing Heart Disease*. New York: Warner Communications Co., 1988.

Valentine, Tom and Carol. *Applied Kinesiology: Muscle Response in Diagnosis, Therapy, and Preventive Medicine*. Rochester, VT: Inner Traditions, 1989.

2

Acupuncture:
The Healing Energy

ONE OF THE FIRST myths surrounding the development of acupuncture retells the story of a young warrior in ancient China. The warrior had been plagued with an ongoing physical disorder for many years.

One day, in the midst of a brutal battle, the young warrior suffered a spear wound to his body. Miraculously, when he recovered from the spear wound he discovered that the previous disorder was healed as well.

As the theory goes—that spear puncture stimulated a blocked energy pathway in the warrior's body, and the released energy, or *ch'i*, was enough to cure him!

WHAT IS CH'I?

It's been over five thousand years since the ancient Chinese discovered a subtle energy in the body that cannot be seen, felt or found in any way with the senses. Philosophers believed that two opposite ends of the spectrum—*yin*, the energy of earth and *yang*, the energy of heaven—combined with the human to create this vital energy.

From that discovery, the Chinese identified "Twelve Branches" or twelve acupuncture meridians along which this energy travels in the human body. Call it *spirit*, the *enlivening spark*, *life essence* or whatever you choose. The ancient Chinese call it *ch'i*—the pure, harmonizing and free-flowing energy that sustains all of life.

The occurrence of disease is due to insufficiently balanced ch'i.
YELLOW EMPEROR'S
CLASSIC ON INTERNAL
MEDICINE

Various Chinese sages have philosophized over the healing properties of this unique and mysterious energy. Throughout history, many different views and approaches have evolved from the wise Chinese about how to perfect physical health.

CLINICAL KINESIOLOGY AND ACUPUNCTURE

Dr. Alan Beardall integrated the philosophies of anatomy, physiology and acupuncture in the development of Clinical Kinesiology.

The Chinese were especially concerned with eliminating energy blockages in the energetic body channels. They created intricate maps of the body's energy system, and used acupuncture needles to draw awareness to specific areas or points where energy blockages occurred, thereby rebalancing the channels. Clinical Kinesiology energetic testing utilizes this significant tool of treatment in correcting energy imbalances in the body's structural, biochemical and electromagnetic systems.

This chapter will be devoted to the electromagnetic aspect of healing explaining the basic importance of maintaining balanced energetic health through the introduction of the energy or *ch'i* that circulates throughout the body, much like an electrical system.

Clinical Kinesiology taps into your system of flowing energy, monitors its activity, accesses vital information, and retrieves it. Clinical Kinesiology incorporates practical aspects of acupuncture theory as an Early Warning Response System for discovering energetic blockages in the body. Familiarization with the different pathways of body energy helps further identify the symptoms that signal deep energetic imbalances.

The material presented in this chapter will help you to:

- Gain new understanding of how acupuncture treatment corrects depleted, excessive or imbalanced energy supplies, making it possible to achieve new healing.

- Recognize the connectedness of each organ/meridian.
- Use the Acupuncture-Energy Body Clock to assess the symptoms of specific imbalances.
- Compare various therapies designed to treat organ/meridian imbalances such as—acupuncture, acupressure, laser and magnet treatment.
- Improve the energy related functioning of your body through self-testing of acupuncture alarm points.
- Determine existing energetic imbalances in your own body.

YOUR INVISIBLE ENERGY SYSTEM

Ch'i circulates along acupuncture pathways or energy channels in the human body (referred to as *meridians*) in a similar way that radio waves travel through space. Although they go unnoticed, radio waves jam the room in which you are presently sitting. Turn a radio on and tune it into one of the bands that conducts radio transmission, and the radio plays!

You have to be able to catch energy and hold it, storing precisely the needed amount and releasing it in measured shares.
LEWIS THOMAS

Acupuncture meridians are like an electrical energy system running throughout the body. Although imperceptible, like radio waves, electricity moving faster than the speed of light continuously charges the body. Your nervous system contains a "visible" set of electrical "wires," while the acupuncture system channels an invisible set. But, watch out! Even though no physical wires appear to identify meridian location, when acupoints are stimulated sparks may fly!

MATTER IS ENERGY

Imagine the nucleus or center of an atom with electrons flowing around the center. As the electrons move, they emit energy, which spins off from the atom. This energy radiates away from the current, producing an electromagnetic field containing both magnetic and electric force.

Science affirms that solid matter—a table, lamp, even the human body—is comprised of mostly empty space, i.e., the space between the atoms and their components. Matter simply consists of focused or *kinetic* energy.

Try tossing a ball back and forth. While the ball sits immobile, it expresses stored or potential energy. Toss the same ball through the air and watch its energy become activated. Now, imagine an arc of energy flowing to the place where the ball was tossed. The arc symbolizes energy that has now dissipated in space—energy released from the movement—or *kinetic* energy. The same energy releases from every single atom at all times within your body and within every object around you. In short, you are a bundle of energy!

In *Your Body Doesn't Lie*, author Dr. John Diamond states that, "...all illness starts as a problem on the energy level."[1] In light of this theory, the more knowledge acquired about the movement or blockage of *ch'i* and the resulting energetic effects in the body, the greater advantage we have in learning to prevent illness and correct imbalances.

MEASURING THE "INVISIBLE"

Electricity will become as ubiquitous in medical practice as surgery or drugs are; in many instances it will replace them.

DR. ANDREW BASSETT,
COLUMBIA-PRESBYTERIAN
MEDICAL CENTER

Dr. Y. Nakatani, M.D., the forefather of the modern-day Japanese electronics industry, developed the *Ryodoraku*, an instrument which may be used to scientifically validate *ch'i*, an energy that remains elusive and etheric.

The *Ryodoraku* supplies electrical output readings of human electromagnetic fields called Electro-Meridian Imaging, or an EMI exam. EMI is a term coined by Dr. John Amaro. Through the International Academy of Clinical Acupuncture, Dr. Amaro teaches doctors to use the *Ryodoraku* or Electro-Meridian Imaging procedures. Dr. Amaro is one of very few who teach this procedure in the United States. The *Ryodoraku* measures the specific energy level and balance in the body's twelve main acupuncture meridians.

Practitioners use a wet cotton swab attached to an electronic probe to touch certain acupuncture points. Each instrument reading is then written down and composed into an energy graph.

Although treatment does not rely solely on this information, the graph indicates an overall view of the body's health.

While acknowledging the *Ryodoraku* as an important "scientific" tool, the same diagnostic testing may be accomplished through Clinical Kinesiology muscle testing. If touching an acupuncture point on the body renders the "indicator" muscle weak, the body is talking—telling you that one or more meridians may be energetically out of balance and need help.

International Academy of Clinical Acupuncture
RYODORAKU

Linda Jones *June 1*

Name Date of Exam

LU 9		P 7		HT 7		SI 4		TH4		LI 4		SP 3		LV 3		KI 3		BL 64		GB 40		ST 42	
L	R	L	R	L	R	L	R	L	R	L	R	L	R	L	R	L	R	L	R	L	R	L	R
200		200		200		200		200		200		200		200		200		200		200		200	
190		190		190		190		190		190		190		190		190		190		190		190	
180		180		180		180		180		180		180		180		180		180		180		180	
170		170		170		170		170		170		170		170		170		170		170		170	
160		160		160		160		160		160		160		160		160		160		160		160	
150		150		150		150		150		150		150		150		150		150		150		150	
140		140		140		140		140		140		140		140		140		140		140		140	
130		130		130		130		130		130		130		130		130		130		130		130	
120		120		120		120		120		120		120		120		120		120		120		120	
110		110		110		110		110		110		110		110		110		110		110		110	
100		100		100		100		100		100		100		100		100		100		100		100	
90		90		90		90		90		90		90		90		90		90		90		90	
80		80		80		80		80		80		80		80		80		80		80		80	
70		70		70		70		70		70		70		70		70		70		70		70	
60		60		60		60		60		60		60		60		60		60		60		60	
50		50		50		50		50		50		50		50		50		50		50		50	
40		40		40		40		40		40		40		40		40		40		40		40	
30		30		30		30		30		30		30		30		30		30		30		30	
20		20		20		20		20		20		20		20		20		20		20		20	
10		10		10		10		10		10		10		10		10		10		10		10	
5		5		5		5		5		5		5		5		5		5		5		5	

Sample energy reading of human electromagnetic field.

YOUR ORGAN/ENERGY SYSTEM

Using acupuncture energy pathways has led holistic healers through the ages to ascertain the body's inner workings. The ancient Chinese saw no differentiation between acupuncture meridians and corresponding organs. They never spoke of an organ (such as the kidney) and its meridian as separate components. They simply referred to both as one system.

The energy/organ system so intertwines that it's not unusual to experience knee pain, for example, when the kidney becomes unbalanced. The reason? The knee is located directly along the course of the Kidney Meridian (see chart of Kidney Meridian p. 59). If an organ/energy pathway is blocked, off balance or "complaining" a bit, that condition is usually connected to a problem in the organ.

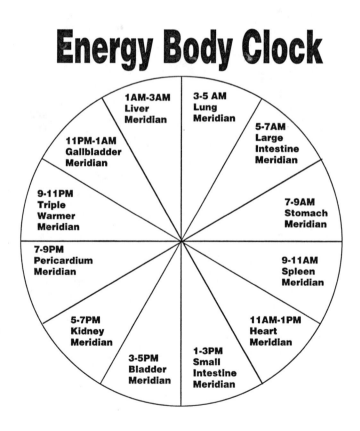

Energy Body Clock

ENERGY BODY CLOCK

According to Chinese theory, energy throughout the acupuncture meridians travels in a circular pattern or moving "body clock" of energy. Every two hours, the main supply of energy predominates in one of the twelve meridians. For example, from 3 to 5 A.M. the major energy in the body centers in the Lung Meridian. Two hours later, it moves to the Large Intestine Meridian and so on.

It's interesting when patients say, "At 3 A.M. I always wake up and have this symptom," or, "I experience low energy every day at 5 P.M." Significant symptoms may be identified from such statements. The meridian that requires energy and proves active at the time may not be sufficiently balanced and strong.

HEALING...STRAIGHT AHEAD!

We are about to embark on an important trip through the body's energy highways. Remember, there are twelve major meridians, but no roadsigns. As we travel, consider the journey as a means to:

The medicine of the future will be energy medicine...
ROBERT JACOBS, N.M.D., D. HOM. LONDON, ENGLAND

- Help you recognize the energetic pathways of major organs and their connectedness to each body part.
- Provide you with a map of the territory of your self—along with easy instructions for use.
- Stimulate you to begin to question your own symptoms and how they might relate to other organs.
- Help you monitor any early-warning signs of energy roadblocks.
- Create new energy at your fingertips.

As you begin to locate the points on your own body realize that acupuncture meridian points follow much the same path on every human being. However, although anatomically similar, each body is also very, very different. According to charts, acupuncture points may typically be found at specific locations; nonetheless, on occasion one might have to probe slightly "off course"—a half-inch in one direction or another—to pinpoint the energy imbalance correctly.

Daily Symptom Log

MERIDIAN	Sunday	Monday	Tuesday	Wednesday	Thursday	Friday	Saturday
3-5AM Lung							
5-7AM Lg. Intestine							
7-9AM Stomach							
9-11AM Spleen							
11AM-1PM Heart							
1-3PM Sm. Intestine							
3-5PM Bladder							
5-7PM Kidney							
7-9PM Pericardium							
9-11PM Tri-Warmer							
11PM-1AM Gallbladder							
1-3AM Liver							

As you follow along with the descriptions of the meridians:

- Try to identify each pathway in your body by tracing your finger along the route described. Note any areas of unexpected tenderness or tissue indentation you might encounter.
- Begin to consider how your energy ebbs and flows throughout the day or season of year.
- Notice any instant feedback from your body, i.e., pressure on a point resulting in body sensation elsewhere.
- Refer to the sample body clock chart included in this section, and use the Daily Symptom Log to record any symptoms that occur at certain hours of the day. Review your symptoms after one or two weeks.

THE LUNG MERIDIAN 3-5 A.M.

An early riser, the Lung Meridian represents the first meridian in the energy cycle. Originating by the shoulder, the Lung meridian progresses down the arm to the thumb. At first you may wonder how this meridian relates to the lungs when it travels a pathway down the arm. The energy of each organ and meridian system can be thought of as a circuit connecting joints, muscle areas and organs. Considering the embryological development of the human body also helps clarify the reasons why each energy pathway connects to its own distinct and distant areas. As the human embryo grew and stretched, its organ/energy pathways also developed and reached into distant parts of the body.

He lives most life whoever breathes most air.
ELIZABETH BARRETT
BROWNING

Study each acupuncture chart in this chapter closely. *You'll find that most of the major meridians also connect to one another deep inside the body.* On the surface of the body the meridians also circulate closely, within a half-inch to an inch of connecting with each other. Each meridian also runs on both sides of the body—mirroring itself.

Symptoms of Lung Meridian Imbalance

Quite simply, lung stress equals heart stress. The following symptoms may also implicate the Lung Meridian in other disorders:

- Throat or trachea soreness, vocal cord problems, coughing
- Sweating, shortness of breath, difficulty breathing, tightness of chest, bronchitis, asthma, emphysema

- Shoulder, elbow, or wrist pain, bulbous thumb (enlarged joint)
- Tightness of diaphragm
- Diarrhea, constipation, colitis

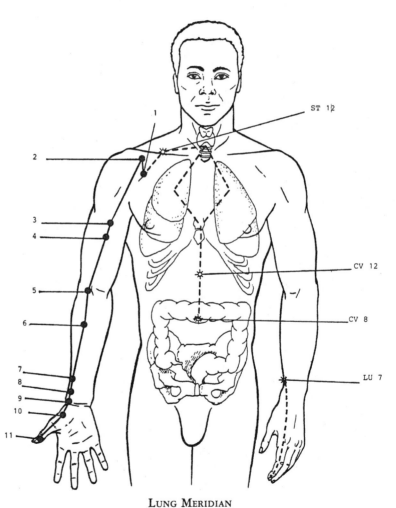

LUNG MERIDIAN
ILLUSTRATION COURTESY OF DR. JOHN AMARO,
INTERNATIONAL ACADEMY OF CLINICAL ACUPUNCTURE. COPYRIGHT © 1981.

Jenny's Story

Jenny suffered from asthma since childhood. In a critical state, she used a minimum of two different asthma inhalers four times a day. After a particularly acute attack, her doctor prescribed a steroid drug. Continuing side effects finally convinced Jenny to pursue other options of treatment.

Clinical Kinesiology testing confirmed Jenny's lung imbalance, which was immediately addressed with acupuncture. Specific points on the lung meridian required stimulation. Additional Core-Level™ lung nutrients (see Product Guide) and other herbs and vitamins strengthened Jenny's lungs enough that she discontinued the use of inhalers. She has now been free of medication for more than two years.

Without ch'i there is no Chinese Medicine.
PROF. REN YING-QUI

THE LARGE INTESTINE MERIDIAN 5-7 A.M.

The Large Intestine Meridian follows next in the circulation of energy or *ch'i*. The first, most obvious points on this meridian concentrate in the face and arm. The meridian flows from a point on the index finger from which the energy travels up the side of the arm to the shoulder and scapula. The energy then inches all the way up to the side of the nose.

SYMPTOMS OF LARGE INTESTINE IMBALANCE

In some cases, the following problems indicate an imbalance in the large intestine:

- Irritable bowel syndrome, intestinal noises, abdominal pain, swelling
- Constipation
- Teeth, nose, sinus problems
- Neck stiffness
- "Bursitis," shoulder or forearm pain, tennis elbow
- Stiffness of index finger, hand pain or weakness

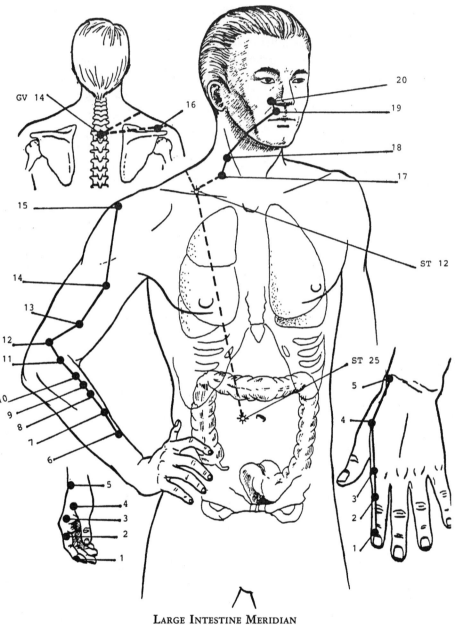

LARGE INTESTINE MERIDIAN
ILLUSTRATION COURTESY OF DR. JOHN AMARO,
INTERNATIONAL ACADEMY OF CLINICAL ACUPUNCTURE. COPYRIGHT © 1981.

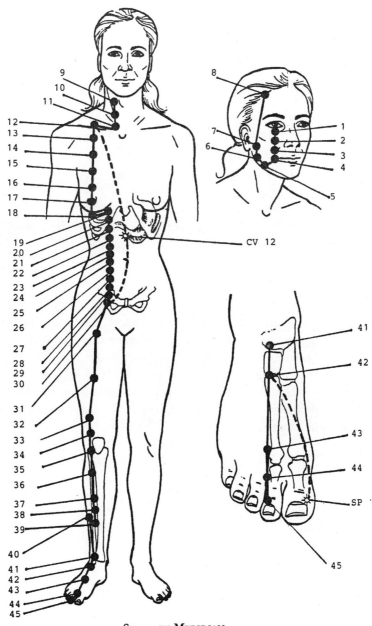

STOMACH MERIDIAN
ILLUSTRATION COURTESY OF DR. JOHN AMARO,
INTERNATIONAL ACADEMY OF CLINICAL ACUPUNCTURE. COPYRIGHT © 1981.

THE STOMACH MERIDIAN 7-9 A.M.

The Stomach Meridian originates directly under the eye, drops down the face, curves around the jaw, circulates back up into the head, then travels from the neck all the way down through the body to the second toe.

Symptoms of Stomach Meridian Imbalance
Stomach Meridian imbalances most often call for treatment of points on the leg for the following symptoms:

Wisdom does not show itself so much in precept as in life a firmness of mind and mastery of appetite.
 SENECA

- Headache, sinus or jaw pain
- Stiff neck, swollen throat
- Tightness of chest
- Stomach, digestive and gastrointestinal problems (hunger pangs, gastritis)
- Hiatal hernia, ulcers
- Pelvic, thigh pain
- Knee and shin problems

Many imbalances of the Stomach Meridian result from a lack of hydrochloric acid (or HCL) and other digestive enzymes in the body. Lack of HCL causes food to linger in the stomach for longer periods than normal, becoming an irritant. *More acid*, not less acid, may be needed. Clinical Kinesiology may be used to quickly evaluate such problems as well as to determine the dosage needed to correct the imbalance.

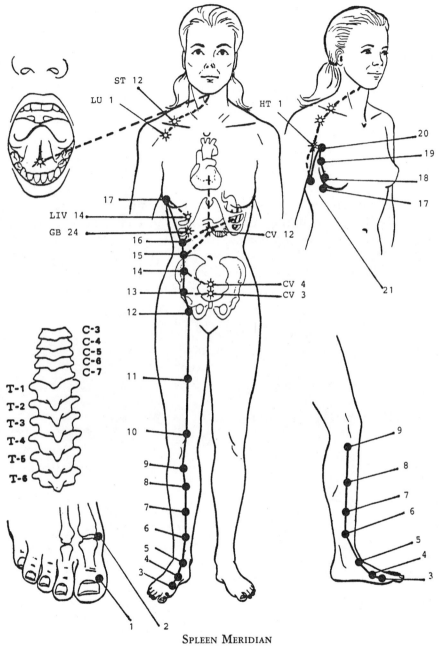

ST 12
LU 1
HT 1

20
19
18
17

17
LIV 14
GB 24
16
15
14
13
12

CV 12
CV 4
CV 3
21

C-3
C-4
C-5
C-6
C-7

T-1
T-2
T-3
T-4
T-5
T-6

11

10

9
8

7

6

5
4
3

9

8

7
6

5
4
3

1 2

SPLEEN MERIDIAN

ILLUSTRATION COURTESY OF DR. JOHN AMARO,
INTERNATIONAL ACADEMY OF CLINICAL ACUPUNCTURE. COPYRIGHT © 1981.

THE SPLEEN MERIDIAN 9-11 A.M.

The root of the way of life, of birth and change is chi (energy). The myriad things of heaven and earth all obey this law.
NEI CHING

The Spleen Meridian may be regarded as a priority connecting point for all the meridians. Its pathway zigzags up and down both sides and terminates under the arm on the side of the body. When an energy chart composed with the *Ryodoraku* indicates several meridians out of balance, treating the Spleen Meridian first proves helpful in beginning the rebalancing.

When I needed treatment for a heart imbalance following a car accident, Dr. Burt Espy treated my Spleen Meridian along with my Heart. The Spleen's internal points travel upward through the neck and directly cross over the Heart Meridian. In my case, Clinical Kinesiology testing results deemed this treatment necessary to expedite the healing process.

Symptoms of Spleen Meridian Imbalance
The spleen regulates the quality of blood in the body. Complaints that signal Spleen Meridian imbalance include:

- Lymphatic congestion
- Loss of appetite, nausea
- Abdominal pain, distention
- Stomach and/or pelvic problems, female imbalances
- Limb fatigue
- Leg, knee, thigh pain

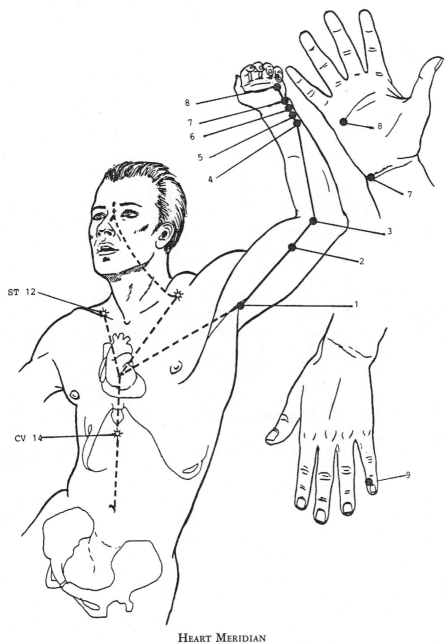

HEART MERIDIAN
ILLUSTRATION COURTESY OF DR. JOHN AMARO,
INTERNATIONAL ACADEMY OF CLINICAL ACUPUNCTURE. COPYRIGHT © 1981.

THE HEART MERIDIAN 11 A.M.-1 P.M.

Because heart problems affect today's society so prominently, the Heart Meridian "reigns," perhaps, as the body's most important meridian. Its energy pathway commences under the armpit and wends down through the elbow and wrist, dissipating on the little finger. The very deep, internal part of the meridian extends into the heart itself, down into the digestive system, and finally, returns through the neck, head, jaw, and face.

Symptoms of Heart Imbalance

Heart imbalances often manifest as:

The same heart beats in every human breast.
MATTHEW ARNOLD

- Headache, face pain
- Dry mouth, nausea
- Heart palpitations, chest pain
- Arm pain/ache, numbness
- Stiffness or pain of neck, forearm, elbow joint, small finger
- Mid-back pain or stiffness
- Weak wrists/Carpal Tunnel Syndrome
- Digestive disorders, constipation, food allergies
- Swollen ankles
- Varicose veins

Vera's and Marian's Stories

Two women came into my office one day with the same complaint— aching pain along the crease of the nose. Vera accidentally bumped into a door. Three months later her pain still hadn't subsided. Marian was involved in a car accident. All of her resulting pain had cleared up except for the same nagging pain near her nose.

Interestingly enough, acupuncture charts show that the nose crease lies directly on the end point of the Heart Meridian. Clinical Kinesiology testing of each woman confirmed the need to treat the Heart Meridian of both after which their similar problems healed.

Heart Taboo

A strange taboo exists in our culture toward people acknowledging heart problems. While in nursing school twenty years ago, I presented a paper on this subject. Then and now, it's curious to me that

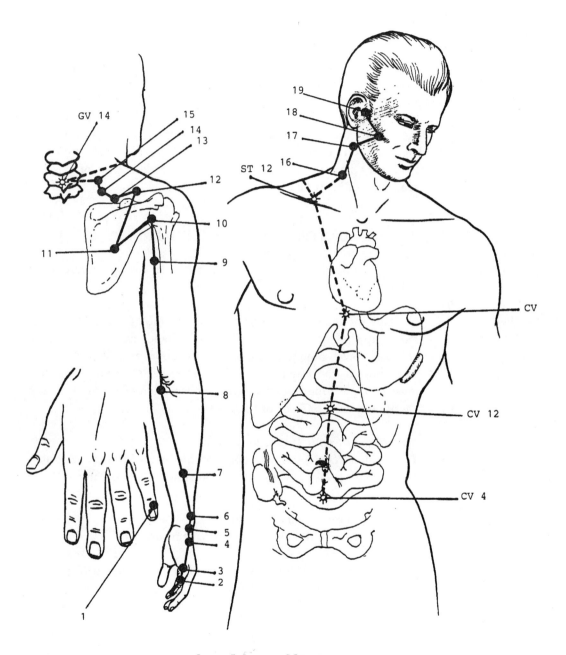

SMALL INTESTINE MERIDIAN
ILLUSTRATION COURTESY OF DR. JOHN AMARO,
INTERNATIONAL ACADEMY OF CLINICAL ACUPUNCTURE. COPYRIGHT © 1981.

people with any type of chest pain or other heart symptom seem bound and determined to deny its existence.

So many people say, "Me? Heart problems? No way! That wasn't chest pain, only indigestion." Even as children, we're trained not to acknowledge the true feelings or genuine expression of our hearts. Consequently, the stifling of the heart in this culture manifests even more heart problems. The word "heartburn" is generally a misnomer used to refer to an acid reflux condition involving the stomach. However, "heartburn" may be right on as a descriptor of this sad syndrome of heart "burnout" in our culture.

THE SMALL INTESTINE MERIDIAN 1-3 P.M.

Strive to preserve your health, and in this you will the better succeed in proportion as you keep clear of the physicians.
LEONARDO DA VINCI

The Small Intestine Meridian greatly influences the digestive system, in partnership with several other meridians. A great deal of the digestive process is accomplished in the small intestine.

This meridian springs forth from the side of the little finger, moves up the lateral or outer edge of the hand, forearm and elbow and then travels around to the back of the upper arm, shoulder joint, and across to the scapula. Here, it crisscrosses the upper trapezius muscle, winds around to the latter or back side of the neck to the cheek, and ends in front of the ear.

Symptoms of Small Intestine Imbalance
The Chinese refer to the end point on the Small Intestine Meridian as "listening palace." Symptoms of possible imbalance are:

- Ear problems, tinnitus, sore throat
- Sore temporomandibular joint
- Digestive difficulties, intestinal flu, diarrhea
- Abdominal pain
- Lateral shoulder pain, length of arm pain and stiffness
- Malabsorption of nutrients
- Crohn's Disease

Alexa's Story
Sixteen-year-old Alexa was brought to my office doubled over in pain. Her mother reported that Alexa, overcome by nausea and vomiting, had been too sick to move. I helped Alexa lie down and stretch out

slowly and performed a Clinical Kinesiology muscle test. Immediately her body feedback signaled the appendix. Within seconds, acupuncture and laser treatments on the Small Intestine Meridian promoted a marked improvement in Alexa's color and severity of symptoms.

The appendix is designed to perform specific functions in the body; therefore, *it must stay in the body*. Although Alexa's appendix had become swollen and inflamed, normalization occurred over two days of consecutive treatments. Poor diet and a propensity for Small Intestine Meridian imbalance often precipitate cases labeled "appendicitis." With more judicious diet choices, Alexa has had no further flareups in over three years. She was young enough and healthy enough that the appendicitis had not reached "the point of no return," which does happen in many cases.

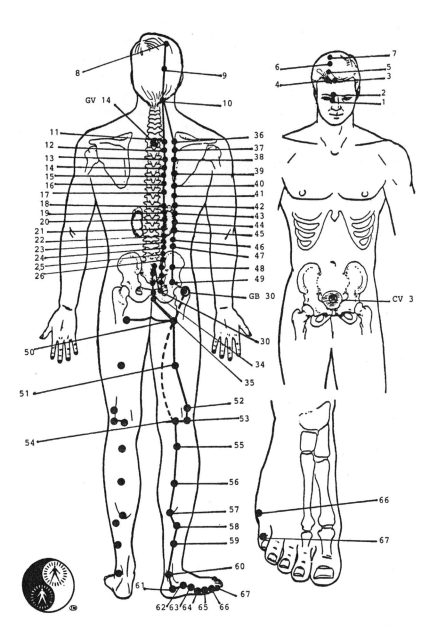

BLADDER MERIDIAN
ILLUSTRATION COURTESY OF DR. JOHN AMARO,
INTERNATIONAL ACADEMY OF CLINICAL ACUPUNCTURE. COPYRIGHT © 1981.

THE BLADDER MERIDIAN 3-5 P.M.

The Bladder Meridian defines the longest meridian in the body. It contains sixty-seven acupuncture points, as compared to the Heart and Circulation/Sex meridians, the shortest meridians, which have only nine points. Bladder energy literally travels from head to toe, through the feet, backtracks up the body, flows back down once more, and finally settles in the little toe.

Through this constant loss of energy, we grow weak and are unable to fight off invasion by germs and other harmful disease causing agents.
DR. STEPHEN T. CHANG

Symptoms of Bladder Imbalance
Normally, the bladder doesn't manifest serious problems, although it retains its own special relationships with other organs. Some complaints involve:

- Incontinence, painful urination
- Kidney, bladder infections, dropping bladder
- Spinal, low back pain or stiffness
- Hip and knee pain
- Leg ache
- Foot pain

Emma's Story
Emma, an eighty-four-year-old patient, came to me with the most unusual bladder problem I'd ever seen. Over forty years before, Emma's doctors recommended she undergo a hysterectomy. During surgery, the operating doctor accidentally nicked Emma's bladder. The surgical mishap resulted in chronic incontinence for which Emma could find no cure.

She underwent seven attempts to repair her damaged bladder, but all failed. In addition, Emma suffered so much scar tissue that, in the eyes of her doctors, nothing more could be done. Ironically, what finally brought Emma to my office was not her bladder problem, but rather, a seemingly unrelated ailment—excruciating pain in both of her feet.

Through Clinical Kinesiology testing, I discovered that Emma's bladder had been so damaged over the years—her imbalance so progressed—that her body began sending out energetic messages *through her feet*. Emma never guessed that her foot pain resulted from a "circuitry" problem which related to her previously damaged bladder.

Embarrassed by her incontinence, Emma also refused to drink water. Once I treated her bladder and kidney meridians, the excruciating pain in her feet subsided. Emma became healthy, her incontinence lessened, and with Clinical Kinesiology testing we had finally pinpointed her true problem.

THE KIDNEY MERIDIAN 5-7 P.M.

The Chinese name, "bubbling spring," refers to the ball of the foot where the Kidney Meridian originates. The Chinese created descriptive names for each acupuncture point, while Westerners have simply numbered the meridians. With hundreds of major acupuncture points, it would be quite a challenge for anyone, even the Chinese, to remember all those names.

For persons suffering from serious illness, "bubbling spring" often proves to be one of the best points to treat. It usually provides a wellspring of new energy. (Then again, it may not be the best point to treat, depending on what the body has to say during Clinical Kinesiology testing.)

The Kidney Meridian curlicues around the ankle and ascends through the inner knee. The internal part of the meridian circulates directly through the lumbar spine and sacrum, to the bladder and on to the kidney. There, it hooks up with energy that flows to the torso.

Symptoms of Kidney Meridian Imbalance
Disorders that stem from Kidney Meridian imbalances are listed as:

- Dry mouth
- Lung congestion
- Kidney, low back, hip pain
- Disc protrusions, ruptures
- Knee, ankle pain or soreness, proneness to injury
- Incontinence
- Foot or ball of foot pain, proneness to injury
- Hemorrhoids, hernia, tailbone pain

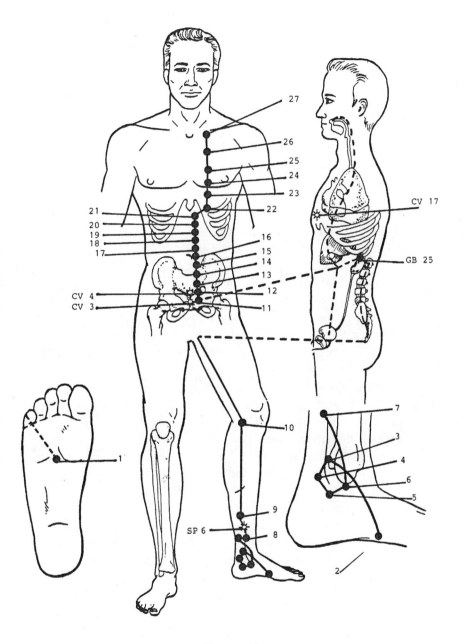

KIDNEY MERIDIAN
ILLUSTRATION COURTESY OF DR. JOHN AMARO,
INTERNATIONAL ACADEMY OF CLINICAL ACUPUNCTURE. COPYRIGHT © 1981.

Hernia and Hemorrhoids

Dr. Burt Espy has treated several cases of hernias which directly related to the Kidney Meridian. Often, hernias and hemorrhoids stem from kidney imbalances because of the deep, internal energy that travels directly through and affects the sacrum or tailbone area of the body.

Jeff, one patient of Dr. Espy's, had already consented to surgery for a hernia. Following successful treatment, Jeff's hernia receded and he cancelled the surgery. In over three years, Jeff has had no further problems.

THE CIRCULATION/SEX OR PERICARDIUM MERIDIAN 7-9 P.M.

The natural force within each one of us is the greatest healer of disease.
HIPPOCRATES

Any hormonal imbalance in the body may be associated with the Circulation/Sex or Pericardium meridian. This meridian's deep inner energy radiates around the heart (the pericardium describes the fibrous protective sac surrounding the heart), extends down into the digestive organs and through the gonadal system or primary sex glands (the ovaries or testes).

The external part of the meridian runs from the lateral side of the breast or chest, around the arm and down to the middle of the palm of the hand. The Circulation/Sex Meridian also manifests a unique relationship with the pituitary gland, due to hormonal aspects, and with the hypothalamus, an "organ" of the brain which regulates many body functions.

The brain is infinitely involved in the energy of the Circulation/Sex Meridian. The stimulation of various cerebral points, in addition to a whole subset of acupuncture stimulation, helps heal certain brain dysfunctions. Cerebral acupuncture also addresses other brain imbalances, including emotional problems such as depression.

As you might imagine, the Circulation/Sex Meridian proves to be quite an overriding meridian. This meridian also contains a circulation point, located part of the way up the forearm, which may be tested for the presence of arteriosclerosis.

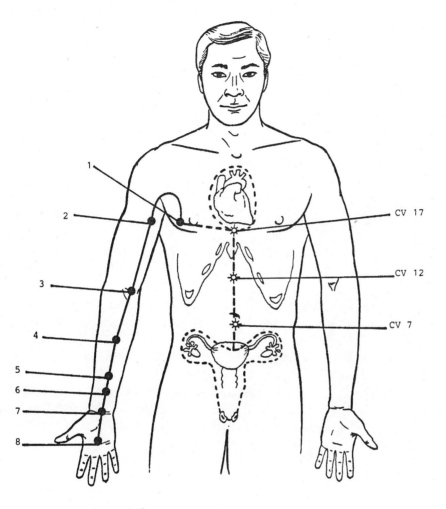

CIRCULATION/SEX-PERICARDIUM MERIDIAN
ILLUSTRATION COURTESY OF DR. JOHN AMARO,
INTERNATIONAL ACADEMY OF CLINICAL ACUPUNCTURE. COPYRIGHT © 1981.

Symptoms of Circulation/Sex Meridian Imbalance

- Eye problems
- Hormonal problems
- Hot flashes, sweaty palms, poor circulation
- Hunger, thirst, sleep disorders
- Rapid heartbeat, arteriosclerosis
- Swollen, painful underarm
- Depression, mood swings
- Poor memory, poor concentration
- Stroke

THE TRIPLE WARMER MERIDIAN 9-11 P.M.

The Triple Warmer Meridian remains intimately tied to the function of the thyroid and, to a lesser degree, the adrenal glands. This pathway of energy emanates from the fourth finger, travels up the back of the arm, across the elbow, shoulder joint, and upper trapezius muscles. It winds around the back of the neck, around the ear, and flows to the edge of the eyebrow.

As its name implies, the Triple Warmer functions as the "silent regulator" of the three "fires" of the body. These include basic metabolism, digestive energy transference from food to cells, and body temperature regulation. People who complain of cold hands and feet, or get chilled easily, may experience a malfunction of the Triple Warmer Meridian and thyroid gland.

Symptoms of Triple Warmer Imbalance

Many aspects of the upper respiratory system may be influenced by the Triple Warmer Meridian/thyroid connection. These symptoms may indicate an imbalance:

- Colds
- Ear infection, tonsillitis, sore throat, swollen glands
- Eye problems, cataracts, pink eye
- Cold hands or feet, excessive sweating, hot flashes
- Jaw pain, shoulder, arm, wrist stiffness
- Thinning hair, dry skin
- Low energy, chronic fatigue immune deficiency syndrome
- Menstrual cycle irregularities

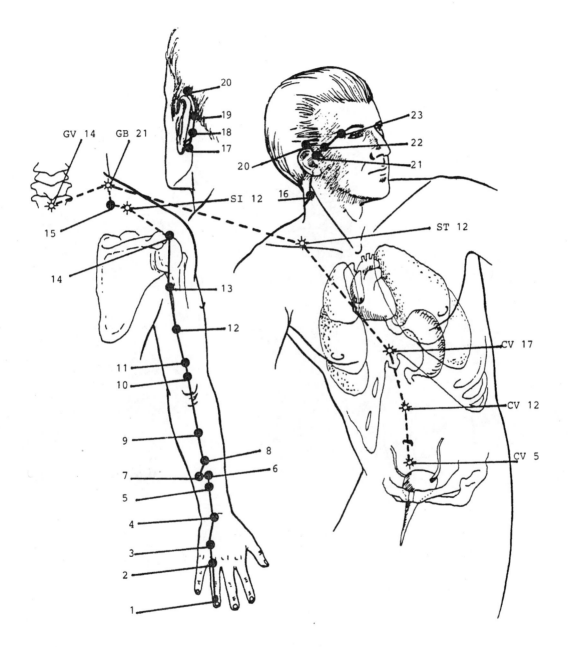

TRIPLE WARMER MERIDIAN

ILLUSTRATION COURTESY OF DR. JOHN AMARO,

INTERNATIONAL ACADEMY OF CLINICAL ACUPUNCTURE. COPYRIGHT © 1981.

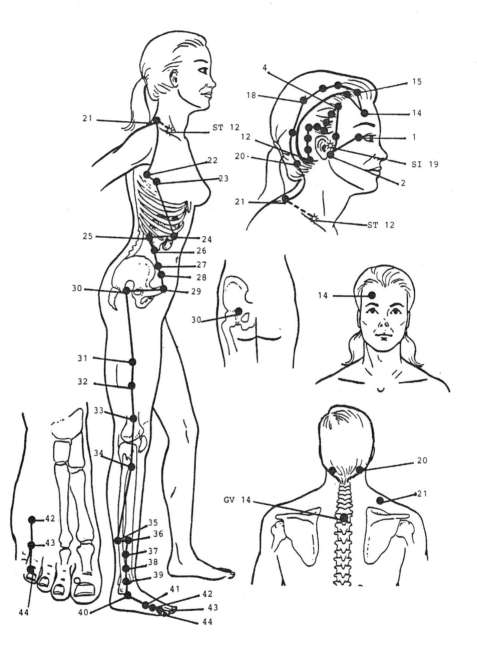

GALLBLADDER MERIDIAN
ILLUSTRATION COURTESY OF DR. JOHN AMARO,
INTERNATIONAL ACADEMY OF CLINICAL ACUPUNCTURE. COPYRIGHT © 1981.

THE GALLBLADDER MERIDIAN 11 P.M.-1 A.M.

The second longest meridian, the Gallbladder Meridian, also contains the second largest number of acupuncture points. The energy channel begins at the edge of the eye, flows down the angle of the jaw, then shortcuts directly up to the hairline.

The meridian then zigzags across the head several times and down the back of the neck to an area around the armpit and lower front ribs. Angling across the pelvis to the hip joint, the energy laterals down the leg and knee to the calf, where it jogs all the way down to the lateral foot and ends near the nail of the fourth toe.

Be imperturbable and the true chi will come to you; concentrate the inner spirit and well-being will follow.
THE YELLOW EMPEROR'S CLASSIC ON INTERNAL MEDICINE

Symptoms of Gallbladder Meridian Imbalance
Additional problems which develop from low energy in the gallbladder meridian are:

- Headaches
- Muscle pain
- Gallbladder pain, stones
- Tightness in ribs, thorax
- Hip, joint stiffness
- Digestive problems, belching, gas
- Lower leg, ankle pain

Gallbladder Surgery
Surgeons routinely cut the Gallbladder Meridian during gallbladder surgery and energetic complications ensue. Any major surgery or scar surrounding the removal of an organ potentially disrupts the flow of acupuncture energy. Organ connections work the same as a sequential string of Christmas tree lights. If one little bulb goes out, the whole circuit is unable to function.

Surgery does not solve the imbalance that causes gallbladder problems. It simply removes the focus of the worst symptoms. The cause of the original imbalance still needs evaluation. In addition, once an operation has taken place, the surgical scar may further prohibit the Gallbladder Meridian from normal function. Two strikes against the gallbladder system inhibit further healing. A person missing the organ that connects to the meridian now has a scar cutting through the meridian—cutting off its energetic impulse.

Dr. Kiiko Matsumoto, author of *Five Elements and Ten Stems*, bases her entire acupuncture practice on treating surgical and injury scars.[2] In my own practice, I recommend the nutrient, superoxide dismutase or SOD for the liver, which revitalizes cells and reduces excessive scar tissue, as well as treating the scar with acupuncture and/or laser.

For most people, gallbladder dysfunctions and remaining scars may be treated through acupuncture and diet changes. The primary factor involves limiting the amount of fat intake in the body. A high fat diet proves extremely irritating to the gallbladder, whether absent or present! In addition, a high fat diet may trigger heart problems later on.

THE LIVER MERIDIAN 1-3 A.M.

The final energy pathway, the Liver Meridian, starts on the inner side of the big toe, travels upward and ends in the right lower ribs near the liver and on the left by the spleen.

Symptoms of Liver Meridian Imbalance
A Liver Meridian which is out of balance exhibits symptoms which may include:

- Eye irritation
- Lump in the throat
- Muscle, joint stiffness
- Back, rib pain
- Knee problems
- Uterus, prostate complaints
- Arthritis
- Skin ailments: eczema, psoriasis, dermatitis

THE HEALING TOOL

Clinical Kinesiology helps practitioners to effectively use acupuncture in designing treatment programs to recover and maintain health. Once familiar with your energetic body and its acupuncture pathways, you can provide yourself the healing support needed to correct your body's functional imbalances.

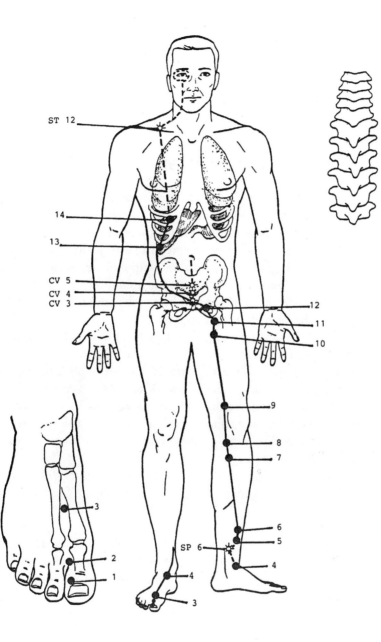

ST 12

14
13

CV 5
CV 4
CV 3

12
11
10

9

8
7

3

2
1

6
5

SP 6

4

4
3

LIVER MERIDIAN
ILLUSTRATION COURTESY OF DR. JOHN AMARO,
INTERNATIONAL ACADEMY OF CLINICAL ACUPUNCTURE. COPYRIGHT © 1981.

Follow along as we cover the following treatment techniques:

- Acupuncture
- Acupressure/Teishin
- Lasers
- Therapeutic Magnets

ACUPUNCTURE TREATMENT

The men and women in the vanguard of the health professions find themselves simultaneously traveling backwards and forwards, listening for echoes of ancient wisdom even as they scale the pinnacles of science.
MARC BARASCH.

Acupuncture needles have been used for centuries in one form or another. Historians suspect pine needles and tiny bones from bird-legs served as the earliest methods for stimulating the points.

Acupuncture needles work much like tiny antennae. When inserted, almost painlessly, into an acupuncture point, the needle immediately begins drawing in the surrounding energy, which then shoots through the meridian and helps rebalance by removing blockages, adding or realigning energy.

Imagine shooting a high intensity blast of water through a corroded pipe. Immediately, you'd clear out most of the corrosion. A few more blasts and the pipe would be clean and functional once again. The acupuncture needles work much the same way.

Most acupuncturists use stainless steel, sterile, disposable acupuncture needles for optimum healing response. The narrow gauge, or diameter, of disposable needles makes them more comfortable and acceptable to most patients.

No matter what needle type, treatment requires direct stimulation of the acupuncture points for effective healing. Treatment relaxes the whole body and spirit and provides an extremely calming effect on inflammation or other active problems.

Initially, treatment of an active problem or inflammation requires longer needle-insertion time. The typical time varies from ten to fifteen minutes. Alternately, the shorter the length of time that the needles are in place, the less sedative effect.

Historically, older techniques required acupuncturists to manipulate the needles in and out, or up and down on the same point. Most manual stimulation involves twirling the needle between two fingers. Twirling the needles stimulates energy movement, or activates the *ch'i*. Today, most disposable needles contain a little handle on the end for such twirling purposes.

Brett's Story

Depending upon the imbalance, each individual body may require different treatment. Brett, a first-time male patient, pulled in so much of the energy being supplied from the acupuncture needle that his skin and tissue actually "tented." This acupuncture term describes skin that pooches up around an acupuncture needle just like a tent. Only after two hours and forty minutes did his body finally release the acupuncture needles.

Brett's body more or less held onto the needles "begging" for more input. Until his body reached a certain state of energy balance it refused to release the needles. Although difficult, it could have been possible for me to remove the needles, but traumatic for Brett's body. If the body says that it really wants that input, the wise thing to do is let the body decide its own pace and continue to allow it to absorb that energy balancing correction from the needle for the appropriate time.

Throughout the two hours and forty minutes, I checked on Brett periodically until his body said, "Ok, I've had enough." Many times, there are emotional factors involved in such instances as we'll see in Chapter Three. In Brett's case, an upcoming move across the country may have been a big factor in the amount of energy his body needed during his acupuncture treatment.

THE NEEDLES

It's unnecessary to place an acupuncture needle extremely deep. This especially holds true when treating external meridian points. Treating external points affects internal points. So, one doesn't need to plunge the needles into the deepest recesses of the body to effect healing.

Acupuncture treatment is generally quite painless. Occasionally, depending on the particular imbalance, some points may prove noticeably tender. Patients who experience an active point in desperate need of treatment, may find it quite tender upon needle insertion. Otherwise, *there's absolutely no comparison* to pain from an injection with a hypodermic needle more than six times as large. At worst, an acupuncture needle insertion feels more like a mild mosquito bite without any of the burning or inflammation.

When acupuncture needles are used, practitioners may gently "close the hole," by rubbing a finger over the open site where the acupuncture needle has been removed. The Chinese of old did this to stop any leakage of the person's *ch'i*—in essence—so they would not lose energy through the tiny opening.

Anyone who uses needle acupuncture must be trained. Appropriate concern for one's health and well-being includes choosing a health practitioner with sufficient training to understand how and where to apply the acupuncture with needles. It's important to remember that the effects of the acupuncture needles are quite dramatic. For example, inappropriate needle stimulation of specific points during early pregnancy can lead to miscarriage in some cases.

ACUPRESSURE AND TEISHEIN

Energy is not obtained from the gross molecular aspects of food and air, but rather from what can be called its "vibrational" essence or its electromagnetism.
DR. STEPHEN T. CHANG.

I do encourage people to be involved in their own healthcare treatment which allows them to do many things for themselves. The *teishein*, or stainless steel acupressure tool may also be used to stimulate the same acupoint without needles. Spring-loaded with a retractable pressure applicator, the *teishein* resembles a ballpoint pen mechanism, and when tapped, applies pressure to an acupuncture point.

Energizing the meridian with the *teishein* comes first, followed by the small laser for additional stimulation. Such gentle tools enable treatment of tiny infants, small children, and other patients as needed.

I've helped several patients to purchase their own acupressure tool or *teishein* to use at home. While not easily available to the public, you may ask your acupuncturist to order a *teishein* for you and instruct you in its use. The best teisheins I have found are available through the International Academy of Clinical Acupuncture. (See Appendix for Product Guide and Associations.) Other acupressure point stimulators may be purchased through health-related magazines, catalogs and at tradeshows. In addition, Panasonic makes the Shiatsu Acu-Tap II® massager, which also stimulates acupressure points and can be ordered from specialty health stores such as The Better Back Store in Denver, Colorado. (See Product Guide.)

LASER AND MAGNETIC THERAPY

Laser therapy provides another exciting field of energetic treatment recently opened to the West. Lasers involve treatment with a focused beam of light, called photon energy. Photon particles carry the force in an electromagnetic field.

Popular in China for at least twenty-five years, therapeutic lasers have been available in this country for approximately eight years. While still fairly uncommon, soft lasers are now being used successfully to augment acupuncture therapy. Acupuncture needles pick up and help direct needed energy into the body. A small laser may then be concentrated directly on the acupoint allowing its energy to penetrate along the course of the needle and into the meridian to help further the healing process.

Lasers project waves of light particles, or beams, into the body to a depth of a half-inch to an inch depending on tissue consistency. Some patients are sensitive enough to feel the beam of laser light as it connects with the energy from the meridian. When this happens, many times, the acupuncture needle itself begins to quiver from the added energy. Small soft lasers may also be purchased from specialty catalogs or through healthcare practitioners.

Joyce's Story

I recently treated Joyce, a female patient who lost a leg in a car accident. Initially, Joyce's complaint stemmed from continuing menopausal symptoms. Upon Clinical Kinesiology diagnosis, however, a liver imbalance pinpointed Joyce's true problem.

After locating specific acupuncture points on Joyce's leg that needed to be energized, I mentioned that it was my practice to stimulate both right and left sides in order to sufficiently treat an imbalance.

In addition to Joyce's acupuncture treatment, I added laser stimulation of the acupuncture point on her right side, even though no leg was present. Continued stimulation of Joyce's *etheric* body—her field of energy, or aura—and the existing current of uninterrupted energy for that area, proved extremely healing. Joyce's leg energy was not removed, even though her physical leg was no longer present.

Magnetic field therapy is a method that penetrates the whole human body and can treat every organ without chemical side effects.

WOLFGANG LUDWIG,
DIRECTOR FOR THE
INSTITUTE OF BIOPHYSICS,
HORB, GERMANY

Energy meridians remain intact. Proof of this may also be found in many situations of phantom leg pain. Joyce, too, described certain sensations in the area where her leg had been removed. What she felt energetically during the three years she'd lived with her amputation compared to reactions of a limb experiencing poor circulation or "falling asleep."

Following the laser stimulation Joyce experienced new energetic sensations much different from the phantom leg pain. She described a new, warm, tingling sensation, more aptly an awakening from "pins and needles." In Joyce's case, application of the laser stimulated her body to begin the necessary rebalancing.

In the coming years, experiencing the effects of laser stimulation should prove an important therapeutic alternative for patients in similar situations. Once only considered to be a tool of the future, lasers now provide far-reaching cures in rebalancing the body and its energetic system.

THERAPEUTIC MAGNETS

Therapeutic magnets supply yet another form of stimulation that may be applied to energize an acupuncture point. Clinical Kinesiology testing provides the means for discovering electromagnetic imbalances in the body. When such imbalances show up, effective treatment may require magnetic or polarity therapy.

Through Clinical Kinesiology muscle testing, a patient may be checked to determine if a "north pole" or a "south pole" magnet is required. Once a particular pole is indicated, the corresponding magnet, attached to a small, round adhesive strip, may be applied to the acupuncture point, where it remains for a few days to a week.

The individual power of therapeutic magnets are typically 800 gauss, (a measurement of magnetic field strength). Such a magnetic force doesn't overpower the body; however, it does help rebalance the electromagnetic system. I caution you against using any magnetic force on any generalized part of your body without specific testing by a trained healthcare practitioner.

Following acupuncture or related therapy, retesting with Clinical Kinesiology confirms the effectiveness of the treatment. Generally, acupoints that registered weak prior to the application, now prove

strong. If all is well, proceeding with further energetic testing determines any additional treatment needs, such as vitamin or nutritional supplementation.

ACUPUNCTURE ALARM POINT TESTS

When an organ/meridian system becomes out of balance, the body's innate wisdom is automatically programmed to set off an alarm, "Ah, there's a problem here!" You do not need to be "alarmed"...merely alerted. (A smoke detector goes off for many reasons other than simply for a fire.)

Correct persistence brings good fortune.
I CHING

The acupuncture alarm point tests provide a series of "checkpoints" along your energetic system. If the body detects a problem, the alarm point is "set-off," and becomes active or often tender. If the alarm point is tender or responds weak to the Clinical Kinesiology muscle test, that alerts you that a particular organ/meridian system needs rebalancing.

The acupuncture alarm point muscle tests provide quick answers so that you do not need to check every individual point on each meridian. Do you need to be concerned about a specific organ or not? Testing the acupuncture alarm points may be the first step to uncovering an imbalance which may not yet be so advanced that it is noticeable through symptoms. Dr. John Amaro stresses the importance of the alarm points.

GO WITH YOUR ENERGY FLOW

If, during testing, you discover problems that indicate an energetic imbalance in your body, you have several choices. Deal with the most important priority first! Energetically treat the problem through acupuncture, diet, nutritional, homeopathic or herbal therapies—and change the imbalance. Treated now, your health may go in a whole new direction.

Left untreated, the imbalance, depending upon the direction the body takes—considering lifestyle factors and mindset—may lead to numerous different ailments. Generally, if you haven't been trained in acupuncture, it's best to seek guidance from an alternative health practitioner following your initial acupuncture alarm point tests.

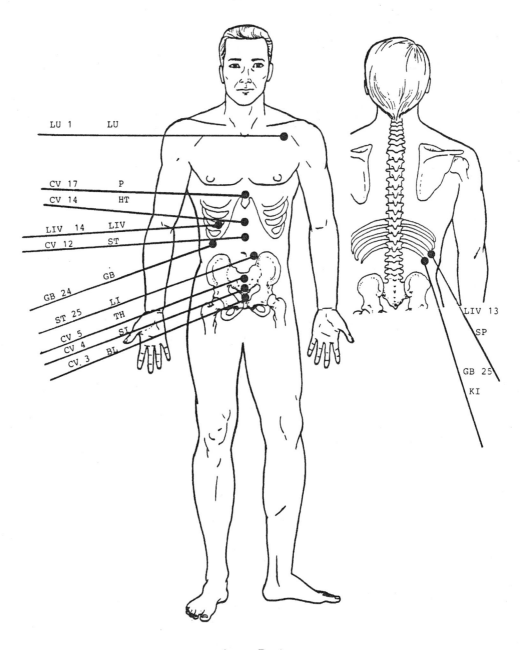

ALARM POINTS
ILLUSTRATION COURTESY OF DR. JOHN AMARO,
INTERNATIONAL ACADEMY OF CLINICAL ACUPUNCTURE. COPYRIGHT © 1981.

HOW TO TEST ACU-ALARM POINTS

Most of the acupuncture alarm points may be located on the front of the torso, with a few points on the posterior or rear of the body. If you are right-handed, *therapy localize* or touch the Acu-Alarm point with your left hand, while the test is performed on your right arm indicator muscle by a test partner.

LUNG ALARM POINT TEST

The alarm point for the lungs (LU 1) may be found on the front of the body, near the shoulder, just below the clavicle.

> Lung alarm point TL + Muscle test + Weak arm = Lung imbalance= Seek guidance from an alternative health practitioner.
>
> Lung alarm point TL + Muscle test + Strong arm = Lung balance.

LARGE INTESTINE ALARM POINT TEST

The large intestine alarm point (ST 25) may be located on the Stomach Meridian two thumb-widths lateral to the navel on both the right or left.

> Large Intestine alarm point TL + Muscle test + Weak arm = Large Intestine imbalance = Seek guidance from an alternative health practitioner.
>
> Large Intestine alarm point TL + Muscle test + Strong arm = Large Intestine balance.

STOMACH ALARM POINT TEST

CV 12 indicates the point to therapy localize for testing the stomach alarm point. This point rests a couple of inches above the navel.

Stomach alarm point TL + Muscle Test + Weak arm = Stomach imbalance = Seek guidance from an alternative health practitioner.
Stomach alarm point TL + Muscle Test + Strong arm = Stomach balance.

SPLEEN ALARM POINT TEST

The spleen alarm point (LIV 13) may be located one rib above the kidney point or at the eleventh rib shown on the diagram. Rarely out of balance, the spleen, however, does have a relationship to the quality of the blood in the body. In addition, the female energetic system may be dramatically affected by spleen energy.

Spleen alarm point TL + Muscle test + Weak arm = Spleen imbalance = Seek guidance from an alternative health practitioner.
Spleen alarm point TL + Muscle test + Strong arm = Spleen balance.

HEART ALARM POINT TEST

On the mid-line of the Circulation Vessel Meridian lies the heart alarm point (CV 14). The heart point lies three or four inches below the pericardium point and even with the ninth or tenth rib innerspace.

Heart alarm point TL + Muscle test + Weak arm = Heart imbalance = Seek guidance from an alternative health practitioner.
Heart alarm point TL + Muscle test + Strong arm = Heart balance.

SMALL INTESTINE ALARM POINT TEST

Another inch below the triple heater point, you may locate the small intestine alarm point (CV 4).

Small Intestine alarm point + Muscle test + Weak arm = Small Intestine imbalance = Seek guidance from an alternative health practitioner.
Small Intestine alarm point + Muscle test + Strong arm = Small Intestine balance.

BLADDER ALARM POINT TEST

Directly above the pubic bone, (CV 3), the bladder alarm point may be located and tested fairly easily because the point corresponds closely to the physical organ.

Bladder alarm point TL + Muscle test + Weak arm = Bladder imbalance = Seek guidance from an alternative health practitioner.
Bladder alarm point TL + Muscle test + Strong arm = Bladder balance.

KIDNEY ALARM POINT TEST

The very bottom or shortest rib located on the posterior low back indicates the area of the kidney alarm point (GB 25). It's also helpful to locate the spine at the twelfth rib and follow it outward to the tip of the rib.

> Kidney alarm point + Muscle test + Weak arm = Kidney imbalance = Seek guidance from an alternative health practitioner.
> Kidney alarm point + Muscle test + Strong arm = Kidney balance.

CIRCULATION/SEX OR PERICARDIUM ALARM POINT TEST

Locate the circulation/sex or pericardium alarm point (CV 17) directly above the inverted V between the ribs about an inch or two above the bony apex. This meridian provides the constant flow of energy that envelops the heart. Thus, it remains an important alarm point to test.

> Pericardium alarm point TL + Muscle test + Weak arm = Pericardium imbalance = Seek guidance from an alternative health practitioner.
> Pericardium alarm point TL + Muscle test + Strong arm = Pericardium balance.

TRIPLE HEATER/THYROID ALARM POINT TEST

The immune system and thyroid share a strong relationship with the triple heater alarm point (CV 5). Because the navel is CV 8, to locate the triple heater point, you may drop down roughly 3 to 3 ½ inches from the navel to reach the correct point.

> Triple Heater alarm point TL + Muscle test + Weak arm = Triple Heater imbalance = Seek guidance from an alternative health practitioner.
>
> Triple Heater alarm point TL + Muscle test + Strong arm = Triple Heater balance.

GALLBLADDER ALARM POINT TEST

The gallbladder alarm point (GB 24) lies at the lowest edge of the front side of the ribs. By therapy localizing the gallbladder alarm point you may also learn about an early gallbladder imbalance. Again, it's preferable to check the gallbladder point on the left rather than the right. Without the actual presence of the gallbladder organ beneath the point, you'll be guaranteed a much more accurate test.

We are part of the Earth and it is part of us. For all things connected.
CHIEF SEATTLE

> Gallbladder alarm point TL + Muscle test + Weak arm = Gallbladder imbalance = Seek guidance from an alternative health practitioner.
>
> Gallbladder alarm point TL + Muscle test + Strong arm = Gallbladder balance.

LIVER ALARM POINT TEST

The liver alarm point rests on the lower right rib cage between the last two ribs that you can feel. The right liver point (LIV 14) is shown by the diagram; however, you may also test the corresponding point on the left. Often, I recommend the left point to avoid the confusion of therapy localizing over liver and gallbladder. For an accurate test, be sure to target the acupoint without allowing involvement of any nearby organ.

Liver alarm point TL + Muscle test + Weak arm = Liver imbalance = Seek guidance from an alternative health practitioner.

Liver alarm point TL + Muscle test + Strong arm = Liver balance.

The relation between the body and the mind is so intimate that, if either of them got out of order, the whole system would suffer.
GHANDI

Taking the time to treat an imbalance early, may create a new, happy and harmonious condition within your body. You, who were once ill, may soon be well! Will it be a miracle cure? I don't think so. All you will be doing is taking the time to "know" about yourself, your body, and the energetic flow of your meridians. It doesn't take many years, or a great deal of experience to get to know your body and to listen to what it has to say. All it takes is your time, attention, and willingness to be well.

This chapter has provided you with new information on the *physical* aspects of energetic imbalances and how Chinese acupuncture facilitates realignment and healing. In Chapter Three, *Energy and Your Emotions*, we'll help you understand the critical role that the *mental and emotional* body plays in maintaining physical health by presenting the Chinese Five Element theory, which interprets organ/emotion relationships through Clinical Kinesiology testing.

CHAPTER TWO SUGGESTED READING

Becker, Robert O., M.D. *Cross Currents: The Perils of Electropollution, the Promise of Electromedicine.* Los Angeles: Jeremy P. Tarcher, Inc., 1990.

Beinfield, Harriet, L.Ac., and Korngold, Efrem, L.Ac., O.M.D. *Between Heaven and Earth: A Guide To Chinese Medicine.* New York: Ballantine Books, 1991.

Diamond, John. *Your Body Doesn't Lie.* New York: Warner Books, 1979.

Eisenberg, D. M.D. and Wright, T. *Encounters with Qi: Exploring Chinese Medicine.* New York: Penguin Books, New York, 1987.

Kaptchuk, Ted O.M.D. *The Web That Has No Weaver: Understanding Chinese Medicine.* New York: Congdon and Weed, 1993.

Manaka, Yoshio M.D. and Urquhart, Ian A. Ph.D. *The Layman's Guide To Acupuncture.* New York: John Weatherhill, Inc., 1992.

Matsumoto, Kiiko and Birch, Stephen. *Five Elements & Ten Stems: Nan-Ching theory, diagnosis, and practice.* Brookline, MA: Paradigm Publications, 1989.

Mitchell, Ellinor R. *Plain Talk About Acupuncture.* New York: Whalehall, Inc., 1987.

Worsley, J. R. *Acupuncture: Is It For You?* New York: Harper and Row, 1973.

3

Energy And
Your Emotions

SEVERAL YEARS AGO, I attended a birthday party for my young nephew, Stevie. The entertainment featured a magician in top-hat and tails whose tricks held the crowd spellbound. At first, the magician's top hat appeared empty. He then magically reached into the hat and pulled out a beautiful red silk scarf. As he pulled, a blue scarf suddenly appeared, attached to the red. Then, a yellow scarf...and a green...and so on.

The magician pulled more hidden and varied scarves seemingly from deep within his hat. Watching these colorful scarves reminded me of another mysterious realm—human emotions. How deeply interconnected our emotions run and to what hidden depths they descend. When we can't "pull out" or express our emotions as readily as this magician pulled out the colored scarves, we suffer—physically, mentally, spiritually. Sometimes an inability to express deep thoughts or feelings of anger, sadness, or love causes emotions to become energetically congested in one or more organ/energy systems of the body. Clinical Kinesiology, then, becomes an invaluable tool in relief of symptoms associated with deep, underlying emotional imbalances.

THE MIND-BODY CONNECTION

In modern Western culture, science has separated mind and body. Other cultures in the world, however, have long held that mind and body are one. The ancient Chinese developed the Chinese Five Element Theory based on the belief that the energy of the mind and body exist as one with heaven and earth.

Dr. Alan Beardall incorporated the Chinese Five Element theory into Clinical Kinesiology testing to assess emotional states in the body. Since his death, several doctors, including Naturopath, Dr. Theresa Dale, and Neural Kinesiologist, Dr. Louisa Williams, have further explored diagnosis and treatment of the critical role emotions play in the well-being of the physical body.

Based on the Chinese Five Element Theory, this chapter focuses on the organ/meridian system as a storage site for deeply hidden negative emotions. In this chapter you will learn:

- How Clinical Kinesiology, through integration of different levels of mind-body energy, may be utilized to diagnose emotional imbalances.
- How homeopathic remedies can help eliminate emotional imbalances.
- How supplementation with amino acids, vitamins and minerals assists in brain metabolism.
- How words and attitudes augment healing through creative visualization and how self-testing the energetic body provides a deeper understanding of and access to underlying emotions.

Your health is bound to be affected if, day after day, you say the opposite of what you feel, if you grovel before what you dislike and rejoice at what brings but misfortune. Our nervous system isn't just a fiction; it's a part of our physical body, and our soul exists in space, and is inside us, like the teeth in our mouth. It can't be forever violated with impunity.

BORIS PASTERNAK

Gaze into the sky on a starlit night and imagine the rotation of the moon around the earth. One evening, you might discover a beautiful full moon. Another night, only a quarter moon. The ever constant moon is always there, however, you may not always notice its quiet, dark side.

Just like the moon, the energy of your emotions is constantly expressed, whether noticed or not. Just as you cannot be separated from the environment, the effects of your feelings, thoughts, emotions, or preconceived ideas cannot be separated from body function, health, illness, or other life experiences.

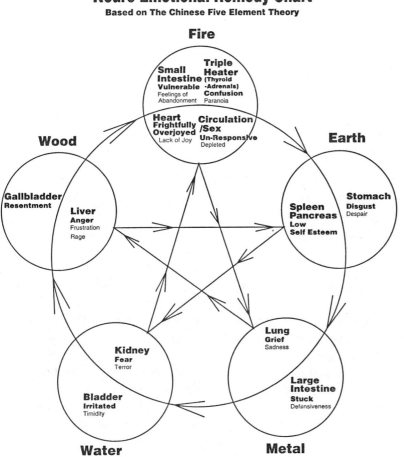

Neuro Emotional Remedy Chart
Based on The Chinese Five Element Theory

Fire

Small Intestine
Vulnerable
Feelings of Abandonment

Triple Heater (Thyroid -Adrenals)
Confusion
Paranoia

Heart
Frightfully Overjoyed
Lack of Joy

Circulation /Sex
Un-Responsive
Depleted

Wood

Gallbladder
Resentment

Liver
Anger
Frustration
Rage

Earth

Stomach
Disgust
Despair

Spleen
Pancreas
Low
Self Esteem

Kidney
Fear
Terror

Lung
Grief
Sadness

Bladder
Irritated
Timidity

Large Intestine
Stuck
Defensiveness

Water

Metal

CHINESE FIVE ELEMENT THEORY

Two to three thousand years ago, the earliest reference of the Chinese Five Element Theory was recorded in *Shu Ching*, a book of Chinese political philosophy.[1] Later, more in-depth theories appeared in the *Nan Ching*, an ancient medical classic.[2]

The book, *Five Elements and Ten Stems*, by Dr. Kiiko Matsumoto and Stephen Birch documents the development of the Chinese Five

Element theory over many centuries.[3] The concept of *Yin* and *Yang* best explain how the Chinese viewed the environment and its effect on human emotions. *Yang*, the energy of heaven, relates to each aspect of the five elements. *Yin*, the energy of earth, corresponds to the twelve main acupuncture meridians. This influence of heaven and earth on the body provides the basis for the Chinese Five Element Theory.

According to the Chinese Five Element Theory, every facet of health or illness may be governed by one of five elements...wood, fire, earth, metal, and water. (Although emotions are the main focus of this chapter, the Chinese Five Elements also include aspects such as taste, color, odor, time of day, sound, and other distinct elements which indicate imbalances in the body.) Each of the five elements relate to a particular season of year, organ/meridian, and emotion.

According to naturopath Dr. Theresa Dale of The Wellness Center for Research and Education of Malibu, California, "...disease manifests as a result of resistance to feelings and emotions regarding an experience, idea or belief."[4] This resistance may occur on a conscious or unconscious level. Take anger, for example. Most people encounter any number of anger-causing events throughout life. However, at the time, anger may go unexpressed for one reason or another. The vestiges of such unreleased anger are then stored inside the body.

New instances that trigger feelings of anger may not simply involve the current event or emotion. Rather, they may be connected to a chain of emotional events—all the way back to the earliest experiences of anger. Dr. Dale further believes, as the ancient Chinese, that such stagnant energy creates an "electromagnetic charge of energy" which may be stored in the corresponding organ/meridian system.

PLUS HOMEOPATHY

Dr. Dale, a former student of Dr. Alan Beardall, has expanded the application of Clinical Kinesiology adding the use of specific homeopathic remedies based on the *Materia medica*, and the Chinese Five Element Theory. Dr. Dale's Neuro-Emotional Remedies are specific formulations currently available only through healthcare

There are no fixtures in nature. The universe is fluid and volatile Permanence is but a word of degrees.

EMERSON

professionals. (See Product Guide.) While they are used specifically by Clinical Kinesiology practitioners, other homeopathic remedies may be used as well.

Homeopathy, from the Greek words "homeo" and "pathos" means "similar suffering." Attributed to Samuel Hahnemann, homeopathy originated from the eighteenth century belief that real illness lies beneath the physical, mental and emotional levels at the energetic level, or level of *ch'i.*

Homeopathy is based on the premise that "like cures like," or as Hippocrates stated, "The same things which cause the disease cure it." Specific homeopathic remedies like Dale's allow release or drainage of "core" emotion/energy from an unbalanced organ or acupuncture meridian.

Furthering the energy/emotion balance may also require physical aspects of treatment including acupuncture, nutrition, gentle chiropractic adjustments, or other natural means. While prominent in most cases, emotional symptoms may be hidden by adaptations in others. As an organ responds to physical treatment, many times the underlying emotional aspect surfaces and requires treatment as well.

The highest ideal of cure is the speedy, gentle, and enduring restoration of health by the most trustworthy and least harmful way.

SAMUEL HAHNEMANN,
FOUNDER OF HOMEOPATHY

HOW NEURO EMOTIONAL REMEDIES WORK

Clinical Kinesiology testing of emotions involves the location and testing of specific acupuncture points on the hands or feet. These reflex or "ting" points were originally researched and identified by German doctors in the 1940s led by Dr. Reinhold Voll, M.D. A weak muscle response in relation to a specific point can instantly diagnose underlying emotional imbalances for which a homeopathic remedy may provide rebalance.

Then, a number of homeopathic remedies may be evaluated by placing them directly on the patient's abdomen or in the energy field. The muscle testing is then performed to narrow down the correct treatment. Again, several other remedies are tested and arm muscle strength monitored until, by a process of elimination, the body "says" which remedy is best.

DISCOVERING THE ELEMENTS FOR YOURSELF

*Our bodies demand our attention;
our bodies demand that we actu-
ally pay attention to what is
going on with our lives.*
CHÖGYAM TRUNGPA, RINPOCHE

Follow along now as each element and its characteristics are identi-
fied. Since each element in the Chinese Five Element theory
corresponds to a specific emotion in the body, use the data that fol-
lows to uncover your own "hidden" emotions. Challenge yourself to
become aware of any emotions you may have been experiencing in
the past weeks or months. Take as much time as needed to observe
any emotions that may come to light. The suggestions that follow
will help you in this process.

Many different techniques will help you to gain deeper insight
into the energy of your emotions. For example:

- prepare a simple visualization that might allow you to trans-
 port yourself back in time and then allow yourself to quietly
 retrieve any past episodes of anger, grief or fear, etc.
- recall ways that you might comfortably intervene (verbal
 affirmations, crying, writing in a journal, pounding a pillow,
 etc.) at an emotional level to help your body overcome or
 cleanse any feelings that float to the surface.
- don't be afraid to speak about any unresolved, unfinished,
 or unexpressed emotions to a trusted friend or therapist.
- reward yourself for your efforts with something special: a
 walk, warm bath, visit to a friend, drive in the park, etc.

Wood Element: Liver and Gallbladder

Just as the earth experiences various "phases" or cycles, so does the
body. The Chinese identified the seasonal elements through the Chi-
nese Five Element Theory and further correlated it to the human
experience.

The season of springtime awakens the wood element's predomi-
nant energy. Rebirth and renewal categorize the time of year for new
grass, fresh shoots, tiny flowers, and budding trees. The whole world
turns green.

The color green correlates significantly to the wood element's
emotional relationship with its main organs, the liver and gallblad-
der. You may have heard people say, "He's 'green' with envy." Or,
"She's 'green' with anger!"

In cases of jaundice, for example, the skin produces a yellow color,
however, the actual hue represents more of a green-yellow shade than

pure yellow. Diseases of the wood element often manifest such a skin tone.

Liver Emotions

In Chinese Five Element theory, the liver represents the *seat of anger*. When someone carries anger it often manifests physically as an imbalance in the liver. Gone unexpressed, the anger/emotion becomes trapped in the liver and problems may ensue.

According to Dr. Dale's research, other emotional aspects of liver imbalance may include:

- frustration
- rage

Caitlin's Story

Following her brother's suicide, Caitlin's liver problems manifested as bad headaches. At the time, Caitlin's parents refused to accept their son's death. Although she bore no responsibility for the suicide, her parents leveled their anger and blame in her direction.

Hurt and grief-stricken, Caitlin internalized her emotions, which included a great deal of anger. Eventually, the pent-up emotions stagnated her liver energy. Her Clinical Kinesiology test signaled that she needed a homeopathic liver remedy, along with acupuncture and other nutrients.

As Caitlin worked on releasing her anger with the remedy, I suggested she imagine her mind/body as a transparent balloon filled with grey smoke. The smoke symbolized her anger, along with other repressed emotions she'd stifled while defending herself against her parents blame.

As Caitlin took the remedy drops, she visualized the smokey grey anger slowly puffing up, up, and away. Her emotional cleansing continued through this visualization until she could "see" the true, clear color of her balloon.

Several months later, Caitlin scheduled a visit with her parents. Before leaving, she worked on her visualizations for about a month and a half. Then, with a great deal of trepidation, she made the journey. The trip went well, and turned out to be the best visit she'd ever had with her folks. While her parents' attitudes were much the same and Caitlin still experienced little jabs and negative comments, she was no longer paralyzed by them. She had vowed not to let her

parents' accusations affect her. Caitlin couldn't change her parents' behavior, so she changed herself.

> **MEDITATION:** You may want to try this simple balloon meditation as described above. Start with imagining a clear balloon filled with grey smoke (representing your pain or emotional turmoil). Then, as you relax, breathing gently, or as you take a nutrient or remedy, "watch" the balloon color gradually change. (Pick a favorite color to brighten up the balloon, a color which makes you feel good.)
>
> Watch as the balloon (your mind/body) becomes clearer and "floats" higher as negative emotions and excess anger leave your body. Cleansing trapped emotions helps release energy blockages on a cellular level and alleviates problems which interfere with body function and physiology.

Forgiveness is the key to happiness.
 A COURSE IN MIRACLES

We all experience emotions we need to feel and express. For Caitlin, taking the remedy drops wouldn't have been nearly as effective without including the mental processing, or visualization. This investment of herself—time, emotions and very soul—provided the true healing.

Gallbladder Emotions

The gallbladder is the body's physiological reservoir for bile, which flows from the liver. In emotional terms, the gallbladder serves as the reservoir for *resentment* which stems from stored anger. Other emotional factors of gallbladder imbalance involve:

- stubbornness
- emotional repression

You may hear the colloquial phrase, "I'm really galled!" Or, "That really galls me!" Most people don't realize that those words have a tremendous impact on the body. The gallbladder listens and hears. All emotions affect organ energy. The development of healthier strategies to deal with your anger situations and inner conflict today may strongly affect tomorrow's health.

Fire Element: Heart and Small Intestines

Imbalances of the fire element manifest in the height of summer through the change of leaves. The fire element encompasses four meridian systems: Heart, Small Intestine, Circulation/Sex and Triple Warmer.

The organs of the Heart and Small Intestine Meridian both comprise the fire element and relate to each other quite a bit. The fire organs provide the body with warmth, light and life.

Heart Emotions

An important emotion corresponding to a heart imbalance has been termed *frightfully overjoyed* by the Chinese. I also find lack of joy in many people. One example involves the pain of a broken heart. Another extreme heart emotion, which leans toward the opposite pole, may be termed *frightfully sad*. According to Dr. Dale, other emotional aspects include abnormal or inappropriate laughter.

Physical heart problems may be easily pinpointed through Clinical Kinesiology energetic testing. Discerning whether any of the above emotions applies (especially if the person doesn't manifest these emotions) requires specific priority testing by a skilled practitioner. Once a remedy or treatment is administered, retesting confirms whether the heart strengthens with the remedy.

Small Intestine Emotions

The small intestine has been called the "sorter" of emotions. It processes those emotions of value to the mind/body and discards the rest.

The main emotional factor affecting the small intestine may be referred to as *vulnerable*. Feeling vulnerable or lost in life may cause this imbalance to show up. Other related emotions involve feelings of abandonment.

Sandy's Story

Sandy came to me with a complaint of dizziness, which she attributed to an inner ear problem she'd been suffering from for over ten years. Treating the physical aspect of Sandy's problem pinpointed a relationship to her thyroid gland. Additionally, a blocked eustachian tube and food sensitivities further contributed to the dizziness.

Simultaneously, Sandy suffered an emotional crisis. This immediately signified to me that something more serious might be going

Some day after mastering the winds, the waves, the tides and gravity, we will harness for God the energies of love. And then, for the second time in the history of the world, humankind will have discovered fire.

TEILHARD DE CHARDIN

Health and cheerfulness mutually beget each other.
ADDISON

on. Through Clinical Kinesiology testing, Sandy's body indicated she needed three or four different remedies. *Vulnerable* proved to be the emotional imbalance that showed up most strongly. It made sense. If a person was feeling extremely vulnerable, his or her head would spin—he or she would feel dizzy.

Since several reflex points proved out of balance in Sandy's case, I suggested she read through a list of emotions and focus on two or three. She recounted abandonment as an issue she clearly related back to early childhood, and reported that she was currently addressing these issues with a psychotherapist. In addition, Sandy's heart proved out of balance. Several nutrients tested positive for strengthening her heart, and at one point testing also uncovered the need for a homeopathic remedy for female problems. Eventually, Sandy required treatment to rebalance every single organ/meridian system in the fire element.

Sandy acknowledged that for many years her emotions had gone unexpressed. Ultimately, they found an escape route through her illnesses—they rolled around in her head causing a great part of her dizziness.

Happily, with treatment, Sandy's ten-year span of dizziness came to an end after roughly four months. She made the transition from suppressed emotions and conflict regarding her career to a situation in which she'd created a three-day work week and a month's leave of absence to resolve her emotional issues, build up her strength, and closely evaluate her future.

Once blocked, both her emotional and physical illnesses were diagnosed and treated through Clinical Kinesiology, opening up for her the possibilities of a whole new life.

Fire Element Glands

The Thyroid and Adrenal glands of the Circulation/Sex and Triple Warmer meridian together are under the Fire element.

Research indicates that ninety percent of the imbalances affecting the thyroid and adrenal glands stem from emotions labeled *confusion*. You may know someone who says, "I can't remember things," or "I can't put two and two together." Muddled instability reflects the main emotion along with the secondary emotion of paranoia.

The Pericardium

The Circulation/Sex or Pericardium meridian is named for the Pericardium, a tiny sac encircling the heart. A great deal of energy radiates around this sac. As a result, stagnation or energetic imbalances may, in turn, energetically block emotions from the heart. Someone who doesn't reach out or express emotions, who may not be thinking or emoting clearly, may indeed have a blockage around the heart.

When an individual suffers a shock or trauma it upsets positive thinking. You may be convinced you're a positive person and live life accordingly, however, when an emotional crisis arises, you may need to regroup and return that positive energy to the body as quickly as possible. Specific homeopathic remedies help clear up and release blocked emotions.

Male and Female Remedies

Emotional imbalances in the Circulation/Sex Meridian affect both males and females. According to Dr. Dale's research, the primary emotional factor involved with male and female problems is *unresponsive*. A number of homeopathic remedies address male and female problems.

Male/female imbalances affect unexpressive individuals or those who do not allow emotions out. An associated emotion has been categorized as *depleted* (from resisting responding).

Many people experience many problems in close relationships with the opposite sex. Most are unaware that emotions play a significant role in the success of those relationships. For example, with uterine or ovarian problems, prostate or testicular problems, the identifiable organ may be treated, however, without treatment of the corresponding emotion, physical response rarely comes as quickly as hoped. Severe problems call upon every factor in Clinical Kinesiology diagnosis to help rectify the situation.

Earth Element: Stomach and Spleen/Pancreas

The earth element predominates during late summer or "Indian summer," as the seasons change from green to yellow colors and plants withdraw into the earth for an early harvest. Imbalances of the earth

element correspond to the stomach and spleen/pancreas. Although imbalances may occur at any time, a strong propensity remains for the earth element to flare up in the fall.

Stomach Emotion

The most relevant emotion assigned to the stomach relates to *disgust*. Many times, patients unknowingly feel disgusted about a situation, an experience, or something of that nature. The remaining ten percent of the impetus for stomach imbalance includes despair.

Spleen/Pancreas Emotions

Illness brings us down to earth, making things seem much more direct and immediate. Disease is a direct message to develop a proper attitude of mindfulness.

CHÖGYAM TRUNGPA, RINPOCHE

The majority of the influence for spleen/pancreas emotional imbalance stems from *low self-esteem*. Low self-esteem originates from feelings of rejection. According to the Chinese Five Element theory, any injury or damage suffered by the spleen or pancreas may also *trigger* low self-esteem.

The spleen manufacturers red blood cells and contains a great deal of lymphatic tissue. It's also a reservoir and recycling center for white blood cells. If the spleen becomes injured in a severe auto accident, it may rupture. Many times, removal of the spleen becomes necessary so an individual won't bleed to death.

Following spleen removal, people often develop immune system imbalances or other problems. Is there a correlation between low immune system functioning, or autoimmune diseases and self-esteem? Is sufficient self-esteem a common denominator in staying healthy? In the near future, these questions may be answered. Suffice it to say, the body and mind remain more interconnected than we ever thought imaginable.

Metal Element: Lungs and Large Intestine

Imbalances in the metal element occur most often in the late fall, its season of peak energy. The essence of metal symbolizes the power of molten rock and minerals which generate energy from deep within the earth's core.

The Chinese discovered imbalances in the metal element affect the lungs and large intestine.

Lung Emotion

Emotional imbalances of the lungs are bound up with *grief*, affecting more than ninety percent of people. The remaining emotion involves sadness.

Commonly, many people suffer a loss in the family and later come down with bronchitis, pneumonia or a cold. In addition, asthma cases often indicate a potential for grief that wasn't handled. Even childhood asthma makes one question what happened in the child's life for which he or she carries grief.

Many times during evaluation, patients refer to grief issues or anger. They'll say, "Since my father died, I've never been well," or, "I felt breathless following my aunt's funeral." Such clues allow initial testing of a specific remedy. If a weak response occurs from the indicator muscle, further testing may be required to narrow down the type of homeopathic remedy which eventually strengthens the imbalance.

Stephen's Story

Sometimes, emotional problems manifest themselves severely. Stephen suffered from uncontrollable shivering each night after getting into bed. No matter how warm, or how bundled, Stephen couldn't stop shivering.

Dr. Burt Espy diagnosed Stephen's emotional imbalance through Clinical Kinesiology testing, and began treating his lungs and thyroid. However, not until well into treatment did Stephen begin to recall the trauma that led to his illness.

Ten years before, a ringing phone startled Stephen from a deep sleep in the middle of the night. Drowsily, he listened to a voice on the other end of the line inform him that both his mother and father had been killed in a car accident. Stunned, Stephen silenced his grief, carrying his pain around inside for the next ten years. Finally, the shivering—his physical manifestation of grief—became totally unbearable.

With Dr. Espy's help Stephen began to confront his unexpressed emotions. Through acupuncture, nutrition, treatment of his chakra energy centers (see Chapter Four), along with the appropriate homeopathic remedy, Stephen was able to peel away the negative emotions which literally "piled up" through body adaptations.

It is the sides of mountains which sustain life, not the top....
ROBERT PIRSIG

Large Intestine Emotions

Emotional imbalances related to the large intestine are best expressed by the term *stuck*. The colloquial term "intestinal fortitude," describes this immovable strength in the intestines.

Imbalances in the large intestine may affect one who requires a set of rules or principles (as in the dogma of a church, or political party) which may result in rigidity. This inflexible emotion may lead to intestinal problems at a later time. According to Dr. Dale, remaining emotional factors include *defensiveness*.

Although the energy of the large intestine projects a dogmatic or forceful aspect, some people with intestinal problems don't manifest these emotions, or, at least, not as obviously.

Water Element: Kidney and Bladder

In winter, everything which flows on earth slows to a standstill. Perhaps all that flows within the body may be affected in the same way. The time of year, winter, also provides a significant correlation to kidney and bladder imbalances of the water element.

Water comprises over seventy-five percent of the human body. Proper intake, balance, and release of water depends on two major organs, the kidneys and bladder. Together, they filter and excrete the body's wastewater and dissolved water products.

Kidney Emotions

Fear serves as the major emotion which affects the kidney meridian. Extreme fears such as phobias (including agoraphobia, panic attacks, fear of heights, water, or close quarters) fall into this category. Through Dr. Dale's research and my own clinical experience, as time goes on we may identify more. While the primary factor affecting the kidney relates to fear, the secondary emotion is *terror*.

Bladder Emotions

In psychological studies, fear and anger are closely involved. It is not surprising then, that the emotion associated with the bladder has been termed *irritated*. Irritation may have more to do with feeling emotionally upset or slighted, rather than with full-blown anger. Another emotion classified with bladder involves *timidity*.

Considering fear in relation to the kidney and bladder, many people may recall experiencing an extremely fearful event actually causing incontinence. Although it is more joked about than probably

A man's correct attitude is never static; it is not something that is achieved once and for all. Rather it is a living, moving, and changing process.
KARLFRIED GRAF VON DURKHEIM

occurs, incontinence remains a strong metaphor for how the emotion of fear is linked to imbalances of the kidney and bladder.

Brandon's Story

One of my patients scheduled treatment for her young son, Brandon, who had begun urinating more often than usual. At the onset, Brandon's medical doctor diagnosed the problem as a "neurogenic bladder." With no available treatment, the problem subsided for a short while, but later returned.

Still troubled, Brandon's mother questioned her son who finally admitted he'd been kicked hard by one of the other children at school. Did his problem stem from the fear that he might be kicked again? What other fear issues were involved?

Due to his young age, Brandon's problem proved more likely to be emotional then physical. Further Clinical Kinesiology testing was required to check that out. Brandon's test did prove positive for a homeopathic kidney remedy. After several months of treatment Brandon experienced no further symptoms.

FIRST LINE OF EMOTIONAL DEFENSE

The Chinese Five Element theory provides important answers to questions about how emotions interact with the total health of the physical body. In addition to the Chinese Five Elements, one of the most simple, "first line of defense" measures to ensure daily emotional health is to continually monitor your mental state and note how often you're experiencing negative thought patterns.

You become what you think about most of the time.
EARL NIGHTENGALE

Pop by the mirror more often and take a look. Are you smiling, frowning, or looking frightened? Pay close attention to how your body reacts during stressful situations, after being presented with sad information or a stressful task to complete. Begin to "feel" and find out how you perceive and are affected by stressful events.

NEGATIVE THOUGHTS

It was King Solomon who said, "Death and life are in the power of the tongue."[5] And, it's true, words and emotions wield so much power. The subconscious mind takes everything literally. Listen to

The greatest discovery of any generation is that human beings can alter their lives by altering the attitudes of their minds.
ALBERT SCHWEITZER

the daily thoughts that run through your head. They might provide important clues which affect your emotional well-being. Many people create unnecessary problems in their lives simply because of what they think and say.

Tonia, a young patient of mine, consistently entertained negative thoughts. Most mornings, as she left her house, she bombarded herself with several negative thoughts all at once: "I probably left the stove on...I hope I remembered to lower the garage door...Did I leave the water running"...and on and on.

I recommended to Tonia that she subjectively evaluate her thoughts and retrain her mind to create a more positive dialogue: "What a beautiful morning...I'm going to have a great day today...I just know I'm going to hear from a good friend!" I reminded Tonia that we "get" what we think about all day long.

In many ways life has become more intense and stressful than it's ever been before. Often, we don't take—or, can't take—the time to evaluate, sort out, cope or express the emotions we have. The quick solution? Unfortunately, simply taking a tranquilizer has become second nature—almost a cultural norm. Most tranquilizing drugs further suppress emotional problems and make coping with stress a nonissue. Tranquilized, we are still a sicker society today than we've ever been. However, it's something that each of us has the power to change. The first step means taking individual responsibility for our negative thoughts. Ronnie, another female patient, also played in her head a running commentary of terrible occurrences. During a lengthy span of treatment for kidney problems, she literally "wrote" her life with a succession of problems. It was one thing after another.

One day, Ronnie called in a state of panic and exclaimed, "I can't come to my appointment today. My apartment is on fire!" A chain-smoker, Ronnie had tried numerous times to quit smoking. This time, she accidentally caught her mattress on fire while smoking in bed.

Ronnie thrives on crises. She experiences crisis after crisis in her life because she's locked into a struggle. Why do people need to create such crisis situations? Unconsciously, they may create their problems from negative thought processes, which, in turn, create negative energy around them.

This negative mental processing, concentration, awareness, and expectation all add up to, "What's going to go wrong today?"

Recent studies speak volumes regarding how negative thoughts trigger physiological changes in the body. Research by Dr. Theresa Dale,[6] Dr. Joan Borysenko[7] and others in the field of psycho-neuroimmunology, indicate an increase in lactic acid and adrenalin as the body reacts to negative word and thought.

Dr. Alan Beardall developed specific handmodes to delve into underlying emotional and psychological states using Clinical Kinesiology. Multiple personality, obsession, entrapment, personal vendetta and other conditions can be explored by using the handmodes documented in Dr. Beardall's handmode books.[8]

THE DECISION FOR HEALTH

Many co-factors determine who gets sick and who doesn't according to Blair Justice, Ph.D., author of *Who Gets Sick*.[9] Beliefs, moods and thoughts affect the mind/body in many ways. Justice believes, "Whatever gives us an increased sense of control—whether it is love, faith, or cognitive coping—seems to mobilize our self-healing systems."[10] Successful recoveries through such mind/body control have allowed many to gain access to their inner self-healers throughout history and in the present day.

Author Norman Cousins led a personal crusade aimed at turning around negative states of mind. He championed the effects of positive thoughts and feelings in several books, including *Anatomy of an Illness as Perceived by the Patient* and *The Healing Heart* in which he documents his own conscious decision to fight the prognosis of a life-threatening collagen disease and subsequent heart attack.[11, 12]

When doctors tell patients, "You will die," they risk giving them a death sentence. A terminal prognosis...death in three, or six months—*is a death sentence*. When patients receive this kind of "programming" how can doctors expect them to live any longer? Health professionals should take into account a person's "fighting" spirit, commitment and will to overcome—to re-create his or her own reality!

Author Justice reports, "...genetic or constitutional traits often determine which parts of our bodies are most vulnerable to dysfunction or disease."[13] Yes, however, even though genetic predisposition for diabetes runs in my family, I've made a conscious

decision that I will not develop diabetes. I don't allow that negative mind-set to enter my thoughts. Protectively, I do take precautions, never eat sugar, and take numerous supplemental nutrients.

If you believe you can or if you believe you can't, you're right!
HENRY FORD

With any type of imbalance, problem, disorder, or dysfunction in the body, the first and strongest part of recovery is the decision, thought, inspiration, or "stick-to-it-ive-ness" to get well. When confronted with pain or illness, affirm with calm, positive self-statements, "I am getting well. My health grows stronger every day." And remember, *you* have the power and the ability to make yourself well.

Don't allow orthodox medical approaches ("Listen to what we say and do what we tell you...") to wrest power away from you, the patient. Instead of promoting dependency in their patients, health professionals should teach, and give options, accepting that the final outcome is not determined by them, but by you.

USING THE MIND FOR HEALING

You can learn to control your mind and thus relax and heal your body—through changing your brain waves.

Jose Silva, originator of The Silva Method Seminars and many other researchers in human consciousness have developed simple methods of using mind and thought processes to control brainwave activity.

There are four different brainwaves, distinguished by their frequency or cycles per second: Beta (the highest frequency), Alpha, Theta and Delta (lowest frequency).

Beta waves characterize most of our thinking, conscious mind. Reading, writing, driving and focusing on many different activities may be done while in the Beta state. When we relax, the brainwaves slow down. It's now believed that this progression from Beta to Alpha (a slower brainwave frequency) becomes necessary to help the healing process. Different methods may be used to make this transition.

Sitting quietly, closing your eyes, listening to soft music or employing meditation, positive thinking or biofeedback can all help you to achieve a calm, relaxed state. Certain people with high levels of anxiety may benefit greatly by putting themselves in Alpha for a short period of time at least once a day.

This and other types of relaxation work has been used successfully by Dr. O. Carl Simonton, M.D., at his world-renowned Cancer Counseling and Research Center in Pacific Palisades, California. (See Referral Guide.) Simonton and family have been practicing mind-body treatment for over twenty years and have documented remarkable successes with cancer patients. (Patients visualize or draw a cancerous tumor or mass. They then "guide" a scissors to the area—and snip it off! Other visualizations involve imagining armies of white blood cells attacking gray, weak and confused cancer cells—killing them.)

Whatever visualization you wish to create in your mind's eye may help trigger subtle changes. Practicing this type of concrete thinking initiates and expedites the process of healing in the body. As little as ten or twenty minutes, two or three times a day, should suffice.

It's well known that humans only utilize between one and fourteen percent of their brain capacity. With that in mind, we've got a great deal of potential to use. By using our minds more positively, I believe we'll find more good things happening in our lives.

THE BRAIN AND EMOTIONS

The book, *The Amazing Brain*, by Robert Ornstein clearly describes the complexity of how the brain affects emotions.[14] The brain is relied on for important functioning of the physical body, emotions, and the stability of the psyche. Because of this, adequate neurotransmitter production remains paramount.

A healthy and adequate diet provides the foundation for supplying raw nutrients which enable the body to manufacture neurotransmitters in maintaining a healthy nervous system. Some individuals with poor absorption or genetic pre-dispositions to brain disorders may need to take specific nutritional supplements to aid in neurotransmitter production.

Neurotransmitters consist of free floating chemicals which the body produces to enable messages to move among the nerves. Receptors represent physical spots or locations in the nervous system which receive and translate those messages. Each of us has explicit lock and key mechanisms which allow us to send and receive neurotransmitter communication.

To contact this wisdom of the body, we have used visualization and imagery, those technqiues that have proven useful for self-healing for thousands of years.
JEAN HOUSTON

To complete a myriad of nerve functions, the brain contains certain shaped neurotransmitters which connect with receptors for a perfect match. Such lock and key mechanisms maintain nervous system function at optimal levels. If the body cannot produce a neurotransmitter of the correct size and shape, the receptor won't receive its message—and cannot complete its job. That job function may entail producing a good mood, maintaining a calm body, avoiding depression, or other functions.

Neurotransmitters include both excitatory and inhibitory transmitters. Of the excitatory transmitters, acetylcholine regulates the autonomic nervous system, including all muscle movements. Other excitatory neurotransmitters include norepinephrine, dopamine, and serotonin.

Inhibitory transmitters, such as polypeptides, inhibit or slow nerve function. That function in itself can be extremely important because some messages may need to get through, while others must be held back. A lack of certain amino acids in the brain may result in anxiety, depression, phobias, and manic disorders.

ANXIETY AND DEPRESSION

The amino acid, Tyrosine proves to be an important neurotransmitter building block for treating depression. Tyrosine is composed of B_6, folic acid, niacin, copper and Vitamin C. These nutritional components are necessary in specific amounts, along with others, in order to help manufacture Tyrosine in the brain.

Other amino acids which facilitate brain and emotional function include: L-Glutamine, which has been used in treatment of alcoholism, L-Aspartate, GABA (gamma-aminobutyric acid), a well-researched, major inhibitory factor in treating anxiety and panic attacks when partnered with B_1, Taurine, and Glycine. Inositol is also an important brain supplement which aids other amino acids.

Deficiencies in the brain do alter thoughts. Therefore, many times emotional problems stem from nutritional deficiencies.

Christine's Story

Shortly after her sixteenth birthday, Christine was suddenly overcome with an inexplicable fear while driving her car. Heart pounding, blood rushing from her head—she felt as though she were about to faint. Forced to pull off to the side of the road, Christine sat flushed, shaking and weak.

The doctors at her medical clinic seemed puzzled: "We're not sure, but it's probably nerves," they told her parents. With no further tests, the doctors sent Christine home with her first bottle of tranquilizers.

Throughout her life, Christine continued to experience unexplained episodes of fearfulness. She learned to avoid crowds, to hover in safe corners of rooms. She even stopped going to restaurants in a vain attempt to mask the dreaded fear that could, at anytime, overtake her without warning.

Eventually, Christine fell in love with a caring young man and got married. Her first few months of marriage seemed blissful; then, something changed. Christine began noticing her husband's every move. He talked too loudly. He laughed too much. She felt so uncomfortable that she could barely sit in the same room with him. Slowly, Christine was developing a new phobia—one that could end her marriage.

Desperately, Christine searched for help, all the while taking more and more tranquilizers to cover her symptoms. She knew she had to find a real cure—and soon. Her panic attacks had progressed to serious phobias and she was now totally dependent on tranquilizing drugs.

With every ounce of energy, Christine began studying. She poured over hundreds of nutrition books and research studies. She became specifically interested in amino acid supplementation and their effects on neurotransmitter production in anxiety and panic attacks. Finally, the answer came.

Christine consulted a naturopathic physician who specialized in orthomolecular therapy. The physician helped her begin a program of supplementation with 500 mg. capsules each of the amino acids GABA, Taurine, and Glycine five times a day. She also supplemented her diet with B-Complex vitamins, and liquid Choline. In addition, Christine took a 1,000 mg. balanced complement of all the amino acids, extra magnesium, calcium, and vitamin C.

Create in me a clean heart, Oh God; and renew a right spirit within me.
PSALMS

With faith, perseverance, and determination to heal, Christine found a cure. Today, her panic attacks and phobias are gone. She takes no tranquilizing drugs, her marriage has never been happier, and she and her husband are expecting their first child. At last, her life is free of crippling fear.

AMINO ACIDS AND DIET

If we continue to solve such (nutritional) problems on the basis of the average man, we will be continuously in a muddle, because the concept of 'average man' is a muddle. Such a man does not exist.

ROGER J. WILLIAMS,
PH.D., NUTRITIONIST

Stunning new research successes will surely propel amino acid therapies into the forefront of nutritional healing and supplementation in the future. Someday, these therapies may very well supplant the need for tranquilizing drugs. However, until more knowledge is gained, the search continues for long-awaited answers to emotional problems stemming from nutritional deficiencies.

The body requires twenty-two essential amino acids. Eating a well balanced, healthy diet, including a variety of whole grains, beans, legumes, and soy, along with vegetables and some protein provide the best compilation of amino acids.

These foods supply complete and balanced nutrition and provide the major building blocks for neurotransmitters. If additional amino acid supplements are needed, you need to be aware of proper dosage and balance. Of course, Clinical Kinesiology evaluation remains the best method for determining the unique plan of supplementation for each person. To simply say, "Take so many milligrams of this or that," is merely a "cookbook" approach and doesn't address all people. Discerning how each individual body and physiology responds *now* remains crucial. The same test may prove different a month earlier, or a month later. Anyone who suffers a great deal of emotional stress, uses up more neurotransmitters. Precipitating factors—individual illness, lifestyle, diet and emotions—all affect testing results.

TESTING THE ENERGY OF EMOTIONS

Emotional aspects continue to affect many physical, as well as energetic health problems and conditions. Often, unexpressed emotions churning under the surface do not manifest obviously enough to be

pinpointed except through energetic muscle testing. People in treatment for physical problems may admit emotional problems to others and themselves—or they may consciously or unconsciously hide that knowledge.

Just as Clinical Kinesiology muscle testing is used to evaluate physical imbalances such as a sore knee or ankle, it can also help the body-mind identify a "sore" emotional point which may be affecting health.

One simple method of using energetic muscle testing to uncover hidden emotional problems involves asking a test-subject a series of questions developed by Dr. Theresa Dale, based on the Chinese Five Element Theory.

THE ORGAN-EMOTION QUESTIONNAIRE

This testing procedure is done on the mental level, thus, no verbal response is necessary. In this case, we're looking only for the muscle test response.

Before beginning any test of emotions, first ask the person being tested to lie down quietly and raise his or her indicator arm. Ask one initial question: Is it appropriate to ask your mind/body the following questions at this time?

Question + Muscle test + Strong arm = yes, proceed with testing.
Question + Muscle test + Weak arm = no, do not proceed at this time.

If the body of the person being tested "says" it's O.K. to proceed, begin asking the following set of questions calmly and clearly. Although the test questions are based on organ/emotion correlations, the test-subject should not therapy localize over any of the organs. Rather, the free hand should rest at his or her side.

As each consecutive test question is asked, the tester should simultaneously perform the muscle test and note either strong or weak

muscle response. We're looking for the muscle test response. If asking a test question triggers a flow of thought, speech or verbalizing emotion, the person should be encouraged to talk about the feelings. That, in itself, may prove therapeutic.

The following emotion test questions are listed along with the corresponding organ:

Small Intestine Question: *Do you feel vulnerable?*

Question + Muscle test + Weak arm = Emotional imbalance affecting small intestine.
Question + Muscle test + Strong arm = No emotional imbalance.

Thyroid/Adrenals Question: *Do you feel confused?*

Question + Muscle test + Weak arm = Emotional imbalance affecting thyroid/adrenals.
Question + Muscle test + Strong arm = No emotional imbalance.

Heart Questions: *Do you feel sad? Do you feel frightfully overjoyed?*

Question + Muscle test + Weak arm = Emotional imbalance affecting the heart.
Question + Muscle test + Strong arm = No emotional imbalance.

Hypothalamus Question: *Do you express emotions easily?*

Question + Muscle test + Weak arm = Emotional imbalance affecting the hypothalamus.
Question + Muscle test + Strong arm = No emotional imbalance.

Stomach Question: *Do you feel disgust?*

> Question + Muscle test + Weak arm = Emotional imbalance affecting the stomach.
> Question + Muscle test + Strong arm = No emotional imbalance.

Spleen/Pancreas Question: *Do you have high self-esteem?*

> Question + Muscle test + Weak arm = Emotional imbalance affecting the spleen/pancreas.
> Question + Muscle test + Strong arm = No emotional imbalance.

Lung Question: *Are you grieving?*

> Question + Muscle test + Weak arm = Emotional imbalance affecting the lung.
> Question + Muscle test + Strong arm = No emotional imbalance.

Large Intestine Question: *Do you feel stuck? Are you tolerant of others?*

> Question + Muscle test + Weak arm = Emotional imbalance affecting the large intestine.
> Question + Muscle test + Strong arm = No emotional imbalance.

Bladder Question: *Are you irritated about something?*

> Question + Muscle test + Weak arm = Emotional imbalance affecting the bladder.
> Question + Muscle test + Strong arm = No emotional imbalance.

Kidney Question: *Do you feel fear?*

> Question + Muscle test + Weak arm = Emotional imbalance affecting the kidney.
> Question + Muscle test + Strong arm = No emotional imbalance.

Gallbladder Question: *Do you feel resentment?*

> Question + Muscle test + Weak arm = Emotional imbalance affecting the gallbladder.
> Question + Muscle test + Strong arm = No emotional imbalance.

Liver Question: *Do you feel anger?*

> Question + Muscle test + Weak arm = Emotional imbalance affecting the liver.
> Question + Muscle test + Strong arm = No emotional imbalance.

Male/Female Organ Question: *Do you express your emotions to loved ones?*

> Question + Muscle test + Weak arm = Emotional imbalance affecting the male or female organs.
> Question + Muscle test + Strong arm = No emotional imbalance.

This proves to be a simple method for delving below the surface emotions of an individual. If you are well acquainted with the person being testing, ask him or her to make a list of some emotional concerns he or she may have, or add to the list a few more which you may have observed.

Once an emotional imbalance is uncovered through a weak arm muscle response to the Clinical Kinesiology muscle test, seek guidance from a skilled practitioner who may follow up, test related reflex points and recommend appropriate treatment, Neuro-emotional or other homeopathic remedies. (See the Resource and Product Guide in the appendix of this book.)

ON TO WELLNESS

You *can* resolve the past, begin to create positive energy around you and reclaim the power over your miraculous mind-body. Begin your journey now with the recognition that sufficient self-esteem, along with the investment of your time, energy, and full range of emotions, may be the secret to maintaining good health on your mental and physical path to wellness.

You need only claim the events of your life to make yourself yours.
FLORIDA- SCOTT MAXWELL.

Truly resolving physical and emotional problems also means addressing and understanding the *spiritual* aspect of health and healing. Often imbalances on the spiritual level have spontaneous effects on both emotional and physical well-being. In Chapter Four, we look at how *Divine Energy* affects and heals subtle energy centers in the body known as the *chakras*.

CHAPTER THREE SUGGESTED READING

Borysenko, Joan, Ph.D. *Fire in the Soul: A New Psychology of Spiritual Optimism.* New York: Warner Books, 1993.

Borysenko, Joan Ph.D. *Minding the Body, Mending the Mind.* New York: Bantam Books, 1988.

Connelly, Diane Ph.D. *Traditional Acupuncture: The Law of the Five Elements.* Columbia, MD: The Centre for Traditional Acupuncture, Inc., 1994.

Cousins, Norman. *The Healing Heart.* New York: Norton, 1983.

Cousins, Norman. *Anatomy of an Illness as Perceived by the Patient.* New York: Norton, 1979.

Goleman, D. *The Meditative Mind.* Los Angeles, CA: Jeremy Tarcher, Inc., 1988.

Justice, Blair, Ph.D. *Who Gets Sick.* Los Angeles, CA: Jeremy Tarcher, Inc., 1988.

Hunt, Douglas M.D. *No More Fears.* New York: Warner Books, 1988.

Matsumoto, Kiiko and Birch, Stephen. *Five Elements & Ten Stems: Nan-Ching theory, diagnosis, and practice.* Brookline, MA: Paradigm Publications, 1989.

Ornstein, Robert. *The Amazing Brain.* Boston: Houghton-Mifflin, 1984.

Pelletier, Kenneth. *Mind As Healer, Mind As Slayer: A Holistic Approach to Preventing Stress Disorders.* New York: Delacorte Press/ St. Lawrence, 1977.

Philpott, W.H. and Kalita, Dwight D. *Brain Allergies.* New Canaan, CT: Keats Publishing, 1987.

Sahley, Billie Jay Ph.D. *The Anxiety Epidemic.* San Antonio, Texas: Pain & Stress Therapy Center Publications, 1994.

Steadman, Alice. *Who's The Matter With Me?* Marina Del Rey, CA: DeVorss, 1977.

Weil, Andrew M.D. *Natural Health, Natural Medicine: A Comprehensive Guide to Wellness and Self-care.* Boston, MA: Houghton Mifflin, 1990.

4

Divine Energy: The Chakras

DISPLAYED IN THE WAITING area of my office is a macrame wall hanging which I designed. The intricately woven "landscape" symbolizes the flowing energy of life: As the snow melts from a mountain top, water flows down from the highest peaks, cascades into a waterfall and forms deep whirlpools of swirling energy. From there, the water of life plummets into a rushing stream that gushes down into a mountain lake. Trickling along, the water spills into a gentle pond rippling a cluster of lily pads. Eventually the pond pours out into numerous streams—the dangling streamers that hang down from the piece. On its endless journey, the river of energy is always flowing and changing.

Like water, the energy in the body's subtle (spiritual) energetic centers known as the *chakras* flows downward from above. Some remains "on the peaks," to illumine the mind, "in the mountain lakes," to open the heart, some "in the pond" to balance the physical health of the whole body and some streams forever onward—to serve the Earth and her inhabitants.

HEALING CHAKRA IMBALANCES

The body is made up of "life energy centers" or *chakras* which connect to all parts of the physical body. Although chakras cannot be seen in the physical realm, proof that they exist come from many-centuries-old religious, metaphysical, esoteric and long-standing spiritual traditions.

The greatest beauty is organic wholeness, the wholeness of life and things, the divine beauty of the universe. Love that, not man apart from that...
ROBINSON JEFFERS

Varied approaches to explaining the chakras are found in ancient Eastern mysticism, Australian aboriginal lore, Native American stories, and Christian and Jewish estoric doctrine. Although there are different outlooks, the common thread that links all approaches to the "spiritual body" involves a form of spiritual development that requires knowledge and practice to balance and create new healing through this channel of unseen Power or Divine energy from God.

When certain emotional problems, traumatic events, or lifestyle disturbances occur, energetic imbalances may begin to affect the physical body, manifesting in particular organs or meridian systems, through the chakras.

The practical goal of this chapter is to examine these deeper, ongoing emotional disturbances which can trigger imbalances in the spiritual body, or chakras. Deeply ingrained or long-lasting emotions, possibly stemming back to childhood, often lead to personality or behavior pattern changes that maintain or perpetuate disturbances in the chakras.

Returning balance and harmony to the body requires that one become an "instrument" or channel through which elimination of energy blockages in the chakras may be accomplished.

Different facets of the electromagnetic body respond to different therapies. Many therapies treat only the physical body, others heal the body of thoughts and emotions, while others treat the spiritual body. Some believe all states of health depend on this level.

Many people, including the late C.W. Leadbeater, foremost author, clairvoyant, and chakra researcher, consider that all disease originates only at deep spiritual levels. It is in this context that we will attempt to explain the importance of the spiritual role of the chakras in the total well-being of the body's energetic system.

"An energy center is very much like a flower bud. If it is properly cared for and receives the necessary sunshine, the bud opens and

turns into a flower," say John Mann and Lar Short, authors of *The Body of Light*.[1]

In this chapter you will:

- Explore the body's spiritual garden, and begin to understand the basic characteristics of each chakra.
- Learn how the circulation of chakra energy or light helps open and heal chakra imbalances.
- Discover how Dr. Alan Beardall further developed Clinical Kinesiology by the introduction of Bach Flower Remedies to provide more accurate testing in locating deep spiritual imbalances.
- Determine through specific exercises and self-testing, how the revitalization and healing of the chakras—the body's spiritual flowers—may be attained through earthly flowers, The Bach Flower Remedies.

THE CHAKRAS

The word *chakra*, translated from ancient Indian Sanskrit, means "wheel." Although symbolic of a "wheel of fate" or life and death, in Clinical Kinesiology diagnosis the chakras relate to a series of wheel-like energy vortices. The Chinese liken the chakras to spiritual or Divine flowers with many petals.

We have the opportunity to recreate our bodies through positive energy.
TARTHANG TULKU

Chakras represent subtle energy centers in the etheric or spiritual body. Unconfined to the physical body, they channel psychic and healing energy from the glandular and nervous systems. This vital force comprises the conscience, "aura" or etheric body, and links physical, psychic, and superphysical or clairvoyant states of consciousness.

The body's seven major chakras consist of an energetic force localized in the physical body but extending beyond the physical body. The chakras coincide with different levels of the spine, (usually in conjunction with an organ). Chakra energy projects several inches from the front of the body, envelopes and flows out the back of the body.

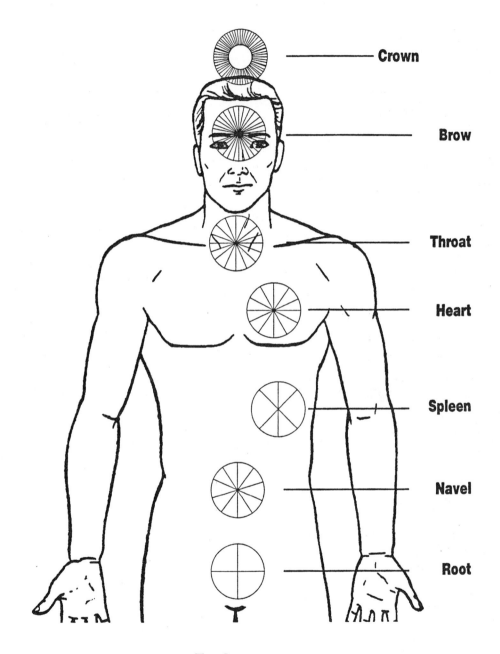

THE CHAKRAS
ILLUSTRATION COURTESY OF DR. JOHN AMARO,
INTERNATIONAL ACADEMY OF CLINICAL ACUPUNCTURE. COPYRIGHT © 1981.

IDENTIFYING CHAKRAS

Chakras, seen only by clairvoyant sight, appear as colorful wheels of light whose centers vary in brightness and hue. Active chakras each contain a corresponding color closely aligned with the type of *vitality* sent to it through other chakras and from the sun.

There is no need to soar heavenward while dragging the body behind as a burden...use the body itself as a means of transcendence.
GAY HENDRICKS

Similar to the Chinese Five Element Theory, each chakra corresponds with a specific element: earth, water, fire, air, or ether (mind). These elements manifest as solid, liquid, fiery or gaseous, airy, and etheric. Each element also represents rising levels of consciousness. For example, the earth element chakra represents the lowest levels of consciousness, while the "ether" elements represent the higher, more developed levels.

C.W. Leadbeater, expert in chakra energy research, suggests that people"...imagine themselves to be looking straight down into the bell of a flower," such as a morning glory, in order to grasp the general appearance of a chakra.[2]

Perpetually rotating, chakra energy centers may be likened to a vortex or whirl of energy spinning at seven distinct centers of the body. Leadbeater further describes chakras as "...the hub or open mouth in which a force from the higher world is always flowing."[3] He states, "Without this inrush of energy, the physical body could not exist."[4]

KUNDALINI ENERGY

The Root or Base Chakra represents the seat of energy, the basic force that infuses life. The Hindu religion refers to this base as the reservoir of *Kundalini* energy. Kundalini is believed to emanate from a central core of the body, physically related to the spine. Through a channel called the *Sushumna*, the energy rises through a cavity in the bony canal of the spinal cord. This physical canal also provides a central connecting electrical system from which the peripheral spinal nerves of the body communicate with the brain.

Kundalini energy rises like a snake along two coiled paths of the Sushumna channel: the *Ida* or female, and *Pengala* or male. The Kundalini base energy then combines with incoming streams of Divine energy from the Power of the Divine Spirit or God. This current

sets up a pressure which causes the mingled forces of energy to form a whirl. As the energies in the Ida and Pengala cross over on their rise up the body, each positive and negative crossing point creates a chakra "flower."

THE SILVER CORD

Sanskrit teachings detail a "silver cord" connecting the human spirit with God, a Higher Power or an overriding Spiritual Principle. This Divine energy flows down through the top of the head, or Crown Chakra. An extension of Sushumna energy, the "silver cord," connects the spirit and body together.

Kundalini yoga or meditation practitioners often teach techniques which implement the movement of Kundalini energy from the Root Chakra at the base of the spine, all the way up the Kundalini Path of energy to the Crown Chakra—and on to connection with the Divine spirit and spiritual reality.

HOW DO CHAKRAS WORK?

According to most spiritual traditions, chakras operate similarly in everyone. However, in Leadbeater's view, in a spiritually undeveloped person, chakras may whirl in a comparatively sluggish motion, merely forming the necessary vortex for the force and no more. Comparatively, in a more spiritually-evolved individual, enormously greater amounts of energy pass through the "flowers," opening additional faculties and possibilities.

Naturally divided into three groups, chakras represent the lower, middle and higher—or respectively, the physiological, personal, and spiritual—aspects of life. Some believe each petal of the force-centers also represent a moral quality. The development of that quality brings each center into activity.

YOUR SPIRITUAL GARDEN

In order to experience chakra energy, you might imagine taking a stroll through your own body's spiritual garden. To assist in this

visualization, picture your favorite type of garden—an English Country garden, or a simple meadow filled with wildflowers.

Ask a friend to read you the descriptions of the seven chakras which follow. Lie down peacefully and imagine yourself sensing the fragrance of each "flower." As you "walk" serenely along your garden pathway:

- Locate each spiritual flower or chakra energy center within your body.
- Hold your hand approximately an inch or two above your body at the location of the chakra.
- Inhale and exhale deeply as you picture each whirling "flower."
- Note any correlations between your spiritual energy and symptoms you may be experiencing.
- Focus briefly on any energy sensations (feelings of warmth or coldness), as you sense each "flower" along the way.

THE ROOT CHAKRA

The Root Chakra or *Muladhara*, centered at the base of the spine, is the lowest or base chakra. It also represents the least highly developed area of the spiritual self: the embodiment of the flesh, regeneration, and physical reproductive functions.

The Root Chakra became the focus for ancient yogic meditation rituals. With certain breathing techniques and other practices, the Kundalini energy was encouraged to rise up the spine, thereby raising the level of consciousness of the practitioner. This same spiritual quest also marked the tradition for monks to remain celibate. Such solidarity trials allowed them to focus on the subtle essence of their spiritual nature and further understand the connection between their spiritual beliefs (or Creator) and themselves.

Physically, the Root Chakra may be found in close proximity to the anus or rectum and connected to the sacrum and coccyx.

Symptoms corresponding to Root Chakra imbalance include glandular problems with the gonads manifesting as:

- Ovarian problems in women, or
- Testicular problems in men.

I don't believe that any of the chakras is better or worse than any of the others. I feel that the whole body is a sacred mandala.
TSULTRIM ALLIONE

Other Root Chakra associations include:

- Root Chakra color: fiery orange/red
- Element: earth
- Negative emotion: fear
- Spiritual Petals: four

THE SPLEEN CHAKRA

An especially radiant, glowing and sun-like chakra, the Spleen Chakra, *Swadisthana*, may be located slightly left of the body midline over the spleen. From Leadbeater's own clairvoyant research, the Spleen Chakra characterizes devotion "...to the specialization, subdivision, and dispersion of the *vitality* which comes from the sun."[5]

Physically, the Spleen Chakra corresponds with the First Lumbar vertebrae, or the area surrounding the ribs. Energetic imbalances in the Spleen Chakra affect:

- Adrenal glands
- Intestines

Other associations include:

- Spleen Chakra color: rose red
- Element: water
- Negative emotion: excessive desire, lust, attachment
- Spiritual Petals: six

Because of the Spleen Chakra's relationship with the water element, chakra imbalances often trigger abnormalities of thirst centers resulting in excessive thirst or dryness. In addition, the adrenal glands and kidneys relate closely, which predisposes Spleen Chakra imbalances to the kidneys.

THE NAVEL CHAKRA

The Navel Chakra or *Manipura* may be located two to three inches above the navel in the area commonly known as the solar plexus. The term solar plexus originates from the word *sun*, which *defines* the center of our solar system.

Rays of the sun are often depicted as concentric circles radiating wider and wider throughout the entire body. Many energy reflex points contain both a solar and a subsidiary plexus. Likewise, the solar plexus represents the gravitational center of the body. Someone who is said to be "centered" or grounded possesses a balanced solar plexus, in harmonious relationship with the earth.

A *plexus* describes a gathering place of tiny nerves that come together in a cluster to communicate messages. Additional nerves also intersect at a plexus and branch off in different directions, similar to the activity of a bustling train station.

Many, many "trains"/nerve impulses arrive from various directions and convene at one spot. Energetic messages ride in on one train, get off and transfer to another train for the final destination. From one central point, or solar plexus, many nerves take off or send their messages in many different directions.

Navel Chakra imbalances associate with:

* pancreas problems
* liver problems
* stomach problems stemming from self-pity

Other Navel Chakra associations include:

* Navel Chakra color: green
* Element: fire
* Negative emotions: anger
* Spiritual Petals: ten

THE HEART CHAKRA

The Heart Chakra, or *Anahata*, centers over the heart, or physically correlates to the sternum. The Heart Chakra may also be referred to as the Thymus Chakra, because of its connection with the Thymus gland.

Other classifications of the Heart Chakra include:

* Heart Chakra color: yellow/gold
* Element: air
* Negative emotion: greed
* Spiritual Petals: twelve

Chest pains often stem from physical reasons. Initially, however, a Heart Chakra imbalance may have precipitated the physical heart to become out of balance. Emotional trauma and shock are among the main reasons why Chakras become imbalanced.

THE THROAT CHAKRA

Every feeling is a field of energy. A pleasant feeling is an energy which can nourish. Irritation is a feeling which can destroy. Under the light of awareness, the energy of irritation can be transformed into an energy which nourishes.

THICH NHAT HANH

The fifth, or Throat Chakra, also known as *Vishuddha*, corresponds physically to the neck and throat. The endocrine gland involved is the thyroid, which suggests the name Thyroid Chakra in some instances.

Other traits include:

- Throat Chakra color: silvery, gleaming blue (like moonlight rippling on water)
- Element: ether or mind
- Negative emotion: pride, egotism, grief
- Spiritual Petals: sixteen

The Throat Chakra evolves from a center of self-expression—the voice. Many times this chakra becomes out of balance when an inability to work through negative emotions, such as pride, ego, or grief exists. Some people then manifest a sore throat, laryngitis or some type of thyroid problem. They may wish to speak and express something, however, suddenly the words don't come.

THE BROW CHAKRA

The Brow Chakra or *Ajna* in Sanskrit classifies the sixth chakra, located between, or possibly an inch or two above, the eyebrows. Due to its nerve plexus relationship with the carotid sinuses, the Brow Chakra often affects blood pressure.

The Pineal gland, which may be reactive to light, is affected by the Brow Chakra. Imbalances in the Brow Chakra may cause Seasonal Affective Disorder in some individuals.

Other classifications include:

- Brow Chakra color: deep, vibrant or Indigo blue
- Spiritual Petals: ninety-six

A vivid blue color signifies mental awareness, while shades of violet to purple suggest spiritual awareness.

The sudden leap in the number of petals from sixteen in the Throat Chakra to ninety-six in the Brow Chakra suggests that this energy center represents an altogether different order from the lower level chakras of the etheric body. More complex and higher principles of life exist in this realm. An increasingly greater modification of energy is required to create the psychic and spiritual expression which this chakra represents.

The Brow Chakra has often been referred to as the *Third Eye.* The ancients spoke of spiritual enlightenment as the opening of the Third Eye. Austerity practices such as fasting and meditation were attempts by Tibetan or Aurveydic (Hindu) monks to lessen input to the physical senses and thereby open the Third Eye.

When the Third Eye opens, spiritual vision opens. At once, one gains the ability to focus, learn, perceive, and impart knowledge on a new spiritual level. A simple method for experiencing the Third Eye is reported in *The Body Of Light*, by John Mann and Lar Short.[6] This practice involves using conscious breathing to focus on the Third Eye.

- In a relaxed state, focus on The Third Eye point, slightly above the point where the eyebrows converge.
- Allow your awareness to penetrate slowly beneath the surface of the skin.
- Note any sensations or experiences.
- Repeat the phrase, "This is the center of my experience."
- Make gentle contact with the point by lifting your forefinger to the area. After ten seconds, remove your finger and notice any new sensations.
- Continue focusing, breathe in and draw new energy to the area, hold your breath for a few moments, allowing that energy to expand.
- Breathe out any emotional tension.
- Repeat this exercise as often as you wish.

THE CROWN CHAKRA

The only solid piece of scientific truth about which I feel totally confident is that we are profoundly ignorant about nature.
LEWIS THOMAS

The Crown Chakra or *Sahasrara*, most resplendent of all, displays two "flowers." In full expression, it radiates 960 outer petals of violet, and twelve inner petals of gold. The Crown usually remains the last chakra to be opened or "awakened." As one gains the optimal in spiritual enlightenment, this magnificent spiritual flower blooms.

Clairvoyant C.W. Leadbeater characterized the Crown Chakra as "...full of indescribable chromatic effects and vibrating with almost inconceivable rapidity."[7] Containing properties unmatched by any other chakra, the Crown Chakra emanates a "...subsidiary central whirlpool of gleaming white flushed with gold in its heart"—through which the divine force flows in from without.

Leadbeater contends, "Only when one realizes a position of divine light...this chakra reverses itself, turning as it were inside out; it is no longer a channel of reception but of radiation...standing out from the head as a dome, a veritable crown of glory."[8]

Ancient Sanskrit drawings often depict individuals with a closed flower bud at the top of the head. Symbolically, this person has yet to reach enlightenment. In great men or women of high spiritual development, however, the Crown Chakra displays a fully open, nearly thousand-petaled flower, historically depicted as a golden glow or halo around the head. This is the basis for the appearance of a halo in many early Christian paintings and figures.

The hypothalamus represents the nerve plexus associated with the Crown Chakra. Endocrine glands affected by Crown Chakra imbalance include the pituitary and pineal.

DR. BACH'S DISCOVERIES

At the same time C.W. Leadbeater (1847–1934) described his clairvoyant research into the nature and functions of the chakras, Dr. Edward Bach, an English microbiologist, made a remarkable discovery of his own. Bach determined that energetic imbalances in the body's "spiritual flowers" could be remedied by earthly flowers.

In the early 1920s, Bach noted that certain patients exhibited differing symptoms and illnesses, although laboratory tests proved all had been infected with the same bacteria. As he puzzled over the different manifestations of the individual "dis-ease" processes, he

correlated the inconsistencies with the scientific understanding of the day and developed a new theory, a new explanation for the inconsistency. Bach recognized a link between emotional states (which correlated to personality types) and physical illness.

SEVEN PERSONALITY TYPES

Soon, Bach began categorizing individuals according to seven basic personality types, finding that patients invariably fell into a certain category or personality type *according to their response to illness*. In essence, the disease-causing bacteria became less important than the underlying personality type which would inherently deal with it.

Behind all disease lies our fears, our anxieties, our greed, our likes and dislikes.
EDWARD BACH

The seven types which Bach identified included people who manifested: fear, loneliness, uncertainty, overcare for the welfare of others, oversensitivity to ideas and influences, despondency and despair and insufficient interest in present circumstances.[9]

Bach's theory not only documented how the seven personality types responded to illness, but how they responded to or coped with life!

Wandering in the English countryside one day, Bach was struck with a spark of Divine revelation. Magnified around him, he suddenly noticed beautiful flowers carpeting the meadows. Bach instinctively *knew* that these flowers held the answers to healing his seven personality types.

This Divine inspiration allowed him to identify a system of picking and categorizing each flower. He placed each one in a crystal bowl of spring water, the universal solvent, and left them to bask in the sunlight. Slowly, the essence of each flower absorbed into the water. He then bottled and used each essence as a concentrate to cure the seven personality types.

All homeopathic remedies, including Bach Flower Remedies, heal on a vibrational level. If the remedy were tested in a lab, its composition would mainly contain a mixture of spring water, diluted by a concentrated essence of flower-soaked water.

As time went on, Bach formulated thirty-nine remedies (currently available at most health food stores), including one special mixture of flowers which he named Rescue Remedy. Rescue Remedy was specifically formulated to be used for urgent or imminent danger, and

crisis situations. The remedy includes essences of Rock Rose, Clematis, Impatiens, Cherry Plum, and Star of Bethlehem flowers.

Averi's Story

On one occasion, a young woman and her baby, Averi, arrived at my office. The child was feverish, restless and pulling at her ear. She and her mother had just flown into town from another state. Little Averi had been fighting a small cold before take-off; however, due to cabin pressure changes, she quickly developed an ear infection. By the time I saw her she was extremely irritable, and cried at every attempt at treatment.

Because Averi suffered from so much pain in the eustachian tube from her throat, she'd stopped taking fluids and proved to be slightly dehydrated. At once, I administered Bach Flower Rescue Remedy to her in a glass of water: the first time she'd successfully drank any quantity of any liquid. Within minutes, Averi calmed down and allowed me to proceed. I was then able to diagnose and treat her ear infection, which resolved a few days later.

Marjie's Story

Crying uncontrollably, Marjie, a distraught patient had just discovered that her beloved cat, Butterscotch, had been killed. An immediate dose of Rescue remedy enabled her to regain composure. Within a few minutes, Marjie became calm and settled into a quiet state of peace.

HEALING CHAKRA IMBALANCES

The Bach Flower remedies have many effective applications. The originator of Clinical Kinesiology, Dr. Alan Beardall, studied Dr. Edward Bach's theories and remedies and developed them as a successful adjunct to Clinical Kinesiology diagnosis. Dr. Alan Beardall correlated Bach's seven personality types to the chakras as follows:

Root Chakra: "for those who have fear."
Spleen Chakra: "...loneliness"
Navel Chakra: "...uncertainty"
Heart Chakra: "...overcare for the welfare of others"

Throat Chakra: "...oversensitive to ideas and influences"
Brow Chakra: "...despondency and despair"
Crown Chakra: "...insufficient interest in present circumstances"

According to Bach, it didn't matter if a person had a cold, an injury or an ailment as serious as kidney failure—depending upon their personality type, they basically responded with fear, loneliness, uncertainty—even despondency and despair. The actual illness or irritating factor was secondary to the response.

Treat people for their emotional unhappiness, allow them to be happy, and they will become well.
EDWARD BACH

Through testing, Beardall discovered that negative emotions may be pinpointed and released to heal energetic imbalances in the chakras.

Bach had classified the Flower Remedies according to their application to each of the seven personality types. Beardall applied this classification to the chakra system beginning with the lowest or Root Chakra, up through the Crown Chakra. Once again, the way in which the appropriate remedy was chosen depended upon the testing of the body's sensitive energetic system.

During initial evaluations of new patients, Clinical Kinesiology may be used to test for chakra imbalances. At first, emotional imbalances may be hidden in body adaptations. However, many times, hidden chakra imbalances appear once other energetic imbalances have been corrected.

Especially difficult cases involve organ problems which remain static; not responding to treatment as they should. That, in itself, may be a signal to dig a little deeper to discover chakra imbalances formerly gone unseen. Any chakra imbalance, once identified, provides a major turning point. As rebalancing begins, formerly static organ conditions often progress dramatically.

Lindsey's Story

During one seminar, I tested a young woman, Lindsey, for chakra imbalance. Lindsey assumed the chakra handmode position, which is four fingers straight, with the thumb bent at the last or distal joint, the tip of the thumb touching the large knuckle of the index finger. The test of Lindsey's indicator arm muscle proved weak, indicating a Chakra imbalance. Once an imbalance was indicated, we were able to move up and test Lindsey's other points to see which one triggered a weak muscle response.

Lindsey assumed the correct handmode position and resisted as I performed the muscle test. Her arm went weak in relation the Root Chakra, indicating *an imbalance of that chakra.*

Experience tells me that a strong muscle test on the lowest or Root Chakra automatically guarantees blockage of all successive chakras. With testing, this proved to be the case for Lindsey.

Initially, the first step in healing Lindsey's blocked chakras concentrated on rebalancing her lowest or Root Chakra. *Again, testing and healing evolves from bottom to top.* When more than one chakra tests out of balance, the lower one must be treated first due to the tendency for the energy to move from the Root Chakra upwards.

As noted earlier, according to Dr. Beardall the lowest or Root Chakra relates to the negative emotion, fear. Often, people who experience a great deal of fear and anxiety manifest imbalances in the Root Chakra. Through Clinical Kinesiology testing, the appropriate Bach Flower Remedy may be identified to successfully alleviate fear and anxiety, allowing it to dissipate and become a less common occurrence.

Since several Bach Flower remedies correlate to the Root Chakra, the question was finding the correct remedy compatible with rebalancing Lindsey's Root Chakra. The possible remedies include Aspen, Cherry Plum, Mimulus, Red Chestnut, and Rock Rose. I tested each bottle of remedy in the energy field of Lindsey's body, while monitoring the strength of her indicator muscle.

Lindsey resisted as each remedy was put to the test. Her etheric body responded and was not quite balanced with Rock Rose, so I tried the next remedy, Aspen. Ah, good muscle strength! Lindsey pushed and resisted again. She did not respond well to the Cherry Plum remedy. Mimulus? Again, not encouraging. Red Chestnut? What does Lindsey's body say? "OK, but not great."

How Much and for How Long?

Aspen proved the most effective Bach Flower Remedy to rebalance Lindsey's Root Chakra. With the correct remedy determined, I need to find the correct dosage. Using Clinical Kinesiology testing, Lindsey's body communicated to me how many drops of the Aspen remedy would be required, and for how long.

Testing for dosage required filling a cup with fresh spring water and then adding several drops of the Aspen Remedy. Lindsey held

the water container directly on her abdomen in the energy field of her body. One drop...two...three...four...five! I test after each drop until Lindsey's indicator muscle proves strong. Generally, dosages range between three and seven drops.

In Lindsey's case, Clinical Kinesiology testing determined that five drops, twice per day for a period of three months was the appropriate dosage. The new remedy is poured into Lindsey's personal remedy bottle. Many alternative practitioners have been taught to *succuss* or tap the water bottle containing the new remedy several times on the palm of the hand to set up a vibration which activates the energy.

Patients who use Bach Flower or other remedies often benefit from doing a bit of positive visualization or meditation at least twice a day, along with taking the drops. Allowing the physical body to come into play along with emotional and spiritual aspects of the chakra rebalancing often speeds recovery.

The Bach Flower Remedies may be found in most healthfood stores. You may request that a store employee assist you in muscle testing various remedies, or seek help from a qualified practitioner who utilizes the remedies.

Once the correct remedy is found, dosage may be calculated as explained in Lindsey's case. Merely test the drops from one up to seven until a strong Clinical Kinesiology muscle test responds to the correct dosage.

ENERGY THERAPY

An adjunct treatment that helps rebalance chakras involves light energy therapy, similar to therapeutic touch. As patients relax, practitioners may place one hand under the body and the other directly over the body at the level of the unbalanced chakra.

Energy focused by moving the hands in a circular motion helps stimulate circulation of chakra energy centers. The energy sets up a flow which continually moves between hands—hooks up to the unbalanced chakra—and moves through the etheric body.

Treatment entails working about three inches above the body, allowing the energy flow to vibrate back and forth. The subtle energy may be felt by the patient in many cases. Treatment continues

Energy is our most precious resource, for it is the means by which we transform our creative potential into meaningful action.
TARTHANG TULKU

The most beautiful and most pro-found emotion we can experience is the sensation of the mystical. It is the sower of all true science.
ALBERT EINSTEIN

in a clockwise motion in an attempt to move, normalize and rebal-ance energy.

Many people actually feel added energy if they stop, sit quietly for a couple of minutes, focus and perceive. Often patients describe the sensation as one of "warm light" or of a "pulsating feeling or vibration."

Energy treatment does not drain practitioners of their own en-ergy. They're not taking energy from within. This underlines the whole idea of subtle energy or the spiritual side of healing. The per-son doing the healing work cannot give away his or her own energy or he/she will weaken his/her own body.

Healing energy is drawn in through the top of the head and allowed to flow out through the hands. Practitioners simply open themselves to a Higher Awareness, meditate a bit, and allow God's Divine healing energy to infuse their own bodies. The practitioner's awareness of the *Sushumna* pathway, the Crown Chakra and his or her own soul connection to the unseen healing Power facilitates the healing of others.

THE ENERGY EXERCISE

Have you ever suffered a bug bite, stubbed toe, or accidentally run your knee into a desk drawer? What happens? If you are like most people, you probably automatically grab the area, hold it...and rub. Without knowing it, you're using your inherent healing energy to help the wounded area. It's an automatic response.

The following exercise provides an effective method for gaining aware-ness of the powerful energy in your body.

1. First, place both hands opposite one another, palm facing palm approximately an inch apart. For a moment, simply begin to perceive the energy between your hands. You may "feel" something between them...then again, you may feel nothing.

2. Now, rub your palms together as if you were trying to warm them from the cold. Notice the friction created after prac-ticing this exercise for at least a minute.

3. Let your hands separate and feel the sensation within each hand. Slowly move your palms toward one another again,

and hold them steady allowing your fingertips to barely touch. Notice any energy sensations between the palms.

4. Next, hold the fingertips of one hand over the palm of the other. Again, observe the different energy sensations. With both hands bouncing energy off one another, many people report that the radiation becomes much more noticeable.

5. Once you've activated the energy built up in your hands, place them over one or more of your chakra energy centers. The practice provides a nice way to wake up the subtle energy in your hands—and body.

The same principle has been used in "palming." Dr. William Bates, who wrote *The Bates Method For Better Eyesight Without Glasses*, originated the treatment of laying the palms over the eyes, without physically touching them, merely to release energy from the hands to help the eyes.[10]

VITALITY: THE COLOR OF ENERGY

According to C.W. Leadbeater, "Just as the sun floods the system with light and heat, so does it perpetually pour out—a force to which has been given the name, 'vitality.'"[11] The color of the chakras corresponds closely with the type of vitality radiated from the sun.

Great spirits have always encountered violent opposition from mediocre minds.
ALBERT EINSTEIN

Vitality radiates on all levels and manifests itself physically, emotionally, and mentally. Upon entering the physical atoms of humans it increases their energy, and renders them animated and glowing. Unlike electricity in the atoms, the force of vitality infuses the atom from without, not from within.

Through Clinical Kinesiology testing, imbalances of color may be tested to help rebalance chakras. For example, imbalances in the Root Chakra, whose color is red and orange, may respond more strongly to one shade than another. Sometimes, people don't experience enough of a healing color. Sometimes they experience too much.

On the whole, it's a good sign if you feel comfortable with a certain color, gravitate toward that color—or, just "love it!" However, one should never dictate, "For Root Chakra imbalances, wear orange or red." On the contrary, that becomes a blanket recommendation. Instead, appropriate colors may be tested for each individual through Clinical Kinesiology testing.

THE COLOR PURPLE

The color monitor on my computer in the office provided a reason for testing recently. During set-up, the computer programmer asked me, "What's your favorite color?" I immediately told him, "Purple." He then proceeded to format the computer monitor screen in a computer version of "purple."

Unfortunately, "computer purple" wasn't the right color, shade or intensity for my office assistants, and caused fatigue for both my receptionist and insurance person. To solve the problem, I had them each sit in front of the computer, without looking at the screen, and administered the Clinical Kinesiology muscle test. Both responded with a strong indicator muscle. Then, I instructed them both to stare at the purple screen for approximately one minute. When I retested, their indicator muscles proved weak.

I immediately called the computer programmer back to the office, told him the background looked beautiful, however, the shade and intensity of the computer purple wasn't healthful for us.

With the programmer's help, I tested all of the remaining screen colors until we found a truly healthy, balanced color for everyone involved. In the end, my favorite color was not the best for everyone—and, the computer purple wasn't even compatible with me.

CHAKRA STRESSORS

Along with color, mental states and emotional stressors negatively affect chakra energy. Experiencing constant irritation on a mental, emotional, environmental or spiritual level, provides continual negative input, which may throw the chakras out of balance.

DEANNA'S STORY

Deanna, a woman in an abusive relationship, manifested a definite chakra imbalance. During initial treatments she didn't tell me about her physically abusive relationship. However, each time she left my office and returned to her threatening situation, fear enveloped her.

Although treatment continued, a powerful degree of mental anguish continually disrupted the energy flow in her Root Chakra. Each time we met, Deanna was back to ground zero, never gaining any improvement.

I reevaluated Deanna's treatment and suggested a different remedy for fear, along with some therapeutic touch over her Root Chakra. Again, Deanna went home and suffered threats and abuse. Her emotional state and abusive situation negated the benefit of her treatment because the causative factor remained.

PROTECTING CHAKRAS

To the degree that one is open to outside influences, the people we are closest to may affect our chakra energy. That can be either beneficial or problematic. Meeting an individual whose Heart Chakra or Navel Chakra is quite open or strong, may cause us to be affected in the same chakra area.

I have and still am a seeker, but I have ceased to question stars and books; I have begun to listen to the teaching my blood whispers to me.

HERMANN HESSE

Many times, individuals energize or draw energy from one another without being aware of what is happening. Acknowledging that our inner state may be negatively or positively affected by others provides opportunities to further discover chakras and how they affect and harmonize our lives.

The following are some simple ways of protecting the chakras.

- Visualize your chakra centers as being "pulled in" closer to your body allowing them more protection than being out in your "aura" or "etheric" body.
- Place a hand over a chakra that may need protection. Especially in cases involving the Heart Chakra or solar plexus you will notice that during a frightful situation, the hand automatically is drawn over the Heart Chakra or solar plexus. Use the hand to protect that chakra and not allow vital energy to leave through that area.
- A four-step tradition known to Catholics and others as "making the sign of the cross" on the body also helps protect the Heart Chakra, Third Eye and the shoulders (which are major joints known as minor chakras). The "making the sign of the cross" procedure begins with touching the right hand to the Third Eye...to the heart...left shoulder and right shoulder.

ELECTROMAGNETIC IMBALANCES

Outside forces, such as environmental electromagnetic fields, also adversely affect chakra imbalances in a myriad of ways on a physical level. The dangers of overexposure to high-voltage power lines, electrical appliances, and microwave ovens may require a closer inspection of your environment in order to minimize electromagnetic pollution. (See Chapter Eight for an in-depth discussion of the dangers of electromagnetic influences.)

SELF-TESTING FOR CHAKRA IMBALANCES

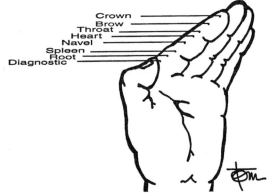

Self-diagnosing imbalances in the energy chakras proves helpful for both energetic and emotional well-being. Because the chakras are so closely associated with various mental and emotional states, unlocking the key to chakra imbalances also leads to recommendations for various Bach Flower Remedies, which can rebalance the chakras.

Chakra energy testing begins as any other Clinical Kinesiology muscle test, with verification of the strength of the test-subject's Indicator muscle. (See Chapter One for instructions.)

The most expedient test for identifying an unbalanced chakra is to simply use the chakra point test. Each chakra corresponds to a specific acupoint and specific emotional imbalance.

Dr. Alan Beardall developed handmodes which may be used to access specific information regarding the chakras, much like the files in a typical office cabinet. The use of handmodes begins a diagnostic process of delving into the underlying secrets of the body. This establishes a priority, order or sequence in resolving an underlying

problem. Assume the handmode position on one hand *while the Clinical Kinesiology muscle test is performed on the opposite arm.*

When testing for chakra imbalance, always begin testing with the lowest or Root Chakra. Should an energy block be found in the Root Chakra—all other chakras will be blocked.

Step 1: First, the individual being tested should assume the Chakra handmode position for the Diagnostic test of chakra imbalance.

Chakra Handmode/Diagnostic Point + Muscle test + Weak arm = chakra imbalance. Proceed with further testing.
Chakra Handmode/Diagnostic Point + Muscle test + Strong arm = No chakra imbalance. No further testing is needed.

Step 2: Use the thumb to touch each specific point. As you proceed through each test, keep in mind that a weak muscle test on a particular point identifies which chakra may be out of balance.

Chakra Handmode/Root Point + Muscle test + Weak arm = Root Chakra imbalance.
or
Chakra Handmode/Spleen + Muscle test + Weak arm = Spleen Chakra imbalance and so on.

Once identified, a chakra imbalance may be remedied by the corresponding Bach Flower Remedy, which may be tested as follows:

Step 3: Place each recommended remedy in the energetic field of the body (usually on torso).

Step 4: Perform the muscle test again while the subject remains in the chakra handmode position which tested weak.

Specific, helpful remedies may be narrowed down by observing which sample remedy triggers the strong muscle response during testing. Refer to the Bach Flower Remedy chart for more information.

BACH FLOWER REMEDIES

Root Chakra
Aspen, Cherry Plum, Mimulus, Red Chestnut, Rock Rose

Spleen Chakra
Heather, Impatiens, Water Violet

Navel Chakra
Cerato, Gentian, Gorse, Hornbeam, Scleranthus, Wild Oat

Heart Chakra
Beech, Chicory, Rock Water, Vervain, Vine

Throat Chakra
Agrimony, Centaury, Holly, Walnut

Brow Chakra
Crabapple, Elm, Larch, Oak, Pine, Star of Bethlehem, Sweet Chestnut, Willow

Crown Chakra
Chestnut Bud, Clematis, Honeysuckle, Mustard, Olive, Wild Rose, White Chestnut

Note: If all chakras are blocked, use Bach's Rescue Remedy.

Weak Root Chakra Handmode Point + Rock Rose + Muscle
test + Weak arm = Check another remedy.
or
Weak Root Chakra Handmode Point + Aspen + Muscle test
+ Strong arm = Use remedy to rebalance Chakra.

Only slight variances of arm strength may be discerned between
each tested remedy. However, as you become more proficient at test-
ing, the correct remedy may be easily found.

Most healthfood and nutrition stores are open to clients for pur-
poses of in-store testing of Bach Flower Remedies. You may want to
contact the store in advance or take a friend with you to enable quick
testing of the remedies.

HELPFUL HINT: It's best to treat only one chakra at a
time. When a weak muscle response indicates a problem with
one of the lower chakras, start with that chakra, figure out
the remedy and take only that remedy. Do not treat another
chakra immediately because it takes some time to rebalance
the first chakra. Helping any unbalanced lower chakra will
have a positive effect on the higher chakras. This allows the
progression of healing energy to move from lower to higher
chakras, more easily "clearing" the energy channel.

HEALTHY CHAKRAS

For the most part, leading a healthy lifestyle helps everyone main-
tain healthier chakra energy centers in the body. Part of that healthy
lifestyle includes providing the body and spirit with clean sources of
vital energy, as well as additional ways of increasing vital energy.

On the most basic level, evaluate diet. Take only pure foods and
liquids into the body, and avoid cigarette smoking, alcohol, prescrip-
tion or recreational drugs. Introducing such impurities only weighs
down and deadens the enlightenment you wish to obtain.

Prevention is better than cure.
CHARLES DICKENS

Provide the body with daily, gentle and reasonable exercise, avoid chemical and environmental pollutants, and always try to remain vitalized. When you are not at risk from these negative forces, you may focus on bringing more natural energy into your life.

Revitalize your chakra energy centers with prayer, meditation, yoga, spiritual or breathing exercises, *tai ch'i*, or other forms of mental awareness. Maintain a positive state of mind, and seek out a natural balance of sun, air and water. Develop your marvelous mind-body through the energy centers known as the chakras and experience a whole new world of energy and healing in your life.

From food for the spirit, we now move to food for the body. In exploring the body's multileveled energetic system, we've seen how The Bach Flower Remedies provide higher levels of emotional and spiritual nurturance. Now, we return to the physical body to illustrate how Clinical Kinesiology diagnoses energy sensitivities to food.

CHAPTER FOUR SUGGESTED READING

Bach, Edward M.D. and Wheeler, F.J. *The Bach Flower Remedies.* New Canaan, CT: Keats Publishing, Inc., 1979.

Bates, William H. *The Bates Method for Better Eyesight Without Glasses.* New York: H. Holt Co., 1943.

Dossey, Larry M.D. *Healing Words: The Power of Prayer and the Practice of Medicine.* San Francisco: Harper, San Francisco, 1994.

Gerber, Richard M.D. *Vibrational Medicine: New Choices For Healing Ourselves.* Santa Fe: Bear and Co., 1988.

Kaslof, L.J. *The Bach Remedies: A Self-Help Guide.* New Canaan, CT: Keats Publishing, Inc., 1988.

Krieger, D. *The Personal Practice of Therapeutic Touch.* Santa Fe: Bear and Co., 1993.

Leadbeater, C.W. *The Chakras.* Wheaton, Illinois: Theosophical Publishing House, 1972.

Liberman, Jacob O.D., Ph.D. *Light, Medicine Of The Future.* Santa Fe: Bear and Co., 1991.

Mann, John and Short, Lar. *The Body of Light.* Boston: Charles E. Tuttle Company, 1993.

Moore, Thomas. *Care of the Soul.* New York: HarperPerennial, 1994.

Wood, Betty. *The Healing Power of Color: How To Use Color To Improve Your Mental, Physical, and Spiritual Well-Being.* Vermont: Inner Traditions, 1992.

II

Energy and The Immune System

Energy Sensitivities
to Food

WARM SUNLIGHT FLOODED THE tiny playroom strewn with colorful toys and stuffed animals. In his happy, well-behaved state, Justin, a young child with severe food sensitivities, sat on the floor eating a snack of white bread and jelly. After a few moments, researchers added a dollop of peanut butter to his bread.

Suddenly, the pleasant world erupted in chaos, as Justin began to writhe, scream, throw toys and tear the playroom apart. For the next several hours he experienced a continuous state of agitation until, near exhaustion, he finally fell asleep on the playroom floor.

Justin had experienced a severe allergic reaction, not simply to one food, rather to a combination of food items. His behavior presented startling and clear proof of the far-reaching dimensions of food sensitivity problems. Like Justin, millions of people are similarly affected by food sensitivities—perhaps on a lesser, but nonetheless serious, scale.

This chapter provides a new perspective on the myriad ways food can be toxic to the body and its energetic system. Today, more than ever, diet affects the immune system, either supporting or negatively impacting the body's major line of defense against disease.

Determining healthier food choices includes the ability to interpret the warning signals or symptoms of immune system malfunction stemming from food sensitivity. It isn't enough to eat well. *The ability to differentiate between compatible and incompatible foods serves as the basis for diagnosing, treating and healing food sensitivities.*

Let thy food be thy medicine and thy medicine be thy food.
HIPPOCRATES

With Clinical Kinesiology testing, discover how easy it is to rely on the body's inner knowingness to access firsthand information on the foods your body can and cannot tolerate. Instant feedback from this indispensable tool provides the vital link to deterring incompatible food patterns, halting the downward spiral of disease.

This chapter will help you familiarize yourself with foods that create imbalances in current states of body physiology, immune, and digestive systems; it will address poor digestion, "leaky gut syndrome," and liver toxicity, as well as examine common high-sensitivity foods that contribute to organ imbalances of the liver and thyroid. It will discuss the dangers of hybridization and microwaving.

You will discover simple methods for breaking the patterns of food sensitivities, finding energetically compatible alternatives which restore the body and immune system. Finally, you will be encouraged to examine symptoms and determine addictions, through self-testing your own foods, vitamins, and pharmaceutical prescriptions.

Take the important first steps to developing a new attitude toward food. As you begin to conquer food sensitivities, discover renewed health and energy, and a more loving relationship toward food and yourself.

WHY LOOK AT FOOD?

Food provides nurturance to life, satisfying not only physical, but emotional, psychological, spiritual, social, and cultural needs. In many cultures, an expected sign of hospitality includes offering food or drink to guests thus solidifying friendship or other bonds.

Throughout the world, age-old religious mores—even taboos—still exist surrounding certain foods. Different religions designate specific foods as clean and unclean, blessed and unblessed, appropriate for certain occasions... while prohibiting other foods from being eaten at all. Throughout history, fasting served as a spiritual cleansing of the body and soul. (Although today, many consider fasting or abstention from eating food to be merely a physical cleansing tech-

nique.) Those who practiced fasting used it to renounce or detach from the physical or secular world.

Psychologically, food has long been used as a reward and a comfort. From early ages, children (quite inappropriately) are told, "If you behave yourself you'll be rewarded with a cookie...an ice cream...a candy bar." Unfortunately, this type of behavior modification reinforces good behavior or good feelings directly associated with sweet or unhealthy food. Nurturance of the physical body remains closely tied to nurturance of the emotional self. Unfortunately, for many people, the urgent need to provide emotional nurturing often includes unhealthy food choices or unneeded quantities.

Often, grossly overweight individuals "comfort eat" to provide nurturance. On the other hand, people with the illness *anorexia nervosa* feel completely unworthy, refuse to be rewarded, and therefore stop eating entirely.

Such early patterning often leads to food sensitivity and addictions. Emotional and psychological problems, nutritional deficiencies, family dietary patterns, and cultural conditioning drive many people to eat solely for taste and enjoyment.

Of course, it's appropriate to enjoy food! It is not necessary to only eat sprouts for the rest of your life. However, people who continually go beyond healthy dietary parameters may begin to develop problems.

Food is fuel. Eating the correct foods in the correct amounts adds to body energy and health. That's why it's so important to learn what foods to eat, including how each body reacts to different foods, in order to avoid food sensitivities and addictions.

Clinical Kinesiology food sensitivity testing provides a simple method for assessing the appropriate foods for each individual body. By using this tool, you will begin to develop a new relationship to food, as you examine its positive and negative affects on your energetic body.

Somehow my sense of God's presence and my complete reliance upon him are heightened when I'm fasting.
DAVID FRÄHM

THE IMMUNE SYSTEM AND FOOD

Diet affects the immune system, white blood cell count, muscles, joints—even thoughts and moods. Medical, environmental, and physiologically-induced factors diminish immune system function.

One thing is clear: If symptoms of food sensitivities exist, such as cravings, dark circles under the eyes, sinus problems, joint and muscle dysfunction, emotional behavior problems, mood swings, headaches, coughing or other upper respiratory problems—even hay fever—*the immune system isn't functioning at its best.*

No one can be clinically healthy except for food sensitivities, hay fever or other allergies. It's not nearly that cut and dried. Priscilla, for example, developed a tiny rash on her arm during the summer she worked at a local Farmer's Market. Clinical Kinesiology food sensitivity testing indicated sensitivity to several items, including a common one—strawberries.

Although Priscilla's rash clearly stemmed from the food allergy, I also suspected underlying problems. Physically, much more was going on to cause the rash than simply the strawberries. Priscilla's immune system had become overburdened and had stopped working at optimum capacity.

THE OAKEN BUCKET

Dr. Steve Olsen, an holistic dentist who removes mercury fillings to strengthen the immune system, describes the immune system as a wonderfully solid oaken bucket that faithfully collects everything dumped into it.

Everyone starts out with perfect health, Olsen explains. As reactions to many external and internal irritants occur, the oaken bucket fills up with everything the immune system must handle, from environmental problems, such as chemical and electromagnetic pollution, to germs, viruses, stress, and now, food sensitivities.

The immune system copes only to the current level of the body's health. Ultimately, the bucket becomes full; its maximum load achieved! That's when many people suddenly begin noticing a number of different symptoms. For some, this "last straw" constitutes a serious crisis.

Instead of filling the oaken bucket to the brim, I suggest you begin to incorporate healthy habits with which to "bail out" your bucket. In doing this, you greatly diminish the chance for illness in the body.

Instead of compromising the immune system, find ways of rebuilding it. Look at the contributing factors for food sensitivity, evaluate the dysfunction, and seek treatment which will ultimately return you on the road to health. Clinical Kinesiology will assist you in doing all of this.

THE ENERGETIC BODY

Every substance known on earth possesses a specific energetic quality. Likewise, each person exhibits a different compatibility with different foods. The same holds true in cases of specific organ imbalances, or genetic patterns.

You can travel fifty thousand miles in America without once tasting a piece of good bread.
HENRY MILLER

Food sensitivities occur when pre-existing energetic weaknesses in the current state of physiology, immune system or digestive function inhibit certain food items from matching the current energy pattern of the body. In short, the body's energetic system proves incompatible with certain foods.

Like an automobile, the body runs on a specific type of fuel. Only *that* fuel contains the correct components, enabling the "engine" to perform at optimum efficiency or health. We all know that certain cars require regular gasoline, others need unleaded or diesel. For a fuel to be appropriate for one car (or body), it must contain a certain energetic balance and chemical composition. Evaluation of the molecular structure of a particular fuel may find it compatible for one type of "engine." Substitute a different fuel, and the engine may not perform appropriately.

Because the body proves much more sensitive than any human-made instrument (such as a car), it's important to use a custom diagnostic tool. Clinical Kinesiology testing quickly and easily indicates the compatibility of any substance with the energy pattern of the body. Once that energy pattern is identified, changed and strengthened, food sensitivities may dissipate.

You can learn to listen carefully to the information that your body imparts about what foods it needs and what foods it doesn't. Then, you can combine that knowledge with Clinical Kinesiology testing in determining wiser, healthier and more *energetically compatible* food choices.

HEALTHY AND UNHEALTHY CHOICES

Each juncture of the healing journey presented with a choice, a turning point. I learned that, even in the midst of dire malady, there is always a path of creative response.

MARC BARASCH

One study involving young kindergarten students shed new light on children's natural understanding of healthy food sources; i.e., the children intuitively knew the connection between food, exercise, health and body fat and were attuned to what foods could be potential health hazards. The study proved that even young children can make correct food choices although such knowledge is not always translated into daily practice.[1]

Adults also make correct food choices, but the majority place heavy emotional connotations on certain foods. Adults also maintain preconceived ideas about foods that they want or don't want to eat.

Busy working adults, such as Karen, one food sensitive individual, more often take the path of least resistance when it comes to food. "I just don't have time to stop and prepare foods myself," Karen complains. The results become habitual dependence on fast or processed foods. In this way, the conscious mind often overshadows the correct decision.

Research indicates that the average American consumes a total of only twenty different food items. Although the items may be prepared in different ways, *twenty items* still constitute a limited diet. This practice alone proves to be a main contributor to food sensitivities.

Continually bombarding the body with the same food items, (especially if proven slightly energetically incompatible) becomes an open invitation to food sensitivities. Time after time, antigens or toxins from that energetically incompatible food cause the body to become more sensitive.

This practice tends to be a problem in the elderly population. Many older people hold long-ingrained habit patterns concerning the choice of food items. Some use the same grocery list every week.

Myra and Roland, two of my clients, actually began to lose a great deal of weight because they routinely bought and ate the same items over and over. Following Clinical Kinesiology food sensitivity evaluation and treatment, they regained most of the lost weight and developed a "healthier" shopping list.

INDICATORS OF FOOD SENSITIVITIES

Disorders attributed to food sensitivity are numerous and varied. They include inflammation of all types such as:

- arthritis
- bursitis
- gastritis
- irritable bowel syndrome

Nutritional research, like a modern star of Bethlehem, brings hope that sickness need not be part of life.
ADELLE DAVIS

Also, people who suffer from seasonal hay fever usually have inflamed respiratory tracts which leave less room for proper airflow.

People with bodies that tend to swell or inflame usually exhibit a number of food sensitivities due to water retention. In addition to swelling, other signs of food sensitivities include:

- red, blotchy skin
- musculo-skeletal soreness or stiffness
- muscle cramping, spasm or other weakness

Pinpointing and eliminating specific food sensitivities automatically calms the system.

Other common disorders stemming from food sensitivities include:

- conjunctivitis or "pink eye"

Extremely infectious, "pink eye" stems from food sensitivities and immune systems in turmoil. Usually, in the spring, a little pollen floats by and it's the last straw for the immune system. The problem results in inflammation, excessive tearing, sensitivity to light, and blurred vision.

Along with the eyes, come the ears. Any type of disorder with the ears may be related to food sensitivities:

- ear noises, ringing, infections
- Meniere's Disease

From my clinical experience, ear infection equals milk allergy in most cases. In addition, the beginnings of joint dysfunction or arthritis, liver and intestinal dysfunction and elimination problems all begin before usual means of diagnosis have discovered food sensitivities.

Progression from joint pain—to stiffness—to swelling or dysfunction—to arthritis, signals that food sensitivities have been causing trouble in the body for a long time.

The beginnings of sinus problems or repeated sinus infections also indicate food sensitivities. As soon as suspected symptoms occur, food sensitivity testing using Clinical Kinesiology and appropriate treatment should be undertaken to arrest or reverse the process.

DIGESTION AND FOOD ALLERGIES

The French fried potato has become an inescapable horror in almost every public eating place in the country. "French fries," say the menus, but they are not French fries any longer. They are a furry-textured substance with the taste of plastic wood.
RUSSELL BAKER.

If everyone ate the correct diet for his or her body and experienced good digestive functioning, most health problems would be eliminated. Unknowingly, in many cases, the digestive process has been "over-AMPed" by food incompatible to the body's energetic system.

When food is not digested properly it leads to further problems such as:

- constipation
- indigestion
- nervous stomach, pains and cramps
- spastic colon
- excess gas, bloating
- nausea, vomiting
- gastric ulcers and other gastrointestinal disorders
- hemorrhoids

Bedwetting in children or young adults is also a symptom. With frequent or burning urination, food sensitivities cause the urine to be more irritating. As a result, the body excretes more frequently to try and rid itself of the problem. Again, my own clinical tests show that the inability to digest milk is the most common link to bedwetting.

Gallbladder attacks may also stem from food sensitivities, or ingesting too much fat from fried food.

Biochemist, Dr. Jeffrey Bland, Ph.D., the CEO of Heathcomm, Inc. explains the seriousness of improper digestion: "Food fragments cross from the intestines into your bloodstream, and cause tissue damage."[2] The condition, known as Leaky Gut Syndrome, occurs

when insufficiently broken down pieces of food enter the bloodstream as oversized particles. This happens from a lack of digestive enzymes and/or hydrochloric acid in the body. Without sufficient digestive enzymes the body cannot absorb the nutrients it needs to create more digestive enzymes leading to the downward spiral of digestive malfunction. Because these large undigested particles cannot be utilized at a cellular level, they end up triggering allergic reactions in the body.

What becomes of toxic residue left floating around in the bloodstream? It travels to the liver to be broken down, reconjugated or recycled. Already taxed with reprocessing and detoxifying unrecognizable food molecules, the liver must then cope with a large number of antigen/antibody reactions, eventually becoming overburdened itself.

For whatsoever you sow, that shall you also reap.
GALATIANS 6:7

These macro molecules of undigested food exact an even greater toll on the already energy-stressed liver, whose own dysfunction goes hand-in-hand with resulting joint dysfunction stemming from food sensitivities. Initially, many people mistake this condition as arthritis; however, it is actually a biochemical reaction in the body to food.

People who unknowingly spend their whole lives battling food sensitivities will have a low tolerance to the insufficiently broken down chemicals which freely enter the bloodstream from the liver. From age thirty-five to fifty, these people may notice a variety of major symptoms.

Their complaints: "My joints feel stiff," "My knees are so swollen that I can barely walk," stem from advanced metabolic poisoning.

The build-up of toxic residue in the joints begins the process of inflammation of those joints. As Gary Null reports in *Gary Null's Complete Guide to Healing Your Body Naturally*, "Because of the specific physiology of the joints, they are especially susceptible to the buildup of toxic materials...."[3] Over time, this metabolic dysfunction truly forms the basis for disorders and imbalances in the body previously mislabeled as "arthritis."

Fifteen or twenty years from now, a set of X-rays may confirm that food sensitivities have progressed to "true" arthritis. However, it's not too late to change eating habits that may prevent that diagnosis from occurring in the future.

THYROID IMBALANCE

Along with the liver, the thyroid, a regulator of metabolism in the body, may become overly stressed due to food sensitivity. The ancient Chinese never referred to the thyroid gland, only its functions, or "three fires," which they called the *Triple Warmer.*

In Chinese theory, the thyroid controls the energetic aspect which extracts heat and energy from food and converts it to energy. This metabolic and energetic process of digestion and assimilation (not to be confused with the chemical process) became known as *cellular respiration.*

Food sensitivities indicate that the body's energy has become out of balance. The thyroid may then become overworked in trying to assist in converting improper foods into usable energy. In this way, food sensitivities and the consumption of energetically incompatible foods adversely affect the liver and thyroid.

Marlene's Story

Shortly after her fiftieth birthday, Marlene developed terribly painful joints, which her doctor labeled as "rheumatoid arthritis." She experienced stiff knees, ankles, shoulders, wrists, and fingers. During her Clinical Kinesiology food sensitivity evaluation, Marlene tested weak to the entire group of Nightshades. (The Nightshades refer to a fleshy family of foods, which include the white potato, all peppers, paprika, eggplant, and tomatoes. Several edible ornamental plants such as the petunia, chalice vine and angel trumpet also belong to the Nightshade family.) Immediately, Marlene was encouraged to discontinue eating the Nightshades for a period of three months. (Generally speaking, anyone who experiences muscle or joint stiffness may benefit from avoiding the Nightshades, pending food sensitivity testing.)

One evening Marlene attended a county fair where, due to a complete lack of good food choices, she decided to eat a baked potato. Instantly, she suffered a severe exacerbation of her symptoms.

During Marlene's treatment, the Nightshades were retested and the potato remained the only item to which she tested weak. Because Marlene hadn't been eating the others for nearly three months, they no longer tested as irritative to her energetic system. However, it only took one potato to trigger stiffness and soreness in Marlene's body.

Until her metabolism and digestion become fully rebalanced, I recommended that Marlene avoid the Nightshade family of foods. Low tolerance for one Nightshade automatically sheds suspicion on all the others, as far as I'm concerned. Of course, the true test lies in Clinical Kinesiology food sensitivity testing.

❧ ❧ ❧

Reaction time to sensitive foods may often be confusing because, unlike Marlene's case, for many people hours or days may pass before symptoms occur. Again, every individual experiences food differently. Without testing, it is difficult to pinpoint food sensitivities.

OVERVIEW OF ALLERGENIC FOODS

The most commonly allergenic foods are milk and dairy, corn, wheat or other grains, citrus and meats. In order to further explain why these particular foods trigger so many instances of food sensitivities let's look at each now.

The most difficult food sensitivities to overcome involve milk and dairy products and usually, during Clinical Kinesiology testing, if someone indicates a dairy sensitivity, he or she should restrict all dairy for several months (at least three) to reduce reactivity.

MILK: NOT SO PERFECT FOOD

For years, advertisers have "sold" Americans on milk— "nature's perfect food!" If that's true, why does an intolerance for dairy products show up most often during food sensitivity testing?

Today's milk is no longer consumed in its natural state. Milk's extreme homogenization and pasteurization process kills natural enzymes which normally help people digest milk. In addition, heating destroys the enzymes and vitamins. To a degree, it also alters the milk's chemical and energetic quality.

Other problems occur as the homogenization process breaks down the milk's large fat molecules. In many cases, homogenization

renders the fat molecules so small that the body cannot recognize them. The result? They go undigested through the bloodstream, coating blood vessels with arterial plaque. This process ultimately leads to arteriosclerosis.

Additionally, many people are introduced to milk at too early an age. In my opinion, milk is "the perfect food" *to grow tiny calves into great big heifers.* That's what milk was naturally designed to do. The consistency of cow's milk is much different from mother's breast milk. The amount of fat is much higher. It takes just one year for a baby calf to mature. By the age of two, it's completely full-sized. Obviously, human babies don't develop at the same rate of growth as a cow. That's why human infants require a much gentler approach with nutrient intake.

Whatsoever was the father of a disease, an ill diet was the mother.
HERBERT

Most milk contains a number of additional chemical additives and preservatives (many of which we are uninformed about). These additives are one reason some milk retains such an unnaturally long shelf life. Some processors have even been known to add preservatives to the wax coating on the inside of the carton. In this way, they avoid identifying such toxic substances on the label.

Other additives in milk include synthetic Vitamins A and D. All these factors cause people who may have been milk intolerant from an early age to experience more food sensitivities than normal.

People who say, "Oh yes, I'm lactose intolerant, but I take lactase tablets or a lactic acid enzyme," perhaps they won't experience as much gas, however, *they're still sensitive to milk* and the way it's processed. Once someone proves milk intolerant, that intolerance usually applies to all forms of milk—yogurt, cheese, regular and skim milk. And, as long as this person continues to drink milk, his or her body will continue to experience symptoms.

Mary Lou's and Faye's Stories

I treated two adults for ear infections, and both had severe food sensitivities and weak thyroid glands. One woman, Mary Lou, really toyed with, "Can I give up my milk?" She went off milk for awhile, then back on milk, resulting in another ear infection.

The other patient, Faye, also complained of a sinus problem. Following food sensitivity testing, I recommended, "The simplest thing to do is try a two-week stint without milk and see how you feel."

She did it and reported, "I feel great...never felt better. I can actually breathe when I lie down at night!" Within a month, Faye was back on milk. She explained, "I decided it was more important for me to have my milk."

What happened? Both Mary Lou and Faye keyed into their desire for milk...and the addiction. It's a personal choice, ultimately.

CORN

Corn also ranks as one of the most common allergenic foods. Anyone who tests sensitive to corn should be wary of corn in all forms—popcorn, corn syrup, cornmeal, cornstarch, even fructose. No matter what form of corn is eaten, the energy pattern remains discordant. Only the physical form has been changed. Corn is corn is corn! If you test energetically sensitive to it, watch out!

GRAIN SENSITIVITY

Grains rank third among the most common food sensitivities, with wheat predominating. Many people test positive to four or five different grains and one of them is usually wheat. (Should they eventually recover from all the grain sensitivities save wheat—that particular food sensitivity may prove lifelong.)

Hybridization

Extreme hybridization is my theory as to why corn, wheat, and citrus (another high-sensitivity food) render so many people weak during food sensitivity testing. *Hybridized foods retain little of the natural properties of the foods they once were.* Indian corn, for example, is an original unhybrid corn. Look at an ear—no straight rows and no perfect kernels; and the ears themselves are a natural hodgepodge of variable sizes. It's difficult to harvest that type of corn with modern farm machinery. The genetics of Indian corn plants were altered solely because of machines.

Corn must be a certain size, the ears a certain proportion, to be harvested by standard machines used today. Scientists also designed ears of certain length and rows of straight kernels to please customers.

The same genetic alterations apply to wheat, and other grains, although wheat remains the most hybridized. Again, because the farmer's combine is only so tall, the wheat is hybridized to match. Certain varieties of wheat require less water, while others have been developed to last longer in storage before being ground.

In citrus fruits, today's "orange" originated as the much smaller mandarin orange. Easily broken and torn, the mandarin orange peel itself is obviously different from hybridized "oranges." In addition, the tiny segments appear more crescent-shaped than today's genetically altered oranges; the seeds more firmly attached to the membranes.

In my teens, during employment at a small produce store, I learned that oranges were named by the size and number that fit into a carton. The smaller Valencia oranges came seventy-two to a box. So, the only identifying factor was the number 72 stamped on the side of the box. The store owner would often instruct me to bring out a box of 72s or 48s (which were navel oranges).

Many reasons exist why our food has been genetically altered—not all of them compatible with health. Scientists create new (and increasingly unnatural) life forms every day. Down-sized lettuce, the "super tomato," and apple-flavored carrots are only a few of the other "foods" being crossbred in laboratories. Hybridization, genetic mutating, and inoculation of genes of one species into another is confusing the whole food system—not to mention the human body. This trend alone provides a good impetus for growing your own food, thereby, maintaining quality control.

MEAT

Even the U.S. government (FDA food pyramid) now recommends grains, vegetables and beans, and minimizes animal products.
MICHIO KUSHI

Meat sensitivities also prove hard to overcome due to the difficulty in digesting heavy protein content. Clinical Kinesiology food sensitivity testing includes the testing of standard grown, versus naturally grown meat.

With commercially grown beef, pork and poultry, a high likelihood exists of numerous drugs being ingested throughout an animal's life. Chemical additives and pesticide residue may also be traced to the animal's feed. So, in addition to the meat allergy, there may be a chemical sensitivity. During testing, a person may prove sensitive

to conventionally grown meat but not have a significant reaction to the organic meat. It's helpful to test both in order to know whether to restrict all conventionally grown meats or recommend organic meats for that person.

EGGS

Animals do have emotions, and many lead desperately unhappy lives. Today's chickens are treated terribly. Penned up their entire lives, they never see sunlight, never scratch. Imagine, chicken on top of chicken—each one catching the droppings of the ones above. In addition, today's chickens ingest antibiotics and synthetic hormones in incredible numbers. Once those drugs enter the food chain, they pose an even bigger hazard—food sensitivities in humans.

A big difference exists between the egg of one-hundred years ago and the egg today. It's also the reason eggs often prove highly allergenic to many people.

DANGERS OF BIOENGINEERING

It's frightening to learn about hybridization and its effects on food sensitivities, especially in light of the latest bioengineering experiments now being conducted on animals.

Tufts Veterinary School is spearheading a biotechnology research program involving sheep and cows in England and Scotland. Geneticists inject sheep with human DNA in order to produce certain clotbuster, or heart drugs, which can be obtained cheaper through the animals' milk. (Early experimental animals already produce thirty grams per liter of drugs in their milk. In addition, these "transdermal sheep" are worth over $100,000 each to the pharmaceutical companies that back the research.)

At issue here is that drugs are being introduced in a high concentration into the food supply. Many people have reactions to prescription drugs which they are *knowingly* taking. Imagine the reactions we may see with drug-sensitive people who had no clear idea they were eating a food biotechnologically laced with pharmaceutical drugs.

This biotechnology research is a political and a health issue. In the Tufts project (which I think is a dangerous and exploitative practice), too many risks exist. Should any contamination take place, we may never find the end of the thread. This particular experiment has become a world controversy, touching off recent fire bombings, near the site of the sheep project, by activists in Great Britain.

Why *are* drug companies so interested in this type of genetic alteration? Mainly, because it's cheaper to produce drugs in sheep, goats and cows than in the laboratory. The pharmaceutical industry is simply further commercializing the production of drugs at the expense of innocent animals and, quite possibly, the entire human race.

COFFEE AND SUGAR

People learn the patterns of their diet not only from the family and its sociocultural background, but from what is available in the marketplace and what is promoted both formally through advertising and informally through general availability in schools, restaurants, supermarkets, workplaces, airports, and so forth.... Nutrition and health education are offered at the same time as barrages of commercials for soft drinks, sugary snacks, high-fat foods, cigarettes and alcohol.

DR. BEVERLY WINIKOFF, DIETARY GOALS FOR THE UNITED STATES.

Another mass-marketed product, caffeine, also remains highly addictive and allergenic to most people. Symptoms of caffeine sensitivity include headaches, flushing, nervous jitters, even diarrhea. Many times, caffeine and sugar go hand in hand because sugar is often used to mask the bitter taste of both coffee and chocolate, two widely used foods containing caffeine.

The sugar cane and sugar beet represent whole foods that contain a natural complement of nutrients which help metabolize the carbohydrate. In sugar processing, those natural nutrients are fractioned out. What's left behind is a toxic chemical to which many adults have become addicted. So addicted, that the average American consumes between 150–170 pounds of sugar each year.

Sugar also triggers a food sensitivity reaction that directly affects the immune system. One research study found that sucrose, fructose, honey and orange juice all decreased the capability of neutrophils (a type of white blood cell) to kill bacteria. The decrease in effectiveness of the white blood cell to kill bacteria lasted up to five hours after consuming sugar.[4]

The body's white blood cells maintain a continuous search for foreign particles, chemicals, dead tissue debris, or suspect cells in the body. As tiny garbage collectors, their job entails cleaning up dead cells in the body.

Because the white blood cells complete such a relentless and detailed search, they often find sugar to be a toxic, foreign chemical in the body and immediately go on the attack. The white blood cells then sacrifice themselves by engulfing that sugar toxin. It poisons them instantly, and they die. That's why less white blood cells can be found in the body following sugar consumption.

ADDITIVES AND PRESERVATIVES

Other chemical toxins which annihilate white blood cells include additives and preservatives unnaturally added to preserve certain foods.

Used in a myriad of ways, additives and preservatives *never* test compatible with the body's physiological or energetic system. These and other environmental toxins simply add to the propensity for food sensitivity problems—and fill up that "oaken bucket," overtaxing your immune system.

Along with hybridization, pesticides and herbicides pose additional threats to the food chain. Pesticides are commonly used in both wheat and citrus farming, and leave residues in grain and other produce.

In testing sensitivity to both organic and regular wheat, most people react to the contaminated wheat, but not the organic wheat. For this reason, it's recommended that everyone buy organic food and produce whenever possible from reputable healthfood supermarkets.

Railie's Story
Railie suffered a great many headaches stemming from food sensitivities. Her exam indicated she was allergic to the MSG or monosodium glutamate in many Chinese dishes, among other items. Her particular sensitivity also added to a great deal of heart-related stress. Following treatment, Railie went for days with no headaches. Then, the bottom fell out.

"What happened?" I asked.

"Well, I went out for Chinese food again," she admitted.

"Did you remember to tell the waitress 'No MSG.'"

"No, I forgot." she sighed. Unfortunately, her headache didn't forget.

ARE YOU ADDICTED TO FOOD?

Food sensitivity and addiction go hand in hand. People who wake up each morning and find they simply *must* have their milk or coffee, may be suffering from a food addiction. Extreme compulsiveness about any food usually signals food sensitivity or an allergy to that item. As we pointed out earlier, with food eaten too frequently the likelihood of developing a sensitivity or addiction increases. Finding ways to break those patterns of food addiction involves exploring other choices.

There's no need for complicated rotation diets, systems, gimmicks or color codes. Simply eat a variety of foods. This one important change stops the perpetuation of habits leading to food sensitivity.

FOOD SENSITIVITIES MAY BE INHERITED

Other addictions also compound food sensitivity susceptibility. An individual whose mother experienced significant food sensitivities and consumed those foods during pregnancy (while the child was in utero) often develops the same sensitivities. Particularly, mothers who use drugs (pharmaceutical or otherwise), alcohol or cigarettes, risk causing their children to become addicted. Such factors compromise the baby's immune system resulting in significant problems.

LEON'S STORY

Unquestionable proof that addictions are passed on to children is seen in fetal alcohol syndrome. I evaluated and helped formulate treatment for a fourteen-year-old boy, Leon, who appeared to be borderline mentally retarded.

While in utero, Leon's mother was an active, heavy drinker. Thus, Leon was born addicted—and severely allergic to sugar. As a result, he was extremely hyperactive...moving every minute! Leon also exhibited various kinds of choroid movements: flicking fingers, moving hands, shaking his head, and twitching his body continuously.

When I first met Leon, he was in detention at a boy's ranch for having attempted to set his mother on fire. Each day, Leon was expected to help with the ranch duties. Instead, he refused to

cooperate, picked fights with the other boys and continually found himself in trouble.

Leon begged, borrowed, or stole money for soda pop. Prior to being taken into custody it was routine for him to drink at least a case of pop a day. Because of his inherited addiction, Leon's body had been severely damaged at birth. The resulting antibody reaction to alcohol set up his sugar addiction, which he liked to get in liquid form.

Leon's case points out how food sensitivity developed in utero can seriously affect mental and emotional behavior. I recommended the elimination of soda pop from the entire ranch and suggested that the pop machines be filled with canned juices, especially for Leon.

Unfortunately, Leon was unable to recover from his addiction and subsequent destructive behavior. He was eventually sent back into the penal system.

No illness which can be treated by diet should be treated by any other means.
MOSES MAIMONIDES

CLINICAL KINESIOLOGY FOOD TESTING

Clinical Kinesiology food sensitivity testing bypasses the conscious mind, including one's preconceived ideas about food. Testing "asks" the energetic system of the body which foods prove compatible. In turn, the body talks, relaying information regarding the appropriate "fit" of the energy pattern of a particular food with the energy pattern of the whole body *at the current time.* (With treatment, that answer may change over time.)

Clinical Kinesiology food sensitivity testing utilizes a battery of approximately 244 food items. The food groups normally tested include seeds and grains, red meat and poultry, nuts, dairy products, herbs and spices, seafood, vegetables, legumes, fruits and other miscellaneous items such as chewing gum, coffee, and soda pop. A grouping of natural and artificial sweeteners, salts, and seaweed items may also be included.

Clinical testing requires the placement of each food item directly in the energy field of the body, or on the abdomen. During testing, food items should be concealed from the patient, so as not to bias the test. Otherwise, the patient might be thinking, "Oh, I hate alfalfa sprouts!" Or, "I just love sugar or coffee," and thereby change the energetic field of the body.

Food items may be tested directly in their plastic containers, just as blood samples are evaluated by a Chromo Spectrophotometer in a laboratory. These sample test-food containers prove basically *inert*, which means they don't interact energetically. Additionally, dried food proves most stable for testing purposes.

HOW TESTING WORKS

I tested a thirty-five-year-old man, Clyde, for food sensitivities. As instructed, Clyde lay down comfortably on the examining table and I performed a preliminary test to check the strength of his indicator muscle. As I pushed, I asked Clyde to resist. His arm proved strong.

The first test items represented the seeds and grains group. Clyde resisted and his muscle responded strong to alfalfa seeds. In this way, his body indicated through the Clinical Kinesiology muscle test, that it was safe for him to eat the alfalfa as sprouts or ground up as an alfalfa supplement.

The next item tested, amaranth, often thought of as a grain, is truly a little seed. Amaranth provides a good alternative for anyone sensitive to wheat or other grains. The amaranth test? Again, Clyde's indicator muscle reacted strongly.

The testing continued with artichoke semolina. I pushed, Clyde resisted—and proved strong. Barley? A big push and the indicator muscle suddenly fell weak. *At this point in time*, Clyde's body proved energetically incompatible with barley. Why? I speculated to myself: Had Clyde eaten too much barley too commonly in his life? Could barley have been introduced in a cereal before his infant digestive tract was mature enough to accept it? Or, was barley simply inappropriate for Clyde's system due to organ imbalance, genetics, individual body chemistry or current digestive process?

Therapy Localizing for Food Sensitivity

Food that tests incompatible with the energy of the central abdomen or whole body may be "therapy localized" over each organ (see Chapter One). An indicator muscle may react weakly to a food placed over the liver, yet hold strong in the energetic field of the thyroid. In this way, organs most sensitive to the item may be pinpointed and treated.

Testing over the liver provides the best indication of food sensitivities. The liver functions as the "workhorse" that breaks down chemicals in the body. Treating the liver or other organs that may contribute to food sensitivity (such as the digestive organs) quickly strengthens the whole body.

Once the affected organs become restrengthened, retesting and reintroduction of foods once sensitive to the body may occur after ninety days. Foods which prove inappropriate during initial tests may now test fine. One caveat? Avoid eating any formerly offending food on a daily basis.

CLYDE'S TEST CONTINUES...

...Clyde resisted and proved strong with couscous. What about flaxseed? Again, strong. Kamut, a grain only slightly longer than the wheat grain came next. (Many times when a person indicates a food sensitivity to wheat it's advisable to substitute kamut for a period of time.) Oats? Once again, Clyde tested strong. Wild rice, pumpkin seed, quinoa, soy flour, and sesame seeds all tested strongly in Clyde's energetic field.

Clyde tested through wheat and wheat products—such as wheatgerm, wheat bran and wheat macaroni—with flying colors. Often patients indicate a sensitivity to all four, or at least to one.

Following completion of the 244-item food sensitivity evaluation, Clyde studied his exam sheet on which each food sensitive item had been circled.

Half-Full Not Half-Empty

I compiled a list of food items for Clyde to avoid for ninety days. (During that time, evaluation and further treatment of organ imbalances, or digestive function might be necessary.) In addition, I recommended nutrients and supplements to help rebuild and restrengthen liver and thyroid function, the organs most affected by food sensitivity.

As Clyde scanned the data from his exam, I encouraged him to concentrate on new food items he'd never eaten before. "Wow, I can eat cucumbers, endive, and kale—but I never eat them," he said. On further investigation he discovered many more new and appealing

items to choose. I recommended interesting recipes for quinoa and soybean dishes he'd previously never tried.

Following food sensitivity testing, Clyde began experimenting with new-found foods and further varying his diet. As with so many aspects of life, we always have the choice of whether to see the glass as "half-empty" ("Oh no, look at all the foods I can't eat") or "half-full" ("Look at how many healthy new food choices I have to increase my energy and well-being").

Clyde continued with treatment of specific organ imbalances that helped restrengthen his digestive process. He also added vitamin, glandular and enzyme supplements to his diet. After three months, I performed a follow-up food sensitivity test which indicated that Clyde was no longer sensitive to many of the originally unacceptable food items. In this way, his body "told" me that his immune system had sufficiently strengthened and Clyde was well on the way to recovery from food sensitivities.

NEW TECHNIQUE

California acupuncturist Dr. Devi S. Nambudripad, D.C., O.M.D., Ph.D., has developed the Nambudripad Allergy Elimination Technique (NAET) to work with hidden allergies. Dr. Nambudripad uses Kinesiology and acupuncture at her Buena Park clinic to change the energetic body's unbalanced response to food items and other substances. Dr. Nambudripad's technique, described in her book, *Say Goodbye To Illness*, allows the food sensitive person to again co-exist with food sensitive items or environments. As a result of her technique, eighty to ninety percent of Dr. Nambudripad's patients have now become allergy free. Approximately 625 doctors across the country have now been trained in NAET.[5] For more in-depth testing, and allergy elimination techniques such as Dr. Nambudripad's, see the Appendix of this book or consult your local alternative or natural healthcare practitioner who can provide follow-up guidance specifically pertaining to food sensitivities.

FOOD SENSITIVITY SELF-TESTING

Meanwhile, you can learn to do some simple self-testing for food sensitivities, instantly identifying foods as compatible or incompatible

with your own particular energetic system. This knowledge and practice can be helpful in discovering underlying effects of specific foods on your body. The following steps will help you and a partner/tester quickly discover a particular food substance to which you may be sensitive.

Step 1: Always begin any series of Clinical Kinesiology testing by first performing the Indicator muscle test. This test determines the base-line strength of the arm the test-subject will be using. (See Chapter One for instructions.) Once Indicator arm muscle strength is determined proceed with further testing.

Step 2: Have the person being tested select a food item to which he or she suspects a sensitivity. Instruct him or her to lie down comfortably and place that food item in the energy field (on the central abdomen) of the body. Perform the test as follows:

> Food + Muscle test + Weak arm = Food sensitivity.
> Food + Muscle test + Strong arm = Energetic compatibility with body.

Out of 2.1 million deaths a year in the United States, 1.6 million are related to poor nutrition.
C. EVERETT KOOP,
FORMER SURGEON GENERAL

To simplify food sensitivity testing, be sure to test only with organic food first, thereby leaving out any influences from modern processing. Negative reactions to an organic product provides a good indication of food sensitivity to the food itself and not to other factors.

MICROWAVED AND GENETICALLY ENGINEERED FOOD

Along with muscle testing for the energetic compatibility of natural foods, you may also want to test the human-made varieties. Microwaved food sends up another red flag for anyone with known food sensitivities. It's radiated, chemically altered and incompatible with the body. To check sensitivity to microwaved foods, do a sample test.

Step 1: First, check for food sensitivity to a potato.
Step 2: If the muscle test proves strong, cut the potato in half. Microwave one half and bake the other half in a conventional oven.
Step 3: Retest the microwaved potato versus the baked potato and note any difference in the sensitivity tests to each potato.

I strongly recommend consulting with a natural health practitioner to assist in strengthening the digestive system and organs over a ninety-day period following food sensitivity testing. Perhaps after a time, as in Clyde's case, the food that tested energetically incompatible may be acceptable.

Following initial self-testing, should any food remain questionable in your mind, retest the food a second time held over the liver, and a third time over the kidney. Sometimes a food item that may irritate the liver or kidney will not irritate the body as a whole.

TESTING VITAMINS, HERBS, AND PRESCRIPTION MEDICINE

The same principles used in testing foods may also be used for Clinical Kinesiology testing of vitamin supplements, herbs, homeopathic remedies—even prescription medications.

Muscle testing can determine if almost any natural or chemical substance is energetically compatible with *your* specific body energy. Many times, people think, "Vitamins are always good for us." I say, *it always depends on the energetic quality of the substance.*

In the case of vitamins, many questions should be raised. What are the raw ingredients? How is the processing done? How careful was the manufacturer in not adding chemicals? (You may not be aware that some vitamins are made by the same pharmaceutical

laboratories that manufacture chemical drugs.) Discount brand vitamins that appear bright purple or green or contain a hard, shiny yellow coat are not natural! As a result, they may irritate the body. The irritation may not show up during the general test, however, during therapy localization over the liver, the muscle test may render the arm weak.

When testing supplements, herbs, homeopathic remedies or medications, test them while in their containers—whether unleaded glass or plastic.

Your actual need for a particular vitamin is almost certain to be different from mine...
LEON CHAITOW

> Supplement + Muscle test + Weak arm = Energetically incompatible. Purchase only natural supplements from a reputable alternative healthcare provider or healthfood store and retest.
>
> Supplement + Muscle test + Strong arm = Energetically compatible.
>
> or
>
> Prescription Medication + Muscle test + Weak arm = Energetically incompatible. Consult your natural healthcare practitioner for alternative treatment in strengthening the organ or condition which required the prescription drug.

Remember, muscle tests may change with time, based upon current body balance, the season of the year, or what may be occurring in each individual system. The tests do initially confirm substances energetically compatible with the body. However, self-testing should become a life-long practice to meet the varying needs of each body.

When self-testing prescription drugs, most people find that, typically, the drugs render the arm muscle weak—especially during therapy localization over the kidney, liver, or both. Be aware of this. Find ways of strengthening the liver and kidney such as periodic cleansing (See Chapter Nine for various liver and kidney flushes), vitamin, herbal or glandular supplementation. Do what you can to strengthen the body so that it no longer exhibits the weakness for which the drug was prescribed.

CONQUERING FOOD SENSITIVITIES

*Tell me what you eat and I will
tell your what you are.*
BRILLAT-SAVARIN

As you begin to feel good about the food you eat, you'll also feel good about yourself. Clearing up suspected problems with food sensitivities or addictions, following specific recommendations and indicating to others new dietary commitments and restrictions are the keys to renewed health.

As you gain new perspective, be encouraged to consider food as physical, emotional and spiritual nourishment. With each bite, lovingly chew your food, and let go of any former mental blocks about that food that may affect your current and future health.

Enjoy foods in their natural forms, along with the energy, vitality and bounty they bring to life. Eat *simply* to live. As you begin to supply nutrients to help body function you'll not only satisfy your hunger, you'll also be rewarded with "high performance" health for an optimal length of time.

As we've seen, the incompatibility that develops between food and the body's energetic system stems from a malfunction of the immune system. Just as the immune system protects the body from its own poorly digested foods or natural by-products of metabolizing that food—it also protects from other unrecognized chemicals and foreign invaders. Chapter Six, *Energizing Your Immune System*, offers specific methods of fighting disease through a healthy and functioning immune system along with protecting it from unnecessary drugs, antibiotics and immunizations, which further undermine immune function.

CHAPTER FIVE SUGGESTED READING

Balch, Phyllis A. C.N.C. and Balch, James F. M.D. *RX: Prescription for Cooking and Dietary Wellness.* Greenfield, Indiana: P.A.B. Publishing, Inc., 1992.

Chaitow Leon and Trenev, N. *Probiotics.* New York: Harper Collins, 1990.

Crook, William M.D. *Tracking Down Hidden Food Allergy.* Jackson, Tennessee: Professional Books, 1980.

Nambudripad, Devi S. *Say Goodbye To Illness.* Buena Park, CA: Delta Publishing, 1993.

Null, Gary, Ph.D. *Gary Null's Complete Guide to Healing Your Body Naturally.* New York: McGraw-Hill Book Company, 1988.

Orenstein, Neil S. Ph.D. and Bingham, Sarah M.S. *Food Allergies: How To Tell If You Have Them, What To Do About Them If You Do.* New York: Perigee Books, 1988.

Philpott, William H., M.D. and Kalita, Dwight K, Ph.D. *Brain Allergies.* New Caanan, CT: Keats Publishing, Inc., 1980.

Santillo, Humbart B.S., M.H. *Food Enzymes, The Missing Link To Radiant Health.* Prescott, AZ: Hohm Press, 1993.

Steinman, David. *Diet for a Poisoned Planet.* New York: Ballantine Books, 1990.

Tracy, Lisa. *The Gradual Vegetarian.* New York: Dell Publishing, 1985.

Twogood, Daniel A. D.C. *No Milk: A Revolutionary Solution to Back Pain and Headaches.* Victorville, CA: Wilhelmina Books, 1992.

Wigmore, Ann. *The Wheatgrass Book.* Garden City Park, New York: Avery Publishing, 1985.

6

Energizing Your Immune System

AMY NERVOUSLY PACED THE halls of the hospital children's ward as her three-year-old daughter, Kaycee, underwent surgery to implant Myringotomy ear-draining tubes.

In the preceding months, Kaycee had been prescribed dose after dose of antibiotics. The little girl always seemed better for a short while, then suddenly developed another ear infection. Each visit to the medical clinic resulted in still more prescriptions of antibiotics.

Eventually, the few remaining strong bacteria in Kaycee's intestinal system multiplied and mutated, forcing the doctor to pull out his strongest arsenal of antibiotics—to no avail. Surgery became the doctor's final solution to months and months of repeated ear infections for which he could find no other cure.

Every day, children like Kaycee literally experience a merry-go-round of drugs that ultimately destroys their young immune systems. As a result, their bodies are left open to a downward cycle of illnesses for which they have no immune system "army" left to fight.

A HEALTHY IMMUNE SYSTEM

Health and good estate of body are above all gold, and a strong body above infinite wealth.

APOCRYPHA

Although a strong immune system is capable of fighting off any disease, its function remains a mystery to most people—*including most medical doctors*. The body relies so much on the integrity of the immune system that, often, until the immune system stops working, most people are unaware of it.

This chapter introduces you to the complex components of the immune system—the network of cell fighters and immune organs. Monitoring that system which provides optimal health requires knowledge of its strongest foundation—diet and nutrition.

Daily care and maintenance of a healthy and functioning immune system also involves individual evaluation of immune function, available for the first time through Clinical Kinesiology energetic testing.

Armed with new knowledge, you will be encouraged to find ways to avoid or change factors which suppress or compromise immune function, including genetic pre-dispositions, overuse of antibiotics, stress, and medical and governmental immunization programs based on money and politics, rather than health.

This chapter will further discuss *informed consent*, your right to choose to protect the health of your immune system, and that of each member of your family, from yearly "flu shots" and other mass advertised vaccination programs.

You can learn to re-establish and maintain natural immunity through self-testing, education, natural diet changes, detoxification, and alternative therapies.

HOW THE IMMUNE SYSTEM WORKS

Many people today are increasingly faced with immune system problems. AIDS, Chronic Fatigue Immune Deficiency Syndrome, Lupus, Rheumatoid Arthritis, Multiple Sclerosis and Scleroderma all occur mainly because immune systems have become weak. In most of these auto-immune diseases the body mistakes normal tissues for invading substances, triggering full-blown attacks on itself. In this mass state of confusion, the weakened body no longer has any resources with which to fight.

The role of a strong immune system in warding off cancer has become central to most treatment. Immune system cells are continually on the lookout for problem areas in the body. Everyone harbors a certain number of cells which, from time to time, begin to divide in crazy patterns. Every year, cancer cells develop in *everyone's* body. Luckily, a strong immune system takes care of them.

A network of Killer T and B cells, lymphocytes and suppressor cells comprise the many types of cells throughout the immune system. Fighters that provide natural immunity, these cells remain continuously on patrol and searching—if the immune system is strong and healthy.

Measure your health by your sympathy with morning and Spring.
THOREAU

Several organs and tissues also defend the body from infectious disease, external chemical irritants and internal imbalances. That defense includes protecting the body from bacteria, viruses, chemicals, and many other foreign invaders. Anytime an individual develops an auto-immune disease, the critical element remains a malfunctioning immune system.

T-Cells

The soldiers of the immune system army constitute several different types of white blood cells called lymphocytes. The most active and most daring are the Killer T-cells.

Produced in the thymus gland, located directly under the sternum, the Killer T-cells seek out and destroy cells in the body which have been invaded by foreign organisms, as well as cells which have become cancerous.

When an individual develops the AIDS virus, the Killer T-cells are most affected. Dangerous viruses, such as HIV, contain some DNA, although not the complete molecule. Viruses typically invade a cell, parasitize it and use the DNA of the host cell to propagate and increase in number.

The host cell may be a blood cell, or any other cell in the body. Ultimately, the host cell becomes "bleached out." With its nutrients expended by the virus, it explodes and spews many viruses throughout the body.

Another set of cells, the Helper T-cells, serve as "directors" of the immune system. Helper T-cells identify invaders and stimulate the production of other immunity cells located in the spleen and

lymph nodes. Through chemical means, the Helper T-cells call up the masses to the problem area.

The macrophage cells, another of the lymphocytes, take on the role of "housekeepers," and function primarily as the front line of defense. Macrophages are readily available throughout the body. Chemically programmed to be attractive to various bacteria and viruses, macrophages engulf and digest any particles left behind as the result of an initial attack.

Electron micrograph enhanced images beautifully portray the activity of a macrophage cell shooting out a killer substance through it's own protoplasm, encircling a bacteria and neutralizing it. Most often, macrophages engulf debris in the body left over from wound healing; in effect, preventing decaying matter from lying around, becoming available for bacteria to feed on.

B-Cells

The B-cells, or Beta cells of the immune system, lie dormant in the spleen and lymph nodes. They act as tiny "guards" in guard-posts scattered throughout the body, awaiting the call to duty. The B-cells wait silently in strategic locations and may be activated quickly.

Stimulated by Helper T-cells, the Beta cells produce potent chemical weapons called antibodies. Antibodies attach themselves to foreign substances in order to neutralize them, allowing other white blood cells to seek out and destroy the dangerous substances.

Once danger passes, the Suppressor T-cells play a vital role in calling off the attack after an infection has been conquered. To enable the body to maintain immunity for future invasions, memory cells are also produced during the initial infection. These cells may circulate in the blood or lymph for years, allowing the body to respond more quickly to a repeated attack or infection.

White and Red Blood Cells

White blood cells comprise the fighters, while red blood cells provide the nutrients, or reinforcements, when a problem develops. The red cells carry oxygen and take on carbon dioxide, helping to move it out of the area.

As cells die or are destroyed the body must recreate most of its one hundred trillion cells. Certain nutritional supplements may be used to help create many of the different immune system cells.

Varying ideas exist on how long it takes to replenish the entire body with new cells; however, a common estimate is seven years. But, most red blood cells live only 120 days. So, if an anemic person is provided with a good diet and adequate supplements, within a short time, his or her red blood cell count improves.

Toxicity in Immunity

Every antigen/antibody reaction works like a lock and key mechanism. The shape of the antigen and antibody molecules are specific and must fit together. When this doesn't happen, immune cells must gobble up offending organisms. Chemicals, pollutants, and toxins in the blood are eradicated in this way too.

A healthy body is the guest-chamber of the soul; a sick, its prison.
FRANCIS BACON

Obviously, the less extra chemicals, toxins, and pollutants from food additives, preservatives, and unnatural items in the blood stream, the less the white blood cells must work to fight off the organism. So, toxicity also becomes an issue in immunity. The more toxic the body, the lower the immunity.

The importance of diet and nutrition as the healthy foundation of the immune system cannot be stressed enough. You are what you eat! Maintaining healthy immune cells and rebuilding lymphatic tissue depend on diet. It alone may be the change that positively affects the immune system for the rest of your life.

The Immune Organs

The dynamic, movable parts of the immune system consist of the white blood cells, while the stationary parts include the thymus gland, located under the sternum or breastbone; the thyroid gland, a butterfly shaped gland in the front region of the throat; and the lymph nodes, located on both sides of the neck and groin, and in each armpit.

Other important areas of lymph tissue strategically placed in the body include the tonsils, appendix, and throughout the intestinal tract. All of these glands and organs support immune system function.

Through the years, myself and many of my colleagues have noticed a high incidence of dental cavities in people who have had their tonsils removed. The tonsils exist as a tiny reservoir for white blood cells. When bacteria reaches the mouth, if the tonsils are doing their job the immune system holds strong.

The tonsils also help stave off upper respiratory infections and kill off bacteria in food that enters the stomach. The appendix provides another important reservoir for the immune system. Contrary to some beliefs, neither the tonsils nor appendix are simply worthless organs that should be eliminated without thought. Reasons exist for the presence of the tonsils and appendix!

A primary organ imbalance which almost always accompanies a weak immune system involves the thymus gland, the main producer of Killer T-cells. The thyroid gland often proves to be the weakest secondary organ most affected.

EVALUATING IMMUNE SYSTEM FUNCTION

Immune system function can be evaluated through Clinical Kinesiology energetic muscle testing. A complete exam also involves investigating past health history and current concerns.

Copper metal is a well-known conductor of electricity. Dr. Burt Espy, a colleague of Dr. Alan Beardall, discovered that utilizing a copper plate placed on the body in conjunction with Clinical Kinesiology energetic muscle testing, lends specific information as to the functioning of the immune system, particularly in determining immune organ dysfunction. The copper "works" by ascertaining the body's currents as either strong or weak through the muscle test.

Following placement of the copper plate on the body, the Clinical Kinesiology muscle test may be performed. If the indicator muscle registers weak, the response determines a lack of proper energetic function of the immune system.

In order to further evaluate if an unbalanced organ is primarily thymus or thyroid, the copper plate may be touched over each of these organs to see if the weak muscle strengthens. The self-testing section at the end of this chapter provides specific instructions for evaluating the current status of individual immune system organ response.

A second method of Clinical Kinesiology evaluation may be used to test thymus- or thyroid-strengthening glandular supplements. Following the initial indicator muscle test, hold the supplement *along with the copper in place*, directly in the energy field of the body. Perform the muscle test. The correct remedy will render the formerly

weak muscle strong. Such supplements strengthen the energy balance of a weak organ or gland along with further balancing the immune system. (See the product guide in the Appendix of this book for supplement distributor information.)

FACTORS WHICH SUPPRESS IMMUNITY

STRESS AND TOXICITY

Anyone subjected to extraordinary stress calls upon the immune system to fight needless battles. The immune "soldiers" become overworked and worn out. The results? They may not be as alert, available or ready in adequate numbers to fight off an invasion. Emotional stress, depression, and mental fatigue are all factors which compromise a healthy immune system.

There is more to life than simply increasing its speed.
MAHATMA GANDHI

The field of psychoneuroimmunology has developed in the last few years to research this problem. It studies the relationship between emotional states of mind and the immune system. Candace Pert, Ph.D., a leading neuroscientist at Rutgers University, discovered neuropeptides—neurochemical substances that cause alterations in mood.

Most significantly, neuropeptides have been discovered not only in the brain, but in the spinal cord, glands, organs and other body tissues. Neuropeptides found throughout the body also affect the functioning of the "whole" body, including the immune system.

Quantification of various types of white blood cells and their activity have been performed and correlated to various states of mind. In other words, we can think ourselves sick! Dr. George F. Solomon, a longtime researcher in psychoneuroimmunology, suggests that an "immunosuppression-prone" personality type often uses hostility or simply gives up when illness strikes.[1] Such depression and lack of interest in one's own well-being affects some people to the point that they become sick from suppressing their immune systems. Other factors which suppress the immune system include: toxicity due to overload of chemical residues from pollution, food preservatives and additives or medications. In addition, toxicity stems from the end-products of poor digestion (rendering food material into metabolic waste). Such end-products continue to reside in body tissues until a cleansing, a major illness, or purging takes place.

Stress, poor diet, toxicity and other lifestyle factors often work together to diminish the effectiveness of the immune system.

If we provide the immune system with the proper conditions, or strengthen a slightly weakened immune system through natural means, we have a greater likelihood of preventing future infections or other illness in the body.

ANTIBIOTICS

Contrary to negative reports in various media, bacterial and viral illnesses do not lurk behind every corner waiting to jump out and inundate the human race with sudden illness. It's true, microbes thrive all around us. However, maintaining the strength of the immune system remains the key to warding off disease.

Louis Pasteur himself developed a theory of immunity that has been largely forgotten by medicine. He suggested that the microbe proliferates only when the host has become too hospitable due to pre-existing illness.[2] Today, pre-existing illness, which characterizes the ability of the immune system to function correctly, stems from the lifestyle and basic level of health of an individual. As Pasteur suggests, maintaining a healthy and functioning immune system is the only proven way to fight disease.

Today when humans or animals contract a type of bacterial infection they are most frequently prescribed an antibiotic. The drug, however, kills off only the weakest of the bacteria. The strongest live, begin reproducing, and eventually may genetically alter the bacterial gene-pool so that the infection flares up again! Then, another antibiotic is administered that kills off a few more bacteria. Once again, the strongest survive and recreate a new generation of even stronger bacteria. One hundred or more separate cold or rhino viruses currently exist. The viruses mutate and constantly change to meet different conditions in the body and environment, *especially to escape antibiotic drugs.*

Much of the standard medical treatment throughout this century has been destructive to the immune system. Many individual doctors have unknowingly prescribed drugs that brought terribly destructive results.

Antibiotic drugs suppress immune cell production. Anytime the body is given a "substitute" (typically, a chemical substitute) for a natural function, the body automatically slows down or halts that function. For example, if the thyroid gland proves slightly under-productive for thyroxin, and a prescription for synthetic thyroxin is taken, the normal function of the thyroid falls off. That's why most patients given synthetic drugs are commonly told, "You must take this for the rest of your life." The reason? The individual's thyroid won't function any longer once the medication is taken.

Antibiotic usage diminishes the strength of the immune system in much the same way. In the last ten years, pharmaceutical companies have developed what they call "broad-spectrum" antibiotics. Imagine going to target practice and aiming to shoot a bull's eye. Instead, the resulting effect of these powerful broad-spectrum drugs becomes more like a machine gun cleaning out the entire area.

NATURAL IMMUNIZATIONS

Remember Kaycee, the three-year-old who underwent surgery to insert ear draining tubes? Who hasn't known a small child who's been prescribed antibiotics? And it's never one dose that is prescribed. On the contrary, it's *repeat...repeat...repeat*, and all the while, the child's immune system becomes weaker.

Experiencing childhood illnesses remains the *only* natural way to stimulate and strengthen the immune system. Such illnesses actually serve as a way of exercising the immune system. In effect, "use it or lose it." That's not to say that children need to contract pertussis or polio, but the milder childhood diseases including the mumps, measles, and chicken pox provide the building blocks in establishing a workout and development program for the immune system. These natural illnesses stimulate the immune system to work at a higher functioning level so children may easily ward off other, more serious, illnesses.

At best, life is a growing and learning process. A little baby learns to crawl first, then walk. The immune system must be trained in the same way. First, a child experiences a little cold, or roseola. Later it's a virus such as measles or chicken pox. Typically, all these child-hood diseases are extremely gentle.

Throughout the centuries, the immune system has handled various exposures and diseases. Obviously, some individuals are weaker than others and people have died. We'll never stop that. Vaccines have never stopped that either!

DANGERS OF IMMUNIZATIONS

Immunizations constitute a great concern because the public has not been informed of the short and long-term side effects, traumas, neurological damage, and deaths which are part and parcel of the artificial immunization or vaccination of children.

The only wholly safe vaccine is a vaccine that is never used.
DR. JAMES SHANNON,
NATIONAL INSTITUTE OF
HEALTH

In this century, the medical profession, along with government authorities, have instituted public immunization programs and issued blanket prescriptions of antibiotics to countless people. Ethical, medical and social edicts regarding "blanket" immunization decisions are more often based on money and politics—and not health.

The immunization issue involves decisions that have been made at the highest levels—for the benefit of a few at the expense of many.[3] Each succeeding generation's immune systems have been weakened as a result.

Initially, scientists who studied immunizations may have thought they represented a valid, plausible idea. However, shortly before Louis Pasteur's death, he reneged on the whole idea of immunizations. Pasteur proclaimed that he wished for the world to understand that the *only* way to fight disease was to maintain a healthy and functioning immune system.

Immunization or vaccination involves a process of exposing an individual to a mild form of a disease in hopes that an antigen/antibody reaction will be stimulated. In truth, it takes a stretch of the imagination to believe that injecting a virulent bacteria or virus (even in a weakened state) into the body, would be good for health. The whole idea that the body must begin fighting this deadly invader is frightening.

When an individual sustains a huge gash or wound (a dog bite, for example), bacteria is injected directly into the bloodstream. (Does someone have a better chance of fighting bacteria that way or by using the respiratory system as a filter, along with the immune system army? How many times have you been exposed to someone with a cold...*and not gotten the cold?*)

Once bitten by a dog, the body must work extremely hard to avoid infection. However, the skin provides the first line of immune defense, while the white blood cells, including the entire immune reserves, wait in the wings.

What defense do you have from an injection of a virus into your bloodstream? By the time an immunization or particular vaccination is produced, the strain of that bacteria or virus may have changed or mutated significantly enough that the vaccine's effectiveness is lessened.

Most major diseases are cyclical, just as everything in life—day and night, summer and winter, hot and cold, birth and death. As diseases evolve, the rate of infection may rise; however, it also always drops. Many of the serious diseases—ones we presently immunize against—were most prevalent in the first half of this century. The danger of contracting them is much less than it was historically.

Many diseases have naturally diminished due to the attrition of one illness and occurrence of other new illnesses. Therefore, when building up and protecting the immune system, the significant risks of immunization mistakes and immunization-caused illnesses must be weighed.

Richard Moskowitz, in "The Case Against Immunizations," states that immunizations promote certain types of chronic diseases. "Far from providing a genuine immunity...vaccines may act by actually interfering with or suppressing the immune response..."[4] Moskowitz soon discovered "...I could no longer bring myself to give the injections even when the parents wished me to."[5]

Dr. Moskowitz documents the occurrence of leukemia in two cases which he specifically relates back to immunizations. He also indicates that the rise in auto-immune diseases is an automatic result of injecting live virus and foreign antigens into children. He believes the virus from immunizations may be permanently incorporated into the genetic material or DNA of a child's cells. The antibody reaction then turns the immune system against the child's cells, which have been invaded from the viruses from the immunization.

Moskowitz also believes that the timing of the administration of many immunizations is not rational. Two-month-old infants, who possess strong immunity from being breast-fed, have a nervous system far too delicate to be exposed to the pertussis vaccine. In

actuality, pertussis is rarely found in infants below five months of age, yet inoculations begin at two months. A high rate of neurological problems from damage to the central nervous system and other problems have been traced directly to the pertussis vaccine.[6]

The newest medical fad consists of mixing three or four vaccines together, with plans to inject up to six separate viruses in one immunization. Such repeated vaccinations exhaust the immune system.

Additionally, many side effects from vaccinations result in both immediate and delayed reactions, including permanent disability. These side effects include mental retardation, cerebral palsy, epilepsy, paralysis, learning disability, recurrent respiratory infections, as well as susceptibility to all types of infectious disorders.

In his book, *The Assault on The American Child: Vaccination, Sociopathy, and Criminality*, Dr. Harris Coulter indicates brain injury (including autism), dyslexia, anti-social behavior, and personality disorders as conditions attributable to vaccinations.[7]

Dr. Coulter also warns that more than half of all children who become fussy and feverish following diphtheria/pertussis shots have more than likely suffered some encephalitis (inflammation of the brain) or probable brain damage, even if minimal. (Unfortunately, for children to be fussy and feverish after DPT shots remains the rule rather than the exception.)

In addition, the effectiveness of today's vaccines must be highly questioned. Documentation shows that fifty to sixty percent of children who contracted measles were previously vaccinated for measles. Other statistics show that between sixty and ninety percent of measles occur in adult individuals who were already vaccinated for measles. Nervous system disorders as severe as encephalitis, retinopathy, blindness and seizures have also been traced to measles vaccine.[8]

THE IMMUNIZATION INDUSTRY

When science turns towards spiritual discoveries, it will make more progress in fifty years than in all its past history.
CHARLES STEINMETZ

Immunization programs are an expensive "industry" costing upwards of one billion dollars a year. The money is made by a few people—the government and pharmaceutical industries.

Every year, drug companies campaign across America. "Don't forget your flu shot!" is the slogan that encourages millions to walk

into the clinic, the office, the grocery store, and even to the drive-up window. "Roll up your sleeves!" they say, "but ask no questions."

The thought of people running to the grocery store or street corner somewhere to get a flu shot is crazy. When I hear it, I think of lemmings running into the ocean. Last year, my patients who came in with the worst cases of the flu were the ones who had gotten the flu shot—and they contracted the flu soon after getting the shot.

When people proclaim, "I get my flu shot every year," they have merely succumbed to mass social marketing techniques and worse. *They are systematically weakening their immune systems.* Do you know the signs to watch out for? The contraindications? Or, the contents of each flu shot? These dangers have been documented by a number of articles published since the 1950s.

In 1974, eighty million people, led by President Ford, rolled up their sleeves and received shots for a flu epidemic which never occurred. Thousands are now paralyzed by Guillain Barre Syndrome. I know because my husband, Dr. Burt Espy, treated a woman who gradually recovered.

Vaccinations, according to Guylaine Lanctôt, author of *The Medical Mafia*, "...permit epidemiological studies of populations to collect data on the resistance of different ethnic groups to different illnesses."[9]

What's really in an immunization? In "quality control" hospital research laboratories, researchers may grow cultures to produce immunizations in one room, conduct AIDS research in another, or make polio vaccine in the third laboratory. Cross contamination through unsanitary hospital and research lab coats is often the norm rather than the exception, says Robert S. Mendelsohn in his book, *Male Practice: How Doctors Manipulate Women*. "...Hospitals are prone to handle their laundry so carelessly that those antiseptic-appearing uniforms are often loaded with germs."[10] Some coats are washed only every six or eight weeks and rarely in scalding water. Technicians often walk from room to room, rubbing a sleeve here, or wiping a thigh with something there. As Sherry Rogers, M.D. relates in *Tired or Toxic? A Blueprint for Health*, "Every afternoon at 1:00 we would don our white lab coats (that we rarely washed because we were too tired) and slave over our formaldehyde-soaked cadavers until dinner. Afterwards, still swaddled in the coats, we studied into the wee hours of the morning."[11]

To do nothing is sometimes a good remedy.

HIPPOCRATES

The air in hospital research laboratories provides another fertile avenue of contamination. Yes, many hospitals and labs try to take precautions on some levels, however, *no one truly knows what is in that immunization.* Researchers don't really know either. Cross contamination can be great, and most cultures are at least somewhat suspect.

Another related issue has to do with what a lab culture is grown on. Unfortunately for our little animal friends, most cultures are grown on monkey livers.

Monkeys frequently carry a virus called Simian 40 (SV 40). In fact, when Dr. Albert Schweitzer directed his clinic in Africa, he treated anyone—unless the patient was suffering from a monkey or an ape bite. In those cases, Dr. Schweitzer gently advised, "Go home to your village, be comfortable and die peacefully." Because Simian 40 is so infectious, and he had no way to cure the virus, he didn't want to risk contaminating his other patients.

Could the Simian 40 virus find its way into a lab culture in the U.S.? Yes, it's possible and warrants more close consideration. Lanctôt reports: "...in 1960, cultures from the manufacture of anti-polio vaccine were discovered to be infested with Simian 40. As a result, millions of children were contaminated before detection. Today, SV 40 is know to cause immune deficiency, congenital anomalies, leukemia, and malignant illnesses," such as brain tumors.[12]

TO IMMUNIZE OR NOT

You, the public, are not told of the dangers of immunizations. I support you in taking greater responsibility for your health. Individual families should retain the right to choose whether or not to expose themselves or their children to mass immunizations which have a low rate of quality control in production.

Today, it's become much too commonplace to accept immunizations without question. I believe that populations who take immunization programs too lightly face an incredible danger. The possibility of being an unknowing subject in an unwanted experimentation is terrifying. The risk that unforeseen items have been added to the vaccines is too big a risk to take.

In her research, Guylaine Lanctôt met with a group of Native American women about the subject of vaccinations. The group's nurse

confided that although the federal government had provided her complete freedom in managing the children's healthcare, the government insisted on one strict condition—*"that every vaccination had to be scrupulously applied to all."*[13]

The federal government's eagerness to require all children to be immunized can be potentially dangerous. The likelihood of these children being injected with substances without their parents' complete knowledge must be addressed. *Parents be forewarned.* Health issues and legal rights' issues are at stake. No one should consent to immunizations without fully exploring the potential dangers.

STRENGTHENING YOUR IMMUNE SYSTEM

Not everyone catches a virus. Lifestyle remains the most important determinant in "who gets sick," followed by genetic predisposition. But the good news is that you can win the fight against genetic predisposition! You can change lifestyle factors and add conditions that the body requires to maintain a healthy immune system!

Once again, the ability of the body to fight disease and avoid illness depends on the health and activity of your immune system "soldiers." Proper nutrient balance remains the major factor which allows the immune system soldiers to remain strong and active.

IMMUNE NUTRIENTS

Anyone who determines that she or he possesses a weak immune system should assume that the body is experiencing nutrient imbalance. Should an immune system demonstrate inadequate functioning, immediate treatment should be instituted even though an individual may not yet prove symptomatic.

Nutrients known to be integral to the functioning of the immune system include vitamins C and E, selenium, vitamin A with beta carotene, zinc, B vitamins, manganese, inositol, iron and copper. Zinc stimulates T-cell production while vitamin A contributes to healthy mucus membranes of the cells. Vitamin E is the oxygenator of the body and also helps in the production of T-cells.

Recently, it's been discovered that bioflavinoids taken with vitamin C assist the body in making more of its own naturally occurring interferon, an essential compound of the immune system. Selenium, found in garlic, provides an important boost to immune system function. It also helps the body hold onto and absorb vitamin E.

Nobel prizewinner, Dr. Linus Pauling was a firm believer in the properties of vitamin C. Dr. Pauling reportedly took mega doses of vitamin C every day until his death well into his 90s.

I take a minimum of 6,000 mg. of vitamin C every day and recommend a high dose throughout the day in a sustained release tablet. Along with nutrition, detoxification programs have proved very successful for anyone with a poorly functioning immune system.

To further build health, immune system building nutrients are available. These include Core Level Thymus™ and Core Level Thyroid™ by Nutri-west®, Immuno Plus and Immuno Genics® by Metagenics, or Immu-Cell™ by Professional Botanicals. (See Product Guide.) Immu-Cell™ contains milkweed, germanium, CoQ10, vitamin A, thymus, ginseng and shark cartilage. These products provide wise yet harmless interventions to protect both adults and children, providing immunity without submission to governmental authorities or threat of danger.

Available in a homeopathic form, these immune stimulators may be used in lieu of immunizations or vaccinations to strengthen the immune system, specifically for bacterial and viral immunity. Excellent versions of these, Bacterial Immune System Stimulator™ and Viral Immune System Stimulator™ are available from Professional Health Products. (See Resource Guide.) In the event that a child has already been exposed to pertussis or other communicable diseases, a new administration of the immune system stimulators can be introduced and may prove helpful.

Consult with a natural healthcare practitioner for any questions you may have regarding the use of natural remedies.

IMMUNE HERBS

Echinacea remains a simple, yet powerful herb for stimulating the immune system. It resembles a daisy, with purple petals and a yellow

bulbous center. The petals grow toward the sun and then turn down, making it an extremely pretty herb.

If you decide to grow your own herb garden, the echinacea root is the most potent part of the plant. Thus I grow plenty of them in my own organic herb garden. Most garden shops sell small echinacea plants or seeds, which take longer to grow.

Why should a person die who has sage in the garden?
UNKNOWN

With the immune-building herbs echinacea or astragulas, plus the infection-fighter golden seal, almost any infection can be deterred. In addition, acidophilus (friendly intestinal flora) proves especially helpful if an antibiotic has been taken previously and the body needs rebalancing by replanting the good bacteria that has been lost.

TESTING IMMUNE SYSTEM FUNCTION

The simplest test designed by Dr. Burt Espy to determine the status of the immune system is the Copper Test. For this, you'll need to visit a neighborhood hardware store and purchase a small strip of copper, approximately two inches square.

Step 1: Place the copper strip in the energy field (or central abdomen) of the body and perform the Clinical Kinesiology muscle test. A weak muscle response indicates an imbalance in the immune system.

Copper strip + Muscle test + Strong arm = Functioning immune system
Copper strip + Muscle test + Weak arm = Weak immune system.

Step 2: If the copper weakens the body, obtain a bottle of Echinacea in tincture form. Place the bottle along with the copper onto the abdomen together, and retest to determine if the Echinacea helps to counteract the weakness and make the immune system stronger.

Copper + Echinacea + Muscle test + Strong arm = Use echinacea to strengthen immune system.

HEALTHY THOUGHTS, ETC.

Finally, in strengthening the immune system the power of thought remains unmistakable. Many times patients call and say, "I don't think I should come today. I have a cold and don't want to give it to you."

I always tell them, "We have strong immune systems. We work on having strong immune systems. So come!"

Take control of your environment and eliminate toxins such as cigarette smoke, pesticides, vapors, and chemical odors, keeping a harmonious environment in your home.

Also, learn to steer clear of the dangers of chemically altering the immune system. Through educating yourself about natural dietary changes, detoxification, alternative therapies, herbal and other nutrients, you will reap wide-ranging benefits in securing a healthful and normal immune system for yourself and your family for generations to come.

By learning about factors which may have undermined our immune system function in the past, we can better prepare to care for our immune system in the future. The foundation of that knowledge may now be used by the millions of people who unknowingly suffer from the systemic infection, Candida albicans. Chapter Seven, *Candida: Causes and Treatment*, provides guidance in identifying Candidiasis along with measures for rebuilding and maintaining the body's immune system following such an overgrowth of unhealthy bacteria.

CHAPTER SIX SUGGESTED READING

Berger, Stuart M.D. *Stuart Berger's Immune Power Diet.* New York: New American Library/Dutton, 1986.

Buttram, Harold M.D. and Hoffman, John Chris. *Vaccinations and Immune Malfunction.* The Humanitarian Publishing Company, 1985.

Coulter, Harris and Fisher, B.L. *DPT, A Shot In The Dark.* San Diego, CA: Harcourt, Brace, Jovanovich, 1985.

Coulter, Harris. Vaccination, *Social Violence, and Criminality: The Medical Assault on the American Brain.* Berkeley, CA: North Atlantic Books, 1990.

Galland, L. and Buchman, D.D. *Superimmunity for Kids.* New York: Dutton, 1988.

Geison, Gerald L. *The Private Science of Louis Pasteur.* Princeton, N.J.: Princeton University Press, 1995.

Gregory, Scott O.M.D. *A Holistic Protocol For The Immune System.* CA: Tree of Life, 1993.

Justice, Blair Ph.D. *Who Gets Sick.* Los Angeles, CA: Jeremy Tarcher, Inc., 1988.

Lanctôt, Guylaine, M.D. *The Medical Mafia: How to Get Out of it Alive and Take Back our Health and Wealth.* Miami: Here's The Key, Inc., 1995.

Mendelsohn, Robert M.D. *How To Raise A Healthy Child In Spite Of Your Doctor.* New York: Ballantine, 1987.

Mendelsohn, Robert S., M.D. *Male Practice: How Doctors Manipulate Women.* Chicago: Contemporary Books, Inc., 1981.

Neustaedter, Randall. *The Immunization Decision: A Guide For Parents.* Berkeley, CA: North Atlantic Books, 1990.

Rogers, Sherry A., M.D. *Tired or Toxic? A Blueprint for Health.* Syracuse, New York: Prestige Publishing, 1990.

Simonton, O. Carl, Matthews-Simonton, Stephanie and Creighton, James L. *Getting Well Again.* Los Angeles: Jeremy P. Tarcher, 1978.

Wade, Carlson. *Immune Power Boosters, The Key to Feeling Younger, Living Longer.* Englewood Cliffs, NJ: Prentice Hall, 1990.

Candida: Causes and Treatment

IMAGINE THE BODY AS a dynamic "living garden" designed especially for growing its own bacteria, a little yeast or fungus, along with all the good nutrients produced on a daily basis.

The earth itself functions on the same premise. The earth is an organism, harboring billions upon billions of tiny parasites (including you and I)—each parasite doing what it does best. In many instances, this co-existence proves quite functional.

During this century, however, we and our earth have become more dysfunctional in relation to the ecological destruction taking place every day. Until recently, this large globe and our human bodies had peacefully co-existed with all the wonderful little parasites and organisms. Dwelling in the twentieth century, however, means sharing our bodies with as many as twenty separate, unnatural viruses, which, for the most part, lie dormant throughout the course of a lifetime. Now both our bodies and the earth may be threatened unless we begin taking steps to keep them healthy.

More than ever, your "living garden" needs a caring gardener. Who could be better for the job than you! With a few helpful suggestions you can begin to rebalance the earth starting with your own body's ecology.

A healthy immune system depends on maintaining the right numbers of the right organisms in the right places in the body. This chapter is about an unfriendly organism, the yeast Candida Albicans, what causes it and how to deal with it. You will learn:

- how to self-diagnose Candida through simple and effective Clinical Kinesiology energetic testing, in addition to the Candida questionnaire
- what symptoms to expect in Candida
- when to treat this condition
- which alternative therapies to use
- how long to maintain the treatment program
- and how to cope with a Candida "die-off," once you are on the road to balanced health

Healthful diet, nutrients, detoxification and replenishment of healthy intestinal flora are the keys for successfully controlling Candida for life and for rebuilding the integrity of the immune system.

BACTERIA: HEALTHY AND UNHEALTHY

Bifidobacteria are the most predominate intestinal flora which are established shortly after birth in infants.
H.W. MODLER

Normally, the human body houses different types of bacteria on the skin, in the mouth, and in the small and large intestine. A number of the body's own B vitamins are produced in the intestines by helpful bacteria.

Orthomolecular biologist Dr. Jeffrey Bland states that over four hundred species of bacteria live in the intestines. The weight of these bacteria is 2½ to 3 pounds, or equal to the weight of an organ the size of the liver. This bacteria forms the basis of your dynamic "living garden."

Macrobiotic researcher and author, Michio Kushi, calls the intestines the body's "roots." Think of your intestinal roots like soil: a great deal of bacteria and some fungus all help to break down the decomposing matter, making the nutrients from food more available to the body.

The intestines complete this process every day. Additionally, quite a few research studies done on breast-fed infants support Kushi's theory. One study consisted of analyzing stool cultures to detect what organisms and life forms thrive in a healthy newborn baby. In its

most natural state, researchers found eighty to ninety percent of the bacteria in a breast-fed baby to be friendly bifidus bacteria.[1]

Microbiology studies also show that the adult human intestinal tract contains a concentration of bifido and acidophilus bacteria, or friendly flora. However, it also contains Escherichia coli, a pathogen or unhealthy bacteria that can make humans quite ill.[2]

In adults with diminished digestive ability, E. coli and other pathogens comprise the most prevalent type of bacteria in the large intestine. Somewhere, in the journey from infancy to adulthood, much of our friendly flora has died out.

E. coli O157:H-7, the same bacteria that made California children critically ill after eating undercooked hamburger at a fast-food restaurant chain in 1992, should not be prevalent in the healthy intestinal tract. Rather, it should exist as a very small minority.

Dr. Jeffrey Bland proposes an interesting theory regarding the E. coli episode in California. His theory suggests that the true contamination may have stemmed from a strain of super mutant bacteria that developed due to excessive amounts of antibiotics fed to the cattle that provided the hamburger.

Diet explains one of the main reasons unfriendly flora has flourished. It hasn't been proven, per se, but one conjecture offers that bifidus and acidophilus bacteria are extremely vulnerable to antibiotics, while the E. coli O157: H-7 bacteria remains strong enough not only to survive...but, as Dr. Bland theorizes, to super mutate and multiply.

Tipping the scale through unhealthy diet, overuse of antibiotics, and other factors throws off the balance of good, protective bacteria—which by sheer numbers alone, normally crowd out offending organisms. However, once you risk leaving the garden gate of your beautiful living garden open, the yeast, Candida Albicans may begin to grow.

ANTIBIOTIC EQUALS ANTI-LIFE?

Before we can discuss how antibiotics upset the body's natural immunity and set the stage for the development of Candida Albicans, a little background data is important.

One particular category of strong poisons, called antibiotics, kills not only the "bad" but the good bacteria in the body. The word *biotic* means life form. Antibiotics, therefore, means "against life forms." The whole idea of an antibiotic is to kill off certain life forms. In that context, taking antibiotics is unnatural, especially in the potent form in which pharmaceutical companies produce them.

More men die of their medicines than their diseases.
MOLIERE

We've all been sold the message that antibiotics are good medicine. Until lately, science has touted antibiotics as wonder drugs that kill infection and stave off unfriendly bacteria! However, few naturally occurring antibiotics exist, which automatically makes one question. Are antibiotics really the medicine that nature intended to keep us healthy? More and more studies say no.[3]

ORIGINS OF ANTIBIOTICS

The manufacture of antibiotics began following the discovery of penicillin. Quite accidentally, a small petrie dish in a lab was contaminated with a small amount of penicillin mold. In the surrounding area, bacteria that had also been cultured in the petrie dish refused to grow. The reason? Both bacteria and mold produce toxins that kill off their competitors.

The same phenomena occurs in the body, on pets, in the ocean, and all over the earth to some degree. As long as an organism maintains a sufficient number of helpful bacteria to counterbalance the effects of potentially harmful bacteria it remains healthy.

Instead of allowing the original, natural concentration used by the penicillin mold to protect itself, new synthetic versions have been designed. Much stronger, and more potent, their whole chemical composition has been altered.

Synthetic penicillin was the first antibiotic on the market. Later, pharmaceutical companies began manufacturing more and more variations—all different chemical renditions of extremely potent antibiotics.

HOW ANTIBIOTICS "WORK"

When people are prescribed antibiotics for a strep throat, the drug also kills off a great deal of the body's good bacteria. It kills the

weakest strep first, and the next weakest after more exposure and many days of taking the antibiotic. Most of the time, though, a little bit of strep survives.

The old adage, "Survival of the fittest," applies. The strongest bacteria represent the ones that survive and re-multiply. A little bit of strep on the skin or in the nose is normal in small amounts. The presence of not-so-friendly bacteria in the body is also normal; however, the chemicals prescribed to kill them aren't health-promoting or normal.

Consequently, scientists in this century have unwittingly aided and abetted the creation of mutant bacteria—bacteria that mutates or changes to meet different conditions in the body and environment simply to survive the assault from antibiotics. The strongest bacteria live, reproduce and eventually genetically alter the bacterial gene-pool.

In retaliation, modern medicine pulls out more munitions and produces stronger "guns" with larger "bullets," or, more powerful antibiotics to kill off the now mutated bacteria. The battle being waged in *your* body begins all over again.

Antibiotics do save people's lives in certain critical situations. However, for every sneeze or itchy, runny nose they are unnecessary. Routinely given, antibiotics merely assist in the breakdown of body ecology. Having a body in such an unbalanced state then opens the door for the yeast Candida Albicans to grow.

WHAT IS CANDIDA ALBICANS?

Candida describes a physical state in which the immune system becomes compromised by a certain type of yeast overgrowth in the body. Candida shouldn't be confused with the kind of yeast found in bread or baked items, although that yeast is a cousin of Candida Albicans. Candida begins when a small percentage of yeast (under less than optimal health conditions) is allowed to grow and become populous, eventually predominating in the system.

Observe moldy bread and you immediately see that in order to feed the mold, nutrients must be extracted—destroying the bread in the process. Obviously bread mold is not the same organism as Candida; however, once Candida becomes ingrained in the system it's just as difficult to extract.

Look to your health; and if you have it, praise God, and value it next to a good conscience; for health is the second blessing that we mortals are capable of; a blessing that money cannot buy.
IZAAK WALTON

Like mold, Candida represents a type of yeast overgrowth syndrome that entrenches itself in the body. Unfortunately, antibiotics, along with sugar consumption, and other dietary indiscretions provide the perfect conditions for the yeast to grow.

Friendly bacteria are an integral part of the immune system. Once it becomes out of balance from poor diet or antibiotics, Candida may grow out of control and become quite severe. Some of the sickest people on earth suffer from yeast overgrowth syndrome, or Candida. When mild cases are caught and treated early, the changes ultimately save the individual from many future problems. Because this disorder is often quite difficult to diagnose, many cases progress to severe levels before being discovered.

Candida attaches itself to the lining of the intestines by implanting its claw-like "fingers" into the tissue of the intestinal wall. Once ingrained, Candida produces tissue damage in the small and large intestine, which contributes to another serious problem, "leaky gut syndrome." Normally, tiny pores in the membranes of the intestines allow nutrients to flow from the bowel into the blood for absorption into the body. Damage from Candida's grip on the intestinal wall causes normal pores to expand, becoming so large that partially digested food that wasn't quite ready to move, permeates the intestinal wall. Food toxins then flow into the bloodstream, and begin to cause food allergy or sensitivity problems. So, many people with Candida experience food and chemical sensitivities. Some feel as though they're allergic to the twentieth century.

Doctors prescribing antibiotics have not been taught to look for Candida. Dr. C. Orian Truss, author of *The Missing Diagnosis*, was a pioneering Candida physician. People came to him exhibiting various symptoms, and at first he struggled to make a diagnosis. Nothing fit until he made the connection to Candida.

Dr. Truss discovered several major symptoms of this yeast problem, including: depression, anxiety, irrational behavior, irritability, diarrhea, abdominal bloating, constipation, heartburn, indigestion, loss of self-confidence, lethargy, migraine headaches and even acne.

Particularly for women, symptoms include irritation of the urethra, bladder, repeated vaginal yeast infections, PMS, and other menstrual difficulties. Since Dr. Truss's original work, indicators show prostatitis or inflammation of the prostate in men may also stem from Candida.

In children, Candida symptoms range from hyperactivity, learning disorders, repeated ear infections, diaper rashes and abdominal discomfort to diarrhea or constipation, poor appetite and erratic sleep patterns.

Originally, both Drs. Orian Truss and William Crook, author of *The Yeast Connection and the Woman*, were demeaned by the medical establishment for their pioneering work with Candida. Today, their work and research have been overwhelmingly accepted by the general public—and by people who experience Candida.

CAUSES OF CANDIDA

Candida represents an iatrogenic or almost totally doctor-induced disease. It stems primarily from overuse of antibiotics and has also been contracted from consumption of beef, chicken, or milk *containing* antibiotics.

Antibiotics fed to dairy cattle contaminate cow's milk, and the antibiotics fed to chickens contaminate the eggs hatched from these chickens. Be wary! You may be in danger of ingesting antibiotics from the food you eat, even though you're determined to avoid antibiotics as a prescription drug.

When the body becomes out of balance with Candida, so many other illnesses have license to overtake it.

In a healthy body, the bifidus and acidophilus bacteria grow side by side. If something interferes with the balance, serious problems might arise. You may liken the use of antibiotics to a forest fire which rages out of control burning down the good flora. After such a fire, it is essential to bring renewal to a charred and blackened forest by replanting little seedlings to begin the reforestation. Treatment for Candida also requires replenishment of decimated populations of bifidus and acidophilus bacteria.

In addition to antibiotics, other drugs prone to stimulate or augment Candida include certain immuno suppressant drugs—a term most people don't often hear. Most have grown accustomed to names such as *steroids*, or *cortisone* instead. Whatever their names, these powerful chemical drugs do suppress the immune system, and do promote the possibility of Candida.

Candidiasis is basically a twentieth-century disease, a disease resulting from medical developments like antibiotics, birth control pills, and estrogen replacement therapy.
LEYARDIA BLACK, N.D.

Although indirectly, asthma is also related to Candida. Often, cases misdiagnosed as asthma are really a reaction to severe food sensitivities. In addition, many asthma sufferers are prescribed steroids. This chain reaction of drugs may also contribute to the imbalanced body chemistry which allows Candida to thrive.

Even hormone replacement therapy may be dangerous for a system prone to Candida, since any synthetic hormone throws off the balance of the body's natural hormones.

Hormone composition may be compared with a banana split, with different versions of the banana split representing different hormones. Building an estrogen-hormone banana split, for example, might begin with the "banana," (the basic cholesterol molecule), "several raisins" (natural steroids), a few "cherries" and some "nuts" in a certain pattern. Rearrange the toppings, add other ingredients in other patterns, and the result will be a different hormone.

When healthy and balanced, the body makes all of its own hormones. However, when hormones are created from a synthetic base, the components are qualitatively different from the natural ones, and therefore confuse the body about exactly how to function.

Synthetic hormones are not compatible or in natural balance with the body. Therefore, prescribing estrogen, progesterone, or birth control pills makes Candida worse. It requires the immune system to work even harder.

Another causative factor in Candida stems from the use of cytotoxic drugs. While antibiotics work "against life," cytotoxic drugs refer to "toxic to cell" drugs. What types of drugs are these? Various chemotherapy drugs.

Cancer is the most common disease treated by chemotherapy drugs; however, cytotoxic drugs may also be used for other disorders. Often times, people develop Candida after finishing a program of chemotherapy. In addition, people suffering from debilitating disease and its prolonged stress on the body, are often more prone to Candida.

IMMUNE-SYSTEM DYSFUNCTION

Candida wears down the immune system and makes it more difficult for the immune system to fight. Of course, many more years of

research and study are needed to completely understand Candida and its relationships to other illnesses. However, Candida remains a complex and potentially serious illness.

Dr. Jeffrey Bland, Ph.D., reports that "...one of the first signs seen in HIV-positive individuals who are progressing to AIDS-related complex are nosocomial gastrointestinal infections." These occur as a consequence of compromised function of the intestinal tract as seen in Candida albicans.[4] Other researchers implicate Candida with the onset of Lupus, also a disorder of the immune system. Most auto-immune diseases which have recently come to light have simply been caused by an overburdening of the immune system.

Approach impossible goals by breaking them down into possible increments. Or, to put it another way: How do you move a mountain? One rock at a time.
JOHN W. TRAVIS, M.D.

Candida is also a prerequisite for colitis, an inflammation of the large intestine. Cases of Crohn's Disease, an inflammation of the small intestine, often reveal that Candida was present first. In short, cure the Candida and it's likely you'll cure the colitis, Crohn's Disease, and Lupus.

Cases of Multiple Sclerosis and Lupus show marked improvement following treatment for Candida. Multiple Sclerosis does have some relationship with the immune system and the integrity of the nervous system—while lupus represents a total immune dysfunction disorder.

People with auto-immune disease are often stymied by their disorders. "Why me?" they question. "How did I get this way?" Although health may often deteriorate quickly, Candida and other immune diseases don't happen overnight.

During critical stages of development, it's quite possible that Candida becomes entrenched in the body, as in the case of Doris.

Doris's Story

Born in the mid-1950s, Doris suffered in infancy with milk allergies as a result of being fed cow's milk instead of breast milk.

Doris's busy mother left her lying hour after hour in the crib with a bottle in her mouth. Due to the improper feeding position, milk flowed into little Doris's eustachian tubes into her ears, and caused an ear infection. Doctors then prescribed antibiotics to get rid of Doris's ear infection. Meanwhile, Doris's milk allergy worsened as her immature digestive system was continually bombarded by the cow's milk, which is too rich for humans.

Again, Doris's mother laid her down in her crib and the cycle began again. Another ear infection, more antibiotics. All the while, the "killing off" of Doris's good bacteria by antibiotics allowed Candida to begin growing throughout her intestinal tract.

Why did Doris's medical doctors fail to see this pattern? Unfortunately, their beliefs and dependence on antibiotic drugs give them few options. Unfortunately, most medical doctors know no other way to treat a patient who is sniffling, wheezing, coughing or suffering from an earache.

Baby Doris grew into a pretty little girl. As she progressed through immunizations and more harmful bacteria in early childhood, the Candida yeast continued to grow. And, what does yeast need to grow? Anyone who has ever made wine or bread knows that a key ingredient must be added to give the yeast something to grow on. That ingredient is sugar. So, it's not surprising that six-year-old Doris loved chocolate candy bars. Because the yeast demanded she bring sugar into her system, candy became an addiction. As a result, her health grew worse and worse. Her bifidus and acidophilus began dying off—bit by bit.

The growth of yeast continued and soon young Doris was diagnosed with a bladder infection. Shortly after that came a yeast infection.

As Doris shyly celebrated her thirteenth birthday, she became noticeably self conscious about a newly-developed problem—acne. Her progression to the standard American teenage diet triggered the Candida in her system to begin producing even more poisons, which meant more work for her liver.

By then, Doris's liver was so overwhelmed, it could no longer adequately filter her body's poisons. She consulted her doctor, who gave her another prescription—for tetracycline.

Never taught to question her doctor, Doris allowed him to take the lion's share of responsibility for her health. "I needed to take this medication. My doctor said so!" she related. So, like so many people, she took the medicine for a year, went off of it and the acne came back. She returned to the tetracycline again and the cycle began again.

If Doris had not suffered through this unhealthy chain reaction, the breakdown of good bifidus and acidophilus bacteria wouldn't have occurred. If she'd only known to avoid an unhealthy diet and better

understood the dangerous repercussions of antibiotic and other drugs, Doris's body wouldn't have enabled the growth of Candida.

Finally, in her early thirties Doris encountered a serious health crisis. She began experiencing every symptom imaginable including fatigue, depression, irritability, memory loss, severe menstrual problems, digestive disorders, itching, infertility, psoriasis, vague muscle and joint pains, repeated ear and respiratory ailments—asthma being only one.

Doris, like so many others, was unknowingly set up at a young age to develop all of these problems. Eventually, if she doesn't get some real help, she'll likely end up with a diagnosis of Lupus, Chronic Fatigue Immune Deficiency Syndrome, or Multiple Sclerosis.

DIAGNOSING CANDIDA

Intervening in Candida involves evaluation of the total body through Clinical Kinesiology testing. Along with the Candida questionnaire and a personal history, Clinical Kinesiology is the simplest method of diagnosis and evaluation of symptoms.

Clinical Kinesiology muscle testing employs a simple handmode (researched and developed by Dr. Burt Espy) for detecting Candida. The index and third finger are curled into the palm, the tip of the thumb and fourth finger are touched together, while the pinky finger rests on the crease of the thumb. This proves to be a difficult position to assume. You may need assistance to insure the correct positioning. (See the self-testing section at the end of this chapter for specific handmode diagrams and testing instructions.) The Clinical Kinesiology muscle test may then be performed to see if the Candida mode results in a strong or weak muscle test.

Another method of diagnosing Candida involves analysis of stool cultures. This test proves fairly inexpensive and does identify the Candida. In many cases, however, the yeast is not readily apparent through such a simple culture, especially if it is lying in dormant forms in the body.

The Live Cell (living sample of blood) evaluation offers still another way to see the yeast. With the help of a darkfield microscope, the yeast may be seen forming in the blood. This is the only method currently known to distinguish the mycelial or "branched out" form of yeast in the blood.

An expensive serum antibody test may also be available for doctors to address Candida. The test does have drawbacks, however, and Clinical Kinesiology testing is preferable, due to the level of accuracy.

DORMANT FORMS OF CANDIDA

Candida is often difficult to pinpoint. When the presence of Candida triggers the body to form antibodies to the yeast, the yeast takes the form of a spore to avoid attack. Spores resemble tiny buds, as in spores of yeast, or spores of mold. Much like an acorn from an oak tree, a spore represents an easily preserved life form. An acorn sits for years and years, one day germinates, and eventually sprouts into a tree. In the same way, yeast spores in the body may sit dormant for years and one day develop into Candida. Spores either grow into a simple mold, or a mycelial form of mold, much like a tree branching out.

The "branching out" form of Candida yeast attaches itself to and begins breaking down the integrity of the intestinal wall. The yeast in spore form resembles a tiny kernel encased in a hard coating.

The spore doesn't trigger the body to produce antibodies as long as most of the yeast remains in the dormant stage. For this reason, the serum antibody test may not identify the Candida, or the test may reveal only a slight case. In reality, though, the Candida may be quite colonized.

THE ROLE OF PARASITES IN CANDIDA

In recent times, some Candida researchers have indicated that people who have Candida may also carry a parasite. A parasite is a life form that lives off another life form.

"Which comes first, the chicken or the egg?" becomes the question in investigating the presence of parasites in Candida patients. Is the body weakened from having Candida, allowing a parasite into the system, or was the parasite present first...allowing the Candida to grow? Or, because of the parasite, was an antibiotic given which didn't affect the parasite, but triggered Candida?

Symbiotic parasitic relationships are often found in the sea. Tiny fish may live on a big fish, eating bacteria or other organisms that may attack the host fish. In this case, the parasites are helping, not hurting. However, most of the time parasites refer to intrusive protozoa, bacteria, fungus, or even viruses, which live off the host and damage it—not adding any beneficial aspect to the relationship.

Candida is truly an unhelpful parasite when it grows out of control in the body, begins overcrowding and "taking over" just as mold does on a piece of bread.

LIFESTYLE FACTORS THAT AFFECT CANDIDA

Incorporating healthy lifestyle changes make a big difference in fighting Candida. First, the yeast must be killed, your living garden replanted, the immune system restrengthened, and diet and lifestyle modified. The most important factor involves withholding the type of food on which the yeast thrives. But remember, the energetically correct food for one person may not necessarily be right for another. Some Candida patients can eat miso and a number of fruits, while other patients cannot tolerate those foods during the time they're battling Candida. Each individual must be tested with Clinical Kinesiology to discover what foods his or her particular body can or cannot tolerate at the time. Then, a program may be designed for each individual's needs, rather than offering everyone the same general guidelines.

Living under conditions of modern life, it is important to bear in mind that the refinement, over processing and cooking of food products either entirely eliminates or in part destroys the vital elements in the original material.

UNITED STATES DEPARTMENT OF AGRICULTURE

WHAT NOT TO EAT...

Until expert testing helps determine individual food sensitivities, it is wise to leave out sugar, refined carbohydrates such as white bread and pasta, alcohol, and even honey. This strict diet regimen is required only for a period of time—not forever. It's done simply to give the body a chance to recover.

Vinegar, soy sauce, and miso are several examples of fermented items that should be avoided by most Candida patients, although there may be a few exceptions.

Restrict the diet from all yeast-containing foods for a minimum of three months. While Candida is different from baker's yeast or brewer's yeast, still, you are advised to adhere to the philosophy that if yeast is growing out of control in the body, any yeast may further upset the immune system. The body begins making antibodies against the yeast, and even the Candida "cousins"—baker's and brewer's yeast—can upset the applecart!

Changing your diet for only three or four weeks and then going off the diet—then back on for three or four weeks doesn't allow for much progress. One patient, Judy, dragged out her Candida "die-off" process for years, because she wasn't able to maintain consistency with her diet. Her Achilles heel is dairy foods. Dairy constitutes a major problem because so many food sensitivities and allergies are connected with it. Certain forms of Candida, not necessarily Candida Albicans, can also be found in dairy products.

Making diet changes means commitment; but what better motivation could one ask for than receiving optimal health?

Dairy Roadblocks

Expect to experience more allergic reactions to yogurt, cheese, or kefir containing some type of yeast. These products tend to set off the immune system again and again. Learning to eat foods less offensive to the immune system allows it to continue to rebuild and strengthen.

Yogurt has been overemphasized in many books, especially with claims such as, "Yogurt is a cure-all." Actually, yogurt doesn't contain the curative properties touted mainly because its amounts of friendly bacteria, acidophilus, are miniscule compared to what is truly needed.

Fungi

It's smart to avoid any fungus or fungus-containing food such as peanuts and mushrooms. The mushroom is a type of fungus which easily irritates a delicate immune system, especially one already producing antibodies against another fungus. It's much easier to leave out fermented and fungal foods—the yeasts, sugars, and alcohol—altogether.

WHAT TO EAT...

The majority of your diet should consist of vegetables, whole grains and proteins. (I don't advocate a great deal of protein, and I differ from most people on this, especially when it comes to animal protein.)

Let nature be your teacher.
WORDSWORTH

In general, grains prove much more favorable as the basis for a healthy diet even though some schools of thought indicate that as the carbohydrates from rice, wheat, soy, and other grains are broken down, the level of blood sugar in the body rises. But, I disagree as long as one has been consistently eating grains and vegetables.

You can fancy up your grains and vegetables with a wide variety of healthy herbs and spices such as garlic, basil, cilantro, or tarragon.

A diet rich in whole grains helps to quell sweet cravings once sugar is eliminated. Fruit also helps. Although fruit contains a naturally occurring sugar, fructose, moderate use of energetically compatible fruits satisfy sweet cravings without feeding the yeast.

Sometimes cravings signal what the body truly needs and other times they're a form of disguised message. With no TV commercials to distract or tempt, we could all put more trust in our cravings. Many times, the body signals the need for a particular food; however, the true signals may be misinterpreted by the brain, often because of the artificial foods, preservatives and flavorings.

A CANDIDA DIE-OFF

Natural treatment logically focuses on encouraging or rebalancing conditions in the body which eventually cause the yeast to die. At the same time it's wise to replenish with healthy bacteria at once, and provide them proper conditions to flourish.

Anyone with a great deal of yeast in the system may experience numerous "die-off" symptoms during the progression of the Candida infestation or course of treatment. The yeast organisms carry poison within them. As they die, their membranes eventually rupture as decomposition occurs, releasing the poison or toxins into the system.

The actual "die-off" causes some extreme "I-just-don't-feel-good" types of symptoms. As the yeast continues to die off the toxins may further weaken the immune system leading to infections, allergies, chronic illness and that "sick all over" feeling. This signifies a healing crisis. Although patients sometimes get worse before getting better, once the poisons are flushed through, they continue to get well.

Patients with Candida of the severity of Doris's could experience a difficult "die-off" period. In those cases, a much gentler approach is used. For a Candida patient experiencing a difficult "die-off" it may be necessary to diminish the amount per dose of the nutrients, herbs or supplements being utilized to attack the Candida.

A few patients have become temporarily disabled from working Candida out of their bodies. Their yeast "die-off" proves more intense comparatively to the normal "die-off" episodes that most people experience. Still, even the most severe episodes are usually short-lived.

DETOX FOLLOWING CANDIDA DIE-OFF

The destiny of nations depends on how they eat.
BRILLAT-SAVARIN

Along with additional nutrients added to the diet, simple herbal detoxification programs prove helpful in the treatment for Candida. Some recommendations include DeTox Tea by The Yogi Tea Company; AM/PM Cleanser by Nature's Secret available in capsules or tablets (available at healthfood stores). I also recommend the A. Vogel 10-Day Cleanse by Bioforce (at healthfood stores) in combination with D-Tox™ by Nutri-West®. Other companies make similar high quality formulas readily available from reputable healthfood stores or natural health practitioners.

I recommend a program which contains herbs and various combinations of vitamins and minerals which help cleanse the liver, kidneys and intestines. A good detox program also supplies a digestive aid and suggests a simple method of getting started if a detoxification program has never been undertaken before.

Another cleansing program on the market, *Ultra Clear,*® has been developed by orthomolecular biologist, Jeffrey Bland Ph.D. His line of probiotic foods consists of powdered predigested protein made of rice proteins and other nutrients which help cleanse the body and rebuild the immune system. *Ultra Clear*® also makes it much easier

for people to continue with their normal responsibilities at home and at work, and do the cleansing program at the same time.

An enema remains the best natural home detox method. Enemas help empty the intestines of toxins and large colonies of Candida. The process actually washes them away. Along with enemas, colonics administered by a professional also prove beneficial. Other natural colon cleansers include *Wachter's*-psysillium seed powder with seaweed and alfalfa powder combined.

REPLENISH

While it's important to cleanse and detoxify, it's also necessary to replenish the body's friendly bacteria following a detoxification plan.

Replenishment of natural intestinal flora may be accomplished with several products. *Ultra Bifidus*™ and *Ultra Dophilus*®, by Metagenics®, to my knowledge provide the best quality and strongest potency acidophilus and bifidus available.

The *Ultra Bifidus*™ and *Ultra Dophilus*® each contain 2.5 billion living organisms per gram guaranteed to a certain date on the bottle. That's the kind of replenishment or reforestation needed! A tiny bit of milk powder is added to each jar as a food supply for the living bacteria. Keeping the bacteria refrigerated slows reproduction so they won't exhaust their food supply. So, anytime you purchase an acidophilus or bifidus product that is unrefrigerated, assume that the bacteria are no longer living and those particular supplements or powders won't be as effective.

OTHER TREATMENTS FOR CANDIDA

I. Tea Tree Oil:
Women with Candida are prone to vaginal infections. A good item to combat this problem is Australian oil of Melaleuca® alternifolia, or Tea Tree oil. The oil, extracted from a special tree called the Tea Tree, has proven quite beneficial. However, always check to make sure that the oil you purchase meets The Australian Standards Association guidelines which has specified that even the *lowest* quality oil have at least thirty percent of the active ingredient, Terpinen 4-ol.

Oil of Melaleuca® alternifolia may be used topically for vaginal infections, or rubbed on skin lesions. For a nail fungal infection, Tea Tree oil combines well with another product, Gentian Violet. Most likely, if growing conditions exist for fungus in the nails, it's probably present elsewhere in the body.

II. Gentian Violet

Older patients may be more familiar with Gentian Violet because it is a treatment that was used years ago. Like it's name, the tincture is a very purple liquid. It may be bought in a drugstore without a prescription. For infection on the fingernails or toenails, simply apply the Gentian Violet around the fungal area and allow it to dry.

Patients must begin to change from passive recipients of medical care to active, self-responsible participants.
ELMER GREEN, PH.D.

Gentian Violet kills yeast without harming cells. The tincture does stain anything it touches, however; so be extra careful. One reason it may be unpopular with some people is because of it's staining power. However, it has been used effectively as a treatment for nail fungus and even vaginal Candida.

III. Immune System Supplements

Many supplements may be used to build and strengthen the immune system. Some of the more powerful ones include yeast-free multi-vitamins. (Many B-vitamins are made with yeast so always read the labels.)

The mineral, germanium, represents a good immune system builder. Several anti-oxidant supplements contain germanium and beta carotene in the same formula. Anyone with Candida requires extra biotin, another B-vitamin. A strong, yeast-free, B-vitamin complex with biotin works well. Remember, always take B-vitamins in a balanced formula. Generally, these formulas contain a full complement of B-vitamins in a B-50 or B-100 capsule or tablet. This means that the majority of the components have 50 or 100 milligrams. B_1, B_2, B_6, B_{12}, niacinimide, pantothenic acid, choline, inositol, biotin and paba are the vitamins which prove most important.

Because of problems involving digestion or previous damage to the intestinal tract from Candida, some people cannot absorb nutrients as well as they should. Therefore, a variety of trace minerals such as manganese, zinc, potassium, selenium, silica, boron, molybdenum, and copper should also be included into the dietary and nutrient regimen.

One supplement that helps kill off Candida is *Capricin*™. Interestingly enough, *Capricin's*™ main ingredients include magnesium and calcium, but only as a medium for the Caprylic acid.

Caprylic acid kills Candida. It's also found in olive oil, which more and more people use quite liberally. Caprylic acid may also be found in goat's milk. It's the acid that gives goat milk it's pungent smell.

IV. Herbs

Echinacea remains a strong yet simple herb for building the immune system; it is recommended to help people avoid and recover from different types of illness. Fungal, bacterial, viral or parasitic patients benefit from adding Echinacea herb to the diet.

Another powerful herb for combating Candida is Pau d'arco (also called Taheebo and Lapacho) from South America. Pau d'arco, an herb gleaned from the shavings of the bark of the tree, kills Candida specifically while also strengthening the immune system.

Pau d'arco can be used as a tea; however, the strongest form remains the tincture. In all cases, be careful to get certified organic, all natural herbs. That certification guarantees that the trees aren't sprayed or chemically fertilized and the herbs are grown and harvested under specific organic conditions.

V. Flaxseed Oil

Flaxseed oil tops the list of essential oils in my book. Everyone should take it! Flaxseed oil provides the essential fatty acids needed for hormone production. It also aids in maintaining the integrity of cell membranes.

Every cell membrane in the body stores essential fatty acids. Nowadays, people have become so conscious about not eating fat, that some aren't getting enough fat in their diets. Flaxseed oil is necessary for a healthy body, as opposed to most other types of fats. This natural oil provides the best balance of the high polyunsaturated and Omega 3, 6, and 9 oils. While fish oil supplements have been touted for this or that, the best complements of oils can be found in flaxseed oil since it contains every type of fat the body needs.

VI. Citricidal®

Citricidal®, manufactured from grapefruit seed extract, produces a potent liquid for killing Candida, fungus, parasites and other organisms. It kills any "bad guy" in the body. Citricidal® is a new product that's been on the market only a few years, yet it has generated a great deal of interest as a result of it's healing properties.

❀ ❀ ❀

All these powerful remedies work; however, the best case scenario continues to require specific Clinical Kinesiology testing on each individual. While one treatment shows up strongest for one person, a different product or treatment may test more helpful for another.

I encourage you to keep the commitment to use only natural therapies to kill off Candida. As more and more people move in a more holistic direction, I hope usage of all of these types of natural therapies will grow.

TESTS AND QUESTIONNAIRES

A valuable test for discovering the presence of Candida has been developed by William Crook, M.D. Filling out and scoring the Candida questionnaire should enable you and your natural health practitioner to evaluate the possible role of Candida in contributing to your health problems.

Immune and auto-immune system problems are different. Auto-immune disorders are those in which the body's immune system turns against itself. Most of the time, Candida Albicans is classified as an immune system disorder, not necessarily auto-immune. If Candida Albicans advances untreated, and the same unhealthy dietary patterns continue, the Candida may lead to various auto-immune disorders such as rheumatoid arthritis, Multiple Sclerosis or Lupus.

Candida Questionnaire And Score Sheet

This questionnaire is designed for adults and the scoring system isn't appropriate for children. It lists factors in your medical history which promote the growth of Candida Albicans (Section A), and symptoms commonly found in individuals with yeast connected illness (Section B and C).

For each "Yes" answer in Section A, circle the Point Score in that section. Total your score and record it in the box at the end of the section. Then move onto Sections B and C and score as directed.

Filling out and scoring this questionnaire should help you and your physician evaluate the possible role of Candida in contributing to your health problems. Yet it will not provide an automatic "Yes" or "No" answer.

Section A: History

1. Have you taken tetracyclines (Sumycin®, Panmycin®, Vibramycin®, Minocin®, etc.) or other antibiotics for acne for 1 month (or longer)?

	25

2. Have you, at any time in your life, taken other "broad spectrum" antibiotics† for respiratory, urinary or other infections (for 2 months or longer, or in shorter courses 4 or more times in a 1-year period?)

	20

3. Have you taken a broad spectrum antibiotic drug† - even a single course? 6

4. Have you, at any time in your life, been bothered by persistent prostatitis, vaginitis, or other problems affecting your reproductive organs? 25

5. Have you been pregnant...	
2 or more times?	5
1 time?	3

6. Have you taken birth control pills...

† Including Keflex, ® amoxicillin, Ceclor, ® Bactrim® and Septra ®. Such antibiotics kill off "good germs" while they're killing off those which cause infection.

For more than 2 years?	15
For 6 months to 2 years?	8

7. Have you taken prednisone, Decadron® or other cortisone-type drugs...

For more than 2 weeks?	15
For 2 weeks or less?	6

8. Does exposure to perfumes, insecticides, fabric shop odors and other chemicals provoke...

Moderate to severe symptoms?	20
Mild symptoms?	5

9. Are your symptoms worse on damp, muggy days or in moldy places?

	20

10. Have you had athlete's foot, ring worm, "jock itch" or other chronic fungus infections of the skin or nails? Have such infections been...

Severe or persistent?	20
Mild to moderate?	10
11. Do you crave sugar?	10
12. Do you crave breads?	10
13. Do you crave alcoholic beverages?	10
14. Does tobacco smoke really bother you?	10

Total Score, Section A _____

Section B Major Symptoms:

For each of your symptoms, enter the appropriate figure in the Point Score column:

If a symptom is occasional or mild, **score 3 points**

If a symptom is frequent and/or moderately severe **score 6 points**

If a symptom is severe and/or disabling **score 9 points**

Add total score and record it in the box at the end of this section.

Point Score

1. Fatigue or lethargy	
2. Feeling of being "drained"	
3. Poor memory	
4. Feeling "spacey" or "unreal"	
5. Depression	
6. Numbness, burning or tingling	

7. Muscle aches	13. Belching and intestinal gas
8. Muscle weakness or paralysis	14. Mucus in stools
9. Pain and/or swelling in joints	15. Hemorrhoids
10. Abdominal pain	16. Dry mouth
11. Constipation	17. Rash or blisters in mouth
12. Diarrhea	18. Bad breath
13. Bloating	19. Joint swelling or arthritis
14. Troublesome vaginal discharge	20. Nasal congestion or discharge
15. Persistent vaginal burning or itching	21. Postnasal drip
16. Prostatitis	22. Nasal itching
17. Impotence	23. Sore or dry throat
18. Loss of sexual desire	24. Cough
19. Endometriosis	25. Pain or tightness in chest
20. Cramps and/or other menstrual irregularities	26. Wheezing or shortness of breath
21. Premenstrual tension	27. Urgency or urinary frequency
22. Spots in front of eyes	28. Burning on urination
23. Erratic vision	29. Failing vision
Total Score, Section B	30. Burning or tearing of eyes
	31. Recurrent infection or fluid in ears
	32. Ear pain or deafness

Section C: Other Symptoms†

For each of your symptoms, enter the appropriate figure in the Point Score column:

If a symptom is occasional or mild
score 1 point

If a symptom is frequent and/or moderately severe **score 2 points**

If a symptom is severe and/or disabling
score 3 points

Add total score and record it in the box at the end of this section.

Point Score

1. Drowsiness
2. Irritability or jitteriness
3. Incoordination
4. Inability to concentrate
5. Frequent mood swings
6. Headache
7. Dizziness/loss of balance
8. Pressure above ears...feeling of head swelling or tingling
9. Itching
10. Other rashes
11. Heartburn
12. Indigestion

Total Score, Section C _____
Total Score, Section A _____
Total Score, Section B _____

Grand Total Score _____

The Grand Total Score will help you and your physician decide if your health problems are yeast-connected. Scores in women will run higher as 7 items in the questionnaire apply exclusively to women, while only 2 apply exclusively to men.

Yeast-connected health problems are almost certainly present in women with scores over 180, and in men with scores over 140.

Yeast-connected health problems are probably present in women with scores over 120 and in men with scores over 40.

With scores of less than 60 in women and 40 in men, yeasts are less apt to cause health problems.

From: Crook, W.G., The Yeast Connection and the Woman, Professional Books, Jackson, TN., 1995. Used with permission.

† While symptoms in this section commonly occur in people with yeast-connected illness, they are also found in other individuals.

CANDIDA HANDMODE TEST

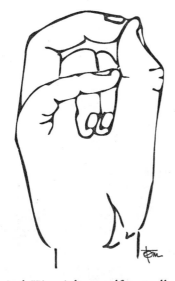

The following Clinical Kinesiology self-test allows you and a partner/tester to determine whether or not Candida is present in your system. Before proceeding with any testing, first perform the Indicator Muscle Test as instructed in Chapter One. Once a strong Indicator muscle is determined you may proceed as follows:

Step 1: Assume the Candida handmode as illustrated.
Step 2: Have a partner/tester perform the Clinical Kinesiology muscle test on the test-subject's opposite

Indicator arm muscle.

Candida Handmode + Muscle test + Strong arm = no presence of Candida.
Candida Handmode + Muscle test + Weak arm = Candida present. Seek further testing and treatment from a trained natural healthcare practitioner.

LUPUS TEST

ILLUSTRATION COURTESY OF
DR. JOHN AMARO,
INTERNATIONAL ACADEMY OF CLINICAL
ACUPUNCTURE. COPYRIGHT © 1981.

An acupuncture point to test for Lupus can be found three-fourths of an inch above the internal ankle, on the Spleen Meridian, half-way between Spleen 5 and 6.

Step 1: Locate the Lupus acu-point and place your finger on the point.

Step 2: Have a partner/tester perform the Clinical Kinesiology muscle test on the opposite arm as follows:

> Touch Lupus Point + Muscle Test + Strong arm = no Lupus present in the body.
> Touch Lupus Point + Muscle Test + Weak arm = Schedule further testing with a natural healthcare professional.

Again, should the Candida questionnaire provide a "yes" score and/or the Candida handmode or Lupus acupoint result in a weak muscle test, consult a natural health practitioner who can further evaluate your situation. Together you can work with your practitioner to design a program to combat your individual Candida problem. Establishing this relationship will allow your natural health practitioner to monitor or oversee your "home" work while you benefit from his or her professional expertise and recommendations.

CHRONIC FATIGUE SYNDROME

Currently, no specific energetic test for Chronic Fatigue Immune Deficiency Syndrome is available. The cases that I've treated all stemmed from a heart imbalance. The patients may be weak and may have some viral exposure connected to the Deficiency; however, in my clinical research, the illness stems from the Heart Meridian.

CONTROL CANDIDA

Understanding lifestyle patterns which help create Candida, along with steps to prevent it—such as healthful diet, supplemental nutrients, detoxification, and replenishment of healthy intestinal flora—are the keys to recovery.

Dwell as near as possible to the channel in which your life flows.
HENRY DAVID THOREAU

Making the commitment to renewed health and taking control of the treatment enables you to create the energy and build the stamina needed to stop the growth of Candida Albicans, ultimately strengthening the integrity of your immune system.

With everything functioning well in the body, plus access to a good diet, clean water, air, exercise and sunshine, many Candida patients may look forward to becoming much healthier people.

Just as Candida Albicans can be considered an "invader" from *within*, another "invader" from *without* alters body cells, acupuncture meridians and organ systems. Chapter Eight, *Unfriendly Energy: Electromagnetic Pollution*, discusses such an invasion from unhealthy external energy and provides recommendations for maintaining the integrity of the body through safe exposure to unhealthy electromagnetic fields or EMFs.

CHAPTER SEVEN SUGGESTED READING

Chaitow, Leon N.D. *Candida Albicans: Is Yeast Your Problem?* Rochester, VT: Inner Traditions International, Ltd., 1989.

Connolly, Pat. *The Candida Albicans Yeast Free Cookbook.* New Canaan, CT: Keats Publishing, Inc.

Crook, William M.D. *Chronic Fatigue Syndrome and the Yeast Connection.* Jackson, TN: Professional Books Future Health, 1992.

Crook, William M.D. *The Yeast Connection.* Jackson, TN: Professional Books Future Health, 1989.

Crook, William M.D. *The Yeast Connection and the Woman.* Jackson, TN: Professional Books Future Health, 1995.

Lorenzani, Shirley Ph.D. *Candida, A Twentieth Century Disease.* New Canaan, CT: Keats Publishing, Inc., 1986.

Mintz, Morton. *The Therapeutic Nightmare.* Boston: Houghton-Mifflin, 1965.

Schmidt, Michael A., Smith, Lendon H., and Schnert Keith W. *Beyond Antibiotics: Fifty Ways To Boost Immunity.* Berkeley, CA: North Atlantic Books, 1994.

Trowbridge, J. and Walker, M. *The Yeast Syndrome.* New York: Bantam Books, 1986.

Truss, C. Orian M.D. *The Missing Diagnosis.* Birmingham, AL: Missing Diagnosis, Inc., 1983.

Unfriendly Energy: Electromagnetic Pollution

THROUGHOUT HER TWENTY-YEAR BROADCAST writing and producing career, my co-author, Carol Lehr, has worked in television stations and production studios which emit incredible amounts of electromagnetic pollution. On a daily basis, errant energy from all manner of television broadcasting equipment, including TV monitors, video switcher panels, satellite dishes, computer editing and production units has whirred in Carol's close proximity. This high concentration of electricity continually focused a great deal of electromagnetic pollution directly to Carol as she worked in the confines of these technical areas.

In 1991, Carol began to experience mid-back and neck muscle spasms and other vague stress-related symptoms. Eventually, these became so severe that she considered giving up her profession. Instead, she chose to be evaluated by Clinical Kinesiology. Carol's muscle tests consistently indicated electromagnetic and geopathic (invisible energies emanating from the Earth affecting the body) imbalances stemming from a heart imbalance.

We can reprogram our brains to perceive unsuitable energies as suitable ones and use them for our benefit rather than allow them to cause energy blockages and imbalances.

DR. DEVI S. NAMBUDRIPAD

Treatment with acupuncture and magnets temporarily strengthened Carol's Heart Meridian. However, returning day after day to the same environment at the television station simply unbalanced her meridians once again. The decisive factor which eventually "cured" Carol's heart imbalance and allowed her to continue her career, was the addition of an EMF-clearing device, the Clarus Clear Wave unit, to her work space.

It's now obvious to Carol that with her body's high degree of sensitivity, she needs protection from the electromagnetic pollution that bathes her and many others every day.

EMFS AND YOU

What is this thing called electricity? More importantly, how have we come to live in a world so dependent upon it without previously questioning its effects on our bodies? Living in an increasingly high-tech society it's more important than ever to evaluate the risks of electromagnetic pollution, including the link between exposure to electric and magnetic fields (EMFs) and susceptibility to a number of disease states.

Worldwide, in twenty-two countries, over three hundred various *invitro*, *invivo* and *epidemiological* studies involving magnetic or electric fields are currently underway or planned. The scope of the questions—which include the relationship between electric power lines and cancer, computers and birth defects, as well as the link between electromagnetic fields and breast cancer and Alzheimer's disease—is enormous.

Despite growing scientific evidence, it's shocking that no public advocates in the form of government health officials or agencies exist in regulating EMF pollution. Instead, those in opposition to the regulation of EMFs include every political power base in the country, from computer manufacturers to consumer electronics industries to real estate, insurance, and—principally—electric utilities. This is reason enough to be concerned.

This chapter will provide you with a new understanding of EMF interaction and effects on the electromagnetic body. It will encourage you to guard against electromagnetic imbalances through new awareness of body symptoms stemming from EMF pollution. You will

be alerted to warnings about the newest and most dangerous electromagnetic polluters of the body, including the magnetic resonance imaging device (MRI), computers, microwave ovens, and hand-held hairdryers.

Suggestions and recommendations for safe exposure to electromagnetic pollution will be offered here, as well as information about unprecedented new methods for diverting or converting unhealthy energy through environmental surveying, EMF monitoring and EMF-clearing devices.

You will discover how easy it is to self-test for EMF exposure through Clinical Kinesiology energetic testing, enabling quick determination of electromagnetic imbalances from overexposure to EMF pollution.

Finally, this chapter will consider invaluable alternative treatments for rebalancing energetic imbalances using acupuncture or therapeutic magnets to help stop short-circuiting the body's energetic system.

THE ELECTROMAGNETIC BODY

Envisioning the electromagnetic body requires some firsthand knowledge of its atomic structure. In today's fast-paced society, most people have had little opportunity to stop and consider their own "electric" body.

Jog your memory a bit. Try to recollect a high school chemistry class and recall the design of an atom. First of all, the average diameter of an atom is 100 billionth of a millimeter, or 10^{-7}. Infinitely small, an atom is comprised of mostly empty space, energy and a tiny amount of matter.

To put the size and attributes of an atom into clearer perspective, imagine the earth as the size of an orange. In relation, the entire orange/earth's atomic matter would amount to the size of several cherries, the nucleus of each cherry no larger than a grain of salt. Likewise, electrons orbiting the cherries would resemble specks of dust. The rest of the "orange" would be empty space and energy.

The human body is composed of the same atomic structure as the earth/orange: mostly empty space and a small amount of matter or energy. Electrical energy...*and* magnetic energy; the two are inseparable.

I sing the Body electric.
WALT WHITMAN

Electrons orbiting between atoms and around the atom's nucleus create the energy patterns or energy in motion that sustains most of life. You, I, and everything else are made of oscillating fields of energy. All energy circulates in waves or pulsations. Certain *frequencies* describe how oscillating waves may be organized or patterned.

Robert Becker, M.D., author of two groundbreaking books, *The Body Electric* and *Cross Currents*, was the first researcher to recognize a link between electromagnetic fields and illness. Becker reported that electromagnetic fields flow in living organisms producing magnetic fields which also extend outside the body. These natural body fields can also be influenced by external magnetic fields.[1] Consequently, when two waves of energy meet, if they're not congruent or precisely the same frequency, size and intensity, the stronger energy field may overpower or destroy the weaker. In addition, when two waves of energy at the wrong interface collide, they may "cancel out" one another.

By understanding the energetic quality of the human body, of all matter and everything surrounding it, you may better understand how a correct balance of energy brings good health, vitality and well-being. Without such balance, the risk for electromagnetic illness becomes much greater.

Throughout the body, the same energy flows continuously. Maintaining energetic balance and health may be best obtained by surrounding oneself with naturally occurring energy forms, such as those within nature—like trees, rocks, and rushing streams. On the other hand, introducing the body into disharmonic energy fields such as those created by high-voltage power lines, microwaves, electric appliances, or other dangerous electromagnetic fields, may prove quite harmful.

In *Longevity: Fulfilling Our Biological Potential*, author Kenneth Pelletier says there appears to be "...a vital link between the electrical potentials of the human organism and those of the physical environment. Electromagnetic fields which pervade the environment have pronounced effects on the human body."[2]

Clinical Kinesiology testing shows, categorically, that human-made energy forms prove incompatible with the human body—interfering not only with individual cellular processes, but with the delicate energetic system as a whole.

HEALING ENERGY IMBALANCES

Robert Becker defines energetic healing as a type of therapy that taps into an invisible common source, "...the body's internal energetic control systems..."[3] Energetic healers, like mechanics, must be able to pinpoint short circuits in the body's energy system. According to Becker, energy therapy such as acupuncture allows the healer "...to produce external electromagnetic energy fields that interact with those of the patient. The interaction could be one that 'restores' balance in the internal forces or that reinforces the electrical system so that the body returns toward a normal condition."[4]

Dr. Alan Beardall understood this unique pre-arranged pattern of body energy when he formulated Clinical Kinesiology diagnostic testing from the centuries-old Chinese acupuncture philosophy. Clinical Kinesiology testing utilizes the body's energetic feedback system to interpret the body's reaction to specific electromagnetic pollution. In addition, testing provides the means for rechanneling naturally occurring energy in the body for healing purposes. Because every individual's electromagnetic body reacts differently, it's important to begin to appreciate your own body as the delicate bundle of energy (with a specific vibration) that it is.

Clinical Kinesiology diagnosis incorporates various electromagnetic therapies which may be used to rebalance the body. Acupuncture gently "boosts" the body through needles which administer energy in amounts similar to that released by the body's own energetic system. In the practice of Therapeutic Touch, healers direct and modulate their own internal energy systems to produce external electromagnetic energy fields that interact with and augment those of their patients.

EMFS: THE SCOPE OF THE PROBLEM

Early Model T and Model A cars were built using engines that required gasoline. At the time, inventors knew little about pollution from fossil fuels. Their all consuming focus? "How do we make this automobile run and move forward?" Now, one hundred years later, we're realizing the dangerous effects that auto emissions, specifically

carbon monoxide, have on health. The same concerns have recently surfaced regarding illness and electromagnetic fields.

Over the years, experimenters have manufactured conductive wires and routed electrical energy in definite frequencies for productive purposes. Yet, as they continued to make discoveries further advancing technology, they failed to address the far-reaching *negative* effects this unknown technology exacts on the human body. Little did electrical engineers know that diverting, controlling, and transporting electrical energy for a multiplicity of purposes in the modern world would result in electromagnetic spin-off, pollution and other negative side effects. The door has been left open! Now, potential risks from such unharnessed electromagnetic fields, or EMFs, affect nearly everyone.

In *Cross Currents*, Dr. Robert Becker illustrates the enormity of the problem.

> "Today, we swim in a sea of energy that is almost totally man-made....The growth of electric power and communication systems was slow at first, but since World War II, it has been increasing at between 5 and 10 percent per year. Commercial telephone and television satellite transmitters and relays blanket the Earth from 25,000 miles in space. Military satellites cruise by every point on Earth once an hour, and from their altitude of only 250 miles, they bounce radar beams off its surface to produce images for later "downloading" over their home countries. New TV and FM stations come on the air weekly. The industry has placed in the hands of the public such gadgets as citizens-band radios and cellular telephones."[5]

Indeed, it's not just the increase in EMFs but increased exposure. It's been estimated that a child living in 1996 is exposed to 350 million times more EMFs than his or her grandparents were, through intrusions such as video games and computers.

Recognizing the negative effects of electromagnetic pollution, spin-off, or excess is only the first step in helping avoid this modern threat to health. As Becker's research concludes, "...the exposure of living organisms to abnormal electromagnetic fields results in significant abnormalities in physiology and function."[6]

We are only beginning to discover the down sides to our advanced technology. While suspected by radar operators since the mid-1940s, the effects of electromagnetic pollution on the environment and the human body are only now being recognized. Epidemiologists and other scientists in the United States, Sweden, Canada, Finland and most all industrialized countries contribute new findings on EMF pollution weekly. As a result, the body of evidence is mounting.

THE GOVERNMENT'S ROLE

Where does the U.S. Government fit into all of this? The Department of Energy established the EMF Rapid Program and allocated $65 million for EMF research. However, the allotment requires that the private sector contribute matching funds. Electric companies, expected to be the prinicpal contributors, have become increasingly nervous about the scientific findings. So nervous, in fact, that their continued financial support for new studies has plummeted and they have now turned to lobbying members of Congress against EMF regulatory increases.[7]

Clearly we do not die, as often as we kill ourselves.
DR. KENNETH PELLETIER

The anti-environmental atmosphere in today's Congress does not bode well for the release of new findings. Not only slow to react, our own government has, in some cases, concealed information on electromagnetic pollution.[8] Federal agencies traditionally downplay the connection between electromagnetic pollution and disease and have yet to establish any safety standards.

In *The EMF Book*, Mark A. Pinsky cites a widely publicized 1990 EPA draft report which recommended classifying electromagnetic fields as a "probable" human carcinogen (cancer-causing agent). Pinsky reports that the Bush administration then "...toned down the EPA's recommendations," sparking media and public outcry following the alteration of the document.[9]

After the advent of the watershed Swedish studies, the head of the EPA, Carol Browner, again looked at EMFs as a carcinogen. The new EPA report has been described by its chief author, Dr. Robert McGaughy, as the strongest official indictment so far of EMF as a cancer promoter.

At the same time, Congress's National Council on Radiation Protection and Measurements (NCRP) committee report on EMFs was recently completed after nine years. Dr. Joe Elder, EPA's program officer for the NCRP study, calls the 800-page draft "...the first comprehensive review of the world's literature on EMF health effects."[10] The new report recommends adopting an ALARA (as low as reasonably achievable) EMF standard limiting all new day care centers, schools, playgrounds, new housing, office and industrial development to *two milligauss*.[11]

CANCER IN CHILDREN

Cancer currently ranks as the number one cause of death by disease in children between the ages of one and fourteen. One third of those deaths are attributed to leukemia. In light of the latest EMF research, considerable evidence suggests that children may exhibit the highest sensitivity and/or susceptibility to electromagnetic hazards.

A pioneering study, conducted by epidemiologist Dr. Nancy Werthheimer at the University of Colorado in 1979, explored the effects of electromagnetic pollution on children. By studying children's death certificates, and later plotting their residences, Werthheimer determined that children who lived near high-power electric lines were two to three times more likely to develop leukemia or brain cancer compared to children living in other areas.[12]

A 1988 follow-up study by Dr. David Savitz also confirmed a possible relationship between magnetic fields from high-voltage electrical lines and childhood cancer. Since then, more and more studies evidence that low-frequency magnetic fields have significant behavioral and central nervous system effects, as well as a stimulating effect, on cancer cell growth.[13]

In 1992, Sweden, a pioneering country in the evaluation of electromagnetic pollution, studied 500,000 children in the most exhaustive EMF residential study ever. Drs. Anders Ahlbom and Maria Feychting found that children living near transmission lines, where they received three milligauss of exposure, were nearly four times as likely to get leukemia. Given the quality of the study and Sweden's Cancer registry, this was considered to be a major breakthrough.[14]

WOMEN AND EMF'S

Along with children, studies suggest that women may also be more susceptible to exposure to EMFs, citing recent links to pregnancy risks, breast cancer and Alzheimer's disease.

In 1986, Wertheimer and Leeper reported that pregnant women who used electric blankets or waterbeds with electric heaters experienced a significantly higher rate of miscarriages and slower fetal development.[15]

Another study released in June of 1994 by University of North Carolina researchers, indicated that women exposed to electrical or magnetic fields on the job had a thirty-eight percent higher incidence of breast cancer than other women.[16]

Also released in 1994, were findings from three studies conducted in Finland and Los Angeles by University of Southern California researchers. USC's Dr. Eugene Sobel and collaborator, Loma Linda University neurologist Zoreh Davanipour, report that EMFs play an important role in Alzheimer's disease.[17]

People with higher occupational exposures to EMFs were three times as likely to develop Alzheimer's as those with low or no occupational exposure. The study suggests that EMFs could affect communication among nerve cells resulting in neurological diseases. Interestingly, the highest EMF exposure common to both the residential and commercial participants came from sewing machines.

MAGNETS AND THE ELECTROMAGNETIC BODY

In support of these findings, a Caltech geobiologist, Joseph Kirschvink, recently made the startling discovery that humans have internal magnets in their brains in the form of magnetite. Like pigeons, fish, and even worms, humans contain a built-in guidance system. This finding, coupled with yet another discovery: a new ferrous (iron-like) material found in each cell of the body, may provide new links between electromagnetic fields and the onset of disease.

The scientists believe that when exposed to strong electric fields, the brain's tiny magnets may re-orient themselves in some way, disrupting the normal flow of materials in and out of cells. This, in turn, affects the health and rate of activity of the cells. Because of this

interaction, certain types of therapeutic magnets may be used to heal the body. (Note: Differing methods of applying therapeutic magnets do exist, however. Problems can occur when the body exhibits an electromagnetic imbalance needing one type of magnetic influence, such as a south pole magnet, but instead, receives a north pole magnet. For this reason, it is wise to consult a health professional before using magnets for an extended period of time.)

FUTURE RESEARCH

Much debate surrounds EMF research results, which vary for a number of reasons. In the past, there has been much debate over the scientific findings. One major factor hindering epidemiological studies is the lack of an unexposed control group. (Everyone living in today's world experiences some EMF exposure.) The second factor involves specific aspects of exposure; the size of field and the length of time exposed. Parameters which constitute "exposure" must be set before consistent scientific results emerge.

Because the United States falls short of Sweden and Canada in providing solid government funding, varying study results between these and other countries will continue to differ. Hopefully, in the near future, a higher priority will be given to research for conclusive evidence of the effects of EMFs on the human body, despite the enormous challenges inherent in their design.

The public has justifiably become increasingly uneasy about electromagnetic fields. The public has a right to substantive answers!

MEASURING THE FIELD

Electromagnetic fields are measured in *milligauss*, (MG.) a unit measurement of a magnetic field. Although small, some people have been affected at a level of only one milligauss. The Swedish government indicates adverse health effects at a level of 2.0 milligauss.

A hand-held device known as a gauss meter measures the strength of the magnetic flux or magnetic field component of EMFs. It may be used to generally identify EMF "hot spots" in the home, or measure the field from electrical appliances in the home.

Another consideration to keep in mind is that the electrical appliances used in the home daily register sixty hertz or sixty cycles per second. Meanwhile, the human body is only "wired" to ideally receive maximum external input of thirty cycles per second (the same as naturally occurring frequencies of the earth) before it becomes unbalanced. That's an instant overload to the body's energetic system, which may have deleterious effects such as headaches, nausea, dizziness, allergies, rash, soft tissue soreness, or nervous system disorders which interfere with many normal body-mind processes.

New awareness, combined with some fairly simple guidelines, enables people to eliminate most unnecessary exposure to magnetic fields.

First, try to determine any existing danger to exposure by taking a careful look around your home or place of business. Make note of any obvious visual indicators: high-voltage power lines and the service drop where lines enter the home. These may need to be re-routed or re-designed. Observe sleeping areas and note the proximity of electrical products or appliances. Check out living and work areas. Determine any unnecessary electrical appliances currently turned on but not in use. For example, be sure to make note of fluorescent lighting both above your head and below your feet on lower floors.

Second, contact your local utility or professional EMF testing company to request that they measure the EMFs in your home or office. They should conduct a thorough audit and provide you with a written record. Or, you may want to purchase your own gauss meter. Because field strengths change, you may want to use your own gauss meter to check more frequently, while traveling, or in the event of a move. Also, your local utility is unlikely to provide you with any health information.

Gauss meters may be obtained through many different companies. HOME SAFE, Inc., of Santa Clara, CA, offers a simple consumer device. (See the Product Guide in the Appendix for specific information on purchasing this device.)

While gauss meters prove quite reliable in testing silent, invisible EMFs, only Clinical Kinesiology can uncover an *individual* response to electromagnetic pollution. Begin to utilize Clinical Kinesiology testing as outlined in the self-testing portion of this chapter to determine EMF effect on each individual body.

Once the intensity of a magnetic field is determined by a gauss meter, or weak muscle test confirmed, move away from the source or rearrange any appliance in use to increase the distance between yourself and the EMF source. Keep children away from EMF sources and never allow them to play directly under power-lines or near transformers. Reduce time spent in any EMF field by turning off computer monitors and unplugging other appliances when not in use; or run them (such as a dishwasher) when you are not at home.

"Prudent avoidance" of electromagnetic pollution is the technical term coined by Pittsburgh's Carnegie Mellon University researchers to describe a no-cost method of reducing exposure to EMFs. However, "prudent" avoidance for one person may prove totally unacceptable for another. When in doubt, seek out professional Clinical Kinesiology evaluation and holistic treatment through acupuncture, homeopathy, and magnet therapy to monitor and rebalance the body's internal electrical system.

Drastically altering one's lifestyle by giving up the comfort and convenience of all electrical appliances still won't provide the complete answer. However, gaining new awareness of the EMF problem and taking a few simple and effective steps to reduce exposure remains to the body's utmost benefit.

ENVIRONMENTAL TESTING

Professional environmental surveyors like Michael Riversong of Qi Consulting, Cheyenne, WY, and Industrial Kinesiologist, Ken Lesser of Advance Living Technology, Denver, CO, can be contracted to go into homes and offices to conduct an environmental audit and recommend solutions. (See Resource Guide.) Some will even offer products designed to help rebalance excess EMF energy.

The nature of electromagnetic fields that these consultants evaluate invariably prove complex. Electromagnetic fields interact with one another. Not only that—they change with the amount of current, which is also constantly changing. (For example, air conditioners draw a large current in the summer causing EMFs to rise.) These complex interactions make determining the extent of exposure more difficult.

An electric current generates a magnetic field. Conversely, a magnetic field will generate an electric current. When current flows,

an electromagnetic field results. Electric and magnetic fields normally exist together. However, most health studies associate the magnetic field with the more severe adverse health effects. Electric fields behave differently and also have different effects on the body.

Sometimes, EMFs emit a low electric field and a high magnetic field, while other times the reverse is true. Computers prove especially interesting this way. Many older computers put forth a low magnetic field and a high electric field. However, the newer the computer the less likely it emits any risky field because manufacturers, of late, have become extremely conscious of EMF pollution.

Electric fields are not robust and can be easily shielded by walls or trees. Magnetic fields, on the other hand, can pass unimpeded through nearly everything—even lead.

Life is not merely to be alive, but to be well.
MARTIAL

As EMF consultant Michael Riversong reports, "Most people spend nearly a third of their lives in the bedroom. In fact, most don't even spend that much time in one spot at work."[18] Not surprisingly, most environmental testing concentrates on one specific room in the home—the bedroom. One quick, effective way to safeguard the bedroom from electromagnetic pollution involves turning off electrical power to any circuits near the bed.

During evaluations, Riversong routinely tests fluorescent lights at 90 milligauss or more. Without exception, the closer the proximity to the source of the electromagnetic pollution, the stronger the milligauss readings—and the further away, the weaker.

Jim Butler, President of HOMESAFE records a striking example of EMF pollution. A man standing under transmission power lines is photographed holding a regular fluorescent light bulb. Although it is dark outside, the photograph shows that the fluorescent tube is illuminated. The resulting light is bright enough to read a book—powered only by invisible electromagnetic fields. The photograph is further evidence of the power of electric currents flowing through the air.

DANGER: MICROWAVES

The electromagnetic spectrum depicts the organization of electromagnetic fields based on their frequency (of oscillation). The spectrum is divided into regions including extra low frequency (ELF), very low

frequency (VLF), radio frequency (RF), microwave, infrared, visible light, ultraviolet (UV), X-rays, and gamma rays.

Hertz (Hz) designates the frequency of electromagnetic radiation in cycles per second. Sixty hertz equals sixty cycles per second. The next higher frequency band is Kilo Hz (1,000), followed by Mega Hz (1,000,000) and Giga Hz (1 billion). An extremely low frequency ranges from zero to 3,000 cycles per second. As mentioned, the human body operates up to 30 cycles per second.

Although humans thrive in natural frequencies from the earth at zero to 30 Hz, the vast arrays of EMF frequencies now dominating the earth are human made. Frequencies which oscillate around a billion cycles per second, are designated as microwaves, a level considered extremely harmful.

Microwaves consist of extremely concentrated beams which may be pointed in specific directions. If they should happen to be concentrated through people's living rooms, they could prove quite harmful. Therefore, current guidelines for regulating microwaves include transmission only in "line of sight" and never through buildings. When microwaves fall out of these bounds, regulators should be notified.

The higher the frequency, up to infrared, the more dramatic effect microwaves have on certain individuals. "Microwaves can and do cook people's internal organs," Qi Consulting's Michael Riversong warns. However, he adds, "Fortunately, the level at which that happens is extremely high and very unlikely."[19] Few people are ever exposed to such a high level of microwaves.

Still, the dangers exist. The former Soviet Union was discovered to have been beaming extremely high intensity microwaves at the American embassy in Moscow for many decades. Columnist Jack Anderson broke the story in 1972, followed by further coverage by *The Boston Globe*. Far above safety standards, the Russians reportedly concentrated microwaves at the embassy twenty-four-hours-a-day to partially de-activate bugging devices.[20]

In 1976, *The Boston Globe* reported that Ambassador Walter Stoessel had developed a rare blood disease similar to leukemia. Two of his predecessors also died of cancer. In addition, about a third of the Moscow staff showed abnormal white blood cell counts.[21] A health investigation of American embassy personnel around the world followed. However, no public result or finding was ever acknowledged.

Fortunately, few people will ever be exposed to such high levels of microwaves on a daily basis. Often, even these can be blocked. Simple experimental procedures utilizing aluminum foil have been effective in safely blocking microwaves at certain frequencies. However, more research and experimentation is needed before the effects of microwaves can be completely understood.

EMFS AT HOME

Professional surveys of electromagnetic pollution indicate certain home appliances and devices are more problematic than others. Can openers often measure as high as 1500 milligauss. Hairdryers emit about seven hundred milligauss and electric razors have been known to register as high as one thousand milligauss during testing. Recently, an EPA manual singled out hand-held electric hairdryers and electric razors as especially unsafe due to the daily use and length of exposure.[22]

Cable TV is also suspected of leaking electromagnetic pollution. Many cable companies install amplifiers on certain cable parts which, from time to time, have been known to leak. Fortunately, Cable TV installations are usually far enough removed from sleeping areas as not to constitute major problems. Cable TV converter boxes may be another story, however. CATV converters and active broadcast satellite dishes (not to be confused with passive home satellite dishes) emit huge magnetic fields.

Some additional "hot" electromagnetic fields to watch out for include microwave ovens, the backs of "instant-on" TV sets, computer printers, water bed heaters and electric blankets.

Wertheimer's study of electric blanket and water bed users proved that seven or eight hours of exposure while sleeping continually bombarded the body with an excessive dosage of electricity for that period, resulting in greater risks for illness or disease.[23]

Again, prudent avoidance of electrical appliances in operation suggests remaining three to five feet from the equipment to lessen the risk of exposure.

EMFS AT WORK: COMPUTERS

While modifications in the home may be fairly inexpensive and controllable, the workplace may prove otherwise. The length of exposure to home or office computers remains important. Some tips to follow in the workplace:

- Routinely get up and move about the office area every half hour.
- Attempt to stay at least twenty inches from any computer monitor screen.

Now I see the secret of the making of the best persons. It is to grow in the open air, and to eat and sleep with the earth.
WALT WHITMAN

Surveys indicate that a majority of the electromagnetic pollution generated from computers may be found emanating from the CRT's power supply. As a result, more EMFs may be emanating from the back or sides of the monitor than from the front. When operating a computer it's advisable to:

- Move the CRT power supply approximately five feet away from office chairs.
- Remain at least three feet from the backs and sides of co-workers video display terminals (VDTs) or computer monitors.

Based on their findings in epidemiological studies, the Swedish government implemented stricter requirements for its nation's sale of video monitors. The Swedish MPR II standard now prohibits monitors from emitting more than 2.5 milligauss at approximately twenty-one inches from the VDT surface. The MPR II has become the *de facto* standard in the computer industry worldwide.[24] The Swedish government is cited most often in studies of electromagnetic fields because, among world governments, they remain the pioneers in setting standards in the area of electromagnetic pollution.

THE MRI

One of the newest medical diagnostic machines, the MRI, or magnetic resonance imaging device, may prove to be one of medicine's most dangerous in terms of electromagnetic pollution. Roughly 4.3 million MRI tests are done each year by a machine that produces the highest magnetic force humans have designed to date.

Magnetic Resonance Imaging machines may be helpful in evaluating critical situations using high levels of electromagnetic radiation. When the diagnostic need arises, however, the vast majority of these tests, in my opinion, *aren't* critical. Obtaining specific information at the risk of such close-range electromagnetic exposure to the body simply cannot be justified!

So far, few studies have been conducted and it's not likely that any forthcoming medical journals will report on any long-term health problems which developed as a result of people receiving MRIs. No, the MRI is such a new innovation that longterm health consequences won't be uncovered for several years. Initially, medicine first needs to recoup its investment from those machines. A top-of-the-line MRI system can cost upwards of 2.5 million dollars. MRI facilities need to perform a great many tests at $800 to $2000 each in order to cover such an investment. The old idea that modern medicine must be a money-making venture is regrettable. Hopefully, that mode of thinking will change in the future. So, in critical cases—the MRI? Yes; however, take caution and weigh all the options before having the test done.

EMF ILLNESSES

What steps can you take if you suspect that you're being over exposed to electromagnetic pollution? According to Robert Becker, there is a growing population of people who are "highly allergic" to electromagnetic fields.[25] Becker cites that continued exposure may also lead to Electromagnetic Hyper-Sensitivity Syndrome, Chronic-Fatigue Syndrome, SIDS (Sudden Infant Death Syndrome), and changes in preexisting diseases such as HIV, Alzheimer's Disease, Parkinson's Disease, cancer, and other mental illnesses.[26]

Many people complain of health problems that are non-specific in nature. They often brush aside symptoms that mysteriously come and go. With no single organic cause identifiable, medical doctors can't help. After numerous tests and examinations, most doctors finally conclude, "It's all in your head." That may be the clue to suspect an electromagnetic imbalance in the body.

Symptoms of electromagnetic imbalances include:

- headaches
- nausea

- dizziness
- irritability
- muscle and joint stiffness
- rash
- mental anxiety
- depression
- chronic fatigue, and other problems

Women, especially, suffer unique reactions affecting menstrual or hormonal cycles which can be traced to electromagnetic pollution. In general, people have varying levels of sensitivity depending on the overall strength of the immune system.

Multiple sensitivity syndrome often results from electromagnetic pollution compounded by exposures to other dangerous environmental or chemical substances called exotoxins. Environmental exposure, a precursor to multiple sensitivity syndrome, may involve severe reactions to any number of exotoxins including heavy metals such as mercury, cadmium, aluminum, arsenic or lead.

Other environmental dangers include chemical hydrocarbons, pesticides, herbicides and thousands of new substances introduced into the environment over the last seventy or eighty years with the advent of the petrochemical age. These toxins, along with electromagnetic sensitivities, may result in near total immune system breakdown for some individuals. From there, some people have no future resistance to any other chemicals or electromagnetic fields.

Many doctors haven't updated their education adequately enough to recognize the rising cases of environmental illnesses now in evidence. This cluster of unique symptoms can be puzzling and aggravating to its victims because most doctors aren't even aware they exist. Many times, without specific energetic testing, it's difficult to determine if one suffers from multiple sensitivity syndrome.

DEBORAH'S STORY

Deborah, the receptionist at a local insurance office, suffered multiple health problems over several months with no apparent organic cause. Her doctors couldn't put a finger on the precise cause of her illnesses.

Then, during a series of electric field measurements of her office, high levels of pollution in excess of thirty volts per meter (a measurement of the amount of force in an electrical current) were found emanating from her electric typewriter, *while it was turned off!*

Deborah switched the typewriter "on" during testing, and the level mysteriously dropped to eleven volts per meter. Still ten times stronger than the human body's one-half to one volt per meter, the reading proved somewhat better than when the typewriter was turned off.

According to Qi Consulting's Michael Riversong, this phenomena occurs many times with machines such as electric typewriters, which house an energy center called a transformer. A small black box radiating huge amounts of electromagnetic energy, half the transformer is energized, the other half is not. By definition, all transformers waste energy. The wasted half of the current then radiates out as an electromagnetic field.

The more serious the illness, the most important it is for you to fight back, mobilizing all your resources—spiritual, emotional, intellectual, physical.
NORMAN COUSINS

In Deborah's case, Riversong recommended she plug the typewriter into an outlet strip, which enabled her to turn the typewriter on and off with her foot. This simple measure assured that the current would be contained to a safe area, rather than being diverted through the transformer to Deborah's body.

Other appliances which often carry a transformer include desk calculators. Most have a thin cord attached to the back, leading to the transformer which is often plugged in *next to a person's feet*. The only good news? In such small transformers the electromagnetic field falls off within a foot or two.

Take caution. The next time you're in the office, look around your workspace, above your head and down at your feet. You may be surprised by what you find. Making a few simple alterations may go a long way in preventing exposure to electromagnetic pollution and serious illness in the long run.

STANDING YOUR GROUND: CLEANING UP ELECTROMAGNETIC POLLUTION

Begin to look for ways to minimize exposure to electromagnetic fields that you can control at reasonable cost, effort and convenience. Several small instruments designed to balance and "clean up" electricity in a general area are now available to consumers.

The Clarus Clear Wave unit, the same EMF-clearing device used by my co-author, Carol Lehr, to protect her from harmful electromagnetic pollution in her television station office, and the stronger Ally II Professional represent two of the numerous instruments manufactured in the United States by Clarus Personal Energy Systems. Currently marketed internationally by Advanced Living Technology of Denver, Colorado, the units reorganize electromagnetic fields in a way that neutralizes harmful EMF stress effects on the human body. (See Product Guide.)

These devices also help promote a calm atmosphere, reduce stress, and diffuse or "re-wire" the negative influences of electromagnetic pollution. The same company also manufactures a pendant, a portable system and other protective systems which clean up electromagnetic pollution.

Dr. William Tiller, a thirty-year Stanford University researcher and acknowledged expert in the area of subtle energy, conducted research and development experiments on the quantum physics of the technology. Tiller confirmed the positive effects of the Clarus's EMF clearing devices by tracking improvements in heart function during EKG testing.[27]

Environmental kinesiologist Ken Lesser believes that electromagnetics, in and of themselves, may not necessarily prove harmful. He contends, "What's been discovered is that the electricity which flows through high-voltage power lines and electrical lines in a house, through the lighting and all the electrical instruments creates an electromagnetic field which *is* disruptive to the body."[28] That disruption manifests in different forms of stress, muscle aches or pains, fatigue, unclear thinking and irritability.

While there may be no simple way to influence the quantity of EMFs, Lesser believes one can influence the "quality" of the EMFs, thus changing the effect on the body. He illustrates the following example: Imagine a friend arriving at a party in a bad mood desperately in need of cheering up. Essentially, these clearing devices put EMFs in a "good mood." The energy, just like that friend, becomes healthier for everyone to be around. In return, a more energetic balance is retained within the body, and other more subtle health problems may begin to subside.

Anyone suffering from an electromagnetic imbalance may notice a difference by plugging in the Clarus unit or other EMF-clearing

device. Often, the healing effects are noticed in little more than three to five days. At present there are three categories of unique EMF-clearing devices on the market. The first category neutralizes biological stress in humans arising from electro pollution. The second restores live performance quality to recordings, and the third allows individuals to sustain special inner states of consciousness. Only two manufacturers currently design EMF-clearing devices for the home. (Refer to the product guide at the end of this book for more information.)

TESTING EMF-CLEARING DEVICES WITH CLINICAL KINESIOLOGY

With fluorescent lighting, wiring, or other invading appliances, EMF-clearing devices help combat electromagnetic pollution at a safe and economic level.

Clinical Kinesiology energetic testing can help determine which electrical appliances currently "over AMP" the body (along with designating the best room in which to place an EMF-clearing device). Conduct your own sample test utilizing a hand-held hairdryer in the following manner:

Step 1: First, plug any hand-held hairdryer into a convenient electrical socket and turn it on.

Step 2: Holding the hairdryer, use Clinical Kinesiology energetic muscle testing to determine if the hairdryer's electromagnetic field weakens an indicator muscle.

Step 3: Turn off the hairdryer and plug an EMF-clearing device into the same outlet as the hairdryer and wait five minutes to allow the clearing device time to activate.

Step 4: Retest the indicator muscle to determine the strength or weakness of the indicator muscle while the hairdryer remains in operation.

The arm test will result in the muscle being fully strong or noticeably stronger with the EMF-clearing device than in the unprotected state. If you find no difference, the EMF-clearing device is not working, or it wasn't given enough time to become activated.

ELECTROMAGNETIC POLLUTION TEST

External, as well as internal information, which the body coordinates, controls, and evaluates may be "displayed" for diagnosis through Clinical Kinesiology muscle testing. To check the body for electromagnetic pollution, enlist the help of a partner/tester to perform specific tests as the individual being tested stands in close proximity to various appliances while they are in operation.

Because incompatible electrical outputs do affect the body, Clinical Kinesiology testing allows individuals to "read" this information, act upon it, and make needed health changes. Testing determines, quickly and easily, any incompatibility of electrical appliances with the electromagnetic body.

Before proceeding with any Clinical Kinesiology muscle test, be sure to first determine the strength of the test-subject's indicator arm muscle. (See Chapter One for instructions.) Following confirmation of the indicator muscle strength:

Step 1: Choose any electrical appliance such as a computer screen, television screen, microwave oven, hairdryer, electric razor, satellite dish, or fluorescent light.

Step 2: Have the test-subject stand approximately one foot from the appliance, which is turned on, and look at the item to be tested.

Step 3: Perform the muscle test.

Step 4: If the test subject's indicator muscle goes weak, the electrical appliance *is* incompatible with his or her body *at this distance.*

Perform the test at distances from close range to many feet away. At some point, the negative energetic effect on the body will begin to drop off, enabling the individual to eventually complete a strong muscle test. Without EMF protection, different individuals may need to keep their electrical appliances at varying distances to insure safe exposure to the electrical field.

❁ ❁ ❁

Consistent overexposure to electromagnetic pollution may be suspect when symptoms reach a certain level of degeneration. The manifestations of EMF pollution can be subtle and varied. Progressive symptoms for which no solution can be found may result from

a case of high level EMF exposure. Many times, after relocation to a new home or office some individuals quickly develop unusual illnesses or exacerbation of an ongoing problem. In that case, EMF pollution is often suspect. EMF exposure typically aggravates the weakest area of the body depending on the individual. For example, someone who uses a computer daily may have significant eyestrain that is much more pronounced than if he or she was simply reading a book. The eyestrain may be more severe and much harder to recover from. The same hours working at a computer versus reading a book will manifest differently simply because of the EMF factor.

While there are many ways to intervene on your own, you must see a trained natural health or Clinical Kinesiology practitioner when you are totally baffled about worsening symptoms and health problems or clearly see health deterioration connected to environmental changes in your life.

Gaining new awareness of your own electromagnetic body and its sensitivities prepares you to make subtle changes. If you accept the hazardous realities of this unseen new health threat, you will be motivated to take the steps you can to avoid it. Your reward will be improved physical and emotional function, and strengthened body energy.

In our exploration of electromagnetic pollution, we have examined a specific quality of energy relating to electrical cycles. Part Three of this book is specifically devoted to the health of the male and female energetic systems, which interestingly enough, maintain their own individual body and life cycles. Chapter Nine: *Premenstrual Syndrome* addresses solutions for women with pre-menstrual syndrome through natural balance of these unique energetic cycles.

CHAPTER EIGHT SUGGESTED READING

Becker, Robert M.D. and Selden, Gary. *The Body Electric: Electromagnetism and the Foundation of Life*. New York: William Morrow and Co, Inc., 1987.

Becker, Robert M.D. *Cross Currents. The Perils of Electropollution, The Promise of Electro-Medicine*. Los Angeles: Jeremy P. Tarcher, Inc., 1990.

Brodeur, Paul. *The Great Power-Line Cover-Up: How the Utilities and the Government Are Trying to Hide the Cancer Hazards Posed by Electromagnetic Fields*. New York: Little, Brown and Company, 1993.

Eisenberg, David M.D. and White, Thomas Lee. *Encounters With Qi, Exploring Chinese Energy*. New York: Viking Penguin, Inc., 1987.

Gerber, Richard M.D. *Vibrational Medicine: New Choices For Healing Ourselves*. Santa Fe: Bear and Co., 1988.

Payne, Buryl Ph.D. *Helping Your Body Heal With Magnetism: The Body Magnetic*. Santa Cruz, CA: Psycho Physics, 1991.

Pelletier, Kenneth. *Longevity: Fulfilling Our Biological Potential*. New York: Delacorte Press, 1981. p. 161.

Pinsky, Mark A. *The EMF Book*. New York: Warner Books, 1995.

Tansley, David O. *Subtle Body Essence and Shadow*. New York: Thames and Hudson, Inc., 1984.

The Female
and Male
Energetic Systems

9

Premenstrual Syndrome

As Lou Anne stooped to pick up the morning paper from her leaf-cluttered driveway, a wave of dizziness overtook her body. Weak and lightheaded, she tenuously clutched her way back into the house and immediately dialed her local woman's clinic.

For several months Lou Anne had coped quietly with her premenstrual symptoms (PMS), enduring the pain and hoping it would eventually subside. Now, the heavy periods and dizzy spells seemed to be worsening with no relief in sight. After the incident in the driveway she wondered if perhaps she'd waited too long.

Lou Anne fidgeted nervously in the clinic waiting area. Finally, a triage nurse beckoned her into a small, sterile room and questioned her briefly about her symptoms. Then the doctor arrived. Within minutes and with no examination and little consultation, a prescription for a synthetic progesterone hormone was thrust into Lou Anne's hand. "Take this for one year," the doctor ordered, "...after that, you'll probably need a hysterectomy. Come back and see us if you have any more problems."

Lou Anne left the clinic in tears.

If you want to know the secret of good health, set up home in your own body, and start loving your-self when there.

JOHN W. TRAVIS, M.D.

Like Lou Anne, many women suffer both physical and psychological symptoms of PMS, yet have found few avenues of treatment offering more than chemical drugs or surgery for premenstrual problems.

This chapter seeks to alter perceptions of the standard accepted medical treatment of PMS. Instead of uncaring or uneducated physicians, unnecessary surgeries, synthetic hormone replacement therapy and tranquilizing medications, it offers new hope and healing to women, recommending safe and simple holistic methods such as Clinical Kinesiology energetic testing.

Readers will be urged to consider that the true "cure" for PMS can be achieved *only by treating the "total" body.* In evaluating previous treatment, assessing symptoms and therapies, Clinical Kinesiology diagnosis and treatment provides lasting improvement through rebalancing the body's organ and hormonal systems, allowing each to heal itself naturally.

This chapter further presents simple healing measures involving diet, nutrition, detoxification, and acupuncture which allow the female energetic body to develop increased energy and functionality. With implementation of simple suggestions, women can *rediscover* a menstrual cycle originally designed to be easy and effortless.

You will learn about little known organ relationships, such as the thyroid/uterus connection, which illustrate how these organs work in tandem to balance the entire female system; and how surgery on any part of the female anatomy, *always* compromises the rest of the system.

Included here is a PMS test which will allow you to identify symptoms and determine specific body imbalances through classifications of the four PMS Types.

Step-by-step Clinical Kinesiology self-testing will be presented to provide important clues to evaluating *current* organ imbalances. Finally, I will share some valuable advice on additional natural therapies such as herbs, nutrition, homeopathy, and acupuncture.

LOU ANNE'S EVALUATION

Lou Anne angrily threw the prescription for synthetic progesterone in the trash. The same day, she underwent a Clinical Kinesiology

evaluation which indicated that both her uterus and thyroid were out of balance and in dire need of treatment.

During treatment, other revelations presented themselves as part and parcel of Lou Anne's physical problems. They included sudden new remembrances of sexual abuse that had occurred many years before.

Acupuncture treatment rebalanced Lou Anne's uterus and thyroid, and specific homeopathic Neuro-emotional remedies dealt with the PMS on an emotional level. Through Clinical Kinesiology testing, Lou Anne's "true" problem slowly emerged as she began to see a clearer connection between her "total" body disorder (which included PMS), and the long-buried sexual abuse.

SEXUAL ABUSE AND PMS

Studying clinical case histories of a number of PMS patients, it is clear to me that women who experience a high degree of PMS are more likely to have suffered some type of sexual abuse in childhood. Any woman who suffers from PMS should question whether this issue applies in her case.

Though unapparent to the conscious mind, abuse victims often repress these experiences in the body—specifically, in the female organs. Because PMS manifests from both psychological and physical problems, many times the unconscious mind needs additional healing. With treatment, psychological or physical abuse may be brought to the surface and released. The good news? Most women can be helped to move beyond limiting or repressed thoughts affecting their physical well-being.

TOTAL HEALTH FOR THE TOTAL BODY

Clinical Kinesiology energetic testing uses the body as a simple feedback system to confirm, "Yes, a problem exists in the uterus, or glandular system." However, in relation to PMS or other menstrual disorders, the body is really saying, *PMS is a total body problem.* Recognizing PMS symptoms may be the first indication that the female energetic system is not totally in balance.

The problem of an imbalanced system didn't start yesterday—many individual factors have been at play for years to cause this situation. However, once the primary imbalance is understood through Clinical Kinesiology evaluation, one can move into the specifics of attitude, diet, lifestyle and the need for supplements or treatment.

Upon learning about "total" body imbalances, some women may feel rather uneasy, bewildered and somewhat frightened, "Gee, I thought I had PMS," they say. "Now, I've discovered I have a liver imbalance, a dysfunctional uterus or an unexpressed emotional trauma that has stifled an organ."

Love cures people, the ones who receive love and the ones who give it, too.

KARL A. MENNINGER

All health problems, including both physical and emotional, stem from "total" body problems. That's why it's important to support all organs and glands in obtaining their most normal function.

Rest assured! *The discovery of that organ/energy imbalance is the important thing.* It's better to make early discoveries and begin treating and rebalancing the organ or gland, than to dwell in confusion and uncertainty about the causes of PMS.

SURGERY IS NOT THE ANSWER

In Lou Anne's case, even though her doctor gave her a prescription for hormones he obviously didn't believe in his own treatment. Otherwise, a hysterectomy would never have been mentioned until much later. Or, is it possible that Lou Anne's condition was something her doctor had seen with so many other women that he simply systematically programmed Lou Anne for a hysterectomy in the same fashion?

Once surgery is performed on one part of the female system, the synergy of the female organs becomes so out of balance that, many times, the problems compound until another surgery may be required...and another. This downward cycle affects so many women.

The underlying symptoms that initially lead most women to undergo surgery for female disorders are the first warnings of a serious imbalance in the "total" body. Whether someone experiences PMS, other menstrual disorders, complications from tubal ligation, endometriosis, or hysterectomy—virtually all these conditions stem from imbalances in the body's glandular system and uterus. Undoubtedly, the uterus is

not functioning correctly and its communications to various other organs and glands have broken down.

Naively, surgeons think, "Remove the uterus...remove the problem." *Instead, all they succeed in doing is taking out the focus of the worst symptoms.* So, yes, there may be some relief at first, but often only partial relief. Many women continue to suffer the same symptoms, and just as many mood swings, as before their surgeries. Some women develop worse problems, but may not realize where they originated.

ORGANS IN TANDEM

Organs that control body functions in the female energetic system work in tandem with one another to maintain homeostasis in many ways.

The hypothalamus, controller of many body functions, is located in the brain about mid-forehead, half-way back in the skull. Directly in the center of the head, the hypothalamus lies close to the pituitary gland. From this proximity, it sends messages to the pituitary, which in turn, communicates with the adrenals, thyroid, ovaries, and uterus.

The uterus acts as a "target" organ for many different hormones. In fact, the uterus does produce small amounts of the hormones estrogen and testosterone. Following a surgery, such as a hysterectomy, the uterus cannot transmit the normal hormonal messages needed to be sent to other organs—and that "short circuitry" sets the stage for an imbalance in the body.

Uterine hormones act as messengers which return to the thyroid and serve as a feedback system to help balance the thyroid. The thyroid and uterus also work in tandem this way. So for many thyroid problems, uterine treatment may be required and vice versa.

Removal of a symptomatic organ, such as the uterus, simply means the true problem has yet to be resolved. The remaining imbalance will resurface at a later time, *as new symptoms; most likely hip, leg, or foot pain.* The uterus may be gone, but the total body imbalances go uncured.

One example which underscores the uterus/thyroid relationship involves women who previously had overactive thyroid glands removed or radiated. These women frequently develop uterine problems of one sort or another, and are directed to have a hysterectomy.

Traditionally, if one organ becomes unnaturally disturbed, the remaining organs usually exhibit more and more problems. Often, surgeons then want to remove the second organ...and so on. This downward cycle happens so often with the uterus affecting the thyroid.

HORMONES FOR THE TOTAL BODY

One could not pluck a flower without troubling a star.
LOREN EISELEY

The body was designed to maintain a complete balance of health—it's own personal software system instructs the female energetic system to produce hormones, build up the uterine lining to prepare for upcoming hormonal changes, and anticipate many other functions. The body was originally created to produce all female hormones in the correct balance. Should an imbalance upset the female system, that delicate equilibrium must be rebalanced and maintained as naturally as possible. The standard allopathic medical approach recommends that if a woman becomes low in this or that hormone "...simply supplement her with the extra hormone."

The body needs the most natural conditions possible to produce needed hormones on its own and to carry out functions correctly *without unnatural chemical supplementation.* Obviously, there will be a few exceptions to this rule; however, reliance on the body's own natural hormonal system should remain the optimal goal for most women.

Many times, hormonal imbalances trigger PMS and other menstrual disorders. Stress constitutes a major factor. Anyone who suffers extreme stress puts added pressure on the adrenal glands to continually pump out more and more adrenalin.

Stress affects the whole endocrine or glandular system, which works together as one. The hypothalamus, pituitary, thyroid, ovary, and uterus represent various endocrine organs and glands that coordinate together to maintain perfect balance in the body. Each one has a part to play. Researchers have only touched the tip of the iceberg in comprehending the observable pathways by which the body's glands and organs communicate. Known hormone messages travel from the pituitary to the thyroid to the ovary. Numerous other hormonal messages can be traced, although many have yet to be discovered.

Observing the body's software system, one can see how each hormone relates to another, or how one stimulates the production of the other. These interactions merely provide the beginning clues to uncovering instances of hormonal communication breakdown. Understanding how wrong messages are sent becomes the impetus for helping the body's glandular systems begin normalizing.

MESSENGER HORMONES

The formation of any hormone requires that a "messenger" hormone first be produced. For example, imagine mailing someone an invitation to a party. The invitation states all the information needed to guarantee a response from a prospective guest. When that guest receives the invitation, he or she naturally responds, often by buying a gift, bringing a dessert, or dressing in a certain manner.

Messenger hormones elicit similar responses in the body. In response to instructions, they produce more of one specific hormone, stop production, or change the chemical content of a needed hormone. Once a messenger hormone delivers its message, it circulates on through the blood and travels to the liver, where its molecular components are broken down and recycled.

Many times a day, the liver must reconjugate or recycle hormone messages. In order to prevent hormone messages from being continuously delivered to the same organs twenty-four-hours-a-day, the liver must stop and start. In this way, the liver employs a system of checks and balances to maintain proper functioning in the body.

Another function allows the liver to save and recycle a large number of the components from each messenger hormone to be utilized again and again. For example, if the thyroid has been running full speed for a certain amount of time, and the body software determines, "It's time to let the thyroid slow down," the pituitary will then produce a messenger hormone that travels to the thyroid and delivers the word, "Slow down for awhile."

The body's complicated hormone circuitry can become broken down in any number of ways. The most common way hormone activity becomes unbalanced and counterproductive involves liver function. A congested or dysfunctional liver cannot break down or recycle the messenger hormones. Messages prevented from getting

through may then "short circuit" the thyroid/uterus connection—resulting not only in a continuation, but an escalation of PMS symptoms.

The same message begins circulating over and over, like a dull needle caught in the groove of a broken record. Although the correct message may have been sent, the liver may be too busy or congested to handle the workload. The messenger hormone then has no alternative but to return to the original organ and deliver the same message *repeatedly*—when, in fact, the body doesn't really need or understand that particular order. The message ultimately ends up taking the body out of balance.

ESTROGEN AND PROGESTERONE

Nature meant woman to be her masterpiece.
G.E. LESSING

Two of the most important hormones that become out of balance, in relation to PMS or menstrual disorders, are estrogen and progesterone. Once again, *the body knows* how to regulate estrogen and progesterone if supplied the correct tools—proper diet, lifestyle and environmental factors. When diet, lifestyle and environmental factors are monitored, organs of the female energetic system such as the ovaries, uterus and thyroid will be less dysfunctional. However, if PMS still occurs, the organs may need further evaluation and treatment. Ultimately, the cases of health-conscious women will be more manageable in the long run than those of women who live a less healthy lifestyle.

In addition to nutrients, diet change and adjustments, acupuncture may be used to rebalance the energy of the ovaries, uterus and thyroid, allowing them to take over and regulate estrogen and progesterone levels more adequately. When that *doesn't* happen, women may become prone to mood swings during their menstrual cycle, stemming from imbalances of estrogen and progesterone hormones.

The level of progesterone affects the level of estrogen and vice versa. If the body is low or high in one form or the other, the related hormone also becomes unbalanced. Too much estrogen may lead to feelings of anxiety, while depression results from the production of too much progesterone. However, simply because someone becomes anxious or depressed, prescribing a synthetic hormone to balance the situation is not the answer! In fact, synthetic hormone supplementation often results in the opposite effect.

Other imbalances of the estrogen hormones may trigger certain types of hypoglycemic reactions. Estrogen naturally lowers blood sugar, while progesterone raises it again. Often, with high levels of estrogen, women begin to experience hypoglycemia or intense food cravings. When this imbalance occurs, many doctors wrongly prescribe even more estrogen. In my experience, the real probability is that the patient needs more progesterone.

Natural Progesterone

Natural progesterone cream or tincture, produced from the wild yam root of South America, rebalances natural hormone levels and may be effectively used by women who want to avoid synthetic hormones. The cream provides a good alternative for women with PMS, difficult periods, pre-menopausal symptoms or as a preventive therapy for early signs of osteoporosis. Women who experience any or all of these symptoms benefit from this pure and natural progesterone cream, which is quite different from synthetic hormone replacement therapy.

Recommended usage of wild yam root cream is ¼ or ½ of a teaspoon rubbed directly into the skin. Most times, the body fully absorbs and accepts the cream as if it was any natural progesterone. As with any natural treatment, each individual body determines whether or not the wild yam root cream is appropriate through Clinical Kinesiology testing. Before using any supplementation, be sure to test the product in the energetic field of the body to be sure of compatibility.

Although one patient, Dina, felt comfortable using the wild yam root cream, during Clinical Kinesiology testing her body indicated that it was unacceptable for her. Eventually, following successful treatment and rebalancing of Dina's liver, she may be able to use the cream. Until that time, however, she must seek a different route.

Estrogen Replacement Therapy

Synthetic estrogen replacement is continually touted to masses of women by their doctors. "Let's just try it for awhile and see how it works," is the tact most medical doctors take. The results may be disastrous, however.

For years, Alice lived a healthy lifestyle, adhered to a basic organic diet, maintained a regular exercise schedule and had preventive

checkups. Nearing age fifty, she gradually began noticing recurring hot flashes and other vague symptoms of menopause. Her medical doctor immediately prescribed an estrogen replacement drug. Within a year, Alice developed breast cancer. Today, Alice believes she can offer no other explanation for her cancer than the introduction of synthetic estrogen into her body. After years and years of a pure, healthy lifestyle, she felt that her body simply could not tolerate the strong, unnatural hormone.

Alice's story is not related with the intent to frighten but to warn, especially when millions of women could be potentially affected in the same way.

Ask questions! How do synthetic hormones effect the body? Will the drugs react as expected? What will the side effects be? These are pointed questions every woman needs to discuss with a doctor.

Natural Estrogen

Work, alternated with needful rest, is the salvation of man or woman.
ANTOINETTE BLACKWELL

Recently, new clinical studies have suggested that a German estrogen replacement product called *Remifemin*™ may be helpful for PMS and/or menopausal symptoms. The product contains black cohosh root. According to studies, Remifemin™ compared to synthetic estrogen has proven quite effective without unnatural side effects or other risks. [1] More information on Remifemin™ may be obtained from your natural healthcare practitioner or at your local healthfood store. By supporting the body's natural functions with proper diet and lifestyle, nutrients, acupuncture and gentle adjustments, the body can learn to self-regulate at a higher level and produce more or less of needed natural estrogen or progesterone hormones to correctly balance itself. Ultimately, successful treatment proves much more complex than figuring out whether a woman's going to use an unnatural, synthetic hormone.

OTHER UNNATURAL HORMONES AND PMS

Artificial hormones in general aren't something that most women have been made aware of mainly due to the extremely effective advertising of the American Dairy Association, Beef Council, and Beef and Poultry Boards.

Women who aren't careful about the food they buy are more likely to ingest a great deal of meat and poultry (including eggs) which contain artificial hormones.

In the course of pursuing a healthier diet, Martha decided to discontinue serving beef to her family. Unbeknownst to her, the supermarket at which she shopped sold chicken containing numerous synthetic hormones. As the family proceeded with their new found "healthier" diet, Martha's nine-year-old son, Eric, slowly began developing breasts. There was no doubt in my mind that Eric's problem stemmed from the artificial estrogen hormone in the supermarket chicken.

A well-known artificial hormone, DES, can still be found in meats in residual form. DES has contaminated the land. When ingested by cattle it shows up in beef products. Traces of DES can be found in the breast milk of women who eat beef. If you're an American and you eat beef, you too have DES in your system.

DES triggers a hormone overload in the body that inflames the entire system. So, anyone who tends to inflame or swell with PMS symptoms would do well to eat little red meat—or stick to naturally grown or organic products. Artificial hormones are the last thing you want to be feeding your body.

Meat, poultry, and eggs are not the only products which contain artificial hormones. Many dairy farmers have openly admitted to using Bovine Growth Formula, the first reported mass use of a genetically engineered product in the American food chain. The hormone is now used by more than 7% of dairy farmers.

Monsanto, the corporation that manufactures Bovine Growth Hormone, sharply opposes labeling milk products containing the drug, claiming it's impossible to tell drug-induced milk from natural milk. Two states, Vermont and Maine have become the first states to mandate labeling of dairy products from animals treated with Bovine Growth Formula. Because the drug boosts production, the economic rewards are luring more and more farmers to try it.

It's important to learn about such health hazards before they reach your body. Ensure your safety by becoming aware of standard practices so that you can make informed choices about the foods you eat.

PMS TYPES

The greatest assassin of life is haste, the desire to reach things before the right time which means overreaching them.

JUAN RAMON JIMENEZ

Total body health is dynamically tied to the health of the female system. Perhaps premenstrual anxiety, bloating, depression, and cravings classify you among the hundreds of thousands of women who suffer monthly from Premenstrual Syndrome. Often, the body provides clues that help pinpoint problem areas before they become full-blown menstrual disorders.

The following overview of the four PMS types, as researched by Dr. Guy Abraham, former Clinical Professor of Obstetrics and Gynecology at UCLA, provide classic examples of recognizable total body imbalances manifested as premenstrual syndrome.[2]

TYPE A - ANXIETY

Emotional and psychological well-being are often affected by more than just attitudes. Growing and continuing stressors in today's society affect current generations of women more than ever before. New hope for women who suffer from extreme anxiety during PMS comes with testing, diagnosis, and treatment with Clinical Kinesiology.

Type A PMS disorders manifest in fearfulness, excessive worry, edginess, insecurity, vulnerability or mood swings. Often, women with Type A PMS may exhibit persecution complexes.

Francine, for example, experiences a typical Type A-Anxiety form of PMS. During PMS, Francine often misinterprets statements from well-meaning friends or coworkers. If her boss asks to meet with her in his office, she suddenly becomes fearful. Her mind races, "Will I be fired?" At other times of the month, she realizes that routine office meetings are necessary only for simple discussions or clarification of office problems.

Francine's Type A PMS also affects her long-term relationship with her fiancé, Bill. Once a month, she becomes extremely insecure about their future together. Francine often finds herself obsessively and repeatedly calling Bill on the telephone—simply to reassure herself that he's alone at home—only to hang up! Francine also exhibits the personalities of "different people" at different times of the month.

The first question that must be raised regarding women with Type A PMS? "Is there an organ or glandular issue, or possibly a neuro-chemical imbalance in the brain?" Upon Clinical Kinesiology testing, specific homeopathic or Neuro-emotional remedies or amino acid therapies may provide help in rebalancing emotional and physical imbalances in the body and brain.

Help For TYPE A
Type A's should consistently be aware of eating the kinds of foods which help promote a calm, happy atmosphere within the body.

One basic diet-related problem stems from excess salt intake. One teaspoon of salt results in the body retaining roughly five pounds of fluid. It takes that much water to absorb the salt that has been consumed. Salt also causes water retention throughout the whole body, including the nervous system and brain. The brain literally swells, causing intense anxiety and other types of mood swings in Type A women prior to their menstrual periods.

Women, such as Francine, who suffer from Type A PMS are also more likely than others to be overly stressed. Many times, Type A PMS symptoms may be alleviated by taking such minerals as chromium, zinc, and especially B vitamins. In nearly every aspect of PMS, B vitamin shortages come into play.

Everyone needs B vitamins, due to the daily stress that often depletes them as fast as they're taken. B_6 helps alleviate PMS symptoms; however, always be sure to take B vitamins in a balanced complement, as can be found in such products as B-Complex™ by Nutri-West®; or check with your local healthfood store. Taking B_6 vitamins alone, for example, may cause the body to become deficient in B_{12}. It is best to take B-Complex as a basic helper for stress and add B_6 or B_{12} if necessary.

TYPE C - CRAVING

Many women notice unusual cravings a week to ten days prior to their period. Women who fit the classic persona of Type C PMS often experience compulsive sweet or sugar cravings and a tendency to hypoglycemia, which are magnified premenstrually. Many times these cravings are a result of the body becoming more responsive to

its own insulin during this time. The body may actually deplete its own insulin so quickly that increased amounts of blood sugar surge into the cells resulting in hypoglycemic conditions and the cravings that follow.

Once Type C's succumb to sugar cravings, the body chemistry is thrown off balance, blood sugar levels lower and headaches often result.

Skip a meal now and then — just for the fun of it.
EVERYWOMAN'S BOOK OF COMMON WISDOM.

Julie typifies a woman who experiences a Type-C Craving PMS disorder. Extremely pale, Julie's skin appears dry, exhibiting a yellow to pallor tint. During her first consultation, Julie informed me that she existed on candy. Beyond the craving stage, Julie had become truly addicted to a high sugar intake.

Coffee with sugar, soda pop, and candy were the "staples" Julie relied on for quick energy. Unfortunately, on this diet Julie was literally "burning out" her body. At PMS time, Julie's cravings were so heightened that she regularly bought bags of candy and carried them with her, keeping one at her desk, and one in her car, while continually gorging on sugar.

Many Type C women like Julie exhibit low hemoglobin levels. From all indications she does not take any chlorophyll or minerals, which are necessary sources of Vitamin A, iron and magnesium, and which regulate and build healthy body function.

Unfortunately, Julie decided not to make the necessary diet changes. She did, however, take one recommendation—a pancreas supplement to strengthen her pancreas and help balance her blood sugar. Electing to continue with her favorite diet probably means Julie will be prone to continuing PMS, difficult menopause, osteoporosis and adult onset diabetes. All these problems may be avoided if Type C's control sugar cravings and refuse to allow tastebuds to overrule logic and common sense.

Help for Type C
In a nutshell, when sugar cravings come, the worst thing a Type C can do is eat sugar. Most of the time the cravings simply lead women astray and actually indicate the need for some type of nutrient that has been excluded from the diet.

Research indicates that most women crave sugar or chocolate at PMS time. Sugar cravings also signal a deficiency in chromium or

zinc. Excessive sugar intake expends the body's stores of chromium and zinc because sugar is a refined carbohydrate and doesn't have any supplies of its own. Simply restricting sugar and processed foods, along with eating more whole grains, contributes a great deal to warding off cravings during PMS time.

Magnesium has also proven to be an important mineral in controlling water retention and cravings. Chocolate cravings usually indicate a lack of magnesium in the body. We've all been told we need much more calcium; however, interestingly enough, the body contains more protective mechanisms to retain calcium than it does magnesium. Magnesium is truly the "forgotten" mineral.

I am ill because my mind is in a rut and refuses to leave.
KAREN GIARDINO

How can Type C women provide more magnesium in their diet? Any "green" food contains a great deal of magnesium. In chemistry class you may remember studying diagrams of a benzene ring structure—a stable, six-sided hexagon.

A chlorophyll molecule is composed of the same benzene ring structure as the hemoglobin in the blood. The only difference? The center of the cholorphyll molecule consists of magnesium while the center atom of hemoglobin contains iron.

Wise Mother Nature consistently tries to match iron with cholorphyll. Dark green foods such as kale, spinach, mustard greens, beet greens, sprouts, wheatgrass and wheatgrass juice provide the body a good supply of magnesium and iron. Upon eating the dark green food, the body instantly says, "Let's extract the magnesium out of the chlorophyll molecule and use it for something else. Then, we'll replace it with iron, and build some more hemoglobin."

In *The Wheatgrass Book*, author Ann Wigmore cites a study done in 1936 in which scientists J.H. Hughs and A. L. Latner of the University of Liverpool increased the speed of hemoglobin regeneration by fifty percent in research animals by feeding them chlorophyll extracted from green plants.[3] Wigmore cites numerous experiments on animals and humans which show chlorophyll as effective in protective oxygenation and treatment in deficiencies of the blood.

Sometimes women experience excess bleeding during their menstrual periods or transition to menopause. With a greater loss of blood, more magnesium, iron and hemoglobin are needed. In essence, all women need more green in their diets.

TYPE H - HYPERHYDRATION

A woman is a creature who has discovered her own nature.
JEAN GIRAUDOUX

Out of a crowd, I can often pick women with inflammatory reactions along with PMS and menstrual disorders. Their condition often worsens around the age of forty, with some women developing noticeably blotchy red cheeks and blotchy areas around the throat and thyroid area. These women also report a general feeling of puffiness and complain of being swollen most of the time.

The tendency for hyperhydation or water retention is just that— a swelling of the body tissues. Often these Type H women are referred to as "swellers" or "inflamers." Physiologically, their bodies tend to swell or inflame more than others. Other Type H symptoms include sore, tight muscles, stiffness, and water retention.

Whenever a slight physical problem develops, it always feels much worse to an "inflamer." They experience daily swelling, premenstrual swelling, or they sustain an injury which lingers for a much longer period of time. Food sensitivities have proven to be a co-factor in most Type H women, especially those who get stiff and swell for no apparent reason.

Jeannette represents a classic case of a woman suffering from Type H PMS. Nearly eighty pounds overweight, Jeannette feels that a great deal of her excess weight results from fluid retention during her period. At PMS time, Jeannette's been known to gain ten to twelve pounds seemingly overnight.

She often complains of painful, swollen ankles. Jeanette's shoes become too tight for her feet, and the rings on her fingers immovable. In addition to this generally bloated feeling throughout the body, all her joints also become stiff.

During Jeannette's Clinical Kinesiology examinations, her hyperhydration problem became quite obvious. Significant indentations appeared as my thumb pressed into her tissue. This *pitting edema* was most pronounced in Jeannette's legs and feet. As a result, any prolonged standing further complicated her joint pain and swelling.

Through Clinical Kinesiology, Jeannette's food sensitivity evaluation uncovered extreme sensitivities to wheat and dairy foods. Once the sensitivities were indicated, an herbal detoxification was recommended to cleanse further impurities from Jeannette's system and begin the rebalancing.

Help for Type H

Figuring out foods to which Type H's are most sensitive, and restricting these foods from the diet, halts the process of inflammation in the body. Pinpointing food sensitivities may be done quickly and easily with Clinical Kinesiology testing.

Generally, women with Type H PMS should avoid salt, (even refined sea salt) or other food sensitive items which stimulate the inflammatory process. Be sure to read labels and avoid prepared soups and processed foods (including dairy foods) which contain extremely high levels of sodium. Celtic Sea Salt, which is totally unrefined and contains a natural, complete balance of ninety-three minerals does not have these adverse effects. (See the product guide in the Appendix of the book.)

Women experiencing Type H symptoms also need to avoid caffeine. Along with coffee, soda pop and certain teas, most of the popular brands of ibuprofen (under various names on the market) also contain caffeine. These drugs further inflame the body and interfere with hormone production.

B-vitamins, magnesium and natural diuretics can be safely taken by Type H women until the body is rebalanced. Some foods and herbal supplements which *temporarily* may be used include dandelion, parsley, alfalfa, fennel seed, shave grass, celery, uva ursi, potassium, and B_6. These are good natural diuretics; however, they are not meant to be used long-term.

Type H healing regimens should also include a daily dose of flaxseed oil, which remains a healthy diet choice for women who experience a great deal of swelling or hyperhydration. Natural, coldpressed flaxseed oil simply puts out the "fire" in the body. Imagine the flaxseed oil as a little fire hose dousing the body and calming down any extra heat or swelling.

I take a teaspoon or two of flaxseed oil every day at home. Quite fragile, the refrigerated oil must never be heated; however, it can be used in salad dressings or marinades if that's preferable to drinking it straight down. Pure flaxseed oil itself proves more effective than processed capsules. Always be sure to check for the date on the bottle. It's easy to store in the refrigerator or freeze it for later use. Containing the best complement of Omega 3, 6 and 9 fatty acids, flaxseed oil provides the most healthful oils, (even better than fish

oils) ever needed in the diet. The oil also contains Vitamin E and serves as an antioxidant. However, just think of it as nature's little firefighter in the body!

Obviously, Type H women should refrain from smoking. In addition to the extra heat from the inflammation, smoking simply adds heat and fire into the body. As a result, oxygen is depleted from the cells. Wherever a cigarette burns, it's consuming oxygen in the air and in body tissues.

Smoke that enters the body, coming into contact with delicate tissues, simply oxidizes or "rusts" the body. So, by stopping smoking, eating non-irritating foods, the use of flaxseed oil, B vitamins and magnesium in the diet, Type H women will go a long way in quelling the hyperhydration of PMS.

TYPE D - DEPRESSION

Extremely volatile emotions can be observed in women with Type D PMS or menstrual disorders. Many times, these emotions represent intensified reactions to everyday occurrences that normally wouldn't be bothersome in the least.

The most severe cases of Type D PMS may involve prolonged depression, self-inflicted injury or suicidal tendencies. Additional symptoms include irritability, forgetfulness, insomnia, or lethargy.

What happens to the hormones during menstruation that leads to depression? Progesterone and estrogen balances become tipped, and the resulting imbalance causes the progesterone overload to lead to depression. Women who suffer from this form of depression do not have enough estrogen to counterbalance the progesterone, so the body often needs help in producing more estrogen.

Occasionally with depression, the possibility of excess lead in the body may also be a contributing factor. Two ways of confirming excess lead poisoning are through Clinical Kinesiology muscle testing, as well as hair analysis (trace mineral analysis of the hair). Hair analysis performed by a laboratory provides measurable readings of low, normal, or high mineral concentrations inside the cells of the body. Consult a natural health practitioner for guidance in scheduling this laboratory procedure.

Andrea, an example of Type D PMS, found herself in a complex situation. Previously diagnosed with Candida, along with fear, anxiety and depression, Andrea exhibited a tendency for premenstrual

violence. The mother of four small children, she routinely became extremely depressed and virtually "out of control" during her PMS time each month.

One morning, Andrea's anger became so violent that she broke several things around the house. Further driven by uncontrollable emotions, she physically "attacked" her washing machine, which wasn't working correctly. Eventually, after many destructive episodes of Type D PMS, she became so concerned that she sent her four children away for six months for fear she would become abusive during her bouts with depression.

Clinical Kinesiology testing ultimately revealed that Andrea lacked progesterone and needed complete rebalancing of her hormonal system. With additional progesterone from the wild yam root, along with successful treatment of her Candida, Andrea eventually overcame her Type D PMS. Her children returned home and she resumed teaching piano lessons in her neighborhood.

Help for Type D

Type D PMS women need to avoid sugar and other refined carbohydrates, or strong stimulants such as coffee, soda pop and alcohol which trigger "pick me up, let me down" reactions. During depression time, rely on simple fruits and vegetables and whole grains, while avoiding any intense spices to maintain calm in the system. In addition, soy products, pumpkin seeds, and almonds prove beneficial.

Supplements which help alleviate Type D symptoms include B and E vitamins, magnesium, zinc, and amino acids as evaluated by Clinical Kinesiology testing. The amino acids Tyrosine, L-Phenylalanine and L-Glutamine are especially useful for depression, as well as liquid Choline or Choline tablets. Valerian and passiflora in herbal tincture form, tablet or combination homeopathics may be used as relaxants, as well as various brands of calming teas such a chamomile. In addition, homeopathic seratonin can be obtained from many health practitioners. Homeopathic Anti-Depression Drops are available from Professional Health Products, Ltd. Ask your health practitioner for more information.

❁ ❁ ❁

For all PMS Types, solving underlying PMS problems through Clinical Kinesiology means evaluating certain organs and glands,

treating with acupuncture, or adding nutritional support. Evaluating diet and the need for additional vitamins and supplements serve to balance the body and allow women to function normally with fewer symptoms of anxiety, craving, hyperhydration and depression.

THE LIVER: YOUR BODY'S VACUUM CLEANER

Laws of health are inexorable; we see people going down and out in the prime of life simply because no attention is paid to them!
PAUL C. BRAGG

A major contributing factor in hormonal imbalances stems from the condition of the liver. For example, think of your age today and then consider that you've been using the same liver/vacuum cleaner all these years—without ever changing the bag! Obviously, if you never attended to your ordinary vacuum cleaner you wouldn't get much carpet cleaned and you would risk polluting the air each time you switched it on.

Daily, the liver serves as a vacuum cleaner for the blood. Today's unhealthy diets, pollution, chemicals and lifestyle factors affect the liver more so than ever before. Changing those factors which you can control, like changing your diet and doing occasional internal cleansing for your liver and other organs (see description of the "liver flush" which follows), can help heal your liver along with your PMS symptoms.

Adult acne constitutes a problem that women encounter prior to or during their monthly period. Again, most acne problems stem from an overburdened liver. Call it dermatitis, excema, or whatever you want—the liver is overburdened and excreting poisons out through the skin. If acne occurs regularly during the menstrual cycle, obviously the liver is excreting certain toxins that it hasn't been able to deal with effectively.

Diet and lifestyle hold the keys to controlling adult acne and other aspects of health. However, it's extremely difficult to monitor everything breathed in the air, drunk in the water, or eaten from the land. The more carefully you plan your diet and manage your lifestyle, the better your chances of protecting your liver.

Yes! Your liver/vacuum needs a rest! Allowing the liver to function correctly by completing its hormone recycling job means giving your liver/vacuum a rest from the constant onslaught of toxic input which ultimately drags down total body function. With a few, simple changes, you can obtain lasting relief from a myriad of problems—PMS being only one.

INTERNAL CLEANSING

In many European countries, the idea of a "spring tonic" or fast has become a tradition. I once employed a woman, Elena, from Finland, who remarked that every home in her native country contained a sauna. Elena recalled wonderful memories of the saunas that she had used since childhood.

Young-looking and vibrant, Elena remarried later in life and gave birth to a baby at the age of forty, although by outward appearances she looked to be only about twenty-eight years old. Elena continued working until the final day before delivering her healthy baby.

We can learn new ways of internal cleansing which our European friends have practiced for centuries. And we can take important cleansing steps right now for future benefit. Anyone who suffers from PMS should routinely cleanse the liver. One of the simplest liver cleansers available is dandelion root, in capsule or tincture form. An additional cleanser, milk thistle, makes these two in combination a powerful liver cleanser.

The Liver Flush

One effective liver flush involves fasting from solid food and drinking only large quantities of organic apple juice or fresh-pressed apple cider for a period of three days. Women who tend to be hypoglycemic may want to dilute the juice and also eat something light each time the juice is drunk.

Besides flushing out accumulated toxins in the liver, the malic acid found in apple juice helps dissolve or soften any gallstones that may be present in the gallbladder, providing a two-fold benefit.

Anyone with suspected or confirmed gallbladder problems may also use the apple juice for longer than the three-day period. However, don't do this without guidance. Try it for three to seven days along with a light diet of organic produce, and the benefits will prove significant.

Another popular liver flush involves juicing half a grapefruit, a whole orange, and half a lemon. Toss the fruit juice into a blender along with six to eight ounces of water. Add up to two cloves of garlic, or for those who may need to be sociable during the day, a ginger substitute is recommended in place of garlic. (Quite woody, raw ginger must be cut into small pieces before blending into any

mixture.) Then, add a good quality olive oil, such as extra virgin—the purest and least processed. The goal requires starting with a small amount of oil and working up to near ¼–½ cup by the end of the flush.

Finally, mix all these wonderful ingredients together in the blender until the drink is smooth and frothy. Discard any small fibers from the ginger root that need to be separated. Drink the entire amount first thing in the morning once a day for seven days. You'll notice terrific results and obtain a much cleaner liver.

The Liver Flush
1 orange
½ grapefruit
½ lemon
6–8 oz of water
2-4-6 oz pure olive oil (gradually increase daily)
2 tablespoons cut raw ginger root or garlic

Most people do not encounter significant problems using the liver flush. However, the higher the level of toxicity in the body, the more likely the individual may experience discomfort ranging from mild nausea to gagging or vomiting. These are indicators that the body is toxic and needs some type of cleansing. Individuals who experience problems should discontinue the liver flush and work at a milder type of cleansing such as Dandelion root or Milk thistle combination capsules, tinctures or various detoxifying teas. If the liver flush is done in conjunction with a fast be cautious when reintegrating food into your system. Eat only easily digestible foods such as raw or steamed vegetables, a light vegetable soup or fresh juices. For questions or further guidance concerning detoxification, consult your natural healthcare practitioner.

Fasting

Fasting proves effective for many women; however, it is difficult for most. The bottom line? Women who aren't psychologically ready to try a fast do have other cleansing alternatives. A good, light cleansing diet of fruits, vegetables and whole grains also works well. For

those who do want a serious fast, I recommend reading: *The Master Cleanser* by Stanley Burroughs, *Juicing For Life* by Cherie Calbo and Maureen Keane, or *Juice Fasting* by Steve Meyerowitz. (See Recommended Reading for this chapter.)

One of the most overlooked and yet valuable modes of healing is the fast.

EVARTS G. LOOMIS,
AMERICAN HOLISTIC
MEDICAL ASSOCIATION

HERBAL REMEDIES FOR PMS

Throughout history, women have relied on herbs for a variety of female problems. Black cohosh root, originally a Native American root, has been used successfully to quell menstrual cramps gently and naturally. It may also be used for women entering menopause who suffer from hot flashes. This herb proves so helpful due to its effect on the thyroid. (Again, we see the interplay of uterus and thyroid, an important balancing act for control of PMS symptoms.) But, do not use the black cohosh root each month while ignoring the underlying conditions resulting in the cramps. Do use the herb (which proves much safer than a chemical drug) *while at the same time figuring out what is really going on in the body*. See your natural healthcare professional.

Another effective herb for balancing the entire hormonal system is the chasteberry. Especially helpful for the pituitary gland, chasteberry communicates with the rest of the endocrine and glandular systems.

In addition, another native American Indian herb, squaw vine, along with red raspberry may be helpful in balancing the uterus. Squaw vine is especially useful in balancing levels of progesterone, while cramp bark rounds out the list of helpful herbs that provide health for the female system in general.

Evening primrose oil, borage oil, black currant seed oil, lecithin and others have long been recommended supplemental oils for women with PMS. Taken in capsule form, the oil helps prevent diarrhea, headaches, and skin eruptions during menstruation.

ON THE PRIMROSE PATH TO HEALTH

No matter which PMS symptom complex, category or type of symptom you suffer, recognize it as the first indicator that somewhere,

something may be out of balance in your female energetic system—your diet, your hormonal or glandular system, acupuncture meridians, or your emotions which involve the neurotransmitters of the brain. Perhaps these remain the untold reasons why PMS has been no primrose path for you.

The following Clinical Kinesiology self-testing steps and PMS questionnaire provide the simplest solution in initially determining what area of the body is out of balance. The next step involves seeking out a trained natural health practitioner who is able to naturally treat underlying imbalances.

PMS QUESTIONNAIRE: DETERMINE YOUR PMS TYPE

MENSTRUAL SYMPTOM QUESTIONNAIRE

Grading of Symptoms

1	none.
2	mild-present but does not interfere with activities
3	moderate-present and interferes with activities but not disabling.
4	severe disabling (unable to function)

Grade Your Symptoms for Last Menstrual Cycle Only

	Symptoms	Week After Period	Week Before Period
PMT-A	Nervous tension Mood swings Irritability Anxiety	Total ☐	Total ☐
PMT-H	Weight gain Swelling of extremities Breast tenderness Abdominal bloating	Total ☐	Total ☐
PMT-C	Headache Craving for sweets Increased appetite Heart pounding Fatigue Dizziness or fainting	Total ☐	Total ☐
PMT-D	Depression Forgetfulness Crying Confusion Insomnia	Total ☐	Total ☐

Total MSQ Score

Adapted From: Abraham G.E.: Nutritional Factors in the Etiology of Premenstrual Tension Syndromes.
Journal of Reproductive Medicine 28: pp. 446-464, 1983.

TESTING THE FEMALE ENERGETIC SYSTEM

The following self-testing instructions may serve as a guide for further examination, for seeking more knowledge or as a preliminary check of your current health status.

Before proceeding with any Clinical Kinesiology testing, refer to Chapter One for instructions on performing the preliminary Indicator Muscle test. Following determination of base-line strength of the Indicator arm, proceed with further testing.

Hypothalamus Test

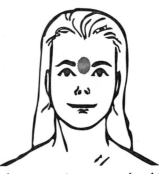

Any test of the female energetic system should begin with testing the hypothalamus. This small part of the brain serves as the master controller of all other glands and organs and directs many body regulating functions.

If out of balance, the hypothalamus may trigger erratic hunger and thirst patterns, wakefulness and sleep patterns, emotional disturbances, mood swings, memory and depression.

Test the hypothalamus by having the test-subject place the index finger directly at the bridge of the nose on the mid-line of the forehead, in the space between the eyebrows. The tester then performs the Clinical Kinesiology muscle test on the subject's opposite arm.

Hypothalamus TL + Muscle test + Strong arm = Hypothalamus balance.

Hypothalamus TL + Muscle test + Weak arm = Imbalance of Hypothalamus.

Should the test indicate the hypothalamus is out of balance, consult a Clinical Kinesiology or natural health practitioner who should be able to help rebuild and strengthen the hypothalamus function through acupuncture, nutrition, or other natural methods.

Thyroid Test

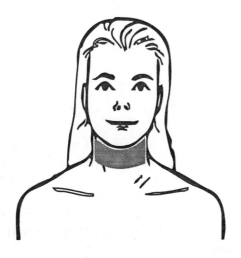

When testing the female energetic system for PMS it's first necessary to check the most relevant organs. The thyroid also plays a key role in balancing the female energetic system.

Problems with fluctuations or flow of the menstrual cycle usually indicate a thyroid malfunction. In order to test the thyroid balance, therapy localize over the thyroid by having the test-subject place an open hand over the front side of the throat, while simultaneously muscle testing the strength of the subject's opposite arm.

Thyroid TL + Muscle test + Strong arm = Thyroid balance.
Thyroid TL + Muscle test + Weak arm = Thyroid imbalance.

Follow up with a Clinical Kinesiologist, acupuncture, nutritional support and other treatment can strengthen the thyroid and change the imbalance.

Uterus Test

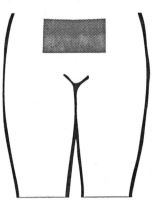

It's a good idea for any woman with female energetic problems to therapy localize over the uterus. To perform this test, the test-subject places the palm of the hand over the lower abdomen approximately three inches below the navel, while the tester checks the strength of the subject's opposite arm. Anyone who has experienced menstrual cramps or labor pains should have little problem locating the uterus.

> Uterus TL + Muscle test + Strong arm = Uterus balance.
> Uterus TL + Muscle test + Weak arm = Uterus imbalance.

Once again, a weak muscle test confirms that the uterus is energetically imbalanced. The test does not necessarily mean a fibroid tumor or any type of pathology or disease is present; simply, that a uterus imbalance has been detected and can be treated with natural measures.

Ovary Test

Following a surgical procedure, some women retain only one ovary. Unfortunately, many times that ovary becomes out of balance. In this case, ovary supplements or glandulars may help strengthen the ovaries. It's difficult to therapy localize over the ovaries because they are so small, so try to be precise.

To locate the ovaries, place both hands on the waist. Slide hands in a downward V until thumbs reach the pointed bones of the hip with the fingers touching the pubic bone. Approximately midway along that V-line you will find the ovaries.

Ovary TL + Muscle test + Strong arm = Ovary balance.
Ovary TL + Muscle test + Weak arm = Ovary imbalance.

If an imbalance is found, consult a Clinical Kinesiologist or an alternative healthcare practitioner.

PITUITARY TEST

The pituitary may be tested by placing the hand two to two and one-half inches above the hypothalamus in the center of the forehead.

Pituitary TL + Muscle test + Strong arm = Pituitary balance.
Pituitary TL + Muscle test + Weak arm = Pituitary or hormonal imbalance. Consult a Clinical Kinesiologist.

THE CHOICE IS YOURS

The goal of any treatment for PMS remains rebalancing the system in a way that enables body cycles to work well and effortlessly for the remainder of a woman's menstruation. Doing this may require acupuncture, additional nutrients, diet changes, detoxification measures or gentle chiropractic adjustments. Many self-help measures may also be implemented as far as lifestyle, exercise, or resolving emotional trauma or stress from abuse in the past. In all cases, any woman with PMS will improve simply by eating a healthier diet.

Don't leave underlying "total" body imbalances untouched by simply treating localized symptoms. Give your body what it needs

naturally and simply. It will heal itself and you will finally achieve a real solution to your problems with PMS.

Conquering Premenstrual Syndrome is an important prerequisite to a healthy transition to menopause. As the body continues through its natural balance of life cycles, finding healthful solutions to menopause remains a woman's most important goal. Chapter Ten, *Menopause*, gives women new hope and new options for meeting the challenges that lie ahead.

CHAPTER NINE SUGGESTED READING

Aguilar, Nona. *The New No Pill, No Risk Birth Control Guide.* New York: McMillan, 1985.

The Boston Women's Health Book Collective. *The New Our Bodies, Ourselves: A Book By And For Women.* New York: Simon and Schuster, 1992.

Burroughs, Stanley. *The Master Cleanser.* Auburn, CA: Burroughs Books, 1993.

Calbom, Cherie and Keane, Maureen. *Juicing For Life: A Guide To The Health Benefits of Fresh Fruit and Vegetable Juicing.* Garden City Park, NY: Avery Publishing, 1992.

Ford, Gillian. *What's Wrong With My Hormones?* Newcastle, CA: Desmond Ford Publications, 1992.

Lark, Susan M.D. *PMS: Self-Help Book: A Woman's Guide.* Berkeley, CA: Celestial Arts, 1984.

Lark, Susan M.D. *Menstrual Cramps: A Self-Help Program.* Los Altos, CA: Westchester Publishing Company, 1993.

Mendelsohn, Robert S. M.D. *Male Practice: How Doctors Manipulate Women.* Chicago: Contemporary Books, Inc., 1981.

Meyerowitz, Steve. *Juice Fasting: A Guide To Self-Healing and Detoxification (3rd Edition).* Great Barrington, MA: The Sprout House, 1992.

Ojeda, Linda. *Exclusively Female: A Nutrition Guide for Better Menstrual Health.* San Bernadino, CA: Borgo Press, 1985.

Wade, Carlson. *Carlson Wade's PMS Book.* New Canaan, CT: Keats Publishing, Inc., 1984.

Wigmore, Ann. *The Wheatgrass Book.* Garden City Park, NY: Avery Publishing, 1985.

Menopause

Sixty-year-old Vyana lives atop a 10,000 foot mountain range in Kashmir, among a village of native tribal people known as the Hunza. In Hunzaland, elderly women are revered, possess great social value and remain the center of attention in the family. All her life, Vyana has lived simply, toiled tirelessly in her village orchards, gardens, and fields. Despite her years, she has never experienced menopausal symptoms. J.I. Rodale's classic book, *The Healthy Hunzas*, and others, document the amazing physical and mental strength Hunza women demonstrate in progressing through natural life transitions such as menstrual cycles, childbirth, and menopause.[1]

How different the health and longevity of women in our society would be if they were embraced with the same love and respect for aged persons that Vyana received in the Hunza village. Until that acceptance is given, natural health processes such as menopause will continue to be a subject of dread (an occasion for anxiety, depression or pain and embarrassment) which subverts the happy, healthy longevity—not only of women, but of the cultures they live in.

SIMPLE AND EASY MENOPAUSE

Viewing menopause and other turning points in life as the simple and natural "passages" they were designed to be may require a new

sense of purposefulness for many women. Giving this healthy transition the high priority it deserves, means finding new ways of diminishing energy stress and increasing the female body's adaptability to better accommodate all body cycles throughout life's natural changes.

This chapter recommends that as with PMS, women readdress "total" body function through improving their diet and lifestyle, and by limiting daily stress. These vital modifications will lessen the chances that future imbalances will disrupt health before, during and after menopause.

Essential prerequisites to a smooth transition to menopause include:

I've been very impressed in my own practice by how much women can really modify their health problems, just by modifying their lifestyle.

SUSAN M. LARK, M.D.

- monitoring symptoms
- counteracting stress depletion of hormones
- increasing awareness of biochemical changes
- and maintaining healthy organ connections.

This chapter encourages women to avoid the chain reaction consequences of synthetic hormones while discovering new therapies which help counteract the outliving of the natural hormones which are meant to function throughout a woman's entire lifespan.

Additional recommendations include the avoidance of unnecessary surgeries, such as hysterectomies, tubal ligations and other invasive procedures, and the use of natural treatments for rebalancing little known organ systems, such as the thyroid/uterus connection.

Finally, this chapter offers new hope for women. Information about their specific health concerns is available with simple self-testing procedures utilizing Clinical Kinesiology testing, diet, herbs, homeopathy, acupuncture and gentle chiropractic. As women begin to trace the true origins of imbalances they take a major step forward on the path to health.

MARY'S STORY

Forty-two-year-old Mary woke up unexpectedly from a sound sleep, her hair, nightgown and sheets soaked with perspiration. Already uneasy about a business presentation the next day, Mary shuddered to think what would happen if she experienced one of her dreaded

"hot flashes" in front of co-workers and clients. (Just the week before, she'd made an unplanned exit from work because of extreme cramping from a heavy menstrual period that wasn't due for another two weeks.)

Confused, extremely weak, tired, and suddenly chilled, Mary quickly changed into a fresh nightgown, took a few sips of water and fell back into a restless sleep.

The next day, however, with all her other attempts at healing failed, Mary chose a new path—one that would lead her to the true cause of her problem along with a natural solution.

Mary's initial Clinical Kinesiology evaluation clearly pointed to an energetic imbalance in her uterus, along with her thyroid. Surprisingly, at her young age, she exhibited the same type of energy imbalance as many older menopausal women.

Acupuncture treatment immediately helped rebalance both her thyroid and uterus. Testing also determined additional nutrients Mary needed to help counteract future problems. After weeks of hot flashes and heavy bleeding, Mary's symptoms completely stopped within three days of her first treatment. All subsequent menstrual periods resumed with regularity and no further complications.

The good news? Mary is going to avoid premature menopause, prescriptions for synthetic hormones, a hysterectomy, or any other drastic treatment as long as she continues with diet and lifestyle changes that promote good health. By rebalancing her uterus and thyroid, Mary was able to heal her female energetic system and her pre-menopausal symptoms ceased.

During treatment, Mary discovered how easy it was to maintain "total" body health, provided the body is given the helpful nudges it needs. She came to appreciate how her body, as the master of so many complex functions, was designed purposefully to function correctly throughout her entire lifespan—including menopause.

Why would it be any other way? Why would the female body be designed to out-live the important hormones (particularly estrogen and progesterone) that it needs to support life? I see two major causes for the deleterious effects on natural menopause. First, *many women's hormonal systems were significantly out of balance prior to the onset of menopause*, and second, *many do not accommodate the natural changes, such as menopause, that do occur*. Both of these causes are tied into one thing—lifestyle.

More than any other aspect, a woman's lifestyle determines the overall well-being of her body and its organ/energy systems. Monitoring diet, exercise, stress, and environmental factors are paramount in the healthy progression through natural menopause.

THE BODY CHANGES

...the necessity for patience had aged her magically; she was content in her age.
JOYCE CAROL OATES

Typically, between the ages of forty and fifty, a natural slowing down of hormonal output by the ovaries begins to occur. This includes a lessening of production of both estrogen and progesterone. One viewpoint, which differs from most of the others, centers on the theory that progesterone production slows down first.

Initial signs of progesterone slowdown usually develop a few years before menstruation ceases. According to medical definition, the actual onset of menopause is indicated when menstruation ceases. However, the progressive changeover in the body actually takes several years, including a premenopausal and postmenopausal stage. The progesterone slowdown theory hints that before a woman begins to notice any other symptoms, numerous "brown spots" or "age spots" appear, and increased skin dryness, wrinkling, and other symptoms develop.

Often, allopathic medical approaches narrowly classify all premenopausal symptoms as stemming from lack of estrogen. Most alternative paths, including Clinical Kinesiology, propose a more holistic approach to the body. Clinical Kinesiology supports many new ideas, most of which are not typically what women are used to reading in mainstream medical journals. As you approach decisions about menopause, keep in mind the dichotomy in thought and practice between different diagnostic methods and modes of treatment which may eventually compromise your health.

PREMATURE MENOPAUSE

More than likely, menopause occurs earlier and earlier due to imbalances in diet, lifestyle, and pre-existing imbalances in our bodies. While not always widely discussed, you might recall or have a sense of when a grandmother or mother experienced the onset of menopause.

You may also know women in their late thirties and forties who are currently experiencing pre-menopausal symptoms. It may even be happening to you.

Women who previously may have suffered from PMS generally experience a more difficult menopause. They experience an earlier age of onset, more severity of symptoms, and more general discomfort. Again, due to pre-existing imbalances in the body, these women may also exhibit more problematic emotional changes at menopause.

Keep your face to the sunshine and you cannot see the shadow.
HELEN KELLER

In today's fast-paced world, women's body functions are slowing down and wearing out too early from many factors—stress being only one. Twenty years ago, the average age for menopause was fifty-five. Today, treatment is often required by quite a few women in their forties. At age forty-two, forty-four, or forty-five many of these women begin to experience symptoms and changes.

Traditional medicine lists some causes for premature menopause as stemming from viral infections, inherited chromosomal abnormalities, defects in gonadotrophic secretion (a hormone from the brain that tells other hormones to be stimulated), auto-immune disorders such as Lupus, or enzyme defects in the body, excessive smoking or cancer. These precursors all constitute strains on the body.

The use of birth control pills has also proven to be a significant factor in the onset of premature menopause. Why? Birth control pills consist of a steroid based drug. All hormones contain a steroid base. However, the steroids in the body which form the building blocks for hormones are completely natural. In chemical drugs, the steroids are synthetically made and unnatural.

During high school days in the late 1960s and early 1970s, many girls complained of irregular periods, only to have their doctors prescribe birth control pills. "Taking birth control pills helps maintain regular cycles," was the popular thought as doctors wrote prescription after prescription. It remains a common practice today.

Synthetic hormones have dramatic effects on young women's bodies. The pills unnaturally force the body to alter its physiology, no longer allowing it to function normally. Wheels are set in motion which throw off the delicate balance of hormones, the repercussions of which these young women may not see for many years.

Other factors which precipitate premenopausal symptoms include fibroid tumors, endometriosis, uterine cancer, and extreme stress.

These traditional medical disorders, which cause lack of ovulation, may lead to premature or difficult menopause increasing the incidence of irregular menstrual patterns and erratic bleeding.

Women who prematurely experience progesterone slowdown should search out the true underlying causes for their disorder and treat them—helping to arrest premenopausal symptoms before they become more serious.

Rebalancing the hormonal system is strongly recommended should illness or trauma prematurely stop the menstrual cycle. Some women experiencing premature menopausal symptoms may be tempted to say, "Oh good...no more periods!" However, at ages under fifty, it remains vitally important to keep menstrual cycles functioning as planned by the body's normal physiology. This proves much better for the body in the long run. That way, the system continues to produce the needed hormones, avoiding additional menopausal symptoms, such as osteoporosis and further imbalances in the body.

Emotional and Physical Trauma

Emotional and physical traumas also cause cessations of menstrual periods, which may not be "true" menopause. Linda, a female patient, experienced an abrupt cessation of her menstrual periods in her thirties following the breakup of a long-term relationship.

During her Clinical Kinesiology evaluation, the muscle testing signaled the priority problem as stemming from her pituitary gland. Following treatment of Linda's pituitary with acupuncture, nutrients, and glandular supplements, her monthly periods came back like clockwork.

Two other women, Monica and Sheryl, required treatment after being severely injured in car accidents. Although outwardly recovered for many months, neither woman had resumed her menstrual periods. Again, Clinical Kinesiology evaluation uncovered imbalances in the pituitary glands of both women. Treatment resulted in their periods returning in a normal, natural cycle.

Without treatment of the pituitary and restoration of energy to other imbalanced organs, these women may have been incorrectly classified as typical cases of "premature" menopause. Most importantly, their problems were treated and resolved.

HORMONES, GLANDS, AND MENOPAUSE

As hormones cycle in a natural rhythm, they regulate the body's glandular system, which maintains the menstrual cycle essentially on schedule each month.

I like to live always at the beginnings of life...I am by nature always beginning.
ANAIS NIN

Often the first symptoms of menopause include hot flashes and night sweats. These stem from imbalances in the thyroid and hypothalamus, the temperature regulating systems of the body. In addition, women may experience fatigue, depression, irritability, and insomnia.

Little is written about the thyroid in most of today's popular books. Much more is written about the hypothalamus. However, Clinical Kinesiology research indicates that the thyroid is the more important organ in healing menopausal problems.

One traditional idea regarding menopause suggests that with a lack of ovulation, the pituitary continues to attempt to stimulate the follicle in the ovary through a follicle-stimulating and a leutinizing hormone, which cause the follicles to ripen and develop at least one egg. Researchers blame the pituitary for attempting to force the ovary to ovulate. Resulting high levels of follicle-stimulating hormones and leutinizing hormones then appear in the blood. Due to the fact that the ovaries have diminished or ceased production of their own hormones (once needed in large amounts) a resulting imbalance of low estrogen and progesterone levels occurs, again resulting in cessation of menstruation.

Along with the primary hormonal system, a secondary source for the manufacture of all hormones exists in the adrenal glands. In addition to estrogen and progesterone, a woman's adrenals also produce testosterone throughout her life. Conversely, men make estrogen in extremely small amounts. Of course, a great deal more remains to be learned about hormone interaction. Researchers have only scratched the surface in describing the job these important messengers hold in a healthy body.

RISKS OF SYNTHETIC HORMONES

The hormonal system comprises many different glands in the body. For it to function effectively requires a number of "pieces and parts,"

including "messenger hormones" which circulate in the body systematically couriering messages from point A to point B and back again. When women ingest synthetic hormones involving human-made attempts to re-create nature, the whole message communication system can be disrupted.

In introducing synthetic hormones into the body, there's always a chain reaction. Imagine a pool table laden with colorful pool balls. The player takes a shot—and all the balls break in different directions, scattering and hitting one another. Although the person may be aiming correctly, still, an unexpected or opposite reaction occurs.

In hormone research, experimenters neglect to ask, "Might there be something missing in the equation that the body needs to correctly decode this hormone's message?"

Good friends are good for your health.
DR. IRWIN SARASON

Take, for example, the "message" of a human-made birth control pill which travels to the ovary. This seems to be modern medicine's attempt to fool the body. Often, synthetic chemicals such as birth control pills cause unnatural reactions and often toxic consequences. Possible side effects of birth control pills include nausea, vomiting and weight gain. They may also increase a woman's chances of cardiovascular disease, breast cancer, and cervical dysplasia (a precancerous cervical condition.) Was something extra added to the hormone message inadvertently commanding an unplanned change in the body? *Doctors don't know.* One thing is sure. Synthetic hormones merely change body physiology rather than augment or heal it.

GENTLE, NATURAL TREATMENT

Normalizing body functions and recommending appropriate therapies enable hormonal messages from the pituitary to trigger the ovary to produce needed estrogen, which stimulates the menstrual cycle.

If an ovary is incapable of producing any longer, medical practitioners should not get out the whip, crack it and demand, "You have to perform!" No, treatment should always be handled in a more gentle, natural way.

The body may accept the help and continue the needed function, or it may say, "Thanks for the extra ginseng or vitamin E; however, I'm not going to use it for that purpose." The body is so wise. It's best to allow it options and choices.

Each woman's genetics and physiology, body imbalances or past traumas will direct the time of menopause. Early menopause is undoubtedly due to some type of body imbalance. Solving the imbalance or remedying the effects of the physical trauma is the important step. As a consequence, if menopause is postponed that means the body's natural pattern warranted a later onset. Menopause coming early is a symptom. The underlying imbalance is the cause. Once the cause is addressed, the symptom may change or it may not. Therefore, women shouldn't necessarily prolong menstrual periods and postpone the onset of menopause strictly in regards to age, but rather for health! Allowing the body to continue its normal functions for the maximum amount of time proves far healthier for most women.

MENOPAUSE: THE ENERGY CONNECTION

The body organs only contain a certain amount of expendable energy. Should the heart require healing, or a biochemical process need changing, energy must be immediately diverted to the needed area. If one area of the body cries out for help, the body probably has the energy to aid in healing. However, if five other areas vie for attention at the same time, none will receive much help. Healing menopausal symptoms, therefore, requires that women relieve the body of as much energy stress as possible.

Obviously serious illnesses such as cancer put a tremendous strain on the body's energy reserves. In many cases, the body prioritizes, saying, "I cannot deal with the irritation to my lungs or the cancer in my body *and* go through a menstrual cycle." The body may then put the menstrual cycle on hold, dealing first with its most pressing problem.

Often, women may notice that major losses in the family or other devastating or disruptive experiences result in missed periods. Again, the body may not have enough energy to proceed through a whole menstrual cycle *and* cope with a loss or devastating episode. This provides another clear indication of the body's hormonal regulation system.

HEART SYMPTOMS AND MENOPAUSE

Numbness and tingling, arm pain or chest pain may occur at menopause in relation to imbalances in the Heart Meridian—all related to the heart under stress. Associated problems in post-menopausal women include increased heart disease.

There is no exercise better for the heart than reaching down and lifting people up.
JOHN A. HOLMES

Researchers say that estrogen prevents heart disease. Indeed, natural estrogen produced in the body does afford women extra protection over their lifespan. Following menopause, however, less estrogen production may result in an increase in heart disease.

A unique relationship between the uterus, thyroid and heart is observed in more and more women. A great deal of women on thyroid medications also experience increased heart problems. As yet, it's unclear whether the dysfunctional thyroid affects the heart, if the drug is the precipitating factor, or both. One thing is for sure; a most definite feedback system exists between the heart and thyroid.

Maintaining proper blood pressure during menopause remains vitally important to all the organ/energy systems. One caveat: treat them naturally. The organs must not be allowed to remain dysfunctional, without help, or be given four or five chemical drugs to further tax the body. Instead, find constructive treatment, rebalance and heal.

BLADDER SYMPTOMS

Increased urinary frequency and incontinence remain common problems related to menopause. Although the bladder and kidney both connect to individual meridians, the kidney more often needs treatment than the bladder.

Sometimes women experience a "dropping" bladder or uterus. This may occur as time progresses and uterine muscle tissue becomes weak from insufficient energy in the area.

Tia's Story
Tia loved to run and play with her two small children in their neighborhood park. One afternoon as she tossed a red rubber ball to her son, Evan, she experienced an uncomfortable feeling within her lower abdomen, as if something had dropped inside. Her symptoms advanced to the point where her cervix noticeably began to protrude.

Because of a dropping uterus, Tia was advised to undergo a hysterectomy.

Tia reluctantly consented to the surgery, only to discover a few months later, that her bladder had begun to drop! Obviously, the hysterectomy did little to change the situation. By now, Tia was beside herself. "What else can I do?" she cried in my office. "I don't want to have surgery again. Now, I have a new problem!"

Following Clinical Kinesiology testing, including acupuncture, nutrients, and a few adjustments to the spine—Tia's dropping bladder receded, the muscle tissue sufficiently restrengthened to support her bladder. Additionally, I recommended Tia take *superoxide dismutase*, a supplement designed to attack scar tissue.

Tia's story illustrates how easy it is, through natural methods, to change most situations, no matter how progressed.

BACK AND HIP PAIN

During menstrual periods some women experience pain or cramping in the lower abdomen, back or both. Interestingly, the back may not hurt at any other time of the month, but the pain may flare up during the menstrual period. This type of pain, located in the lower body, again clearly illustrates the relationship between the uterus and referred pain areas close to the uterus. The lower back represents one such referred pain area and the hip another. These external pains, that seemingly have no other connection with the menstrual period, are actually referred pains from the female organs.

HYSTERECTOMIES:
THE UTERUS/THYROID CONNECTION

Within one year, I treated Sonia and Eleanor for hip pain associated with hysterectomies they had received twenty years previous. As I worked with them I again pondered, "Why do so many women agree to such surgery?" Sadly, most base their decision for surgery on a desire to alleviate heavy menstrual bleeding, fibroid tumors, endometriosis, or other ongoing symptoms for which their doctors tell them there is no other cure.

A culture that does not value the mind/body relationship on an individual level is unlikely to produce a system of health care that appreciates the patient as a human being, one who can establish a dignified relationship with disease—or health for that matter. It is no wonder that when we seek a health professional because of illness, hoping to find some measure of genuine openness and compassion, we often find someone who is more frightened and confused than we are.

DR. MITCHELL LEVY

For many women, however, hysterectomies prove devastating. Think about it. Part of the body is removed! And afterward, many women, like Sonia and Eleanor, find that the surgery didn't solve their problems after all. *It merely removed the focus of the worst symptoms.*

Surgeons removing a uterus don't really fix the energetic problem related to it. The uterus just happens to be the most symptomatic part. Meanwhile, the problem needs to be traced through the entire body system just as an electrician will search out the reason for a blackout in your home, or a car mechanic will test out the electrical system of your car. Only then can you expect to rebalance and "rewire" the energy needed to maintain the health of a symptomatic organ.

The body's electrical system runs like the compact car I drove while attending Chiropractic college in Portland, Oregon. A mysterious malfunction kept making the car's battery go dead. I immediately had the battery tested, along with the entire electrical system, and the mechanic assured me everything was fine. As a precaution, however, the mechanic recommended that I buy a new battery anyway. I did, and the car still wouldn't run. New battery cables? Negative results. Whenever the car was left sitting in a temperature below twenty degrees, it simply wouldn't start—even with a new battery and cables.

Finally, two mechanics, one new battery and new cables later—the solution! The car's "starter" had been the culprit all along and the cold temperatures merely provided added stress. I could have installed a new battery every day, yet, until the real electrical problem was uncovered, the car refused to function correctly.

The acupuncture system within the human body works exactly on the same premise as the electrical system of a car. A simple "short" someplace in the body's system may render the meridian unable to hold a charge. Until the basis for the "glitch" in the body's electrical system is discovered, the true problem remains unsolved.

Removing the end organ that ties into that electrical system renders the system unbalanced and unhappy. In addition, an energy spill-over may then occur. The spill-over of unbalanced energy may now affect the thyroid, causing new problems that weren't noticeable before—such as difficulties with temperature regulation or metabolism.

In case after case, more organ correlations can be drawn. As the connections are explored, an interesting pattern repeats itself. In my experience, hysterectomies send the body into an energy "black-out," if you will.

We've all seen the effects of a power outage followed by a return to normal: lights flash, digital clocks blink, alarms ring, and we have to go around and reset everything that was thrown off by the power outage. The same thing happens in the body. Not only *doesn't* the hysterectomy solve the imbalance; now, energy that normally flows from the meridian to the uterus has no place to go. Consequently, the removal of the uterus forces the energy to be diverted. This excess energy over-AMPs the thyroid, throws it out of proper function and, in a chain reaction, the thyroid then affects the heart.

What happens when there's no one around to re-balance or "reset" your body's electrical system? Serious organ/energy imbalances take a period of years to manifest in disease or disorders.

At this time, research money is very limited to evaluate further and document energetic healing and non-invasive diagnostic methods, such as Clinical Kinesiology. Sadly, until then, women will continue to be told that surgery is the only answer.

MENOPAUSAL CHAIN REACTIONS

I treat *absent* uteruses and *present* ones. In actuality, I'm treating the electrical system that connects to the uterus. Researchers have recently discovered that the uterus does indeed produce hormones.

A hormone message delivered to the thyroid might say, "The uterus is balanced and happy now and you, thyroid, can continue functioning as you are." Or, "The uterus isn't quite happy and you need to change your function." All hormones serve as messengers in your body telling glands and organs alike how to interact more harmoniously with each others. Make a drastic change in the body and you will experience repercussions. Whether the change involves something as serious as a hysterectomy, the removal of an ovary or something as seemingly routine as a tubal ligation, doctors are tampering with nature. Sara's case sadly demonstrates the menopausal chain reaction which can follow such tampering.

Many years ago, Sara consented to surgery to remove an ovary. Following the ovary removal, and I believe, quite uncoincidentally, two years later, a tubal pregnancy occurred requiring another surgery. The result was premature menopause in her thirties. Sara, now sixty-five, has developed serious bleeding. Her doctors, typically, have recommended a hysterectomy.

TUBAL LIGATIONS

Woman is woman's natural ally.
EURIPIDES

Women considering any surgery on the female organs should be cautious, especially regarding tubal ligations. Often, following this type of surgery, the female system becomes extremely out of balance. Menstrual periods also become more difficult.

Fortunately, doctors do recommend fewer hysterectomies these days. Quite possibly, many of them are gaining some understanding of how seriously the body can be traumatized. Most medical doctors, however, still have little or no knowledge of the body's energetic system.

Acupuncture meridians are disturbed by tubal ligation surgery. Somewhere, something *changes* in the complex system of hormone communication. Damage occurs to the fallopian tubes which often results in the uterus becoming out of balance.

Research is unavailable to pinpoint the exact cause of the imbalance; however, the energetics that control the organ/meridian system (including the hormonal system) are disturbed. Like a house with too many appliances plugged into the electrical outlets, the body's circuitry becomes overloaded and it's electrical system (like the house's circuit breaker) flips off and shuts down.

Any time one experiences a major disruption or change in the body, it most likely triggers another organ imbalance as a result. It may not happen the next day. In fact, it may be months or even years later that questionable symptoms appear. At first you may not think, "Gee, ...*this* problem relates back to when I had *that* surgery." But many times it does.

RELIEF FOR MENOPAUSAL SYMPTOMS

Connecting all the pieces of the menopausal health puzzle includes recognizing and dealing with emotional changes and mood swings, together with physical symptoms. Awareness that such mind-body imbalances may be largely nutritional and stem from obtaining the right balance of vitamins, minerals, and amino acids provides an important first step. Supplementing the building blocks of neurotransmitters in the brain better regulates mood and helps allay physical symptoms.

DIET

A basic, healthy diet should be the core of your regimen. Eating fresh fruit, vegetables, grains, and drinking clear, pure water will do much to aid the functioning of the body. Many women feel like a weight has been lifted as they buoy up with more health and energy.

Diet cures more than doctors.
A.B. CHEALES

Evening primrose and black currant oil provide essential fatty acids which provide the necessary building blocks for a balanced hormonal system. Essential fatty acids also help the digestive process, enhance skin texture and moisture, and assist in joint lubrication. Both oils are commonly found in capsule form and are taken orally.

Flaxseed oil, another highly recommended oil, helps alleviate menopausal symptoms in the same way. In the cold-pressed liquid form, flaxseed oil taken orally helps lubricate the body and its tissues. It also fights inflammation by stopping excess build-up of irritating toxins and chemicals. Additionally, flaxseed oil naturally lowers the blood fat level in lessening the chance of arteriosclerosis following menopause.

Foods and supplements high in calcium and magnesium, including dandelion greens, also supply needed nutrients during menopause. Current popular journals recommend twice as much, or even three times as much, calcium to magnesium. I believe there is a greater need to focus on the magnesium. Balanced multiple-mineral supplements provide overall support; additional specific minerals may be added at the body's "request."

Unfortunately, many women need to be reminded about diet because it's the one thing most tend to overlook. Healthy plants

require good soil, sunlight and additional nutrients. Healthy pets thrive on the best quality food that can be found. Do the same for yourself and you'll set the groundwork for a much healthier menopause.

GLANDULAR SUPPLEMENTS

Specific glandular formulas, based on protomorphogen therapy (tissue-derived concentrates which operate at a tissue specific level) originated around the turn of the century. Dr. Royal Lee was one of the first holistic practitioners to see the need for adding a glandular substance to help build and rebuild an imbalanced organ or gland.

For example, if an ovary tests weak, specifically designed glandular supplements may be used which support the ovary. If the uterus proves out of balance, another supplement formulated especially for the uterus may be beneficial. In cases involving a missing uterus, ovary or other organ, practitioners may use the corresponding glandular to provide additional support to the body.

The best quality glandulars contain organ tissue from livestock grown in New Zealand, an area still environmentally unpolluted. Although I'm a vegetarian, I do take glandulars to help build tissue in organs or glands that specifically need extra energy. The bovine glandular tissue of the uterus may contain some of the same hormones that I believe the uterus produces.

As mentioned, a present as well as an absent uterus may be treated with glandulars. With a missing uterus, the needed hormones and the glandular supplement can help the body to compensate. Glandular supplements for all the major glands and organs, including the heart, kidney, lung—even the brain, may be found in most healthfood stores. I recommend the Core-Level™ brand from Nutri-West®, formulated by Dr. Alan Beardall, the originator of Clinical Kinesiology muscle testing. Dr. Beardall experimented until he isolated the nutritional components which help balance a particular organ or gland. He then formulated a synergistic complement. Each glandular contains at least fifteen ingredients that include vitamins, minerals, amino acids, and herbs, making this brand quite different from most glandulars on the market. Uter-X™ by Nutri-West is an excellent choice. (See Product Guide.)

VITAMINS AND SUPPLEMENTS FOR MENOPAUSE

The aging process (the wrinkling process included) may be characterized by the loss of oxygen from body tissues. As normal hormone production decreases, the body's oxidation process increases. Along with glandulars, the multi-vitamins, minerals (including potassium) and antioxidants such as selenium all work to strengthen the hormones. Germanium serves as an effective antioxidant mineral to help build immune system and tissue strength.

The wild yam root (a source of natural progesterone) also proves helpful for many women in giving a "kick-start" to a sluggish hormonal system. B-complex and vitamin C are also highly recommended for this same reason.

Each woman may be tested with Clinical Kinesiology to specifically determine what her uterus, thyroid or pituitary needs. It's important to know specifically which vitamins and minerals work best for you.

The revival of interest in herbal medicines is a worldwide phenomenon.

MARK BLUMENTHAL,
AMERICAN BOTANICAL
COUNCIL

HERBAL TEAS AND TINCTURES

Licorice taken in herbal teas and tinctures proves quite effective for alleviating menopausal symptoms. It may be used as a uterine tonic to help the body make estrogen, counteract the effects of stress, and as an anti-inflammatory agent and detoxifying herb. Licorice is well known in Chinese medicine for its properties as a balancing agent. The root itself may even be chewed in some cases.

Raspberry and squaw vine may also be used to balance the female system at any time of life. Squaw vine, a Native American herb, helps the body make its own progesterone. Other tinctures, such as helonias root or false unicorn root, are also effective in balancing the uterus.

In addition, blue cohosh root and black cohosh root, (including the new German estrogen replacement product, Remifemin™) taken in supplement form also help the uterus maintain proper balance. I suggest black cohosh for women who complain of hip pain—referred from the uterus. Even when no menopausal symptoms are present, black cohosh works well to strengthen and tone the uterus in many stages of life.

As mentioned previously, often when the uterus tests out of balance there is a thyroid connection. In order to rebalance the thyroid, women may use an herb called bladderwrack. Bladderwrack has a double identity in health food stores. It's used as an herb, under the name *bladderwrack*, and in another aisle *bladderwrack* is known as "seaweed" or kelp.

HCL

Just as nausea normally accompanies the first trimester of pregnancy, it's also a menopausal symptom. Why? Because of continual fluctuations in the hormonal system. Balancing the hormones aids all the other glands in interacting better. Provide them the healthy diets and nutrients such as HCL (hydrochloric acid), and it's likely symptoms of nausea will fade out.

Menopausal women, as most older people, tend not to produce sufficient quantities of hydrochloric acid in their stomachs. Hydrochloric acid tablets aid in proper digestion for menopausal women. However, some gastro-intestinal symptoms or distress may be early indications of a larger problem. Through individual testing with Clinical Kinesiology, we can investigate the need to help the digestive system and all other systems work better.

CLINICAL KINESIOLOGY TESTING

Through Clinical Kinesiology testing, you may glean as much information as possible regarding the body's reactions to different stimuli...whether it's food, medication, nutritional supplements or natural progesterone.

For example, on every woman I've tested, synthetic progesterone such as Upjohn's Provera®, renders the indicator muscle *consistently* weak. Synthetic estrogen, such as Wyeth-Ayerst's Premarin® doesn't always result in weak muscle tests; however, remember that the medication is only being tested at the current moment in time. Often, the *prolonged use* of a synthetic drug such as estrogen may later manifest problems or create imbalances in the body.

Every woman, no matter what her age or how advanced her menopausal symptoms, needs to build progress toward natural healing. Part of that progress may involve scheduling treatment with a local natural health practitioner. While self-testing may be used to gain familiarity with the female energetic system, it should not be used in lieu of professional treatment.

TESTING THE FEMALE ENERGETIC SYSTEM

The following self-testing instructions may serve as a guide for further examination, for seeking more knowledge or as a preliminary check of your current health status.

Before proceeding with any Clinical Kinesiology testing refer to Chapter One for instructions on performing the Indicator Muscle Test. Once confirmation of a strong arm is determined, proceed as follows:

Woman...you are the gates of the body, and you are the gates of the soul.

WALT WHITMAN

Hypothalamus Test

Any test of the female energetic system should begin with testing the hypothalamus. This small "organ" in the brain serves as the controller of other glands and organs and directs many body-regulating functions.

If out of balance, the hypothalamus may trigger erratic hunger and thirst patterns, wakefulness and sleep patterns, emotional disturbances, mood swings, and depression.

Test the hypothalamus by having the test-subject place the index finger directly at the bridge of the nose on the mid-line of the forehead, in the space between the eyebrows. The tester then performs the Clinical Kinesiology muscle test on the subject's opposite arm.

> Hypothalamus TL + Muscle test + Strong arm = Hypothalamus balance.
> Hypothalamus TL + Muscle test + Weak arm = Imbalance of Hypothalamus.

Should the test indicate the hypothalamus is out of balance, consult a Clinical Kinesiology or natural health practitioner who should be able to help rebuild and strengthen the hypothalamus function through acupuncture, nutrition, or other natural methods.

Thyroid Test

When testing the female energetic system for menopausal symptoms, it's first necessary to check the most relevant organs. The thyroid also plays a key role in balancing the female energetic system.

Problems with fluctuations or flow of the menstrual cycle or symptoms of approaching menopause, including hot flashes, usually indicate a thyroid malfunction. In order to test the thyroid balance, therapy localize over the thyroid by having the test-subject place an open hand over the front side of the throat, while you simultaneously muscle test the strength of the subject's opposite arm.

> Thyroid TL + Muscle test + Strong arm = Thyroid balance.
> Thyroid TL + Muscle test + Weak arm = Thyroid imbalance.

Follow up with a Clinical Kinesiologist, acupuncture, nutritional support and other treatment can strengthen the thyroid and change the imbalance.

Uterus Test

It's a good idea for any woman with female energetic problems to therapy localize over the uterus. To perform this test, the test-subject places the palm of the hand over the lower abdomen approximately three inches below the navel, while the tester checks the strength of the subject's opposite arm. Anyone who has experienced menstrual cramps or labor pains should have little problem locating the uterus.

Uterus TL + Muscle test + Strong arm = Uterus balance.
Uterus TL + Muscle test + Weak arm = Uterus imbalance.

Once again, a weak muscle test confirms that the uterus is energetically imbalanced. The test *does not* necessarily mean a fibroid tumor or any type of pathology or disease is present, simply that a uterus imbalance has been detected and you should consult your natural healthcare practitioner.

Ovary Test

A post-menopausal woman should experience good overall health. Even after menopause, a healthy ovary should test strong, not weak. However, following a surgical procedure, some women retain only one ovary and, unfortunately, many times that ovary becomes out of balance. Whether a woman has both or only one ovary, if the test is weak, ovary supplements or glandulars may help strengthen the ovaries before, during or after menopause. It's difficult to therapy localize over the ovaries because they are so small, so be precise.

To locate the ovaries, place both hands on the waist. Slide hands in a downward V until thumbs reach the pointed bones of the hip with the fingers touching the pubic bone. Approximately midway along that V-line you will find the ovaries.

Ovary TL + Muscle test + Strong arm = Ovary balance.
Ovary TL + Muscle test + Weak arm = Ovary imbalance.

If you locate an ovarian imbalance, check with your natural healthcare practitioner for guidance and treatment.

Pituitary Test

The pituitary may be tested by placing the hand two to two and one-half inches above the hypothalamus in the center of the forehead.

Pituitary TL + Muscle test + Strong arm = Pituitary balance.
Pituitary TL + Muscle test + Weak arm = Pituitary or hormonal imbalance. Consult a Clinical Kinesiologist.

All of the organs in the female energetic system relate to one another. Treatment often requires strengthening the pituitary, hypothalamus, thyroid, ovary, and uterus.

Troublesome menopause may stem from a lack of self-esteem, a stressful job, difficult family relations, insufficient exercise, or unhealthy eating habits. Every factor of environment, diet, and lifestyle impacts your life. Begin to benefit from reevaluating those factors more often as you explore Clinical Kinesiology diagnosis and natural treatment on your path to new healing for natural menopause.

While each individual proves different, women and men need to be appraised of each other's health concerns in order for both to reach a deeper understanding and fuller support of one another. Chapter Eleven, *The Male Energetic System*, is specifically devoted to optimal health for the male energetic system and educates male and female readers on steps to maintain overall health throughout life.

CHAPTER TEN SUGGESTED READING

Ford, Gillian. *What's Wrong With My Hormones?* Newcastle, CA: Desmond Ford Publications, 1992.

Hufnael, V.G. and Golant, S.K. *No More Hysterectomies.* New York: Penguin Books, 1989.

Lark, Susan M.D. *Dr. Susan Lark's The Menopause Self Help Book: A Woman's Guide to Feeling Wonderful the Second Half of Her Life.* Berkeley, CA: Celestial Arts, 1990.

Perry, Susan and O'Hanlan, Katherine, M.D. *Natural Menopause— Guide to a Woman's Most Misunderstood Passage.* New York: Addison-Wesley, 1992.

Rodale, J.I. *The Healthy Hunzas.* Emmaus, PA: Rodale Press, 1948.

Weed, Susan S. *Menopausal Years.* New York: Ash Tree Publishing, 1992.

Wolfe, Honora Lee. *Menopause: A Second Spring.* Boulder, CO: Blue Poppy Press, 1992.

Wood, Lawrence C. M.D., F.A.C.P. et al. *Your Thyroid, A Home Reference.* New York: Ballantine, 1986.

The Male Energetic System

Two-day-old Michael slept peacefully, snuggling deep into his mother's arms. Suddenly, a pair of dutiful hands scooped up the new baby boy. "Just standard procedure," the nurse assured his mother.

Minutes later, an orderly wheeled baby Michael into a brightly lit operating room. Stripped of his warm gown and soft diaper, doctors strapped Michael's legs and arms onto a molded plastic board, much like a child's infant carrier.

The baby's eyelashes slowly began to flutter open as the doctor expertly affixed a stainless steel metal device to the little boy's penis. A sharp scalpel methodically spun around, surgically cutting the foreskin from Michael's body.

Instantly, tiny Michael began to scream.

THE STAGES/THE AGES OF MAN

From the first moments of life, men face increased susceptibility to cardiovascular disease, cancer, lung problems, liver ailments, and diabetes. Often, their reluctance to treatment results in higher rates

Health is the proper relationship between the microcosm, which is man, and the macrocosm, which is the universe. Disease is the disruption of this relationship.

DR. YESHE DONDEN,
PHYSICIAN TO THE
DALAI LAMA

of early illness and death. On average, they live seven years less than women.

While many new health issues for adult men are recently coming to light, I believe the key to maintaining healthy function begins at birth. For clarity, this chapter addresses health issues affecting the male energetic system organized by specific male age categories.

Complete alternative healthcare of the male body begins with birth to age twenty (Stage One), and covers early issues such as circumcision, hyperactivity, bedwetting, and hernias.

Stage Two, early adulthood issues, involves the maintenance of a healthy and functioning genitourinary system. Topics in this stage range from hair loss, impotence, infertility and depression, to complications from vasectomy.

Middle and older age male concerns will be covered in Stage Three. Here we will explore general vitality, diet and stress-related disorders, digestion, and prostate problems.

Preventive measures include simple exercises, nutritional recommendations, suggested herbal and homeopathic remedies and Clinical Kinesiology self-testing procedures, which round out the care of the male energetic system.

STAGE ONE: BIRTH—TWENTY YEARS

CIRCUMCISION

Early parental choices often result in far-reaching consequences on the body and health of the male infant. Many times, these procedures set the stage for practices that affect men's health through adulthood, middle age and eventually old age.

Circumcision poses one issue which may have life-long effects significant to males. As many parents address the question of whether or not to circumcise a male child, many negatives should be weighed.

During my early student nursing career, I worked in labor, delivery and post-partum areas of the hospital. I was often required to be present and assist during circumcisions. In my opinion, the procedure is inhumane, harsh and difficult. First of all, circumcision is performed with no anesthetic of any type, and usually no parental presence or contact. During the procedure, the baby boys scream as if they are being injured—which they are.

Natural pain relieving measures, such as numbing the region with ice, could be undertaken during circumcision; however, the typical harsh tact remains, "It just takes a minute! It will be over with and then the baby forgets it." However, anyone who has witnessed circumcision would disagree with doctors who insist, "There is no pain," or, "Circumcision doesn't hurt."

Circumcision must be considered in light of the psychological trauma it may cause newborns. If not complete trauma, it may signal the beginning or seed of psychological trauma that may affect some men throughout life. How can one justify a circumcision which represents a defenseless little person being aggressively and unkindly treated in his first hours. How does one explain such unexpected pain? Many psychologists concur that often our earliest experiences do guide and mold individuals in later life. Personality, behavior, emotional patterns of responding and reacting may all be negatively influenced by this practice.

In some cases, circumcision may be done out of religious and cultural tradition, passed down through generations, stemming from the concept of "permanent cleanliness." In olden days, conditions were not terribly hygienic and circumcision provided a method for assuring cleanliness. Today, that has changed—yet the tradition remains. Natural counterpoints indicate that good personal hygiene, including retraction of the foreskin during cleaning, works just as well as circumcision.

MALE EMOTIONAL HEALTH

Although naturally inborn differences exist between males and females, our culture often promotes these differences in specific ways which may manifest problems for males—particularly the social pressure on boys to follow certain occupations and conform to a model of male superiority.

Oftentimes, in grade school, one child may be compared with a room full of children. Other children may be reading at a certain level, retaining information and sitting quietly until called on. When a child does not fit this mold, he may be labeled as a learning disabled or an Attention Deficit Hyperactivity Disorder (ADHD) child.

Visible signs of ADHD are more noticeable among school age boys between first and third grades. Complicated and controversial to diagnose, hyperactive children usually lack self control, are inattentive, overly talkative, exhibit nervous mannerisms, impulsivity, and sometimes excessive irritability.

Hyperactivity may stem from sensitivities to foods, chemical additives and preservatives, excessive sugar intake, heavy metal toxicity and/or an imbalance of the hypothalamus.

Jamie's Story

The remedy for all blunders, the cure of blindness, the cure of crime, is love.
EMERSON

"The prinicpal will see you now," smiled the administrative assistant. Mrs. Edwards had been summoned by the school principal and a district psychologist after her seven-year-old son, Jamie, had been warned following several outbursts of disruptive behavior.

"We believe your son may have an attention deficit hyperactivity disorder," the psychologist began.

"Jamie?" Mrs. Edwards' flushed. "But, he's a smart boy."

"Mrs. Edwards," the prinicpal continued, "Jamie exhibits an above average level of intelligence. We simply don't want to see that potential go unrewarded."

Mrs. Edwards nodded.

The psychologist snapped close his briefcase. "We suggest you put your son on Ritalin...if you want him to remain in school. Of course," he smiled, "the choice is entirely up to you."

At first, Jamie's mother was determined to follow an all natural treatment plan. Following Clinical Kinesiology evaluation and treatment of Jamie's hypothalamus with acupuncture, his anxiety calmed and family and school conflicts lessened. His attention span lengthened and previous sleep problems resolved.

Then suddenly, at Christmas, Jamie's mother started him on Ritalin. "I want him to be sitting down in January, taking notes, and paying attention," she said determinedly. "It will be better for everyone."

Ultimately, Jamie's mother ended up giving her son a drug. She had broken down due to the pressure school authorities were placing on her.

Will the drug enable Jamie to get to the root of the problem and heal his hyperactivity? No. With Ritalin, Jamie risks continued imbalance, possible addiction, and later withdrawal from the drug on which his body has become dependent. Unfortunately, medical

researchers not only urge pediatricians to use Ritalin with ADHD children, but lately are recommending that doctors *increase* dosages from twice a day to three times a day to further relax the child.

Along with other side effects, Ritalin acts as a stimulant in adults. In many areas, parent's groups have formed to warn other parents, teachers, and the public of the Ritalin risk factors, including Ritalin withdrawal which triggers higher risks of suicide.

Help for Hyperactivity

Often, chemical imbalances in the brains of children with ADHD, such as Jamie, stem from nutritional deficiency, digestive disorders and the mother's diet while the child was in utero. The main factor in each indicates an energetic imbalance of the hypothalamus, which results in improper functioning of hunger and thirst patterns, wakefulness and sleep patterns, memory, moods, concentration and hormonal functions.

Whether or not our children eat proper foods, eat regularly, eat carefully, and eat politely has an effect on their health and their personalities.

NATIONAL EDUCATION ASSOCIATION, 1940.

Hyperactive children often benefit from a Nutri-West® glandular, Core-Level™ Brain-Spinal,™ which includes brain tissues and a number of vitamins and minerals complexed together. Such a comprehensive, nutritional supplement for this part of the brain may be helpful. Rather than using tranquilizing drugs, which merely cover up symptoms, natural supplements provide nutrients that the body utilizes to help balance itself. In addition, chemical drugs *always* alter or change the normal physiology of the body, while the inherent problem continues to degenerate below the surface.

Alternative therapies include totally natural treatments such as amino acid therapy, nutrients for the hypothalamus, a calming diet which excludes sugar, caffeine, food additives, and other stimulants. Supplemental vitamins needed may include niacin, Vitamin C, magnesium and zinc.

In addition, a diet high in complex carbohydrates, including whole grains, vegetables and legumes may be especially beneficial. Following these guidelines within a context of love and acceptance promises a good response for children who once exhibited hyperactivity problems.

Bedwetting

Another emotional issue that affects many young school age boys (and girls) involves involuntary bedwetting during the night. Although bedwetting may indicate deeper, underlying problems, it may

also stem from emotional stress, small or weakened bladders, over-consumption of liquids, heredity, or other behavioral issues.

Many children report that during sound sleep they often do not have an awareness of the need to urinate; therefore, don't wake up. However, bedwetting may serve as a psychological method of controlling or manipulating parents. Often, a bedwetting child may be feeling too constricted or regulated without understanding why. Subconsciously these children may think, "I'll show them! I'm going to make some work." Bedwetting remains an area that the child alone can control.

In other cases when children who previously had no bedwetting problem experience stress, trauma, or a change in their lives, bedwetting may suddenly occur. One young boy, Roger, never had a problem until he reached the age of thirteen. Then, suddenly, the bedwetting started. In Roger's case the emotional component does seem to have played a major role.

Bedwetting may also be linked to hypoglycemia, diabetes, urinary tract infections and food sensitivities. The biggest food factor to suspect in bedwetting stems from allergies to dairy foods.

One simple remedy for a bedwetting child may involve avoiding milk for several weeks. Milk contains tryptophan, which works as a relaxant. While some parents use milk to help a child obtain deeper sleep, many bedwetters have been found to be milk allergic. Upon elimination of milk, bedwetting may no longer be an issue.

Following Clinical Kinesiology evaluation, treatment for bedwetting often requires stimulation of acupuncture points on the Kidney Meridian and, occasionally, the Bladder Meridian. In diagnosing bedwetting problems, the kidney proves predominant in controlling more functions, which means it usually requires more help.

The bladder remains the stronger of the two organs. However, treating the kidney automatically helps the bladder. Other times, the bladder needs specific treatment, depending on the results of Clinical Kinesiology testing.

Helpful supplements include amino acids, magnesium, calcium, B-complex and a high quality multi-vitamin. Herbal recommendations include horsetail, St. John's wort, cornsilk, and lemon balm before bed. In addition, some parents find berberis, a homeopathic remedy, to be helpful.

HERNIAS

Some young boys are prone to develop hernias, which result from bulging of tissue through a weakened area of the abdominal wall. Hernias may also involve an organ or some portion of the intestinal tract.

Usually, Clinical Kinesiology testing indicates that inguinal or lower abdominal hernias relate to an imbalanced Kidney meridian. The muscles of the abdomen prove initially weak due to kidney stress. Hernias may be treated naturally without surgery following Clinical Kinesiology evaluation.

At the age of five, Benjamin developed a hernia in his lower abdomen. His doctor recommended immediate surgery to repair it. Two weeks after Benjamin underwent the surgery his mother discovered another hernia two inches above the previous one.

During Clinical Kinesiology testing, little Ben's kidney responded weak and his evaluation further indicated many nutritional deficiencies and hidden emotional imbalances. During a full year of treatment, Ben's hernia did recede; however, he continued to suffer from a myriad of emotional problems involved with his kidney.

Surgically fixing Benjamin's hernia did not attend to his deeper problem of the imbalanced kidneys. Continuing on the same path, Ben would merely keep repairing and repairing. Hernia surgery may temporarily patch up the problem, but it doesn't heal the underlying reason for the hernia.

Specific nutritional remedies for hernias include Core-Level™ Kidney™, various Kidney/Bladder herbals or tinctures including stinging nettle, goldenrod, horsetail, shavegrass, uva ursi, and juniper. Homeopathic remedies which may be used for the kidney are Renal Drops from Professional Health Products, or belladonna, lobelia, and atropine.

Health is a precious thing, and the only one, in truth, meriting that a man should lay out, not only his time, sweat, labor and goods, but also his life itself to obtain it.

MONTAIGNE

STAGE TWO: YOUNG MEN AGE 20-40

TEEN GUIDANCE

During male teenage years, important individual decisions that affect the rest of a young man's life begin to be made. Questions such

as smoking, drinking, taking risks, or involvement in situations that may have long-term emotional, social and health consequences often carry a price. While parents should offer prior guidance and teaching, most times the final decisions rest on the free will of the male teen.

Unlike early Native American cultures which guided their young braves, our culture's response to the young male remains fairly amorphous. As a result, many teen males simply roll along with what the other kids are doing.

Our body will take care of us if given the slightest chance. It already has the best of nature within it and will survive if we will only let it, if we give it half the chance it has given and continues to give us each day.
RONALD J. GLASSER,
THE BODY IS THE HERO.

Young men need the opportunity and guidance to be able to choose a wise, healthy lifestyle. Without cultural care and attention to guide them, many young men often find it difficult to make the transition to manhood. Such "lostness" often leads to a high rate of teenage suicide, which has been increasing over the last several years. Young men ponder, "Where am I? What am I supposed to be doing? What are my values? What's the value of my health? My life?"

Teenage boys who make a commitment to being healthy can successfully walk that path and go forward. *But, they will not be walking the commonly tread path.* They will constantly have to fight the social compulsion to do what the rest of the crowd is doing. With regards to diet, for example, it is difficult in this fast food world—to say no! However, if parents can impart, "This is the healthful way to eat and live. This is *my* diet plan," and carry that through, young men will have strong role models to follow, and hence an easier time. When tempted, they can say, "I eat this way, simply and healthily!" Consequently, their peers will know where they stand from the beginning. No further explanations will be needed.

Boys who grow into adulthood without the information and role-modeling to make healthy decisions may eventually be faced with more serious underlying health issues. Patterns of neglect or abuse become set. What happens to men who aren't taught to pay attention to their bodies, listen to symptoms or have health checks? From age twenty to forty, signals being sent from the body may be saying, "Hey, I need help! I'm not quite balanced. Everything isn't functioning perfectly any longer."

Young men in this age category begin to notice definitive health glitches. Glandular and hormonal systems may not be functioning correctly. Organs may be breaking down due to energetic stressors. Often, this age group of men complain, "I just don't have the energy

I used to have." or, "When I was younger I could do such and so, now, I'm too tired."

HAIR LOSS

One sign that the body may be out of balance is male pattern baldness. Hair loss, male pattern balding, hair thinning—many words describe this issue of concern to over thirty-three million American men.

According to the American Hair Loss Council, two out of every three men face balding by the age of fifty. Expensive hair loss clinics, scalp treatments, transplants, and the drug Monoxodil don't fix the problem. They really aren't addressing the bottom line of what's energetically gone wrong in the body.

While some hair loss can be traced to genetic abnormalities, in other cases diet seems to be the underlying cause. Dr. Paavo Airola, author of *Stop Hair Loss* cites countries such as Japan, China and Italy as cultures which exhibit little hair loss among men. Their diets of fruits, vegetables and grains, including seaweed, which is rarely eaten in U.S. culture, are linked to decreased hair loss.[1]

Healthy alternatives to cosmetic treatment for hair loss do exist. Clinical Kinesiology evaluation may identify one or more weak organs or systems that may contribute to hair loss. The kidney, liver, heart and thyroid are pinpointed most often. Most of the time, the primary organ imbalance involves the liver.

Tom was often complimented on his thick, black shiny hair. Suddenly at age thirty-eight, he began developing a large bald spot a couple of inches in diameter on one side of his head. When Clinical Kinesiology testing indicated an imbalance of his liver and thyroid, both were treated with acupuncture and specific nutrients. Tom's hair began growing back almost immediately.

In another case, Stan, a middle-aged man with thinning hair, experienced two serious episodes of stress involving an impending divorce and the death of a friend. Suddenly, his hair began falling out in handfuls. In Stan's case, the Clinical Kinesiology test determined that his kidney was the culprit.

As noted, hair loss may stem from a number of different organ weaknesses, or a combination of more than one. During Clinical

Kinesiology testing of actual bald areas, the individual touches the scalp or area of concern. Then, the Clinical Kinesiology test may be performed to determine which organ is involved.

Many times, hair loss and other negative health factors stem from the cumulative effects of prescription drugs, poor nutrition, hormonal changes, or physical and emotional stress. It's that same old pattern of emotional stuffing—men holding in emotions which in turn stagnate the energy of an organ.

Additional remedies for hair loss include supplementing with antioxidant vitamins A, C, E, and biotin (which promotes both growth and strengthening), along with the mineral, silica, rich in the herb, horsetail.

DEPRESSION

Despise no new accident in your body, but ask opinion of it.
FRANCIS BACON

An increasing number of men in the twenty to forty age group experience serious depression. The first questions to ask regarding depression are what's going on in these men's diets? Are they, like the hyperactive child, consuming sugar, coffee, artificial sweeteners, soda pop?

Along with hyperactivity, depression often stems from underlying imbalances in the hypothalamus and associated organs which may be confirmed through Clinical Kinesiology testing. Treatment involves acupuncture and supplementation with Core-Level™ Brain/Spinal™ by Nutri-West® or other brain glandulars. Homeopathic drops may also be used for depression and anxiety, including specific Anxiety Drops, Anti-Depression Drops, and Neuro-Calming Drops by Professional Health Products. (See Product Guide.) In addition, homeopathic drops are available for insomnia, also a symptom of depression.

While homeopathics and nutritional supplements may be used as helpful assistants, emotional health stems from lifestyle and body balance. Help is readily available; however, many men desperately need to learn how to balance their obsession for work with a more healthy, stress-reduced lifestyle.

Scott, a courier for a huge Colorado aerospace company reported for work one morning. Without notice, his boss informed him, "You're going to Washington, D.C." An envelope was thrust into his

hand with orders, "You are not to sleep while this is in your possession." No hotel room. No sleeping on the plane. Scott was warned not to let the top secret document out of his sight until he delivered it. Scott routinely made cross-country trips several times a month, at all hours of the night. It wasn't surprising that Scott developed increasing anxiety and depression after a year on the job.

Logic should tell Scott's company and its employees that something needs to be drastically reorganized, or a more healthful plan implemented to keep important people healthier longer.

In *The 7 Habits of Highly Effective People*, Stephen Covey relates the old fable of the goose that laid the golden egg. As the story goes: A farmer discovers a magic goose capable of laying golden eggs. Unsatisfied, the greedy farmer kills the goose to get all the golden eggs at once. Covey admonishes those businesses who continue to kill the goose—the good employee—simply to get the golden eggs.[2]

In today's world, sometimes you can't fight, you can't flee. The only way out is to learn to flow.
ROBERT ELIOT, M.D.

When the body balks, men are told, "Don't pay attention...just keep on going." The body then wears down and men succumb to stress, depression, cardiovascular disease, stomach upsets, or cancer, and they die at much younger ages than their female counterparts.

The irony of it all? In fifty years, will anyone remember all the blood, sweat and tears that men have shed as a result of the pressures of their jobs?

ULCERS

The first symptoms of an ulcer involve an irritated stomach, or gastritis. The stomach simply doesn't feel good. "Stressed executive" often equals stomach pain. "Ah," the man complains, "I think I've got an ulcer." He schedules a visit with a doctor who may or may not recommend an upper gastrointestinal examination to confirm the problem. More than likely, the doctor recommends a pill or antacid drink to coat the stomach. Unfortunately, the antacid also slows down digestion, and guarantees that the man will no longer absorb any minerals out of his food. While it may placate the body into thinking the stomach feels better for a little while, what's really needed is *more acid*...for digestion.

Few doctors test to evaluate, "Is there enough stomach acid? Too little? Is digestion functioning properly?" No, the stomach may be slightly upset, so the first thing doctors prescribe is an antacid.

Many men (as well as women) require extra hydrochloric acid, the natural acid produced in the stomach, to aid digestion. Otherwise, poorly or slow digesting food may become an irritant to the stomach lining. Taking antacids compound the problem, leading to an endless cycle that can quickly develop into an ulcer. *From my own personal case studies tested with Clinical Kinesiology, most of the people who develop an ulcer are the ones who have been taking antacids for a long period of time.*

Every now and then medical journals publish a new study that touts, "OK, now we've really figured out the cause of ulcers. It's a bacteria in the stomach. We'll call it helicobacter pylori." However, if the stomach contains enough hydrochloric acid *bacteria couldn't grow in the system in the first place.*

Do not attempt to stop your stomach from making acid. Many people (doctors included) are unaware that stomach acid remains a critically important factor in digestion and immunity. Strong stomach acid kills bacteria and prevents illness. It's supposed to be there.

My Clinical Kinesiology practice includes a specific test to determine if enough Hydrochloric acid exists in the stomach. Refer to the end of the chapter for self-testing procedures.

HIATAL HERNIA

What are the main reasons so many men don't make enough hydrochloric acid? Excessive stress, overeating or eating too fast, not relaxing over an enjoyable meal are several contributing factors. A hiatal hernia is another.

An umbrella-shaped muscle, the diaphragm separates the thoracic cavity which holds the heart and lungs from the abdominal cavity, containing the intestinal tract. The diaphragm also includes an opening through which the esophagus connects with the stomach. This area is called the hiatus.

Pressure on the stomach often pushes it against the diaphragm. Then, the stomach may begin protruding through the hiatal opening into the esophagus triggering a condition known as a hiatal hernia. As a result, the hiatus can no longer prevent stomach contents—including strong acids—from moving upwards.

Symptoms of a hiatal hernia include a full feeling, heartburn and possible chest pain. Men who suspect this condition should specifically avoid overeating, spicy and fried foods, coffee, carbonated drinks and alcohol. To lower the risk for hiatal hernia, more fiber should be added to the diet in small meals throughout the day. Also avoiding drinking liquids during meals to allow for better digestion.

Physical manipulation of the stomach by a trained practitioner may release pressure on the hiatus. In addition, specific reflex and acupoints may be stimulated to help rebalance the process and retain function. Additionally, the stomach meridian may also need rebalancing.

Relief for hiatal hernia may be obtained through extra hydrochloric acid, supplemental digestive enzymes, vitamin B complex, liquid chlorophyll and aloe vera juice.

BURPING, BELCHING, BLOATING

In addition to hiatal hernias, many men suffer from burping, belching, and bloating, or a gassy overly-full feeling, after eating. If this condition lingers for an abnormally long period of time, it's probably an indication that the meal hasn't been properly digested. Again, additional hydrochloric acid may be needed.

A true wellness program goes far beyond traditional health education and preventive medicine. It involves learning about yourself and why you tend to make the choices you do.

DR. GRANT CHRISTOPHER

People who experience diarrhea or vomiting also benefit from extra HCL. A female patient, Renee, suffered from diarrhea for a full year before obtaining treatment. She began to take two hydrochloric acid tablets after each meal, and the diarrhea went away. So, many aspects of digestion may be affected.

A gentian herb, known as herbal bitters, may also stimulate the body to make more hydrochloric acid. Bitters can be found in most healthfood stores. Also, apple cider vinegar and other fermented foods, such as sauerkraut and miso, prove to be important digestive aids which inspire helpful bacteria to grow.

HEMORRHOIDS

Men are especially susceptible to hemorrhoids—enlarged or varicose veins in the lining of the rectum. Men commonly require more

treatment for bleeding, protruding tissues, itching, mucosal discharge, discomfort and pain than do women. Because of embarrassment, fewer men seek help for hemorrhoids resulting in a progression of symptoms and discomfort.

I saw few die of hunger—of eating, a hundred-thousand.
BENJAMIN FRANKLIN

Although women are also prone to hemorrhoids, men generally practice dietary and lifestyle factors which more often predispose them to hemorrhoids. Lifestyle factors which lead to hemorrhoids include excess caffeine intake—including coffee and soda pop—which irritates the kidneys. Improper digestion of proteins leading to constipation is another factor that promotes hemorrhoids. Constipation also means added back pressure which compounds distention of internal and external veins.

As with hernias, hemorrhoids most often occur in response to imbalances of the Kidney Meridian, which energy flows directly through the rectal area. Along with stroke, heart attack, and other vein problems, hemorrhoids may also be related to Heart and Circulation/Sex Meridians.

In general, recommendations for treatment include a high fiber diet including whole grains, vegetables, nuts, grains, and seeds. (This diet greatly diminishes the risk of chronic constipation.) In addition, good quantities of fluids (juices and pure water), along with a daily teaspoon of organic flaxseed or other healthful oil also help reduce the inflammation of hemorrhoids. Vitamin C with bioflavinoids, vitamin A, beta-carotene, B-complex and zinc are also beneficial. For immediate relief, sitz baths and Epsom salts baths reduce pressure and inflammation of hemorrhoids.

Treatment may also include stimulation of acupuncture points on the Kidney Meridians, specific kidney nutrients, homeopathic remedies for inflammation or specific herbal formulas for hemorrhoids. Also, rubbing the crown of the head is often helpful.

A.J.'s Story

A.J. developed a coffee-caused hemorrhoid problem at the age of thirty-five. The more incessantly he drank coffee, the more stressed his Kidney Meridian became. A.J. even underwent surgery to repair the damaged tissue; however, he continued to experience constipation and other kidney-related ailments.

Once he was finally able to give up coffee he began using a magnesium/oxygen supplement called Oxyflex® to ease his

constipation. Without the coffee he managed to avoid irritating his kidneys any further and the hemorrhoids began to heal.

MEN'S DIETS

Diet remains the root of so many male health problems. Men in the twenty to forty-year-old age group routinely pay less attention to their diets than women do. When looking at broad generalizations and parameters, it's fairly appropriate to say that men don't often take a great deal of responsibility in diet decision-making or family meal planning. The question that more men need to address is, "Am I eating this because it's good for my body, or simply because it appeals to my tastebuds?" Many men are easy targets of the fast-food world. Under pressure in the job, driving here and there, busy men may only have a short time for lunch. They want something quick, and don't want to have to cook it! Thus, some men eat on the job or while they drive to the next appointment. This need for "convenience" lures them into fast-food chains more than any other group. That in itself is an occupational hazard!

It's well documented that fast foods contain more high-fat/high-salt content and overcooked fats (believed to be carcinogenic) than other foods. As of late, many fast-food restaurants have amended their menus to include healthier items; however, from what I see of men in regards to their health and diet when they come in for treatment, most of the them don't seem to be ordering those healthier items.

Men would do well to start bringing their own healthy lunches to work, possibly leftovers from the previous night's dinner or some healthy, wholesome foods. Frequenting a salad bar or other more naturally-orientated type of restaurant or healthfood store can make a big difference.

As a nation we have come to believe that medicine and medical technology can solve our major health problems. The role of such important factors as diet in cancer and heart disease has long been obscured by the emphasis on the conquest of these diseases through the miracles of modern medicine. Treatment, not prevention, has been the order of the day.

PHILIP LEE, M.D.

INFERTILITY

The basic level of diet and health have also been linked to today's steadily increasing infertility rates among both males and females. Infertility remains an emotionally charged issue. Fifty percent of the

time, the reason a couple cannot conceive has been traced to the man. Often, it's hard for men to admit, "Maybe there's infertility because something is out of balance in my body."

In *The Wisdom of Amish Folk Medicine* by Patrick Quillin, Ph.D., R.D., it is reported that folk medicine from this German sect suggests that both men and women should consume a daily tablespoon of carrot seed oil and wheatgerm oil. This oil is concentrated in vitamin E, which does help the reproductive system and process.[3]

The Amish also recommend that men consume large amounts of alfalfa sprouts, which provide minerals, enzymes and other concentrated nutrients. Various other remedies include eating pumpkin seeds or taking a daily zinc supplement. Additional vitamin B_{12} up to 6,000 micrograms is also beneficial. Other recommendations include adding vitamin C, or the amino acid L-Arginine to the diet.

A healthy diet does have a significant impact on the male reproductive system. With a poor diet today, a man's body has a difficult time simply struggling with it's own health. When asked to deal with reproduction, it doesn't have the strength or stamina to produce the right balance of substances necessary to procreate.

The Potenger Study

Dr. Francis Potenger conducted a pioneering study of dietary effects on cat mortality in the 1940s.[5] Potenger fed one group of cats devitalized, dry, commercially-produced cat food. Another group was fed an all natural, raw meat diet along with a tiny bit of vegetable matter, similar to the diet of a cat in the wild. Potenger then studied the cats for several generations. The results of the experiments indicated that the synthetically fed cats produced a significantly lower number of second generation kittens with lower birth weights than the naturally fed cats. The longevity of the adult cats was also shorter with the synthetic diet; their infant mortality rate was significantly higher than that of the cats fed the natural diet. After only three generations of eating synthetically produced foods, all the cats died out. The naturally fed cats on the healthy diet maintained the same birthrate throughout the three generations.

Among the findings, Dr. Potenger concluded that the diet of the parents genetically altered the offspring. Genetically weakened offspring result in a decline of strength and less aptitude for healthy procreation. Applying these findings to human males, the

extrapolation is that infertility may stem from the current diet and from diet patterns passed down genetically through an individual's parents.

A study in the *British Medical Journal* which evaluated sixty-one studies from 1938 to 1991 reported that sperm counts have dropped fifty percent over the last fifty years. The study cited lifestyle factors, diet, the use of prescription drugs (Tagamet® is specifically documented), toxic chemicals, and even synthetic clothing as primary causes for lowered sperm count.[5]

Bitter Herbs

Herbs that combat infertility include saw palmetto which helps increase sperm count and sperm motility, burdock, ginseng, licorice root, hawthorn, ginkgo, gentian, sarsaparilla, mugwort, yarrow, wild yam and goldenseal. Bitter herbs, such as gentian, mugwort, yarrow and goldenseal are listed in *The Male Herbal* by James Green, who discusses the importance of using bitter flavors in a healthy culture.[6]

People in the U.S. culture avoid bitter tastes, however. Many addict themselves to beer, coffee and chocolate as a result of few opportunities given to eat bitter foods. In these cases, sugar is added to the mix, making the bitter unhealthy.

Green correlates the bitters with the Chinese Five Element Theory, stating that bitter herbs are specifically beneficial to the Fire Element containing the Heart Meridian or cardiovascular system, and the Circulation/Sex Meridian, which regulates hormonal production in the body.

Further treatment for infertility as a result of imbalances in the male glands and organs may require acupuncture, and nutrients for building up the tissue and health of the testicles and prostrate, specifically.

There is no cure for birth and death save to enjoy the interval.
GEORGE SANTAYANA

VASECTOMY

While infertility poses problems affecting men and women equally, family planning has long been an issue relegated to women. Then, in the 1970s a new surgical procedure promised men more control, more responsibility in family planning and birth control. Millions of

men rushed to have vasectomies performed. Today, however, important new health issues are coming to light regarding vasectomies that need to be addressed for men.

Doug's Story

Doug and Veronica both agreed that he would undergo a vasectomy after the birth of their third child. The fairly painless procedure took only minutes and Doug went home from the clinic feeling fine.

About a year and a half later, however, Doug began to notice extreme weakness and obvious weight loss. As the months went by, he began to feel sicker and sicker. Friends and acquaintances were shocked at Doug's decline in health. His wife became alarmed to the point where she felt he must be suffering from a serious undiagnosed cancer.

Together, Doug and his wife consulted doctor after doctor. None could pinpoint the problem. Eventually, he became so concerned that he put himself on the Gerson Cancer therapy program.[8] He detoxified his body, ate a macrobiotic diet, but nothing worked. Doug was dying and no one knew why.

Finally, Doug visited a female colleague of mine who suggested that Doug may have become allergic to the sperm build-up in his body as a result of his vasectomy several years before. She urged him to have the vasectomy reversed, which he did. At once, Doug's immune system recovered and he began to get well.

Dangers Of Vasectomy

The safety of vasectomy has yet to be determined. First of all, vasectomy is surgery, and complications and the risk of side effects exist with any surgery.

In a normal male, sperm is continually being made in the body. With vasectomy, the body retains the sperm, which now has no normal route out of the body. In turn, the sperm may now build up in the system. Seminal fluid build-up may then prompt the body to begin manufacturing antibodies against its own sperm. Reacting as though the sperm isn't a friendly or normal function or tissue, the antibodies cause some men to become quite ill. Such a chain of events may lead to environmental illness, immune system disorder, and serious auto-immune problems.

Men who have undergone vasectomy may also be more vulnerable to impotence in later years. Although impossible to predict, it is something that also needs to be monitored closely. Again, vasectomy should not be undertaken lightly. Every man needs to weigh the potential risks and problems that could develop before undertaking this or any other surgery.

Natural Treatment For Vasectomy Scars
In cases where scar tissue develops, treatment includes concentrating a large, soft laser on the scar, which helps diminish any further perineal scarring. In addition, rubbing vitamin E oil over vasectomy scar tissue nightly, allowing the oil to soak in, is helpful especially where there's been an incision. Castor oil packs are also useful when heated a bit.

Acupuncture may also be used directly on the surgical incision or any other large cut that's healed. The nutrient superoxide dismutase may also be used to combat the formation of scar tissue.

DETOXIFICATION: FOR ALL MEN

The most common men's health problems involve the male genitourinary system. Disorders include impotence, complications from vasectomy, enlarged prostate, prostatitis and prostate cancer. As these growing health concerns are imperative to the complete health of the male body, they must be readily addressed.

With many types of male infertility or other health problems, one of the first things a man needs to do is detoxify his "total" body. Various helpful cleansing methods and flushes exist, for which men may want to refer back to the women's chapter on PMS.

Toxicity takes so many forms. Food sensitivity, metal toxicity, mercury fillings, lead poisoning, or occupational hazards which expose workers to various toxins on a daily basis need to be addressed. Men who labor in heavy industry, in mechanical trades, in chemical labs, or near asbestos, or in plants where chemicals are used on the job need to be aware of the risks.

Traditionally, men are exposed to more chemical hazards than women. There are homeopathic remedies to purge toxic chemicals out of the system. Another remedy, Metex by Professional Health

Serious illness doesn't bother me for long because I am too inhospitable a host.
Dr. Albert Schweitzer

Products, Ltd. is good for purging heavy metals. (Refer to the product guide at the end of this book). Clinical Kinesiology testing may be used to test for particular heavy metal toxicity and to see which homeopathic remedy works the best.

Although many health problems have a basis in toxicity, it's only one piece of the puzzle. Detoxification specifically helps promote the highest level of health and longevity possible. On a daily basis, it's a protective measure also.

My male clients ask, "Should I detoxify for one month, six months, a year?" I tell them there is no magic number: "You must detoxify until your body is clean." Some preparatory work in detoxification includes drinking huge quantities of fresh, pure water.

The liver remains one of the most important organs that benefits from detoxification. Dandelion root and milk thistle herbs prove to be powerful, simple steps that can be taken to ease the way into a longer, more specific detoxification plan. Again, you may want to refer to Chapter Nine, *Premenstrual Syndrome*, for more information and specific cleansing procedures.

SAUL'S STORY

Saul was a man deeply in need of detoxification. One Friday afternoon he hobbled into my office hoping to get some relief from severe knee pain before playing in a weekend golf tournament. In addition to his painful knees, Saul's Clinical Kinesiology test indicated prostate problems.

For three or four successive Friday afternoons, Saul's treatment entailed stimulation of acupuncture points on his Liver Meridian along with herbal supplements. As always, he jovially looked forward to his upcoming golfing weekend. Each week, as Saul slid off the treatment table he'd casually remark, "Gotta go...I have to pick up a case of beer for the cookout before tomorrow's game."

"Mmmm," I began thinking, "Saul drinks beer after each treatment and comes back still complaining of the knee and prostate. We're not getting anywhere here."

Finally, I suggested that Saul attempt a few weeks without drinking beer to reestablish balance of his liver and allow us to work more effectively on his prostate, since treatment of these two go hand in hand.

Saul never came back. Ultimately, that was his decision to make. Each person's response is influenced by his own priorities. Only Saul could decide what was truly important as far as his own individual health and well-being.

STAGE THREE: AGES 40 AND OVER

IMPOTENCE

Impotence currently affects over ten million men in the United States. Although it is not solely a problem of men over forty, it will be considered here because it has been traced to prolonged usage of prescription drugs, high blood pressure, arteriosclerosis, prostatitis, diabetes, Multiple Sclerosis and Parkinson's disease—problems found more often in the older man. In cases where impotence becomes a factor in infertility, I consistently find a strong link to imbalances of the Kidney Meridian.

Poor food choices produce poor health.
CHERYL TOWNSLEY

An estimated eighty percent of impotence may also be related to emotional or psychological imbalances, including low self-esteem, performance anxiety, and depression.

Following Clinical Kinesiology evaluation, stimulation of Kidney Meridian acupoints, specific herbal remedies for impotence may include: yohimbe, ginkgo biloba, muira puama, saw palmetto and ginseng.

PROSTATE

An important centrally located organ in the male energetic system is the prostate gland. Endocrine dependent, the glandular system must be working effectively to keep the prostate gland functioning well.

Proper prostate function begins with the hypothalamus, which represents the part of the brain that controls the pituitary gland. In turn, the pituitary regulates other glands and sends messages to the thyroid. The chain of command is: hypothalamus to pituitary to thyroid to prostate...etc.

The size of a walnut, the prostate secretes a milky protein fluid which is discharged into the urethra during the emission of semen. This fluid then mixes with the semen to transport the sperm out of the body. Generally, the prostate has a thick, muscular wall. During enlargement of the prostate, a hypertrophy or thickening of the prostate wall causes it to become much larger than usual.

By age fifty, nearly thirty percent of men may begin to notice problems with urination due to prostate imbalances. Because the prostate surrounds the lower bladder and upper urethra, symptoms of prostate enlargement involve more frequent urination, a slowing or change in force of urine stream, incontinence or dribbling.

Medical doctors often perform a "transurethral prostatectomy" (TURP) procedure which temporarily relieves symptoms of an enlarged prostate. An electrified blade "scores" out the central part of the prostate and the obstructing tissue is removed in an attempt to make a larger space for the passing of urine through the urethra. This procedure is traumatic and not necessarily successful. Complications can include sexual dysfunction and scarring of the urethra causing recurrent blockage. Men who've gone through it once often end up having it done again. And, again.

Imagine a prostate with tissue out of balance, added pressure from constipation, insufficient circulation in the pelvis, and nutritional deficiencies. It all adds up to prostate problems.

The prostate gland does not have its own acupuncture meridian. Rather, it shares energy with the Liver Meridian, which traverses both sides of the body, with two halves crossing over in the mid-pelvic area.

As one views the male and female body anatomically, the organs are basically the same. Both male and female have a single organ in the mid-line of the body—the prostate in males and the uterus in females are analogous or comparable organs. Each of these organs shares the Liver Meridian with the liver.

The prostate is also a gland which makes hormones. (In my opinion, many of those hormones have yet to be discovered.) A relationship in women (mentioned in the PMS and Menopause Chapters) exists between the thyroid and the uterus. Although more clinical research is needed, I believe a corresponding relationship is also likely to exist between the thyroid and the prostate in men. Because the uterus and prostate are analogous organs—same location, same

hookup to the meridian system and the nerves—it's logical to assume the same relationship exists in both sexes. Helping a man's thyroid likely helps his prostate.

Lyle, an eighty-year-old patient, has had two surgeries to reduce the enlargement of his prostate. Prior to the surgery, he had been on thyroid medication for many years. In my opinion, the thyroid weakness contributed to his prostate problems to some degree.

Lyle now takes an herbal/vitamin-based nutrient with good success. In fact, on his last medical evaluation, his ultrasound showed no increase in the enlargement of his prostate gland.

One mineral especially helpful for the prostate is zinc. Men typically need more zinc than women. Acne or other skin lesions can be traced to a zinc deficiency.

Signs of a zinc deficiency include white dots on the fingernails, low resistance to infection and immunity problems.

Prostatitis

The Male Herbal contends that," Men push their worries into their prostate."[8] Indeed, a common prostate problem is prostatitis, caused by inflammation or infection of the prostate, which may be irritated by cold, dampness, prolonged sitting, excess alcohol, caffeine, or hot spices.

What we nurture in ourselves will grow; that is nature's eternal law.
GOETHE

Symptoms of prostatitis include difficulty in urination including frequency or urgency, muscosal discharge from the urethra, along with a burning sensation. Severe symptoms may involve pain and tenderness, pressure or throbbing in the rectal area, fever, chills, and general fatigue. Prostatitis may occur due to bacteria in the urine or auto-immune disorders stemming from a lack of zinc, vitamin C, and specific enzymes which thwart infection.

Although huge doses of antibiotics remain the standard medical treatment for prostatitis, simple, natural measures work just as well, and do not lead to other problems from the medication. For many cases of prostatitis, goldenseal herb proves wonderfully healing. The herb echinacea works as an immune system builder for prostate infections and inflammations, along with pipsissewa, uva ursi, and horsetail.

Saw palmetto remains a good preventive herb for enlarged prostate and prostate infection. Men who are suffering from any prostate problems should begin taking saw palmetto on a daily basis for an

indefinite period of time. This herb specifically nourishes the prostate and increases its health and resistance to disease. Saw palmetto is available in capsule or tincture form, along with combinations of other nutrients.

Prostate Cancer

In 1995, the second leading cause of death in men (following skin cancer) was prostate cancer. Over 35,000 men lose their lives each year, while 165,000 more develop the disease during the same period.

How do men develop prostate cancer? It's not a condition that suddenly sneaks up and appears one day. With few detectable physical symptoms, prostate cancer stems from an energetic imbalance and improper function, poor nutrition, poor circulation, and genetic and hormonal factors which disallow prostate health. Healthy prostates do not develop cancer. They must first become unhealthy, be debilitated and function improperly to allow cancer to take hold in the body.

Poor diet has been linked as one major cause of prostate disease. Anyone with prostate problems should avoid caffeine, alcohol, spicy foods, tobacco, high-fat, high-carbohydrate foods. Also, avoid prolonged sitting. Such periods of inactivity result in a weakening of muscles of the pelvic floor, which proves harmful for the prostate. Poor nutrition, poor circulation and electromagnetic imbalances which go unaddressed lay the groundwork for the types of serious imbalances which support cancer. In early stages, the prostate may contain only a few cancer cells. Normalizing any prostate problem early, and getting that organ as functional as possible, protects from cancer developing or taking hold. The job of a healthy immune system is to purge cancer cells out of the body.

Natural methods do exist to rebalance the prostate gland and return it to normal function. The book *Third Opinion* by John M. Fink provides options to standard chemotherapy or radiation treatment. The author offers a listing of holistic health cancer clinics all over the world including the Hoxsey Cancer Clinics.[9] The late Harry Hoxsey, N.D. developed successful alternative cancer treatments still used today.

Preventive therapy remains the key to a healthy prostate. Don't risk being examined at a local health fair at age fifty-five and being

told, "Your prostate feels abnormal." Instead, from ages twenty to forty concentrate on maintaining a healthy diet, exercise, stress-free lifestyle, and preventive therapies, including Clinical Kinesiology testing to assure that the organs and energetic balance of the prostate remains healthy for life.

Healing The Prostate

Healing the prostate often requires treatment of the Liver Meridian, which may be strengthened by acupuncture, along with specific vitamin and herbal supplements. B-complex, vitamins C, D, E and garlic are crucial to prostate health. Essential fatty acids, including flaxseed oil which contains a good balance of Omega 3, 6, and 9, also foster good hormonal balance.

Let not your heart be troubled.
JOHN 14.1

For its antibacterial and cleansing effects, men need more of the mineral zinc, found in high concentrations in seminal fluid. As semen leaves the body, the zinc concentration in the body becomes depleted. Calcium, copper, iron, potassium, magnesium, selenium, silicon, and sulphur are also recommended.

The prostate may also be strengthened with oregon grape, echinacea, uva ursi, couch grass, saw palmetto, pipsissewa, cornsilk, marshmallow, comfrey, horsetail, hydrangea root. Also, milk thistle, dandelion root or a combination of the two. In addition, beets and beet greens and juice, carrots and carrot juice are natural cleansers.

Besides the herb saw palmetto, the nutrient compound Prosta-X™ by Nutri-West®, and Palmetto-Plus by Biotics, as well as other male glandular supplements are also available for the prostate. A sometimes difficult-to-find herb known as flowering willow herb, from an old European treatment for prostate enlargement, is common in Europe and thought to be wonderful for the prostate.

Exercises for the Prostate

The following three-part Kegel exercise has been used by many men to stimulate circulation, restrengthen the pelvic floor and rebalance the prostate.

Exercise Position: Lying down on your back, raise the pubococcygeal muscle or PC muscle, (which runs from the pubic bone to the coccyx) by raising the lower back and the back of the pelvis off the ground.

- Attempt to contract the PC muscle up into the body for a slow, clenched count of three and then relax.
 Or,
- Rapidly clench and relax the PC muscle as quickly as you can.
 Or,
- Push or bear down with the PC muscle using moderate pressure for a count of three, and then relax.

Begin with only a few repetitions daily and build up as you build muscle strength.

Massage

While the simple exercises above strengthen the pelvic floor muscles, men may also massage the deep muscles around the perineum in the lower abdomen between the scrotum and rectum with the thumb or forefinger.

This massage may be done regularly as a preventive measure; however, it is not recommended during cases of prostatitis as it may spread the infection. In combination with massage, I suggest use of a natural progesterone cream, or wild yam root to augment the healing.

Sitz Baths

Another method of relieving pressure around the prostate involves taking hot and cold sitz baths. Alternating hot and cold water baths, similar to applying a hot and then a cold pack, affects the prostate and can be helpful.

One source suggests using a plastic basting syringe to insert the water into the rectum, which is in close proximity to the prostate. Be sure to first test the hot water on the skin so it doesn't burn delicate tissues.

Kegel exercises, massage, and sitz baths are some of the easiest self-help remedies to heal the prostate. Also, be sure to check the Liver Meridian, apply acupressure, and work on any tender points that may be found. Or, once acupuncture points are treated professionally, follow up by rubbing those points on your own. You can use these simple procedures to strengthen weak organ systems and thus achieve added vitality and the ability to ward off specific diseases.

SELF-TESTING THE MALE ENERGETIC SYSTEM

Prostate Test

Following self-evaluation of prostate symptoms, utilize the aid of a partner/tester to follow up with a Clinical Kinesiology therapy localization over the prostate area.

Before performing any Clinical Kinesiology muscle test, a preliminary Indicator arm muscle test should be completed. See Chapter One for instructions.

Following confirmation of a strong Indicator muscle, the Prostate test may be done by having the test-subject place one hand over the lower front abdomen. (Since this area is also near the bladder, any bladder problem may also present a positive test.) As the person being tested touches the area, the tester performs the muscle test on the test-subject's opposite Indicator arm:

We must be willing to deal directly with our disease. This means learning about it, and learning what adjustments in lifestyle may be required to control it—in short, taking responsibility for our body and our disease.

DR. MITCHELL LEVY

Prostate TL + Muscle test + Strong arm = no current prostate or bladder imbalance.

Prostate TL + Muscle test + Weak arm = possible prostate or bladder imbalance. Seek guidance or further testing from a natural health practitioner.

If you're unsure of the prostate test results, obtain a good quality saw palmetto herb in capsule or tincture. *If therapy localization over the prostate rendered the indicator muscle weak*, retest while holding the herb over the same area.

> Prostate TL With Saw Palmetto + Muscle test + Strong arm = Prostate needs supplementation with the herb. Bladder problem is no longer the issue.

As always, any positive self-test including symptoms should be followed up with professional evaluation by a natural practitioner or other physician.

Hypothalamus Test

Depression, hyperactivity, and impotence may be pinpointed by self-testing the hypothalamus.

Use two fingertips (the index and third finger) which cover a larger area than one finger. Place them mid-line on the forehead between the eyebrows and over the hypothalamus and perform the Clinical Kinesiology muscle test.

> Hypothalamus TL + Muscle test + Strong arm = no current imbalance.
> Hypothalamus TL + Muscle test + Weak arm = imbalance of hypothalamus. Consult a trained natural health practitioner for further testing and treatment recommendations.

Hydrochloric Acid Test

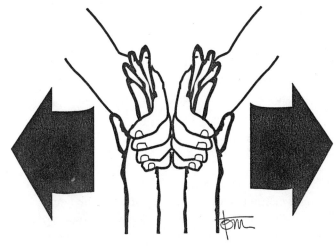

To evaluate the need for additional hydrochloric acid/HCL or to check for less than optimal digestion, perform a bi-lateral, pectoralis major muscle-strength test. This test is best done lying flat on the back. It's difficult to obtain an accurate test while standing.

Once the test-subject is lying down, ask him or her to place the back sides of the hands and wrists together, with the elbows straight. Instruct the person being tested to hold the arms perpendicular to the body or at a ninety degree angle. While the person being tested attempts to maintain the backs of the hands together, the tester firmly tries to pull the hands apart, or separate them.

HCL Pectoralis major test + Muscle test + No hand separation = no HCL supplementation needed.

HCL Pectoralis major test + Muscle test + Hand separation = need for HCL supplementation. *As a double check, place a bottle of HCL on the stomach after an initial weak muscle test. Retest with the HCL in the energetic system of the body. If the hands remain closed with the HCL, it's confirmation that the stomach requires more hydrochloric acid for digestion.*

The pectoralis major is the group of muscles being used to control the hands. Any hydrochloric acid deficiency may be pinpointed in this way. Dr. George Goodheart originated the pectoralis major test during the formulation of Applied Kinesiology.

Along with hydrochloric acid, a number of digestive enzymes may also be tested in the energetic system to further pinpoint one or more combinations of supplements.

HEALTH IS YOUR BIRTHRIGHT

The next major advances in health of the American people will come from the assumption of individual responsibility for one's own health and a necessary change in lifestyle for the majority of Americans.
JOHN H. KNOWLES, M.D.

Vibrant health stems from a harmonious balance among structural, chemical, and energetic components of your whole being. Your body remains the ultimate source of information about your health. Clinical Kinesiology energetic testing has given you but a glimpse of how your body can talk. Your healing biocomputer constantly relays new information about your body's current state of function. Are you listening?

Remember, a natural solution exists for almost every health condition. Your lifestyle determines your quality of life, and the robust state of health that you will enjoy for years to come depends upon your choices today.

As you learn to accept new responsibility for your health, include into your lifestyle those healthy measures that strengthen and heal the correct organs. Keep your energetic system moving forward and realize the radiant and miraculous health that is your birthright.

CHAPTER ELEVEN SUGGESTED READING

Airola, Paavo M.D. *Stop Hair Loss*. Sherwood, OR: Health Plus Publishers, 1994.

Biser, Sam. *Save Your Prostate*. Charlottesville, VA: University of Natural Healing, Inc., 1993.

Chaitow, Leon D.O., N.D. *Prostate Troubles*. Wellingborough, England: Thorsons Publishers Ltd., 1988

Covey, Stephen R. *The 7 Habits of Highly Effective People*. New York: Fireside, 1990.

Feingold, B. *Why Your Child Is Hyperactive*. New York: Random House, 1975.

Fink, John M. *Third Opinion*. Garden City Park, New York: Avery Publishing, 1992.

Flatto, Edwin M.D. *Super Potency At Any Age*. New York: Instant Improvement Inc., 1991.

Gerson, Max, M.D. *A Cancer Therapy: Results of Fifty Cases*. 5th edition. Bonita, CA: Gerson Institute, 1990.

Green, James. *The Male Herbal*. Freedom, CA: The Crossing Press, 1991.

Kulvinskas, Viktoras. *Survival Into The 21st Century*. Fairfield, IA: Omangod Press, 1975.

Murray, Michael T. N.D. *Male Sexual Vitality*. Rocklin, CA: Prima Publishing, 1994.

Quillin, Patrick Ph.D., R.D. *The Wisdom of Amish Folk Medicine*. North Canton, OH: The Leader Co, Inc., 1993.

Afterword

ORGAN MEDITATION

IT'S WISE TO DO something healthy for all of our organs every day. You may want to seek the assistance of a holistic practitioner for guidance. However, in addition, an effective daily practice may involve spending a few moments meditating and visualizing each of your organs or organ systems surrounded by strong energy, in perfect balance and happy.

You may choose to work on specific organs at specific times, especially if symptoms have manifested and you want to focus on an individual organ. Or, you may use the meditation to relax, rejuvenate and renew the energy of all your organs together.

Simply have a friend read these instructions while you lie quietly and relax. Or, use your own voice to tape record the instructions, preferably with some soft, soothing music playing nearby.

PREPARATION

Prepare yourself for the meditation by doing a few moments of soft, deep breathing. Breathe in through your nose, fill your lungs completely and

breathe out through your mouth. As you breathe, gently stretch the muscles of your whole body, relax and be at peace.

You may also want to picture yourself in your favorite place. For example, see yourself in a green mountain meadow surrounded by wildflowers, the dramatic blue sky and puffy white clouds above. Or, imagine yourself on a sandy beach with the ocean waves lapping just inches away, a bit of sea spray sprinkling your body.

As you address each organ individually, visualize one harmonious symphony of organs and body parts interacting, being energized and helping you to be a more functional, healthy, happy, and whole human being. As you proceed, you may also want to characterize each organ with a particular color, or specific facial characteristics, smiles, or features of your favorite animal. Take as much or as little time as you need to fully recognize each organ during your meditation.

We offer this Organ Meditation as a lasting gift to help you become more healthy in body, mind and spirit. We hope you will call on this Organ Meditation at any time or in any place to help yourself along your healing journey.

THE MEDITATION

In order to permanently eliminate a condition, we must first work to dissolve the mental cause.
LOUISE L. HAY

In the event that you are missing one or more of your body parts, acknowledge the loss calmly and quietly. However, do something extraordinary! Visualize the organ or body part as being intact, healthy, and revived. Know that in your energy body, the energetic aspect of that organ is still alive!

Allow that missing organ to express itself through all your thoughts and meditations. Encourage the energy essence of that missing part to continue to play a role in the symphony of organs.

Begin your organ meditation with the pituitary gland, a small gland in the upper forehead. In your mind's eye, see it being enveloped in white light, radiating peace and well-balanced energy. Envision your pituitary as stable, strong, and functioning perfectly. Take several deep breaths as you focus on your pituitary and its role as a master gland in your healthy body.

After a minute or two, move your focus down midway between the eyebrows to the hypothalamus. Watch the hypothalamus, your

wonderful air traffic controller, directing and regulating traffic, and helping your whole energetic system to function effortlessly. Allow all thoughts to surround your hypothalamus as you relax and release your healing energy upon it.

With a calm spirit, enter inside your mouth. Notice and acknowledge your tongue and vocal chords. Know that these organs are a part of your body's deepest expression. See them well balanced, fully functioning and connecting to the thyroid as you experience complete access to all your emotions. Relax and breathe deeply.

Using imagery to designate something gentle yet strong, explore the beautiful butterfly-shaped thyroid at your throat. This powerful gland rules over your metabolism and many other important functions. See it smiling and fluttering, working well, producing its hormones, connecting to the other glands and helping them to maintain correct balance. Notice your body giving complete trust to your organs as they heal and energize one another.

Slowly, move down and discover the trachea, bronchial tubes, and lungs. Notice this entire airway filled with light. Feel it breathing the essence of life in and out of your body. Quietly experience this entire area with no restriction—freely breathing and moving air and energy into your body. Float and relax.

Lovingly touch your heart with your thought and spirit. Picture it as a beautiful valentine full of love. See your heart energetically strong, complete and full. Envision all four chambers healthy and functioning correctly. Notice all the blood vessels clear and having sufficient room for the blood flow. Recognize and trust your heart as the seat of all your emotions, full of clarity and expression, whole and unbroken. Imagine that with your attention you can gently heal any tiny cracks, bruises, or hurts from past brokenness. With loving thoughts, polish your heart to a smooth, shiny new surface. Know that your heart is smiling and happy with expression and a renewed abundance of joy.

Slowly, let your awareness travel down and acknowledge your entire esophagus from your throat to your stomach. See its pathway as clear, open and functioning well. Notice your stomach being pleased with the healthy food it is given, enabling it to function and digest and work with that food to bring nutrients and energy to your entire body. Breathe deeply and give thanks.

You alone know how your body feels. No one else care; no one else knows but you.

CHÖGYAM TRUNGPA, RINPOCHE

Meditate quietly on your pancreas, hidden under the V of the ribcage. Allow that pancreas to be confident and full of self-esteem. See it faithfully working daily to keep your digestion functioning and blood sugar in balance. Envision it being vibrant, healthy and active throughout your entire lifetime.

Crossover to the right of your body's midline and acknowledge your liver and gallbladder. See the red color of the liver and the green of the gallbladder. Notice them happy and smiling, unbound by anger and resentment. Thank your liver and gallbladder for doing their hard, hard job of cleansing the blood, making and storing bile, helping with digestion and other functions. Recognize them working like clockwork together as you pamper your liver and gallbladder through healthy lifestyle choices.

Look to the left side of the lower ribcage and visualize your spleen pleasantly participating with all of the organs to keep your blood system pure and vibrant. See the spleen keeping quality control of the blood, keeping it circulating and healthy. Infuse your spleen with confidence, character and love as you continue to energize your body.

Let your imagination acknowledge the continuous flow from mouth to esophagus to the small intestine through the ileo cecal valve to the large intestine. See this continuous digestive flow of energy and the breaking down of food into the building blocks of life. Envision that energizing vital force growing from the nutrients being absorbed from your system.

Say "yes" to your kidneys happy and smiling, gleefully filtering your blood, saving the good and reusable factors and pushing out the toxins, poisons and excess fluid. At rest, see your kidneys serene and calm in response to healthy liquids and nutrients, pleased to do their work and no longer holding onto fear. Envision your kidneys full of energy and light, moving your body forward.

All women, affectionately perceive your uterus and ovaries. See these inner parts as the deepest essence of the woman. Marvel at the growth potential and nurturing aspect of these loving organs. See them contentedly participating in the whole body throughout all stages of your life. Notice the uterus in synchrony with all body rhythms. Listen and see the thyroid, uterus and ovaries communicating correctly with each other and maintaining every function in proper flow. Continue to breathe life-giving energy into your body.

All men, visualize your prostate and testicles. Contemplate your prostate being of correct size and texture. Mentally remove any aspect of inflammation or overgrowth. Envision your testicles as healthy and functioning optimally with proper hormone secretion. Know that this deepest reflection of your manhood is balanced, healthy, and whole.

Through your own meditation and visualization, create the completeness that allows all your body parts to work together. Once you've acknowledged all the organs and body parts, see your total self and acknowledge your entire being: body, mind, and spirit.

Relax, rejuvenate, energize. Most of all, enjoy *being* in the beautiful healthy body that you have helped create for yourself, now and for the rest of your life.

Endnotes

CHAPTER ONE

1. Beardall, Alan G., D.C. "Differentiating The Muscles of the Low Back and Abdomen: Selected Papers of the *International College of Applied Kinesiology*." Lawrence, KS: *International College of Applied Kinesiology*, 1980.
2. Beardall, Alan G., D.C. *Clinical Kinesiology, Vols. I, II, III, IV, V.* Lake Oswego, OR: A.G. Beardall, D.C., Inc., 1980, 1981, 1982, 1983, 1985.
3. Bond, Jack, ed. "Clinical Kinesiology—A Personal Focus." *Clinical Kinesiology Organization for Research and Education*. Portland, OR: Human Bio-dynamics, Inc., 1993.

CHAPTER TWO

1. Diamond, John. *Your Body Doesn't Lie*. New York: Warner Books, 1979, p. 27.
2. Matsumoto, Kiiko and Birch, Stephen. *Five Elements & Ten Stems: Nan-Ching theory, diagnosis, and practice*. Brookline, MA: Paradigm Publications, 1989.

CHAPTER THREE

1. Shu Jing, (Historical Classic). Anon. *Science and Civilization in China V, Part III.* New York: Joseph Needham. ca. Zhou dynasty.
2. Wang Shu He. *Commentary on the Nan Ching.* (Nan Ching, Classic of Difficulties.) Anon., circa 100 B.C.–100 A.D., Second edition, 1970.
3. Matsumoto, Kiiko and Birch, Stephen. *Five Elements & Ten Stems: Nan-Ching theory, diagnosis, and practice.* Brookline, MA: Paradigm Publications, 1989.
4. Dale, Theresa, N.D. *NER's (Neuro Emotional Remedies).* Douglas, WY: Nutri-West® Publishers, 1992, p. 2.
5. King Solomon. Proverbs 18:21. *The Holy Bible: Old And New Testaments.* Wichita, KS: Heirloom Bible Publishers, Inc. 1964, p. 410.
6. Dale, see note 4..
7. Borysenko, Joan, Ph.D. *Fire in the Soul: A New Psychology of Spiritual Optimism.* New York: Warner Books, 1993.
8. Beardall, Alan G., D.C. *Clinical Kinesiology, Vols. I, II, III, IV, V.* Lake Oswego, Oregon: A.G. Beardall, D.C., Inc., 1980, 1981, 1982, 1983, 1985.
9. Justice, Blair, Ph.D. *Who Gets Sick.* Los Angeles, CA: Jeremy Tarcher, Inc., 1988.
10. *Ibid.,* p. 30.
11. Cousins, Norman. *Anatomy of an Illness as Perceived by the Patient.* New York: Norton, 1979.
12. Cousins, Norman. *The Healing Heart.* New York: Norton, 1983.
13. Justice, *Who Gets Sick.* p. 39.
14. Ornstein, Robert. *The Amazing Brain.* Boston: Houghton-Mifflin, 1984.

CHAPTER FOUR

1. Mann, John and Short, Lar. *The Body of Light.* Boston: Charles E. Tuttle Company, Inc., 1990, p. 31.
2. Leadbeater, C.W. *The Chakras.* Adyar, Madras, India: Theosophical Publishing House, 1927, p. 4.

3. *Ibid.*, p. 5.

4. *Ibid.*, p. 5.

5. *Ibid.*, p. 12.

6. Mann, J. and Short, L. *The Body of Light.* See Note 1, pp. 27, 28.

7. Leadbeater, C.W. *The Chakras.* Adyar, Madras, India: Theosophical Publishing House, 1927, p. 15.

8. *Ibid.*, p. 15.

9. Bach, Edward. *Heal Thyself.* London: C.W. Daniel Co. Ltd., 1931.

10. Bates, William H. *The Bates Method for Better Eyesight Without Glasses.* New York: H. Holt Co., 1943.

11. Leadbeater, *The Chakras*, see Note 7, p. 15.

CHAPTER FIVE

1. Murphy, Anne S. et al. "Kindergarten students' food preferences are not consistent with their knowledge of the dietary Guidelines." *Journal of the American Dietetic Association.* 95: no. 2, p. 219-223.

2. Bland, Jeffrey, Ph.D. "Managing Arthritis" Audiotape lecture of the KEEPING HEALTHY SERIES. Side 1, Gig Harbor, WA: HealthComm, Inc. 1986.

3. Null, Gary, Ph.D. *Gary Null's Complete Guide to Healing Your Body Naturally.* New York: McGraw-Hill Book Company, 1988, p. 183.

4. Sanchez, Albert, et al. "Role of sugars in human neutrophilic phagocytosis." *The American Journal of Clinical Nutrition,* 26: no. 11, pp. 1180-1184.

5. Nambudripad, Devi S. *Say Goodbye To Illness.* Buena Park, CA: Delta Publishing, 1993.

CHAPTER SIX

1. Justice, Blair, Ph.D. *Who Gets Sick.* Los Angeles, CA: Jeremy Tarcher, Inc., 1988, p. 154.

2. Geison, Gerald L. *The Private Science of Louis Pasteur*. Princeton, N.J.: Princeton University Press, 1995, p. 163. and from Pasteur, Louis. *Oeuvres VI*, pp. 290-291. (Refer to the "Table chronique.")

3. Lanctôt, Guylaine, M.D. *The Medical Mafia: How to Get Out of it Alive and Take Back our Health and Wealth*. Miami: Here's The Key, Inc., 1995, pp. 123-130. and *What you NEED to know about immunizations (to protect your health and your rights!)* World Chiropractic Alliance pamphlet, 1995.

4. Moskowitz, Richard, M.D. "The Case Against Immunizations." *Journal of the American Institute of Homeopathy*, American Institute of Homeopathy, Washington, D.C.: 1983, p. 15.

5. *Ibid.*, p. 7.

6. *Ibid.*, p. 7-25.

7. Coulter, Harris, M.D. *Vaccination, Social Violence and Criminality— The Medical Assault on the American Brain*. Berkeley, CA: North Atlantic Books, 1990.

8. Moskowitz, "The Case Against Immunizations." See Note 4, pp. 7-25.

9. Lanctôt, *The Medical Mafia*. See Note 3.

10. Mendelsohn, Robert S., M.D. *Male Practice: How Doctors Manipulate Women*. Chicago: Contemporary Books, Inc., 1981, p. 84.

11. Rogers, Sherry A., M.D. *Tired or Toxic? A Blueprint for Health*. Syracuse, New York: Prestige Publishing, 1990, p. 359.

12. Geison, G. *The Private Science of Louis Pasteur*. See note 2.

13. *Ibid.*, p. 128.

CHAPTER SEVEN

1. Rasic, Jeremija, Lj. and Kurmenn, Joseph A. *Bifidobacteria And Their Role*. Boston, MA: Birkhauser Verlag, 1983, p. 22.

2. Hentges, D.J. "Does diet influence human fecal microflora composition? *Nutrition Review* 38: pp. 329-337. and, Jawetz, E., Melnick, J.L., and Adelberg, E.A. *Review of Medical Microbiology 13th edition*, Los Altos, CA: LANGE Medical Publications, 1978.

3. Mintz, Morton. *The Therapeutic Nightmare*. Boston: Houghton-Mifflin, 1965.

4. Bland, Jeffrey, Ph.D. *New Clinical Breakthroughs In The Management of Chronic Fatigue Syndrome, Intestinal Dysbiosis, Immune*

Dysregulation and Cellular Toxicity. Gig Harbor, Washington: Health Comm, Inc., 1992, p. 33.

CHAPTER EIGHT

1. Becker, Robert O., M.D. *Cross Currents: The Perils of Electropollution, The Promise of Electromedicine.* Los Angeles: Jeremy P. Tarcher, Inc., 1990, p. 69.
2. Pelletier, Kenneth. *Longevity: Fulfilling Our Biological Potential.* New York: Delacorte Press, 1981, p. 161.
3. Becker, *Cross Currents.* p. 92.
4. *Ibid.*, p. 108.
5. *Ibid.*, p. 187.
6. *Ibid.*
7. Brodeur, Paul. *The Great Power-Line Cover-Up: How the Utilities and the Government Are Trying to Hide the Cancer Hazards Posed by Electromagnetic Fields.* New York: Little, Brown and Company, 1993.
8. *Ibid.*
9. Pinsky, Mark A. *The EMF Book.* New York: Warner Books, 1995. p. 121.
10. Slesin, Louis, Ed. *Draft NCRP Report Seeks Strong Action To Curb EMFs.* Microwave News, Vol. XV, No. 4, July/August, 1995, p. 1.
11. The National Council on Radiation Protection and Measurements (NCRP). *Section 8 of the Report of NCRP Scientific Committee 89-3 on Extremely Low Frequency Electric and Magnetic Fields.* United States Congress. Reprinted in Microwave News, Vol. XV, No. 4, July/August, 1995, pp. 12-15.
12. Wertheimer, Nancy and Leeper, Edward. "Electric Wiring Configurations and Childhood Cancer." *American Journal of Epidemiology* 109: pp. 273-284.
13. Savitz, D.A., Wachtel, H. Barnes, F. A. et al. "Case Control Study of Childhood Cancer and Exposure to 60-Hz Magnetic Fields." *American Journal of Epidemiology* 128: pp. 21-38.
14. Ahlbom, Anders and Feychting, Maria. "Magnetic Fields and Cancer in Children Residing Near Swedish High Voltage Power Lines." *American Journal of Epidemiology* 138: no. 7: pp. 467-481.

15. Wertheimer, Nancy and Leeper, Edward. "Possible Effects of Electric Blankets and Heated Waterbeds on Fetal Development." *Bioelectromagnetics* 7: pp. 13-22.

16. Associated Press wire report, June 15, 1994, and National Institute of Environmental Health Sciences and U.S. Dept. of Energy (DOE/EE-0040), *Questions and Answers About E.M.F. Electric and Magnetic Fields Associated With the Use of Electric Power.* January, 1995, p. 20.

17. Sobel, Eugene, Davanipour, Zoreh, and Pey-Jiuan, Lee. "Occupations with Exposure to Electromagnetic Fields: A Possible Risk Factor for Alzheimer's Disease." *American Journal of Epidemiology* 142: no 5, p. 515.

18. M. Riversong (personal communications, 1992-1995).

19. *Ibid.*

20. Becker, Robert O., M.D. and Selden, Gary. *The Body Electric: Electromagnetism and the Foundation of Life.* New York: William Morrow and Company, Inc., 1985, p. 316.

21. *Ibid.*

22. National Institute of Environmental Health Sciences and U.S. Dept. of Energy (DOE/EE-0040), *Questions and Answers About Electric and Magnetic Fields Associated With the Use of Electric Power.* January, 1995.

23. Wertheimer, N. and Leeper, E. "Possible Effects of Electric Blankets..."

24. National Institute of Environmental Health Sciences, see note 22.

25. Becker, *Cross Currents*, p. 249.

26. *Ibid.*, pp. 248-266.

27. RAYA Subtle Energy Products. (Interview with William Tiller, Ph.D.) "A Review of RAYA Technology." San Diego, CA: RAYA Subtle Energy Products, December, 1994. Photocopied.

28. K. Lesser (personal communications, 1992-1995).

CHAPTER NINE

1. Gazella, Karolyn A. Ed., *Health Counselor.* Green Bay: IMPAKT Communications, Inc. 7: No. 6, December/January, 1996, p. 7.

2. Lark, Susan, M.D. *PMS: Self-Help Book: A Woman's Guide.* Berkeley, CA: Celestial Arts, 1984.
3. Wigmore, Ann. *The Wheatgrass Book.* Garden City Park, NY: Avery Publishing, 1985.

CHAPTER TEN

1. Rodale, J.I. *The Healthy Hunzas.* Emmaus, PA: Rodale Press, 1948.

CHAPTER ELEVEN

1. Airola, Paavo, M.D. *Stop Hair Loss.* (Revised Edition) Sherwood, OR: Health Plus Publishers, 1994.
2. Covey, Stephen R. *The 7 Habits of Highly Effective People.* New York: Fireside, 1989.
3. Quillin, Patrick, Ph.D., R.D. *The Wisdom of Amish Folk Medicine.* North Canton, OH: The Leader Co, Inc., 1993.
4. Kulvinskas, Viktoras. *Survival Into The 21st Century.* Fairfield, IA: Omangod Press, 1975.
5. Aesoph, Lauri M., N.D. "Coping With Male Infertility." *Delicious!* September, 1995, p. 50.
6. Green, James. *The Male Herbal.* Freedom, CA: The Crossing Press, 1991.
7. Gerson, Max, M.D. *A Cancer Therapy: Results of Fifty Cases.* 5th edition. Bonita, CA: Gerson Institute, 1990.
8. Ibid., p. 101.
9. Fink, John M. *Third Opinion.* Garden City Park, NY: Avery Publishing, 1992.

Appendix

ASSOCIATIONS/PROFESSIONALS AND PRODUCT/RESOURCE GUIDE

ASSOCIATIONS AND PROFESSIONALS

Susan L. Levy, D.C.
Advanced Health Systems
P. O. Box 58
Durango, CO 81301

1-800-770-6704

Dr. Susan Levy is in private practice. Available for seminars, lectures and consultation. She also provides information, referrals and a mail order supplement service for patient needs and requests.

The Alan G. Beardall Foundation
Christopher Beardall, D.C.
6291 S.W. Pamela Street
Portland, OR 97219

E-mail address: beardall@msn.com

Research and scholarship organization designed to further the work of the late Alan G. Beardall, D.C. Provides information, teaching manuals, books for professionals who wish to learn the Clinical Kinesiology technique.

❁ ❁ ❁

International Academy of Clinical Acupuncture
John A. Amaro, D.C., F.I.A.C.A, Dipl. Ac.
Box 1003
Carefree, AZ 85377

1-602-488-9787

Academic programs and training seminars for professionals who wish to become certified in acupuncture.

❁ ❁ ❁

Acupressure Institute
1533 Shattuck Avenue
Berkeley, CA 94709

1-510-845-1059

Information, training, referrals.

❁ ❁ ❁

American Association of Acupuncture and Oriental Medicine
4101 Lake Boone Trail
Suite 201
Raleigh, NC 27607

1-919-787-5181

National referral of professional acupuncturists.

❁ ❁ ❁

American Association of Naturopathic Physicians
2366 Eastlake Avenue
Suite 322
Seattle, WA 98102

1-800-206-7610

Listing of nationwide professionals, newsletter.

❁ ❁ ❁

American Colon Therapy Association
11739 Washington Boulevard
Los Angles, CA 90066

1-310-390-5424

National referral of therapists, seminars, training, information, pamphlets.

❁ ❁ ❁

The American Herbalists Guild
P. O. Box 1683
Sequel, CA 95073

Information, training directory, membership.

❁ ❁ ❁

Gerson Cancer Therapy
P. O. Box 430
Bonita, CA 91908

1-619-472-7450

Alternative cancer therapies.

❁ ❁ ❁

International College of Applied Kinesiology (ICAK)
P.O. Box 905
Lawrence, KS 66044-9005

(913) 542-1801
(913) 542-1746 (Fax)

❁ ❁ ❁

International Institute of Reflexology
P. O. Box 12462
St. Petersburg, FL 33733

1-813-343-4811

Information, publications, referrals.

❁ ❁ ❁

International Foundation for Homeopathy
2366 Eastlake Avenue, East
Suite 301
Seattle, WA 98102

1-206-324-8230

Referrals of homeopathic health practitioners.

❁ ❁ ❁

International Health Foundation
Dr. William Crook
Box 3494
Jackson, TN 38303

1-901-423-5400

*Professional association for treatment of Candida and CFIDS founded by
Dr. William Crook. Information, Dr. Crook's books, newsletter, referrals.*

❁ ❁ ❁

International Institute for Bau-biology and Ecology, Inc. (IBE)
Helmut Ziehe
Box 387
Clearwater, FL 34615

1-813-461-4371

Non-profit organization that informs and educates the general public about environmental concerns adversely impacting personal health. Seminars, lectures, professional certification classes and products which address toxic chemicals and EMF pollution.

❀ ❀ ❀

International Kinesiology College (IKC)
Hurbigstrasse 157
CH-8454 Buchberg
Sqitzerland

Phone: 011 41-1-8677-14-77

❀ ❀ ❀

National Center for Homeopathy
801 North Fairfax
Suite 306
Alexandria, VA 22314

1-703-548-7790

Information, referrals of homeopathic health professionals.

❀ ❀ ❀

Microwave News and/or VDT News
Box 1799
Grand Central Station
New York, NY 10163

1-212-517-2800
1-212-734-0316 (Fax)

Newsletter informing public of risks of EMFs.

❀ ❀ ❀

National Vaccine Information Center
512 W. Maple Avenue
Suite 206
Vienna, VA 22180

1-703-938-0342
1-703-938-5768 (Fax)

National non-profit educational center devoted to preventing vaccine injury and death. Information, advocate line.

Pain Clinic
Devi S. Nambudripad, D.C., O.M.D., Ph.D.
6714 Beach Blvd.
Buena Park, CA 90621

1-714-523-0800

Appointments or referrals for doctors using Nambudripad Allergy Elimination Technique, newsletter, books.

❁ ❁ ❁

Simonton Cancer Center
P. O. Box 890
Pacific Palisades, CA 90272

1-310-459-4434

Center for guided imagery healing. Information, referrals.

❁ ❁ ❁

Touch For Health Association of America (TFHA)
 6955 Fernhill Dr., Ste. 2
 Malibu, CA 90265

 (800) 466-8342; (310) 457-8343
 (310) 457-9287 (Fax)

❁ ❁ ❁

The Wellness Center for Research and Education, Inc.
Attention: Dr. Theresa Dale
13050 San Vicente Blvd.
Los Angeles, CA 90049

1-310-656-7117

Researcher and distributor of Neuro Emotional Remedies, training classes, information, clinic.

PRODUCT/RESOURCE GUIDE

Amino Acids

Jo-Mar Laboratories
251-B East Hacienda
Campbell, CA 95008

1-800-538-4545

Mail order distributor of amino acids. Offers 10% discount on first order.

✿ ✿ ✿

Bach Flower Remedies

Pegasus Products, Inc.
P.O. Box 228
Boulder, CO 80306

1-800-527-6104

Ellon USA, Inc.
644 Merrick Road
Lynbrook, New York 11563

1-516-593-2206

Distributors of Bach Flower Remedies.

✿ ✿ ✿

Capricin

Probiologics
807 148th Avenue N.E.
Redmond, WA 98052

1-800-678-8218

Information and referrals only.

✿ ✿ ✿

Celtic Sea Salt

Grain and Salt Society
273 Fairway Drive
Asheville, NC 28805

1-916-872-5800
1-916-872-5524 (Fax)

Distributors of Celtic Sea Salt.

❁ ❁ ❁

Citricidal®

Nutri-biotics
P.O. Box 238
Lakeport, CA 95453

1-800-225-4345
1-707-263-0411

Information and referrals only.

❁ ❁ ❁

Core-Level™ *Nutritional Supplements*

Nutri-West®
P.O. Box 950
2130 E. Richard Street
Douglas, WY 82633

1-800-443-3333

Distributor of Dr. Alan Beardall's Core-Level™ *nutrients including Core-Level Thyro*™*, Core-Level Thyroid*™*, Core-Level Brain-Spinal*™*, Core-Level Kidney*™*, D-Tox*™*, Prosta X*™ *and other Core-Level*™ *formulas. Information and referrals.*

EMF Clearing Devices

Advanced Living Technology
Ken Lesser
2442 Meade Street
Denver, CO 88021-4440

1-800-317-9969
1-303-480-9226
1-303-480-9416 (fax)
E-mail: EMFrelief@aol.com

Distributor of Clarus EMF-clearing devices which protect against electro-magnetic radiation. Full product line.

✿ ✿ ✿

Environmental Testing

Michael Riversong
Qi Consulting
P.O. Box 2775
Cheyenne, WY 82003

1-303-829-0774

Comprehensive private environmental consulting: EMFs, air quality, design evaluation, ergonomics, geo-biology.

✿ ✿ ✿

Gauss Meters

Home Safe Inc.
Jim Butler, President
2212 St. Claire Ct.
Santa Clara, CA 95054

1-800-800-3400
1-408-727-3337
1-408-727-3336 (Fax)

Manufactures and sells MAGNATEC 60 gauss meters for home testing of EMFs. Provides environmental testing.

✿ ✿ ✿

Herbal Remedies

Herb Pharm
Ed Smith
P.O. Box 116
Williams, OR 97544

1-800-348-4372

Distributor of wild crafted herbs, teas, tinctures. Provides retail sales to the public.

Professional Botanicals™
2675 Industrial Drive
Building 3
Ogden, UT 84401

1-801-731-3190

*Distributors of Immu Cell™. **Referrals provided.***

❁ ❁ ❁

Homeopathic Remedies

Professional Health Products, Ltd.
79 N. Industrial Park
211 Overlook Drive
Bay #5
Sewickley, PA 15143

1-800-929-4133

Distributors of Bacterial and Viral Immune System Stimulators, Renal Drops, Neuro-Calming Drops, Anxiety Drops and Anti-Depression Drops. Also, Metex for purging heavy metals. Referrals provided.

❈ ❈ ❈

Natural Progesterone

Klabin Marketing
115 Central Park West
New York, NY 10023

1-800-933-9440
1-212-877-3632

Distributors of natural progesterone. Provides retail sales to the public.

Professional Health Products, Ltd.
79 N. Industrial Park
211 Overlook Drive
Bay #5
Sewickley, PA 15143

1-800-929-4133

Distributors of natural progesterone.

❈ ❈ ❈

Neuro Emotional Remedies

The Wellness Center for Research and Education, Inc.
Attention: Dr. Theresa Dale
23410 Civic Center Way
Suite E-11
Malibu, CA 90265

1-310-317-4441

Originator and distributor of Neuro Emotional Remedies, training classes, information, referrals, clinic.

❈ ❈ ❈

Nutritional Supplements

Metagenics®, Inc.
971 Calle Negocio
San Clemente, CA 92670

1-800-692-9400

Distributor of nutritional remedies including Immuno Plus™, Ultra Clear®, Ultra Bifidus™, Ultra Dophilus®. Information and referrals.

Nutri-West®
P.O. Box 950
2130 E. Richard Street
Douglas, WY 82633

1-800-443-3333

Distributor of Dr. Alan Beardall's Core-Level™ nutrients including Core-Level Thyro™, Core-Level Thymus™, Core-Level Brain-Spinal™, Core-Level Kidney™, D-Tox™, Prosta X™ and other Core-Level™ formulas.

❖ ❖ ❖

Oxyflex®

Ameriflex
232 N.E. Lincoln
Suite I
Hillsboro, OR 97124

1-800-487-5463

Distributor of Oxyflex. Referrals provided.

❖ ❖ ❖

Panasonic® Shiatsu Acu-Tap II massager

The Better Back Store
7939 E. Arapahoe Road
Greenwood Village, CO 80112

1-800-903-2225 (BACK)
1-303-773-2225

National mail order company.

❁ ❁ ❁

INDEX

Energy *(continued)*

energetic body, 8, 12-13, 19, 30, 32, 36-38, 41, 57, 66, 72-73, 76, 80, 84, 111-113, 122, 125, 133, 136, 141, 143, 145, 148, 157, 159, 162-163, 166, 174, 217-219, 225, 234, 236-237, 242-243, 245, 249, 286, 325-326, 330

energetic compatibility (of food), 145, 163

energetic imbalance, 13, 30, 57, 73, 275, 301, 320

energetic incompatibility (of food or supplements), 166

energetic muscle testing, 9, 104-105, 133, 160, 163, 174, 235, 266, 291 *(Also see:* Clinical Kinesiology, muscle testing)

energetic therapies (or energy therapy), 12, 14, 71, 127, 160, 219

energy body clock, 37,40-41, 43

energy exercise, 121, 128, 276

energy flow, 17, 32, 65, 73, 78, 127, 131, 332

energy field(s), 38, 76, 213, 218-220, 226, 234, 238, 240, 340

energy system, 1, 4, 6, 32, 36-37, 40, 43, 76, 86, 112, 139, 218-219, 284-285

female energetic system, 76, 243, 245-246, 248, 264, 266-267, 275, 291-292, 295

healing energy, 6, 32, 35-36, 71, 80, 112-113, 128, 135-136, 219, 281, 331

kinetic energy, 37-38

kundalini energy, 115-117

male energetic system, 295, 297-298, 317, 323

organ/energy system, 40-67

unfriendly energy, 213, 215

Environmental illness, 314

Environmental pollution, 29, 144, 217, 227, 232, 347 *(Also see:* Electromagnetic pollution)

Environmental stress, 144, 276

Enzymes, 11, 13, 48, 149, 151-152, 162, 167, 277, 309, 312, 319, 326

Essential fatty acids, 207, 287, 321

Estrogen, natural, 196, 249-250, 275-276, 280, 282, 290

Estrogen replacement therapy, 249

Espy, Burt, 10, 16, 50, 60, 95, 174, 181, 185, 199

Evening Primrose Oil, 263, 287

Exercise, 136, 146, 213, 249, 270, 276, 295

Exercises, 32, 121, 128, 321

Eye disorders, 62, 147

F

False Unicorn Root, 289

Fasting, 121, 142-143, 261-263, 272 *(Also see:* Juice fasting; Liver flush)

Fat, in diet, 29, 66, 207, 311

Fatty acids, essential, 207, 287, 321

Fear, 88, 96-97, 103-104, 108, 118, 123-126, 130-131, 258-259, 332

Female health, 241-296 *(Also see:* Menopause; Premenstrual Syndrome; etc.)

Fetal alcohol syndrome, 158

Feychting, Maria, 222, 339

Fink, John, 320, 327, 341

Fire Element, 86, 91-92, 115, 119, 313

Flaxseed oil, 207, 257-258, 287, 310, 321

Flower Remedies, 6, 14, 113, 123-127, 132-133, 135-137, 348-349

Flowering Willow Herb, 321

Food *(Also see:* Diet; Grain; Milk; Vegetables; etc.)

sensitivities to, 141-155, 157-158, 160-163, 165-166, 194, 196, 201-202, 252-260, 300, 302 *(Also see:* Allergies)

self testing for sensitivities, 162-164

whole foods, 104, 154, 156, 159, 161, 164, 255

Foot reflexology, 346

Friendly bacteria, 185, 191, 194, 202, 205

Fruit, 203, 261, 272, 287

Fruit juicing, 261, 272

ADDITIONAL HEALTH TITLES FROM HOHM PRESS

NATURAL HEALING WITH HERBS
by Humbart Santillo, N.D.
Foreword by Robert S. Mendelsohn, M.D.

Dr. Santillo's first book, and Hohm Press' long-standing bestseller, is a classic handbook on herbal and naturopathic treatment. Acclaimed as the most comprehensive work of its kind, *Natural Healing With Herbs* details (in layperson's terms) the properties and uses of 120 of the most common herbs and lists comprehensive therapies for more than 140 common ailments. All in alphabetical order for quick reference. Includes special sections on: • Diagnosis • How to make herbal remedies • The nature of health and disease • Diet and detoxification • Homeopathy. . .and more.

Over 175,000 copies in print.

Paper, 408 pages, $16.95 ISBN: 0-934252-08-4

• • •

INTUITIVE EATING:
EveryBody's Guild to Vibrant Health and Lifelong Vitality Through Food
by Humbart "Smokey" Santillo, N.D.

The natural voice of the body has been drowned out by the shouts of addictions, over-consumption, and devitalized and preserved foods. Millions battle the scale daily, experimenting with diets and nutritional programs, only to find their victories short-lived at best, confusing and demoralizing at worst. *Intuitive Eating* offers an alternative — a tested method for: • strengthening the immune system • natural weight loss • increasing energy • making the transition from a degenerative diet to a regenerative diet • slowing the aging process.

Paper, 450 pages, $16.95 ISBN: 0-934252-27-0

• • •

TO ORDER PLEASE SEE ACCOMPANYING ORDER FORM.

ADDITIONAL HEALTH TITLES FROM HOHM PRESS

10 ESSENTIAL HERBS, REVISED EDITION
by Lalitha Thomas

Peppermint. . .Garlic. . .Ginger. . .Cayenne. . .Clove. . . and 5 other everyday herbs win the author's vote as the "Top 10" most versatile and effective herbal applications for hundreds of health and beauty need. *Ten Essential Herbs* offers fascinating stories and easy, step-by-step direction for both beginners and seasoned herbalists. Learn how to use cayenne for headaches, how to make a facial scrub with ginger, how to calm motion sickness and other stomach distress with peppermint, how to make slippery-elm cough drops for sore-throat relief. Special sections in each chapter explain the application of these herbs with children and pets too.

Over 25,000 copies in print.

Paper, 395 pages, $16.95. ISBN: 0-934252-48-3

• • •

LIVE LONGER LIVE HEALTHIER: THE POWER OF PYCNOGENOL
by Hasnain Walji, Ph.D.

Pycnogenol (extracted from pine bark or grape seeds) • slows the aging process by reducing cell damage • acts as a free-radical scavenger, 50 times more effective than Vitamin E, and 20 times more effective than Vitamin C! • reduces the free-radical damage that encourages **cancer** • guards against **stroke** by protecting brain and nerve tissue • relieves the distress of **arthritis** by reducing inflammation • helps in the prevention and reversal of **heart disease** • strengthens the immune system and thus fends off degenerative disease. This new book by medical journalist and researcher, **Hasnain Walji, Ph.D.** author of *Melatonin* (HarperCollins, 1995), gives practical advice for how to add this invaluable substance to the diet, and contains the most up-to-date research on this wonder antioxidant.

Paper, 120 pages, $12.95 ISBN: 0-934252-63-7

• • •

TO ORDER PLEASE SEE ACCOMPANYING ORDER FORM.

ADDITIONAL HEALTH TITLES FROM HOHM PRESS

FOOD ENZYMES - THE MISSING LINK TO RADIANT HEALTH
by Humbart "Smokey" Santillo, N.D.

Immune system health is a subject of concern for everyone today. This book explains how the body's immune system, as well as every other human metabolic function, requires enzymes in order to work properly. Food enzyme supplementation is more essential today than ever before, since stress, unhealthy food and environmental pollutants readily deplete enzymes from the body. Dr. Santillo's breakthrough book presents the most current research in this field, and encourages simple, straightforward steps for how to make enzyme supplementation a natural addition to a nutrition-conscious lifestyle. Special sections on: • Longevity and disease • The value of raw food and Juicing • Detoxification • Prevention of allergies and candida • Sports and nutrition.

Over 200,000 copies in print.

Now available in both Spanish and German language versions.

Paper, 108 pages. U.S. $7.95 ISBN:0-934252-40-8 (English)
ISBN: 0-934252-49-1(Spanish)

• • •

DHEA: THE ULTIMATE REJUVENATING HORMONE
by Hasnain Walji, Ph.D.

This is the first published book about the age-slowing hormone, DHEA, which is fast being acknowledged as a new "wonder substance." Many studies indicate DHEA's positive usage for athletes and others concerned with losing weight without reducing caloric intake (DHEA blocks a fat-producing enzyme), as an aid to both short and long-term memory loss, and in such conditions as diabetes, cancer, Chronic Fatigue Syndrome, heart disease and immune system deficiencies. Contains a comprehensive but user-friendly review of research and relevant nutritional information.

Paper, 95 pages, $9.95 ISBN: 0-934252-70-X

TO ORDER PLEASE SEE ACCOMPANYING ORDER FORM.

RETAIL ORDER FORM FOR HOHM PRESS HEALTH BOOKS

Name_____ Phone ()_____

Street Address or P.O. Box _____

City _____ State _____ Zip Code _____

	QTY	TITLE	ITEM PRICE	TOTAL PRICE	
1		**10 ESSENTIAL HERBS**	$16.95		
2		**DHEA: The Ultimate Rejuvenating Hormone**	$9.95		
3		**FOOD ENZYMES**	$7.95		
4		**INTUITIVE EATING**	$16.95		
5		**LIVE LONGER, LIVE HEALTHIER**	$12.95		
6		**NATURAL HEALING WITH HERBS**	$16.95		
7		**YOUR BODY CAN TALK: How to Listen...**	$19.95		
			SUBTOTAL:		
			SHIPPING: (see below)		
			TOTAL:		

SURFACE SHIPPING CHARGES

1st book ...$4.00

Each additional item$1.00

SHIP MY ORDER

☐ Surface U.S. Mail—Priority

☐ UPS (Mail + $2.00)

☐ 2nd-Day Air (Mail + $5.00)

☐ Next-Day Air (Mail + $15.00)

METHOD OF PAYMENT:

☐ Check or M.O. Payable to Hohm Press, P.O. Box 2501, Prescott, AZ 86302

☐ Call 1-800-381-2700 to place your credit card order

☐ Or call 1-520-717-1779 to fax your credit card order

☐ Information for Visa/MasterCard order only:

Card #_____–_____–_____–_____

Expiration Date_____

ORDER NOW!
Call 1-800-381-2700 or fax your order to 1-520-717-1779. (Remember to include your credit card information.)